Eva/Ave

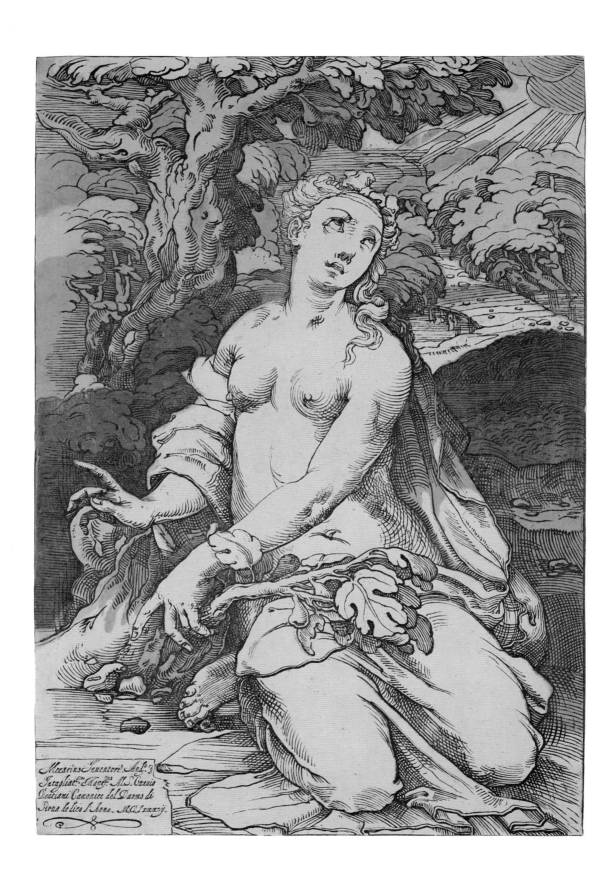

Mecarius Inuentori And:
Intagliat: Mar^o: M.S. Crauio
Occitiani Canonico del Duom di
Siena de fece l'Anno. MDlxxxvj.

Eva/Ave

Woman in Renaissance and Baroque Prints

H. Diane Russell

with Bernadine Barnes

National Gallery of Art, Washington
The Feminist Press at The City University of New York

This book was produced by the Editors Office, National
Gallery of Art, Editor-in-Chief, Frances P. Smyth
Designed by Phyllis Hecht

The type is Galliard, set by BG Composition, Baltimore
Printed on LOE dull by Eastern Press, Inc., New Haven

Published by the National Gallery of Art, Washington, with
The Feminist Press at The City University of New York,
311 East 94th Street, New York, N.Y. 10128
Distributed by The Talman Company, 150 Fifth Avenue,
New York, N.Y. 10011

Library of Congress Cataloging-in-Publication Data
Russell, H. Diane (Helen Diane)
 Eva/Ave: woman in Renaissance and Baroque prints /
H. Diane Russell; Bernadine Barnes, contributor.
 Includes bibliographical references and index.
 ISBN 0-89468-157-5 (pbk.—NGA).
 ISBN 1-55861-040-5 (pbk.—Feminist).
 ISBN 1-55861-039-1 (cloth).
 1. Women in art—Exhibitions. 2. Prints,
Renaissance—Exhibitions. 3. Prints, Baroque—
Exhibitions. 4. National Gallery of Art (U.S.)—
Exhibitions. I. Barnes, Bernadine Ann.
II. National Gallery of Art (U.S.) III. Title.
NE962.W65R87 1990
769'.424'094074753—dc20 90-15521
 CIP

Front cover: Federico Barocci, *The Annunciation*, cat. 36 (detail)
Back cover: Rembrandt van Rijn, *Adam and Eve*, cat. 73
 [only for cloth and NGA paperback editions]
Frontispiece: Andrea Andreani, *Eve*, cat. 75

CONTENTS

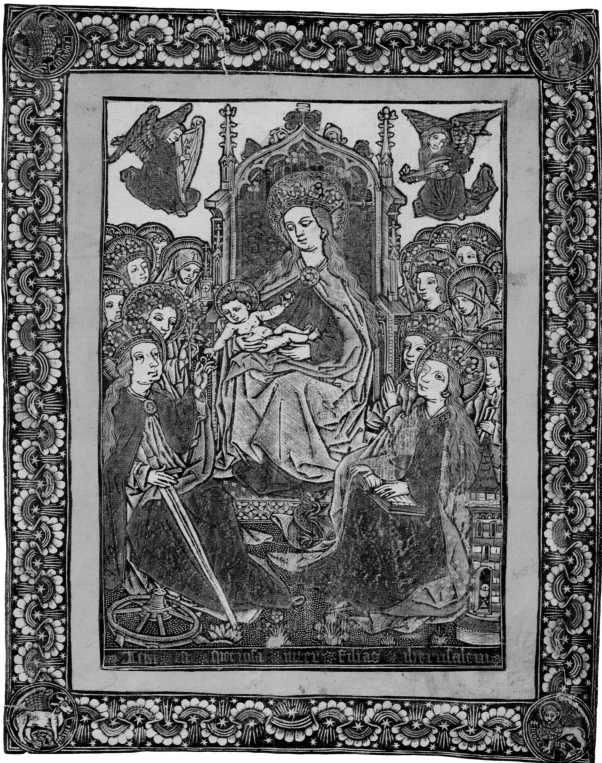

cat. 58

FOREWORD

The National Gallery of Art is pleased to have this opportunity to present to the public a broad selection of our holdings of old master prints from the Renaissance and baroque periods, organized in a thematic exhibition. The theme, the iconography of woman, is a reflection of more than twenty years of increasingly intensive scholarly investigations in the field of gender studies.

The exhibition is also a reflection of the National Gallery's splendid collection of old master prints, supplemented with only two important loans, generously provided by the Museum of Fine Arts, Boston. The richness of our own collection of old master prints is due, above all, to the marvelous gifts, over many years, of the late Lessing J. Rosenwald. The Rosenwald Collection is known throughout the world as one of the major collections in this field. We are, therefore, especially pleased to note that the exhibition commemorates the one-hundredth anniversary of Mr. Rosenwald's birth.

I am grateful to all staff members who have participated in the realization of this large project, and especially to H. Diane Russell, whose idea the exhibition originally was and who has brought it so knowledgeably to fruition, and also to Bernadine Barnes, for her contribution to the catalogue.

J. Carter Brown
Director

PREFACE

The images of women in prints chosen for presentation here have been subject to two criteria that have had a direct bearing on the contents of this exhibition. First, a decision was made at an early date to limit the works included to objects in the National Gallery's collection of old master prints. By adhering to what was available in this collection, we have avoided an even more arbitrary activity: that of creating a "master list" of images of women. We have had no desire to signal particular images as more important than vast numbers of others. The second criterion is that the selection was made by a particular curator, that is, by me. Although I have been receptive to suggestions, I am responsible for the final selection of images, and hence the show is inevitably a product of my judgment and interests. To elaborate a bit: I would gauge my interest in the theme to be dependent on my female gender. (There are, however, a number of men who are prominent in the field of women's studies.) In addition, I would point to certain societal and intellectual occurrences that I have experienced and that have affected me as a scholar and a person. These are: the rise of feminism as a political movement in the past thirty years; the emergence of the interdisciplinary fields of women's studies and gender studies; and the work of a number of art historians who want to understand the functions of the visual arts, past and present, beyond their evident importance as often beautiful objects of intrinsic merit.

Finally, a few comments on the specific nature of the National Gallery's old master print collection are in order. It is a collection that has been put together along well-established and purposely restrictive guidelines. These guidelines may be said to define a focus on prints of high aesthetic merit by important printmakers, some of whom were talented artists in other media as well, especially painting. There has been a further emphasis on securing impressions of fine or exceptional quality;

such impressions were usually made early in the printing process and attended to by the artist himself. These guidelines were followed by the late Lessing J. Rosenwald, the Gallery's principal donor of old master prints, during the many years in which he amassed a remarkable collection and generously gave it to this institution.

The collection, therefore, may be characterized as one rooted in principles of connoisseurship as practiced not only by its donors but also by its curators. Knowledgeable about the history of prints, a very broad and rich field of study, they have paid due attention to the subject matter and iconography of prints, while recognizing that the visual properties and quality of the images have been their paramount concern. This means that the Gallery's collection does not include many of the following types of prints: broadsheets, posters, maps, reproductive prints, didactic material of various sorts. Nor does it have many portraits of actual Renaissance and baroque women. Outside of such queens as Elizabeth I of England and the French queens regent, Marie de Médicis and Anne of Austria, there were, in fact, relatively few portraits of women made in the print media during these periods.

A similar situation exists with regard to women printmakers. Fairly few have been identified from the Renaissance and baroque periods, and this collection contains only a few sheets. In order to maintain a clear focus on the male imaging of females, then, we chose not to include any works known to be by women artists. Had we wished to focus on prints of the eighteenth to twentieth centuries, we would have found it important to include works by both men and women. And that, of course, would have been a different show.

H. Diane Russell
Curator of Old Master Prints

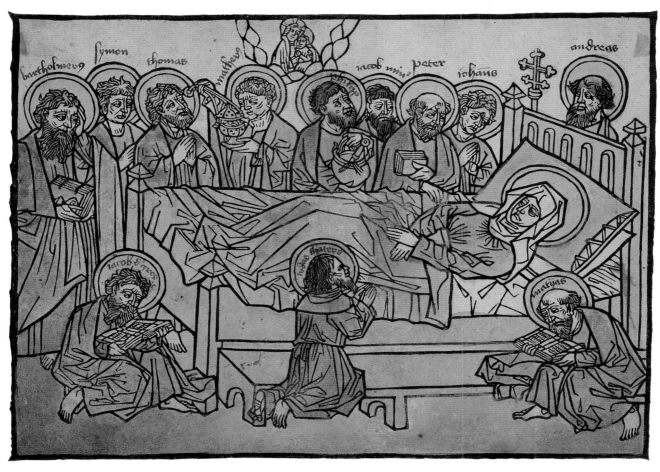

cat. 41

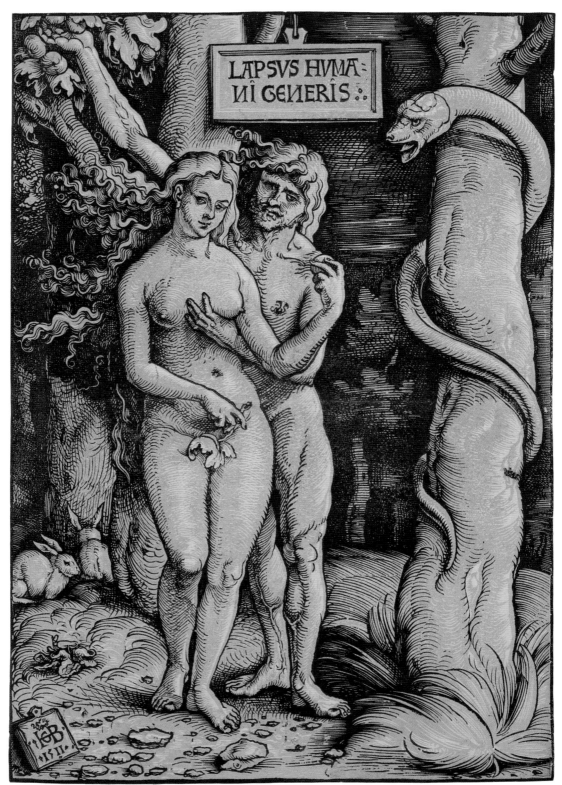

cat. 71

ACKNOWLEDGMENTS

The steadfast support of Andrew Robison, head of the division of prints, drawings, and photographs, has been essential in bringing this project to completion. In addition, I am especially grateful to Bernadine Barnes, who, while on the staff of the National Gallery in 1985 as acting curator of Italian drawings, helped make the selection of prints for the exhibition, and who has contributed an important section to the catalogue. She is now teaching at Wake Forest University.

Many others in the division have given valuable help. Gregory Jecmen has dealt expertly with many aspects of the catalogue. I also wish to thank Susanne L. Cook, Margaret Morgan Grasselli, Sally Metzler, Jane Savoca, David Shen, and Lisa Shovers. Other offices have contributed their customary expertise to the project, especially the editors office, under the direction of Frances P. Smyth, and the department of design and installation, under Gaillard F. Ravenel, Mark Leithauser, and Gordon Anson. My special thanks go to Tam Curry, editor, and Phyllis Hecht, designer, for their work on the catalogue. Thomas McGill of the library tracked down important sources, as always. Two summer interns, John Farmer in 1987 and Elisa Barsoum in 1988, were extremely helpful and, just as important, radiated enthusiasm for the project.

I profited from attending, for four years, the Evening Colloquium on Women in the Renaissance at the Folger Institute, Washington, D.C. Made up of scholars from a number of disciplines, it was a stimulating gathering. Various colleagues and friends have also made useful suggestions with regard to the subject matter of the exhibition, especially Robert Baldwin, Mary Garrard, and Claire Sherman. I am especially indebted to the two official readers of this manuscript, Pamela Askew and Larry Silver, first for their willingness to undertake the task at a late date and hence under considerable pressure; and second, and of great importance, for their astute criticism. The errors that remain, and the lacunae that still necessarily exist, are, of course, solely my own responsibility.

Finally, I appreciate the constant encouragement of Jodi Watts and the constant good cheer of Pompey.

H.D.R.

That angel who greets you with ''Ave''
Reverses sinful Eva's name.
Lead us back, O holy Virgin
Whence the falling sinner came.

Peter Damian, eleventh century
translated and quoted by Henry Kraus
in Broude and Garrard 1982

INTRODUCTION

H. Diane Russell

Many of us will recall this nursery rhyme: "There was a little girl who had a little curl, right in the middle of her forehead. When she was good, she was very, very good, and when she was bad, she was horrid." The same would seem to be the case with grown women. During the middle ages, people especially liked anagrams and sometimes found them to be of high significance, as in the epigraph on the facing page. Eve, the mother of humankind, *Eva*, whom theologians, in particular, had found to be either wholly or partly responsible for the loss of Eden, had sinned against God. She had, moreover, tempted her husband, Adam, with the fruit of the Tree of Knowledge of Good and Evil, and they both ate the fruit. Thereafter, God ordered them to be expelled from Paradise. As a consequence, Adam had had to toil, Eve had had to suffer the pain of childbirth and to be ruled by her husband, and both were made subject to physical death. What is more, humankind has similarly suffered from that original sin ever since, having been born with it. The hope for the descendants of Adam and Eve is to regain Paradise on the day of Judgment. To assist our progress in that direction, there is a second *Eva*, who is to be emulated and prayed to: *Ave, Maria*. "Hail, O favored one, the Lord is with you," said the angel Gabriel. Eve and Mary: quintessentially bad and quintessentially good. One woman was disobedient and lustful, the other was immaculate—born without Original Sin—and herself the closed vessel—the virginal mother—who gave birth to the Savior. She, Mary, body and soul, sits at the right hand of God.

This is an exhibition about *woman* and some of the guises, good and bad, in which she was represented by male artists of the Renaissance and baroque periods, a time span that bridges three centuries, from about 1460 to the later seventeenth century. It consists of 152 prints on 159 sheets. All but two of these are old master prints from the collection of the National Gallery of Art. The works are by artists from Italian, French, German, Dutch, and Flemish geographical regions, and the prints are woodcuts, metalcuts, engravings, and etchings. As is usual with fifteenth-century woodcuts and metalcuts, those included here are by anonymous artists. It is possible that some of these artists were women, for some prints like these are known to have come from nunneries, but the assumption has always been otherwise in scholarly studies.[1] The other prints exhibited are, for the most part, by well-known printmakers, some of whom were also active as painters. These include Schongauer, Dürer, Baldung Grien, Marcantonio Raimondi, G. B. Castiglione, Callot, and Rembrandt.

Many of the images will be familiar to viewers because they are the best known of old master prints: woodcuts by Dürer from his *Life of the Virgin* series, *Bewitched Groom* by Baldung Grien, *Angry Wife* by Israhel van Meckenem, *Susanna and the Elders* by Jegher after Rubens. The choice of works, however, has not been dependent on whether they are well or little known but on their apparent interest and contribution to the theme of the show, woman in her various guises. On examining a vast number of prints featuring women, certain divisions of subject matter became clear. The most obvious is representations of the Virgin, who is simply the woman most frequently depicted in prints of these centuries. Worthy women or heroines, like Lucretia and Judith, were popular during the periods covered, as were images of Eve, often shown with Adam. The "Power of Women" topos, which originated in medieval decorative arts, enjoyed a renascent appeal at the end of the fifteenth and beginning of the sixteenth centuries, propelled in part by the growth and popularity of prints as collectible items. Women like Salome and Delilah were depicted using their female wiles, which is to say sexual power, to overwhelm men who were, in one way or another, their adversaries. During the Renaissance and baroque periods, images of lovers of various ilks also abounded, including those of lovers who are suddenly confronted by death. Finally, there are prints that represent Fortune (*Fortuna*), who was most often depicted as a female nude, or prints with images closely related to Fortune. Although Fortune might seem to embody ideas in conflict with religious beliefs of the time, she was nevertheless considered a powerful force that affected the course of a person's life.

In recent years, many scholars have come to realize and to admit that scholarship is by no means a totally rational and objective enterprise. It is, rather, an activity that is ultimately reflective of its historical period and of the particular individuals who take part in it. If objectivity is an unattainable goal, it nevertheless is one to strive toward. Like most curators, I hope the visual material presented here will engage the interest of both specialists and nonspecialists, will prompt productive debate, and will stimulate new thoughts about and perceptions of works of art, however familiar they may be.

Gendered Images

The visual image is increasingly seen as one discourse among the many in society that form constructs of power and knowledge.[2] Visual representations and language are, indeed, the two principal modes of discourse. That they are deeply gendered has become apparent through the work of many scholars in various disciplines. The word "gender" itself continues to be debated as to its meaning, and the interdisciplinary field of gender studies is distinguished by the variety of approaches and products, not by any kind of unitary vision. No doubt this is a prime reason for the vital and thought-provoking nature of the scholarship.[3] Here, partly for purposes of clarity, I would point to Joan Wallach Scott's definition: "gender is a constitutive element of social relationships based on perceived differences between the sexes, and gender is a primary way of signifying relationships of power."[4] In simplistic terms, gender differences are something that one *learns* from the society in which one lives, society in all of its numerous and specific manifestations: religious beliefs, laws, work, politics, and so on. As Scott has pointed out, these gender differences typically become fixed into the binary opposites male and female, masculine and feminine. They then tend to coalesce into "the appearance of timeless permanence in binary representation."[5]

Images obviously can and do convey gendered ideas about religion, law, work, and the like, but as a powerful mode of discourse in their own right, they need to be examined in their own terms. For art historians who wish to deal with images from the standpoint of gender relationships and significations of power, the ways to do that remain to be mapped out, although there have been valuable beginnings.[6] In the broadest sense, mapping would include the careful attention to differences and similarities between the works of male and female artists, and the responses of male and female viewers to those works at given historical times. In recent years, there have been a number of illuminating studies of how images have been viewed in the past, and how they might now be studied with respect to gender issues. Issues of class and race structures of society, moreover, are seen by many scholars to be intimately conjoined with gender.[7] The importance and complexities of these matters cannot be explored here. They are mentioned in the hope that the viewer/reader will become aware of them, if he or she is not already so. We live in an era when scholarship in the humanities is often contentious, disturbing and abstruse, but it is, I think, above all vivifying.

As indicated above, power is considered to be interlocked with gender. In terms of visual images of women created by male artists, the images may be seen as part of a patriarchal discourse on women, which often asserts itself as *power over women*. As in the case of gender, and inseparable from it, this power is presented in a context that appears natural and logical.[8] Linda Nochlin, for example, has pointed to such "ostensibly realistic representations of the customs of picturesque Orientals" as the nineteenth-century French artist Jean-Léon Gérôme's *Oriental Slave Market* (Sterling and Francine Clark Art Institute, Williamstown). In the painting, a nude woman is having her teeth examined by a prospective male buyer. Nochlin comments that such paintings are "suitably veiled affirmations of the fact that women are actually for sale to men for the latter's sexual satisfaction—in Paris just as in the Near East."[9] Feminist art historians are dedicated to probing images in order to reveal what is really being conveyed by them.

To return to the images at hand: woman is good, woman is bad. She is the Virgin, and she is Eve. There are, of course, gradations between these two polar extremes, and the prints themselves are evidence of the wide-ranging concern with women's conduct. Woman is shown as saint, virgin, carnal temptress, lover, witch, shrew, worthy. There are overlaps, moreover, between some of these categories, especially as regards the sexual nature and behavior of women.

In the images presented, the degree to which violence and eroticism are emphasized may well be surprising. Few of the depictions communicate tranquillity, much less warmth, between the sexes. Love as expressed in tenderness toward another is found almost exclusively in the prints devoted to the Virgin and Child. By contrast, the carnality of love is everywhere: in the seductive images of Eve and Venus, in the frantic grasping of Potiphar's wife after the fleeing Joseph, in the calculating exchange of money between man and prostitute. During the periods under survey, the most patently evil use of sexual power was supposed to be exercised by witches (see cats. 104, 105). According to the authors of the infamous *Malleus Maleficarum*, a treatise on witches first published about 1486, "All witchcraft comes from carnal lust, which is in women insatiable."[10] Even in the section devoted to worthies or heroines, many of the images are laced with sex and brutality. Judith, for example, does not simply courageously decapitate Holofernes, the enemy of her people (cat. 32). She pushes her fingers into his mouth and thrusts vigorously downward with a large knife, and she seems to do this with a cold-blooded enjoyment.

Of course some images here are much less grave in their presentation. Indeed some are simply rather straightforwardly titillating in their sexual components (see cat. 114). That women are thought to hold power over men, however, and that it is sexual power, is made explicit in the prints depicting the "Power of Women" topos. In *Phyllis Riding Aristotle* (cat. 87), a key representation, the august and wise philosopher is shown down on all fours, like a beast, a situation to which he has been brought by having lusted after Phyllis. It was men, during the Renaissance and baroque periods, who

· H ·
BVRGKMAIR

Joß de Negker.

cat. 132

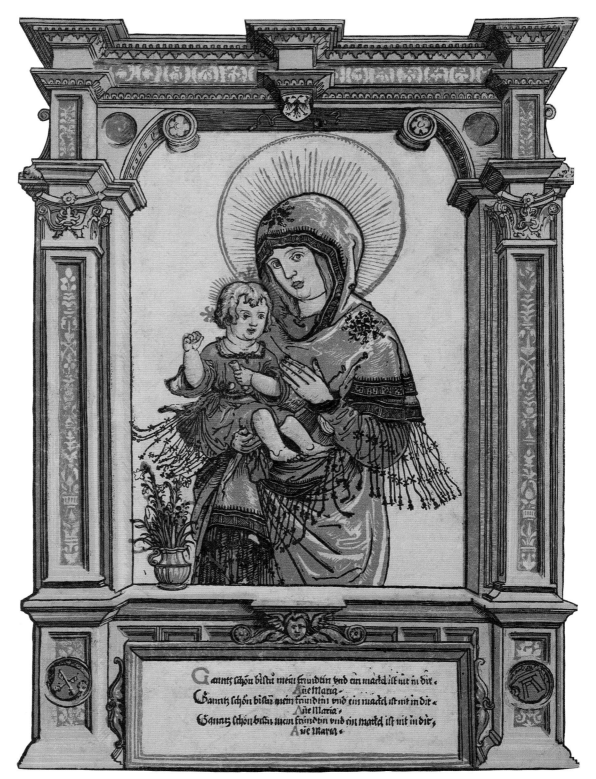

cat. 53

were considered to have the capacity for the highest forms of reason. The humiliation of Aristotle, paradigmatic man of reason, clearly conveys the dangers of women.

The images of the Virgin present a very different woman, and one who was consistently extolled as the ultimate role-model for ordinary women. This is true despite the fact that in many respects she is a figure who is far removed from what is ordinary. She was born without sin, she gave birth but remained a virgin, and she was assumed into heaven immediately after her death. The Virgin is a woman of enormous beneficent power, and that power is manifested in countless images of her (for example, cat. 46). For both men and women, she acts as intercessor with God, a manifestation of her love for humankind and her merciful attitude. At the same time, she was obedient to God, accepting his decision that she should bear his son (cat. 36). Having borne Christ, she was always the loving, caring mother, from his infancy to the moment of his death and afterward (see cats. 40, 48, 54). In all respects, then, she represents the best of female qualities, while at the same time, she exceeds them as a unique, perfect woman.

The recognition that images are gendered is no doubt one step toward an understanding of why gendering is so prevalent. Images that are genuinely misogynistic are more difficult to absorb and understand. It is not surprising that a number of feminist scholars in various disciplines have turned to the study of psychoanalytic feminism in an effort to enhance their understanding of sex and gender in culture.[11]

Men and Women Living in the Renaissance and Baroque Periods

In a survey exhibition of considerable chronological and geographical scope, only the briefest outline of the societal history relevant to our study can be provided. In recent years, many historians have focused their efforts on aspects of the private lives of men, women, and children during the Renaissance and baroque periods. This scholarship has added immeasurably to our knowledge and has created a vivid and fascinating picture of the past. The information that has been gathered, often from various kinds of records in archives, must itself be carefully interpreted; significantly, many historians now see their discipline more as an art than a science. In any case, more is now known than ever before about the lives of women in these periods.[12]

Being born a biological male or female was perhaps the most portentous sign in one's life, leading almost always to gendered patterns of existence. At the beginning of the Renaissance, following the thought of both Aristotle and Galen, woman was determined by medical doctors to be anatomically and physiologically less fully developed than man.[13]

"She is further characterized by deprived, passive and material traits, cold and moist dominant humours and a desire for completion by intercourse with the male."[14] After 1600, woman was no longer considered to be an imperfect male, but certain other important medical ideas continued to be held as before. She was still thought to have colder and moister humors. Her uterus was said to make her prone to irrational behavior so that she lacked the mental powers and control of man. This made her both more violently passionate and more vengeful, but also more compassionate. Altogether, she was considered to be best suited for private as opposed to public life, to taking care of children, and to being herself protected by a man. As Ian Maclean has pointed out, the medical doctors of the time thus provided a "natural" justification for women's relegation to the private sphere and a foundation for such other matters as the legal subservience of women.[15]

The biological sex of a child could also bear on whether or not the child survived infancy. In wealthy Florentine households, for example, mothers did not usually nurse their infants, and girl babies were the ones most often sent to a wet nurse who lived some distance away and kept the child for at least two years.[16] The mortality rates for these children were high. Sometimes, infanticide was also practiced in Florence (the august city that gave birth to humanism), and again, girls were the most frequent victims.[17] Many illegitimate children were born to women domestics and women slaves in wealthy Florentine households, often sired by members of the master's family. This was a prime factor in the establishment of foundling hospitals in the early fifteenth century, including the Ospedale degli Innocenti, famous for its façade by Brunelleschi. Of the foundlings, about seventy percent were girls, boys being more likely to remain with the family. Mortality rates for these children were also high.[18]

During the Renaissance period, a woman's life could take either of two principal courses as she reached adulthood. These were marriage or joining a convent (until these religious institutions were closed in areas that adopted Protestantism). In the case of marriage, women's (or men's) place of residence and their social class affected whom they would marry and at what age, what kind of work they might do (in addition to their duties as wife and mother), what kind of living quarters they and their families occupied, and the number and kind of people who might share those quarters—servants, slaves, relatives. Even within the boundaries of what we now define as national states—for example, Italy and Germany—there were substantive differences in customs, laws, and the like among urban areas that were geographically close to one another; differences are also to be observed between urban and rural environments.[19]

A considerable amount of information has recently been revealed concerning private life in quattrocento Florence.[20]

In patrician families, the wife's place was in the home, where she was responsible for domestic concord. She had usually married between the ages of sixteen and eighteen and was some eight to ten years younger than her husband. The husband was, according to a thirteenth-century adage, "a king in his own castle," a status that cut across class lines. He was the sole trustee of all family property, and he managed his wife's dowry and often the dowries of his daughters-in-law. His household usually included his male relatives, and he had authoritative power over his children and his grandchildren, no matter what his own age or their ages were.

The wife presided over servants and slaves and devoted herself to her children. Well-to-do families usually educated their children at home. Very few girls, however, were taught to read and write. They were instructed, instead, in such matters as religion and morals, weaving and needlework. Boys, whether at home or at school, were prepared to assume an active, public life. They usually studied reading, writing, and mathematics, and upper-class youths learned Latin and were immersed in works of the Latin authors.[21]

While the husband was the ultimate authority over his family, the wife managed domestic affairs on a daily basis. Her world was a private and contained one (it is reflected in the architecture of fifteenth-century palazzi in Florence, which most often offer a forbidding façade to the street and include an interior courtyard where the family functions usually took place). Women did go out, of course, to visit or to go to confession and Mass, but whatever the purpose, they usually went in groups.

During the Renaissance and baroque periods, an interest in the proper behavior and education of women and men of the upper classes gave rise to the writing and publication of many books that are sometimes referred to as "conduct books."[22] Such works communicate what was held to be ideal conduct for both men and women in leading productive, virtuous lives. As discourse, they established and also reinforced societal views. An early effort was made by the Italian architect and theorist, Leon Battista Alberti, who wrote a long work, *On the Family* (*Della Famiglia*, completed by 1441). In it, as Renée Neu Watkins has pointed out, Alberti deals with the social and moral conflicts of early capitalist society; he sees the family as the fundamental social unit and as an essential part of an ethical society.[23] While the husband was active in the public world, as head of the household, he had to instruct his wife meticulously in the ways she was to manage the household. Alberti places the woman in a remarkably clear, interior space, where she is one important point in a carefully constructed perspectival scheme of the family as a whole.[24]

A second very famous and frequently reprinted book is Juan Luis Vives' *Instructions to a Christian Woman* (*Institutio foeminae christianae*), written in 1523, and thereafter translated into a number of European languages.[25] Vives, like many other writers, strongly emphasized that women should be "chaste, silent and obedient." Of these virtues, chastity was held to be the most important. As Vives himself put it, "For a man, various virtues are necessary, such as wisdom, eloquence, a good memory, a sense of justice, strength, charity and magnanimity. But for a woman, these male virtues do not apply; for her, only chastity is essential, for if that is lacking, it is as if a man should lack all the qualities mentioned. Then the woman becomes utterly dishonorable, and losing her honor, she loses all."[26]

Men ideally were also to be chaste, although this is not often mentioned in the conduct books for them; the "double standard" of sexual behavior familiar to us was in evidence then. Conjugal sex, in Italy as well as in northern Europe, was supposed to be for the purpose of procreation, but it obviously was considered a respectable outlet for one's physical drives. Theoretically, it kept illicit lust at bay. Rather surprisingly, physicians pronounced that the conception and birth of a healthy child required the full sexual arousal of the female, and some gave instructions on how to accomplish this.[27] Conjugal sodomy was forbidden in most locales, although some scholars think it was practiced as a device for birth control.

Illicit sex, needless to say, was common enough, despite prohibitions by both church and state. Prostitution was widely tolerated, and in Nuremberg, for example, it was controlled by the city government.[28] Venice and Rome were well known for their courtesans, a number of whom were famous and some of whom had an almost mythic status.[29] In the earlier sixteenth century, before the strictures imposed by both Protestant and Catholic reformers, a good deal of pornographic literature and visual imagery was produced by well-known writers and artists. Sexual offenses, however, were often prosecuted, among them the rape of girls or boys, but also of married women.[30] Homosexual acts were punished, too. Homosexuality was much discussed in quattrocento Florence; the preacher Bernadine of Siena (c. 1420), among others, railed against it. *Florenzer* became the term used by Germans when they meant homosexual.[31]

Upper-class marriages, as well as many middle-class ones, were arranged by the prospective bride's and groom's parents. Negotiations were complexly ritualized and usually took place over a number of months. Women had to be provided by their families with dowries, sometimes involving extravagant sums of money. In Florence, men were expected to give their brides various kinds of gifts, especially clothing, which was often sumptuous. If a woman was widowed, however, and chose to leave her husband's family, she was entitled to take only her dowry, or what remained of it, with her. In order for a woman to keep gifts given to her by her husband, it was

necessary that he stipulate in his will or a codicil to it that she was to be permitted to do so. Moreover, even a widow's children usually remained with her husband's family if she returned to her birth family or remarried.[32]

Nevertheless, evidence suggests that some marriages proved to be especially loving and companionate unions. Steven Ozment has translated and published the wonderful letters of Balthasar Paumgartner (1551–1600), a Nuremberg merchant, and his wife, Magdalena Behaim (1555–1642).[33] They begin in 1582, during the couple's engagement, and extend to 1598. They are characterized by their markedly warm and affectionate nature, and interestingly, they also demonstrate that Magdalena managed her husband's affairs when he was traveling on business.

There is scanter information on another Nuremberg marriage, that of the artist Albrecht Dürer and his wife, Agnes, but it is of a tantalizing nature because of its ambiguities and the art historian's desire to know more about Dürer's private life. Almost immediately after the marriage, Dürer left on his first trip to Italy, where he stayed for some months. The couple remained childless. As a successful artist, Dürer owned a large house in the city; Agnes used to sit outside it and sell his prints to passers-by. In July 1520, Dürer took Agnes and her maid with him on a year-long journey to the Netherlands. When he died in 1528, his lifelong friend, the humanist Pirckheimer, wrote that Agnes had driven him to his death by her greed. Erwin Panofsky suggested that Albrecht and Agnes were particularly incompatible because of the great intellectual growth he manifested during the course of his life; his interests were alien to hers.[34] It needs to be emphasized that the Nuremberg guilds had precise marriage regulations: apprentices could not marry; but journeymen were required to marry in order to attain the level of masters.

It can be argued that women who were not of the upper classes had more freedom than those who were, if by that one means the freedom to move about the city. Such women were frequently found in the marketplace, both as vendors and customers. They sometimes also worked as midwives for pregnant women, maids in public bathhouses, nurses for the sick in hospitals, or domestic servants.[35] These are, of course, occupations still thought of as typically female ones. If they were married to craftsmen of various kinds, or to merchants, they sometimes worked with their husbands. Women could easily work in a production unit that was familial, but they were increasingly refused entry into guilds and production that took place outside the family. This development has sometimes been attributed to the rise of capitalism, but Martha Howell considers it a result of the patriarchal social structure.[36] Occasionally, depending on the laws of a particular community, the wife was permitted to carry on the business if her husband died; there are instances of this in the printing

trade. This was, however, unusual, and most often widows rather quickly married assistants in workshops, and the men then became the masters.[37]

In the early sixteenth century, the Protestant Reformation caused an enormous upheaval in society. Among many other areas of life, the movement deeply affected marriage and family life. Debates flourished concerning men's and women's proper roles in both the religious and secular fields. Many of the reformers, who, like Luther, had been priests of the Roman Church, now decided to marry, and sometimes they married women who had been nuns. The sexual activities of some members of the Roman clergy were, of course, a matter of great concern at this time. For both the Roman Church and the Protestant sects, the states of celibacy and virginity were considered "better and more blessed than the bonds of matrimony," but the reformers acknowledged that it was better to marry than to burn in hell.[38] In many respects, the Reformation created a new emphasis on the household and on the wife as a "model of domesticity." The wives of Protestant pastors, especially, became exemplars of women's proper role; they were expected by their husbands and others to be obedient and to perform acts of Christian charity, including the feeding and care of refugees and providing assistance at orphanages and hospitals. Some of the early Protestant pastors' wives were well educated and were involved in theological discussions, but their roles became increasingly circumscribed.[39]

The Protestant Reformation had one other major effect on women. Convents (and monasteries) were closed or were permitted to remain open only until the last of their members died. While women in Catholic regions could still choose (or be forced into) the cloistered life, women in Protestant regions no longer had that option. The desirability of marriage hence loomed larger than ever. It has further been argued that the Protestant Reformation obliterated powerful role models for women in the personae of the Virgin and female saints. Protestantism, as Marina Warner has put it, "is altogether too much like a gentleman's club to which the ladies are only admitted on special days."[40]

Old women and poor women, whether widows or otherwise, who lived literally on the fringes of their communities, became increasingly isolated and suspect. They were perceived by men as being quintessentially an "Other," foreign, frightening, and lethal. From around 1560 until about 1650, they were the women who were most often accused of witchcraft. Many of them were burned at the stake.[41]

There were some well-educated women during the Renaissance and baroque periods, although they were certainly a minority even among the upper classes. One of the earliest and best known of these was Christine de Pisan (1365–1430?), who was also a champion of women's rights. Born in Venice, she was taken to Paris by her family, where her father had been

invited to become court astrologer to King Charles V. She was educated at her father's command, a pattern true of nearly all educated women at the time. *The Book of the City of Ladies* is one of her best-known works. In it, she seeks to combat condescending and sometimes misogynistic attitudes toward women, and she demonstrates women's contributions to human civilization.[42]

Other young women were given specifically Latin- and Greek-oriented educations. These were the daughters of men who were humanists of great learning, and some of these women excelled. One outstandingly learned Florentine woman was Alessandra Scala, who was trained by her father, Bartolommeo, a chancellor of the city. But such unusual women were also found in other Italian cities, and sometimes in northern Europe. Among the latter was the daughter of the chancellor of England, Sir Thomas More. There was, however, a point at which these women had to choose between marrying, which effectively ended their own humanist activities, or entering a convent. In either case, these women subsequently assumed a life of public silence. Indeed, when More's daughter Margaret married, he wrote her that her learning was solely for the audience composed of himself and her husband.[43]

While a learned woman was still active, she could be subjected to quite scurrilous attacks. A well-known example is the attack on Isotta Nogarola of Verona, the essence of which was that she was disobedient and unchaste. In an anonymous pamphlet, Nogarola was charged with having committed incest with her brother and of having had indiscriminate intercourse with many men, owing to her "filthy lust." The writer repeats the aphorism that "the woman of fluent speech is never chaste."[44]

Anthony Grafton and Lisa Jardine have pointed out that "the accomplishment of the educated woman (the 'learned lady') is an end in itself, like fine needlepoint or the ability to perform ably on lute or virginals. It is not viewed as a training for anything, perhaps not even for virtue (except insofar as these activities keep their idle hands and minds busy)."[45] Yet some women of accomplishment are now being recovered from the recesses of history; these women were sometimes active in religious or political life or were poets, visual artists, or patrons.[46] Some, like Christine de Pisan, constructed essentially feminist rebuttals of misogynistic attitudes and behaviors, whatever the form of expression. In these efforts, they were occasionally joined by feminist men.[47] The vast majority of women, nevertheless, lived out their lives in traditionally female roles.

It is important that we continue to increase our understanding of women's lives in their historical context. For the art historian, however, there is not a simple one-to-one relationship between visual imagery and the "real" world. As Foucault remarked, all language (to which we may add imagery) is allegorical. What we must ask is "what are we saying in what we are saying?"

Images and Power

Renewed attention is being given to the concept of the "power" of visual images, and the conclusions move beyond the assumptions traditionally associated with the word. In the past, the power of an image was often understood as its impact on the viewer in a way that was considered inseparable from its aesthetic merit. A second, traditional understanding identified the power of an art object as equivalent to its propagandistic uses, whether for religious or secular purposes.[48] The questions now being raised by students of visual imagery focus on such matters as: the *kind* of power, how it conveys itself, and its effects on viewers.

Marxists, feminists, and semioticians, while not necessarily agreeing on answers, have all contributed reflections on these questions.[49] Perhaps the most important benefit to emerge from these ongoing explorations is the realization that power is a ubiquitous part of all discourse. It is not a fact or concept limited to political life, to individuals and institutions concerned with governing states, to persons leading the "active life" as distinguished from those leading the "contemplative life." Indeed Foucault wanted to understand power in "its capillary form of existence," to probe "the extent to which power seeps into the very grain of individuals . . . permeates their gestures . . . what they say, how they learn to live and work with other people."[50]

Norman Bryson, in studying visual imagery, has proposed that power "will be found in every act of looking: where the discursive form of the image meets the discourses brought to bear on the image of the viewer, and effects a change; where, in order to recognize the new discursive form that is the image, existing boundaries of discourse—the categories and codes of recognition—must be moved, turned and overturned, in order to recognize what the image is. . . ."[51]

David Freedberg recently devoted a long study to the power of images.[52] His concern was with all manner of images, those from "high art" to "low art," from "primitive" to non-Western to Western images. He emphasizes that his book is not about the history of art but rather "is about the relations between images and people in history." His focus is on the great variety of ways in which people respond to images: from those that involve the sexual arousal of the viewer to the idolization of images to their destruction by iconoclasts.

Questions about the power of images, historical responses to them, and our own responses to them are implicit in the theme of this exhibition and are dealt with explicitly on occa-

sion in the catalogue. In any case, it is no longer possible for many students of art history to regard images simply as benign expressions or as ideologically and emotionally remote or neutral objects. Visual images do not belong in some rarified cultural category. They are one of the many discourses of society forming constructs of power and knowledge.

Prints and Power

A number of factors made the print media of the Renaissance and baroque eras a powerful mode of discourse. The most signal characteristic of the print, in contrast to other visual media, is that a given design, carved into the woodblock or incised into the metal plate, can be replicated exactly on paper hundreds of times. Only after the block or plate has been inked and passed through the press repeatedly will the wood or metal begin to wear and the resulting impressions show any noticeable loss of visual definition.[53] Hence an artist could use one "invention" innumerable times.

Prints also "travel," as the saying goes. Printed on paper, they can be easily transported, by hand or light conveyance, over widespread geographical areas. Only the printed text, exactly replicated by the printing press, had the same inherent potential to affect large numbers of people in different locales.[54] In addition, prints have been, for the most part, much less expensive to purchase than have such other visual media as paintings and sculpture. Many people could afford to own them.

The earliest prints were made around 1400. By midcentury, prints existed in profusion, and their numbers continued to grow throughout the sixteenth and seventeenth centuries. Some prints were commissioned for specific purposes, but vast numbers of them were made for the open market.[55] This meant that artists would often assess what would sell and would supply the demand for such objects. It also meant that they had considerable choice of subject matter and of the way in which they could depict it. They usually did not have to answer the desires of particular patrons or conform to stipulations in contracts.

In the first century of printmaking, from about 1400 to 1500, the overwhelming number of prints focused on religious subjects, as one would expect. Such prints were frequently employed for private, devotional uses. They were tacked up on walls or stuck in boxes (fig. 47b) or made into portable altars (cat. 54). Indeed, in addition to the portability of prints, their comparatively small size and their paper ground encouraged the owner's personal perusal, whatever the subject was. People who made it a habit to collect large numbers of prints during the Renaissance and baroque periods most often pasted them into albums, to be viewed in private and at their leisure.[56]

This potential of prints for personal use eventually encouraged printmakers to avail themselves of a broader latitude of subject matter. As secular imagery became increasingly popular toward the end of the fifteenth century, it appeared in prints earlier and more widely than in painting or sculpture. Printmakers both invented new themes and also looked to secular images that had appeared in the decorative arts and in the margins of manuscripts during the waning middle ages. Among the most popular images were those grouped here under the "Power of Women" (see cat. 87).

When the Protestant Reformation fully materialized in the early sixteenth century, one effect, especially in Germany, was the fall in demand for religious works of art. In Nuremberg, iconoclasts did not destroy works that had been produced for the Roman Catholic churches there, but living artists had to look to new subjects as well as to new markets for their works. It was at this time that satiric and erotic subjects and images became extremely popular, as evidenced especially in prints. Sexual and satiric elements are found, for example, in the prints of Barthel and Hans Sebald Beham, Nuremberg natives (see cat. 114 A–D). Prints were also a favorite medium for pornographic images, sometimes accompanied by correspondingly pornographic texts.[57] Even some religious subjects of the early sixteenth century are newly imbued with eroticism, although usually it is inherent in the subject; one thinks particularly of the many depictions of Adam and Eve by Hans Baldung Grien (see cat. 72). Later in the century, certain erotic and pornographic images fell prey to censors, especially those of the Roman Church, and these included prints (see cats. 82–83).

In geographical areas where the Roman Catholic Church retained its strength, printmakers as well as other artists were called upon to create images that strongly extolled the Virgin and saints and otherwise propagandized the rightness and power of the Catholic faith. Notable among these artists was Peter Paul Rubens, who early recognized the power and the multitudinous uses of the print media. Rubens made designs of religious as well as other subjects and had them executed by professional engravers, usually under his direct supervision (see cat. 45).[58]

The print, then, was a powerful conduit for visual imagery. Its capacity for replication and circulation was unique among visual objects. At the same time, because the print facilitated individual and leisurely study, it had a particular immediacy that is different from large-scale public works. The print media were influential, as well, in disseminating the imagery of various artists to other artists who lived in distant areas and at different periods of time. Hence it was possible for many artists to see and sometimes to use imagery they otherwise would not have known.

It will be apparent that the printed image was an especially

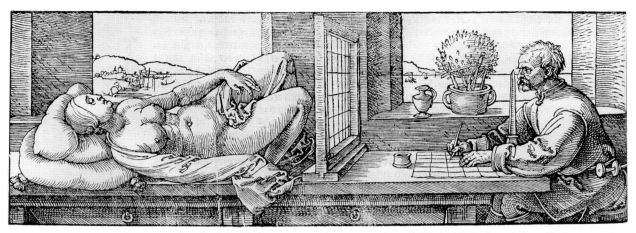

fig. 1. Albrecht Dürer, *Draftsman Drawing a Reclining Nude*, c. 1527, woodcut, 76 x 212 (3 x 8⅜) (Meder/Hollstein 271), from *Underweysung der Messung mit dem Zirchel und Richtscheyt . . .*, 2d ed., The Library of Congress, Washington, D.C., Lessing J. Rosenwald Collection.

powerful vehicle for gendered images and for perceptions of gender issues. Indeed, one might propose that many of the prints here seem almost literally to illustrate, as it were, Scott's observation that gender differences become fixed into the binary opposition of male and female. As much as the print made possible wide acquaintance with all kinds of images by many artists, it could also promote the formulation of striking stereotypes in form and subject. Not least among these are the guises in which woman is represented.

Artists and Power

The artists whose works are shown here grew up in different locales and circumstances. Their training sometimes differed significantly, as did their life experiences. Some, like Callot, were exclusively professional printmakers, but many others, including Dürer, Cranach, Castiglione, and Rembrandt, were also active in painting or other media. In the present context, these artists will not be focused on as individuals; for many of them, very good monographic studies exist.

It is clear, however, that throughout the Renaissance and baroque periods, artists increasingly assumed a position of control in relation to the images they were creating. More and more artists rejected the medieval idea that art was one of the crafts and saw the making of art, instead, as an intellectual as well as a creative endeavor. They did not aim solely at reflecting the sensory world in their images. They subjected all parts of the world, animate and inanimate, to their scrutiny and judgment, ordering it, reconstructing it, recreating it. They pitted themselves, as it were, against Nature (*Natura*, Mother

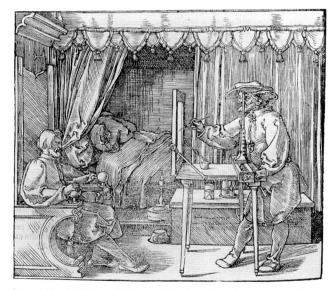

fig. 2. Albrecht Dürer, *Draftsman Drawing a Portrait*, c. 1525, woodcut, 130 x 148 (5⅛ x 5⅞) (Meder/Hollstein 268), from *Underweysung der Messung mit dem Zirchel und Richtscheyt . . .*, 1st ed., The Library of Congress, Washington, D.C., Lessing J. Rosenwald Collection.

Earth) in the sense that they sought to probe Nature and understand her by rational means rooted in mathematical perspective and theories such as those of human proportion.[59]

One of the artists who quintessentially personifies this kind of approach and who was instrumental in effecting it was Al-

22

brecht Dürer. Dürer, who was both a painter and a print-maker, wanted to raise the status of the German artist to the level he had seen occupied by contemporary Italian artists. To this end, in his maturity, he wrote three books aimed at German artists and artisans. These were intended to acquaint their readers with rational, mathematical approaches to visual imagery. In addition to composing the texts, Dürer made woodcut illustrations for the books. Having worked as a young man on making woodcuts for printed books, he was well aware of the power of both images and text.

In one woodcut for his treatise on geometry, he showed how the reclining human figure may be drawn in perspective by use of a reticulated net set up between artist and subject (fig. 1). The artist can simply transfer the image as seen in the small units that divide the net onto a piece of paper with corresponding squares. In another woodcut (fig. 2), Dürer demonstrates how a portrait painter, by using an eyepiece, can sight his subject and draw in the subject's contours onto a piece of glass.

The illustrations help to make the text clear, and the methods of rendering the human image are in these cases both clever and practical. At the same time, beyond the obvious artistic methods being suggested, gendered messages are being conveyed, perhaps quite unconsciously. The reclining figure is a half-nude female who has her eyes closed. She is an object on a table, just as are a lute and a vase that are shown in two other perspective woodcuts in the treatise.[60] In the portrait illustration, by contrast, the subject is a man. He is fully dressed and sits upright in a chair, a posture that bespeaks inherent dignity. He, moreover, looks directly and alertly back at the artist.

1. The key work on the early woodcut throughout Europe is still Hind 1963. He notes that among the convents (meaning both male and female religious institutions) known to have produced numerous woodcuts in the first half of the fifteenth century was the Nunnery of Saint Catherine, Nuremberg (see 1:108 n. 2).

2. Among the many discussions that might be referenced here, I would point to that by Norman Bryson, *Vision and Painting: The Logic of the Gaze* (New Haven and London, 1983), especially 133–162, for his essay, "Image, Discourse, Power." Bryson's approach is rooted firmly in semiotics. Non-art-historical discussions of discourse, power, and knowledge are especially relevant and important in many of Foucault's publications. See, for example, Michael Foucault, *Power/Knowledge: Selected Interviews and Other Writings, 1972–1977*, ed. Colin Gorden (New York, 1980). On how many of his views are a fruitful source for feminist scholarship, see the excellent essays in Diamond and Quinby 1988.

3. Among the outstanding studies produced to date is Evelyn Fox Keller, *Reflections on Gender and Science* (New Haven and London, 1985), in which the author defines her subject as "how the making of men and women has affected the making of science." For many interdisciplinary studies related to our own subject, see Patricia

Simons, *Gender and Sexuality in Renaissance and Baroque Italy: A Working Bibliography,* Power Institute of Fine Arts Occasional Paper, No. 7 (Sydney, 1988).

4. Scott 1988, 42, but see the entire essay, 28–50.

5. Scott 1988, 43.

6. Especially stimulating works are Nochlin 1988; Garrard 1989; and Pollock 1988. Garrard explores how a seventeenth-century woman artist, Artemisia Gentileschi, dealt with popular subject matter in a way that was different from her male contemporaries (for example, such subjects as Judith with the head of Holofernes, Cleopatra, and Lucretia). Pollock examines the ways in which male and female nineteenth-century artists chose exterior and interior settings for their subjects, and how they depicted those spaces and the people who occupy them in different ways. Nochlin discusses many eighteenth-through twentieth-century works. In comments on David's *Oath of the Horatii* (Louvre, Paris), she says "that it is the representation of gender differences—male versus female—that immediately establishes that opposition of strength and weakness which is the point of the picture" (p. 3).

7. The work of Carol Duncan is especially important in this respect; see her essays, for example, in Broude and Garrard 1982. We could point to a good many other works, but might simply comment that feminists who are also Marxists have been most alert to the impact of class structures, as one would expect. On Marxism and feminist art history, see also Pollock 1988, 18–49.

8. Nochlin 1988, 3, has noted that the "discourse of power over women masks itself in the veil of the natural—indeed, of the logical."

9. Nochlin 1988, 11, and see fig. 6, for Gerôme's painting.

10. Summers 1970, 47.

11. Among the works of these scholars, I will cite two recent contributions: Nancy J. Chodorow, *Feminism and Psychoanalytic Theory* (New Haven and London, 1989); and Lisa Tickner, "Feminism, Art History and Sexual Difference," *Genders* 3 (November 1988): especially 110–117. Tickner's entire essay is concerned with feminist approaches to art history and is an important contribution to the growing literature. We should note, as well, that psychoanalytic approaches to the arts are a prominent feature of French feminist scholarship. See, for example, the works of Julia Kristeva, who is both a semiologist and a psychoanalyst, especially her *Desire in Language: A Semiotic Approach to Literature and Art,* ed. Leon S. Roudiez, trans. Thomas Gora, Alice Jardine, and Leon S. Roudiez (New York, 1980).

12. For a convenient survey with extensive bibliography, see Bonnie S. Anderson and Judith P. Zinsser, *A History of Their Own: Women in Europe,* 2 vols. (New York, 1988).

13. See especially Maclean 1980, 28–46; and Thomas W. Laquer, "Amor Veneris, vel Dulcedo Appeletur," *Zone 5: Fragments for a History of the Human Body, Part Three,* ed. Michel Feher, Ramona Naddaff, and Nadia Tazi (New York, 1989), 90–131. The latter focuses on the history of the clitoris in medical thought.

14. Maclean 1980, 30.

15. Maclean 1980, 46.

16. See Klapisch-Zuber 1985, 132–164, as well as James Bruce Ross, "The Middle-Class Child in Urban Italy, Fourteenth to Early Sixteenth Century," in *The History of Childhood,* ed. Lloyd deMause (New York and Hagerstown, 1974), 183–228.

17. Herlihy and Klapisch-Zuber 1985, especially 145–148.

18. Herlihy and Klapisch-Zuber 1985, 145–148. See also Iris Origo, "The Domestic Enemy: Eastern Slaves in Tuscany in the Fourteenth and Fifteenth Centuries," *Speculum* 30 (1955): 321–366.

19. On laws, customs, and occupations as they affected working women in six German cities, including Frankfurt, Nuremberg, and

Strasbourg, see Wiesner 1986. On labor practices in Cologne and Leyden, see Howell 1986.

20. The information on Florence that follows is drawn from Herlihy and Klapisch-Zuber 1985; and the essay by Charles de la Roncière in Duby 1988, 156–309, which also appears to draw on the former work. Duby's book, part of a series on private life, has fascinating illustrations and an extensive bibliography.

21. On humanistic education, see especially Grafton and Jardine 1986.

22. The most comprehensive study of conduct books is still that by Kelso 1956.

23. See the translator's excellent introduction in Leon Battista Alberti, *The Family in Renaissance Florence*, trans. Renée Neu Watkins (Columbia, S.C., 1969), 1–20.

24. Alberti's illegitimacy, the exile of his father's family from Florence when he was a young boy, and his lifelong bachelorhood are no doubt all important factors in his views on the family. *Della Famiglia* is also dependent on ideas drawn from antiquity as well as on other writings in Alberti's own time.

25. On Vives' book, see especially Kaufman 1978. Vives (1492–1540), a Spanish humanist, went to England in 1523 as preceptor to Mary, Princess of Wales. His book, dedicated to Catherine of Aragon, was first published in Antwerp in 1524. The first English translation appeared in 1541. Some members of the former Folger Institute Colloquium on Women in the Renaissance, under the direction of Elizabeth Hageman, are preparing a new English edition of the work.

26. As translated from the Dutch and quoted by Veldman 1986, 119.

27. Goffen 1987, 699, has referred, for example, to a treatise by Anthonius Guainerious, professor of medicine at Pavia in the early fifteenth century, in this respect.

28. See Wiesner 1986, 99–106.

29. On courtesans, real and imaginary, see Lawner 1987. The *cortigiana onesta* (respectable or honest courtesan) should not be confused with an ordinary prostitute. She was cultured, could perform music, sometimes wrote poetry, and had liaisons only with men of the upper class. Among these women was the Venetian, Gaspara Stampa (born 1524), considered by many to be "the greatest woman poet of the Italian Renaissance." See Wilson 1987, 3–21.

30. For an extensive study of sexuality in Venice, including criminal prosecution, see Ruggiero 1985.

31. See Duby 1988, 156–309. On homosexuality in Venice, see Ruggiero 1985, especially 135–145.

32. See Klapisch-Zuber 1985, 213–246. See also the important article by Diana Owen Hughes, "From Brideprice to Dowry in Mediterranean Europe," *Journal of Family History* 3 (1978): 262–296.

33. Steven Ozment, *Magdalena and Balthasar* (New York, 1986).

34. Panofsky 1971, 6–7. On marriage regulations in German shops, see Wiesner 1986, 163.

35. Wiesner 1986.

36. Howell 1986.

37. See Wiesner 1986, 157–163, on masters' widows. On an English widow printer of the sixteenth century, see Susan M. Allen, "Jane Yetsweirt (1541–?) Claiming Her Place," *Printing History* 9, no. 2 (1987): 5–12. On a French widow printer, see Beatrice Beech, "Charlotte Guillard: A Sixteenth-Century Business Woman," *Renaissance Quarterly* 36, no. 3 (1983): 345–367. Beech points out Paris guilds of the period "allowed women to take over the direction of the businesses after the deaths of their husbands, even in those businesses which were normally closed to women."

38. For an extensive and excellent study of marriage and the family in Reformation Europe, see Steven Ozment, *When Fathers Ruled: Family Life in Reformation Europe* (Cambridge, Mass., and London, 1983).

39. See, for example, Merry E. Wiesner's essay in Marshall 1989, 8–28. Four articles dealing with the role of women in the Reformation, some especially concerned with marriage among the reformers, remain very useful: see the essays by Roland H. Bainton, Miriam U. Chrisman, Nancy Lyman Roelker, and Charmarie Jenkins Blaisdell, in *Archiv für Reformationsgeschicte* 63 (1972): 141–225.

40. Warner 1976, 338.

41. Works on witchcraft are legion. Some are of a very superficial nature. I have found the following especially useful: Richard Kieckhefer, *European Witch Trials: Their Foundations in Popular and Learned Culture, 1300–1500* (Berkeley, 1976); H. C. Erik Midelfort, *Witch Hunting in Southwestern Germany, 1562–1684* (Stanford, 1972); Davidson 1987; Klaits 1985; and Ladurie 1987.

42. There are a number of recent studies of Christine de Pisan, but see especially Charity Willard Cannon, *Christine de Pizan* (New York, 1986).

43. The passage is quoted in full by Grafton and Jardine 1986, 56–57, n. 83, but see also 29–57, for a discussion of the education of other women humanists. Two other important sources on learned women in Italy and northern Europe are King and Rabil 1983; and Labalme 1984.

44. Quoted in Grafton and Jardine 1986, 40.

45. Grafton and Jardine 1986, 56. In the introduction, xi–xvi, the authors cast critical eyes on humanist education for men of the fifteenth and sixteenth centuries, thinking that "the price of collaboration in the renewal of art and literature was collaboration in the construction of society and polity." They further suggest that humanities studies today, which developed out of humanism, is "a curriculum training a social elite to fulfil its predetermined social role."

46. Among the innumerable studies now available, I would simply point to the following as especially stimulating: the women writers discussed in Wilson 1987; women religious in Schulte van Kessel 1986; women artists in Los Angeles 1976. There are, of course, a number of articles and monographs now on individual women.

47. On feminist writings during the Renaissance and baroque periods, see, for example, Kelly 1984, 65–109; Jordan 1986; and Maclean 1977. A good summary of historical feminism and female iconography is in Garrard 1989, 141–179.

48. An interesting discussion of the uses of painting by secular rulers is Michael Levey, *Painting at Court* (New York, 1971), 81–114. On the uses of woodcuts and broadsheets for religious as well as political purposes, see Moxey 1989, 19–34.

49. Feminists and semioticians, who may also be Marxists, are concerned with expanding analyses of power in society beyond Marxism's traditional view of economic determinism. See Pollock 1988, 18–49; and Diamond and Quinby 1988, especially 3–19.

50. Foucault as quoted in Diamond and Quinby 1988, 6.

51. Bryson 1988, xxvii–xxviii.

52. Freedberg 1989.

53. Eventually woodblocks may break or suffer damage from worms, and the lines on metal plates, whether done by engraving or etching processes, will show wear and will not hold the ink well. Where possible in this exhibition we have pointed out both especially fine impressions and those that demonstrate wear. How "good" an impression is (the quality of it) obviously affects its expressive impact to some extent.

54. For an exhaustive study of the printed text, with many implications for an investigation of the print, see Elizabeth L. Eisenstein, *The Printing Press as an Agent of Change: Communications and Cultural Transformations in Early-Modern Europe*, 2 vols. (Cambridge, 1979; combined paperback edition, 1982).

55. For two instances of commissioned prints, see Edith W. Hoff-

man, "Some Engravings Executed by the Master E. S. for the Bene-
dictine Monastery at Einsiedeln," *Art Bulletin* 43 (1961): 231–237; and
Larry Silver, "Prints for a Prince: Maximilian, Nuremberg, and the
Woodcut," in *New Perspectives on the Art of Renaissance Nuremberg:
Five Essays*, ed. Jeffrey Chipps Smith (Austin, 1985): 6–21.

56. On individuals forming large collections of prints, which began as
early as the later fifteenth century, see Bury 1985, 12–26; and Boston
1981, xxvii–xlviii. In large early collections, prints were often arranged
by categories of subject matter, but it also quickly became usual to
separate out the works of certain masters and to arrange them accord-
ing to artists' names. Among the latter were prints by Schongauer,
Dürer, and Lucas van Leyden. These printmakers hence achieved a
canonical status among early collectors and connoisseurs.

57. Among these works is the series of sixteen prints known as *I modi*,
designed by Giulio Romano in 1524 and executed by Marcantonio
Raimondi. They show sixteen positions for sexual intercourse. A sec-
ond edition of the prints was accompanied by sonnets by Pietro
Aretino, who has been called "the first modern pornographer." See
I modi: The Sixteen Pleasures, ed. and trans. Lynne Lawner, foreword
by George Szabo (Evanston, Ill., 1988).

58. See, for example, Rome 1977.

59. For a still-useful account of the development of artistic theory
along these lines, see Anthony Blunt, *Artistic Theory in Italy 1450–
1600* (Oxford, 1956), especially chaps. 1, 2, and 4.

60. For a discussion of the treatise on geometry, see Washington 1971,
353–355, cat. 215. A first edition was published in 1525, a second in 1538,
ten years after the artist's death. The woodcuts of the vase and lute
are illustrated there. Depicting a reclining female nude also brings up
the idea of "the male gaze," much discussed in recent years; by this is
meant that images of women, especially nude women, were meant for
the delectation of the male viewer. See especially Berger 1985, 45–64;
but also Snow 1989 for a kind of rebuttal.

Note to the Reader

The prints included in the exhibition can also be found in the standard catalogues raisonné under numbers provided in the headnotes to the entries here. However, only in special exhibition catalogues are many of the prints discussed from an art historical point of view (style, iconography, and the like). The reader is frequently referred to these publications throughout the present work. Although some of these catalogues may not be readily available, most are indispensable for further study, especially because our own focus is almost solely on the thematic content of the prints from the point of view of gender. We have made a conscious effort to refer to English language publications, wherever possible, for the convenience of the broadest spectrum of American readers.

Dimensions are given height before width, in millimeters (or centimeters for illustrations of paintings) followed by inches. For prints from our own collections (all but cats. 6 and 87) we have omitted "National Gallery of Art, Washington" from individual credit lines.

CATALOGUE

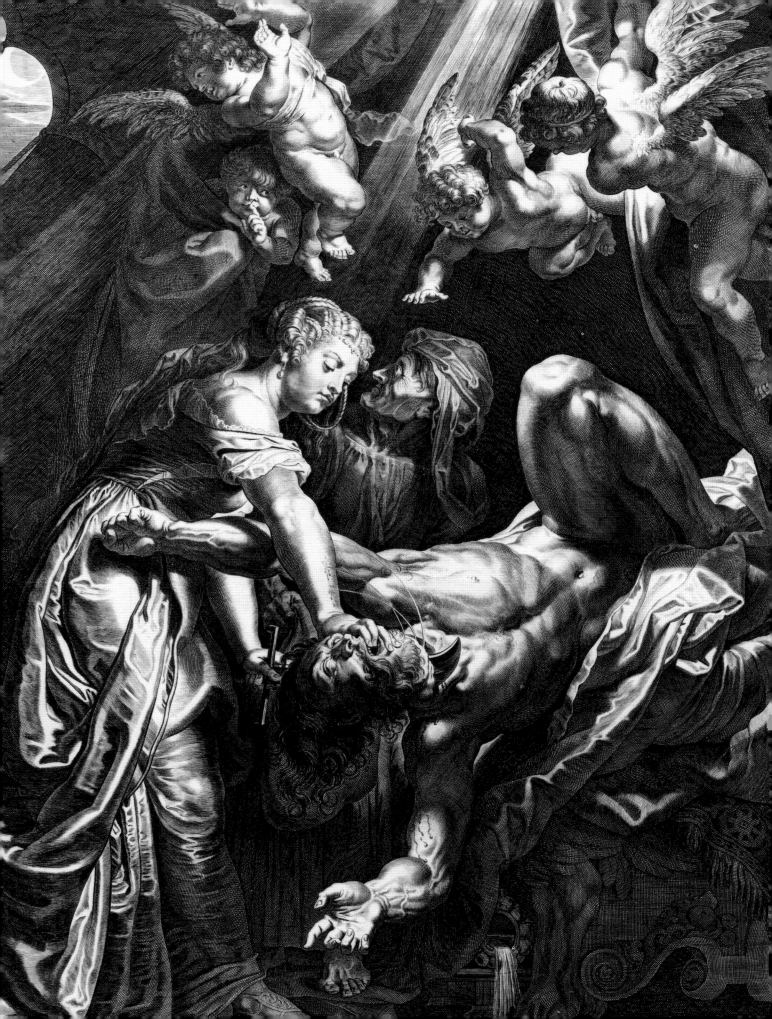

I

HEROINES AND WORTHY WOMEN

Bernadine Barnes

The hero, in the imagination of artists and writers of the Renaissance, was a leader or a warrior, usually a man of character, but more important, a man of action. Images of heroes placed in palaces and city squares served as symbols of personal or civic power and provided models of behavior for leaders through their display of valor, strength, prowess, and loyalty. Sometimes a militant saint or a great soldier from ancient mythology was depicted. More often male heroism was represented by a historical person renowned for his conquests.[1]

The representation of heroic women, however, presented a different problem, because the heroine served not only as a symbol of power but also as an example to women, and the very virtues that make for heroic behavior are often antithetical to the virtues of the ideal women. Writings about women from the late middle ages through the seventeenth century offer a consistent picture of the virtuous woman—chaste, silent, modest, humble, obedient.[2] The ideal woman withdrew from the world, she was not a leader in it. She was devoted to her family, she did not leave it to do battle. Clearly these virtues would protect a man's power over wife and daughter. (It should come as no surprise that the treatises were almost always written by men.) The virtues extolled, however, also kept women from the public sphere and from the active roles of leadership that defined the male hero. Women in the early modern period who defied these constraints were not often glorified in literature or the visual arts.[3] Instead, artists or writers who chose to describe heroic women turned to classical history and to the Old Testament. These remote, nearly mythological women could be turned into allegories of womanly virtue, but they could also serve as vehicles for expressing misogynist stereotypes and the ambivalent feelings that men often felt toward powerful women.

In literature these opposing tendencies can be seen in the collections of the lives of famous women that became increasingly popular in the Renaissance. The best known of these was Boccaccio's *De claris mulieribus (Concerning Famous Women)*, written between 1361 and 1375 and reprinted many times during the Renaissance.[4] Nearly all of Boccaccio's examples are drawn from classical history and mythology, since those women were "spurred by the desire for this fleeting glory" rather than seeking eternal glory in another life as Hebrew and Christian women did. He also avoids references to women from the recent past, with the exception of Joanna, queen of Sicily. Joanna, however, was so extraordinary that Boccaccio dedicated the book to a different woman, one who was more like normal women and would serve as a better example for them.[5] His collection is not wholly in praise of women: the admirable and the infamous are set side-by-side. As one scholar has put it, for Boccaccio, women's fame "is a form of notoriety."[6] A good many of the women are famous for their humiliation of men, or for their vice. Even the most virtuous women, who held steadfastly to their chastity or their silence, met with death or military defeat rather than glory. Those women who were most unequivocally admirable in Boccaccio's collection were praised for being like men, a way of removing them from the larger class of women and making them exceptions rather than examples for other women. Women were, in effect, warned not to enter the public arena, not to strive for fame, not to upset the established hierarchies of society.

These conflicting purposes—to exemplify virtue and admonish women to shun public life as well as to warn men against the power of women—come head-to-head in Renaissance and baroque images of heroic women. When the image is a print, a number of other purposes can be assumed. Prints had more personal uses than, say, a statue of a hero in a town square. Women might see them as inspirational images; their husbands might hope they would.[7] Artists could use prints to popularize great works of art and to display their skill with the female form. Men might collect them privately, to be enjoyed for their beauty or for their erotic value. The selection of prints presented here illustrates this variety of appeal very clearly. Some works serve as symbols of virtue, others as more lascivious objects, still others as images with a hidden meaning, causing the viewer to sympathize more with the heroine's conquered foe than with the heroine herself. Even those prints that present the most admiring image of the heroine often convey a subtle message: that womanly virtue, not public fame, is the goal toward which women should strive.

One opportunity for representing heroic women in the Renaissance was in the context of the nine worthies. The tra-

dition of nine male worthies was fairly well established by the end of the fourteenth century. A corresponding group of female worthies developed at the same time but appeared less frequently, and there was more freedom in deciding which women should be depicted.[8] Sometimes the warrior aspect would be emphasized, with the group consisting largely of Amazons, but artists lessened the ferocity of such women by giving them the benign appearance of ladies of the court.[9] Until the sixteenth century it seems not to have occurred to artists that the nine women should comprise three pagans, three Jews, and three Christians, just as the nine men did. The first known instance of this kind of arrangement of women worthies in the visual arts is a set of engravings by Hans Burgkmair (cat. 1A–C). This may at first suggest a more equitable treatment of heroes and heroines, but Burgkmair's selection of women and the manner in which he presents them make a clear distinction between the virtues appropriate to men and those appropriate to women. Although each of the men is dressed for battle, most of the women hold identifying attributes, not unlike the traditional representations of Virtues or of saints (in fact, three of Burgkmair's worthies are saints). Judith and Jael, the only women of the nine who performed violent deeds comparable to the bloody conquests of the men, are restrained and seem to listen intently to that great peacemaker, Esther. In this instance, as with all of Burgkmair's worthy women, acceptable womanly virtue is emphasized, whether it be peacemaking, chastity, silence, or piety.

Among Burgkmair's pagan women stands Lucretia, the heroine whose rape and suicide play an important role in the legends surrounding the founding of the Roman republic. Her story was a popular subject for both art and literature from the classical period onward, and particularly in the sixteenth century.[10] The legend begins with a debate among the young men of the Tarquin family over whose wife was most virtuous. The participants included Lucretia's husband and Tarquinius Sextus, the son of the tyrannical king. To decide the issue, the young men rode to their home only to find their wives at a luxurious banquet. Only Lucretia was home with her maidservants spinning. Seeing such diligence and knowing Lucretia's reputation for chastity, Tarquin was seized with desire. He returned to her home, where Lucretia welcomed him as a kinsman, but late in the night he entered her bedchamber and, armed with a sword, tried to persuade her to submit to him. Since she continued to resist, he finally threatened her with disgrace, saying that he would murder her and a slave and tell everyone that he had killed them when he discovered them in the act of adultery.[11] Faced with this threat of dishonor—to herself and to her husband, to whom she would be unable to explain—she submitted to the rape.[12] Afterward Lucretia told her husband and her father of the as-

sault. She asked them to punish Tarquin, but added "I do not absolve myself from punishment; nor in time to come shall ever unchaste women live through the example of Lucretia."[13] With these words, she pulled a knife from her dress and stabbed herself. Brutus, one of the men who had witnessed the suicide, drew the knife from Lucretia's breast, held it high, and rallied the people of Rome to use Lucretia's example to overthrow the Tarquin kings.

Lucretia's heroism, for most of the classical writers, lay in her dramatic suicide, which inspired the people to overthrow tyranny. The political importance of Lucretia's act was not entirely forgotten in the Renaissance, though in the visual arts it surfaced only briefly in republican Florence.[14] More important was the use of Lucretia as symbol of chastity, a strong tradition throughout the middle ages and into the Renaissance.[15] A darker side to the legend was also kept alive through this period: the story of Lucretia served as the focus of a debate about rape, and about whether or not the woman should be considered a guilty participant. Already in the fourth century Saint Augustine questioned Lucretia's motives: if she were not guilty, why did she take her own life? A woman would not feel shame, Augustine said, unless she felt some pleasure in the act, unless she consented to it.[16] This shadow of doubt cast on Lucretia's character enters into later retellings of the myth. Sometimes a writer defends her strongly. At other times her enjoyment is played up, even to the point of farce.[17] Machiavelli, for example, parodied the legend in his *Mandragola,* in which he casts Lucretia as a beautiful but overly virtuous wife whose husband's desire for children is seen as an excellent opportunity for her admirer, Callimaco, to gain access to her bed.[18] This reworking suggests that Lucretia enjoyed, even invited, her rape.

A similar range of interpretation appears in the prints of Lucretia. A few emphasize her chastity (cat. 1A) or the notion that her suicide preserved the honor of her father and husband (cat. 2). In more typical presentations (cats. 4, 6, 7, 10) Lucretia stands nude or partially draped, holding the knife pointed toward (or already deeply plunged into) her breast. These images were probably inspired by a fragmentary classical statue found in Rome in or before 1508 that was quickly identified as a Lucretia, the first Roman example to be found showing the heroine.[19] Although the written sources tell of Lucretia's modest dress at the time of her suicide, the statue (which was surely nude or nearly so) gave classical precedent to increasingly erotic images of this heroine.

Lucretia's sensuality was also emphasized in images that depict the suicide on the bed, as if Lucretia had immediately risen up after the rape and, still naked, stabbed herself.[20] The most suggestive images, however, show the rape itself, or more precisely, Tarquin threatening Lucretia just before the rape. In all the prints and paintings of the subject Lucretia is

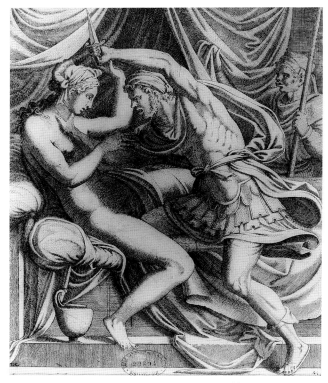

fig. 1. Master LD, *Tarquin and Lucretia*, c. 1546, etching, 269 x 214 (10⁵/₈ x 8⁷/₁₆), Bibliothèque de l'Ecole des Beaux-Arts, Paris (Zerner 71).

completely nude in her bed, whereas Tarquin is usually fully clothed and sometimes wears armor (fig. 1).[21] This increases the contrast between Tarquin and Lucretia—between the pure whiteness of her skin and the darker shades of his clothing, between her vulnerability and his power. This contrast could make the viewer share Lucretia's feelings of terror and helplessness, or it could have the opposite effect, making her seem all the more desirable because of her vulnerability. The second interpretation is reinforced in the prints where Lucretia is shown as if she were on display, encouraging the viewer to identify with Tarquin in his lustfulness or with the slave who observes the rape like a voyeur.[22]

In the few exceptions where Tarquin is nude, he often appears to be Lucretia's lover rather than a rapist. In Georg Pencz' print (cat. 14) Tarquin's gesture seems more of an embrace than a threat, and Lucretia's expression can be read as longing. A print by Agostino Veneziano (fig. 14a) is the visual equivalent of the satires that portrayed Lucretia as a willing participant in the rape.[23] Here Lucretia shows little sign of fear, and her right hand is hidden by Tarquin's body in a most ambiguous fashion. Tarquin hardly looks terrifying in

his nakedness, holding a piece of drapery that assumes a not very subtle phallic form. In case the point was missed by all of these references, the engraving shows two dogs copulating in the foreground. Lucretia, no longer a heroine, becomes the subject of thinly disguised pornography.[24]

Pursuing yet another interpretation, some artists attributed to Lucretia a wild psychological state at the moment of her suicide. Marcantonio Raimondi and Hans Sebald Beham (cats. 6, 11) both show Lucretia's hair flying madly—the former has her turning her head sharply away from the sword, the latter tearing at her clothes. These are images of a passionate woman driven to suicide, and they have little to do with the Lucretia presented in classical sources. These images may be a way of suggesting Lucretia's guilt, since it seems to have been a convention in the Renaissance that virtuous women died painlessly, and only the wicked were horrified or frightened by death.[25] The meaning of this convention was not absolutely fixed, however, and it is not always clear whether Lucretia is being equated with or contrasted to other less noble suicides. One might assume, for example, that Lucretia and Cleopatra, often paired in prints, would be contrasted, since Cleopatra was famous for her lustful behavior.[26] Yet no such judgment about the character of the two women is being made in two engravings by Barthel Beham (cats. 9, 10)—Cleopatra is serene, while Lucretia seems distraught.[27]

Lucretia could also be compared to Dido, the queen of ancient Carthage, who stabbed herself before falling on her self-made funeral pyre. In fact, it would seem that the two were interchangeable in the minds of artists, since the same poses are often used for both (cf. cats. 5 and 6, also 4 and 8). This transference of pose would only have increased the ambiguity that already existed with regard to Lucretia's virtue, because Dido was a controversial figure herself. Two quite different accounts of her death were known in the Renaissance. Boccaccio tells of her great love for her husband, Acerbas, who was killed by her greedy brother Pygmalion. After the founding of Carthage she lived a life of purest chastity, but the king of a neighboring tribe wanted to marry her and threatened to destroy her city if she did not agree to his wishes. In order to save her city and still preserve her honor, Dido stabbed herself to death upon a pyre.[28] The other version of the story is told in Virgil's *Aeneid*, where Dido is portrayed as Aeneas' lover, who kills herself when he abandons her.[29] Some images of Dido make clear whether she is to be seen as a desperate lover (cat. 12) or as a woman who saved her city and preserved her chastity, but most do not. As with Lucretia, her nudity is ambiguous—it could be a reference to classical art, or a sign of the seductiveness that led to her downfall.

Lucretia and Dido share a further characteristic: their heroic deeds are self-destructive. Although self-sacrifice underlies almost all heroic tales, the motivation for the sacrifices of these

women differs markedly from that of male heroes. Men offer their lives to preserve the lives of others or for the sake of their countries, their religion, or some greater good. They are most often killed by their enemies in the heat of battle. Male suicides, while not unknown in mythology, rarely serve as subject matter for the visual arts.[30] Lucretia and Dido (following the more honorable version of her story) sacrificed their lives for one cause—chastity. In both cases there were important political consequences to their deaths, but the power each woman exercised was directed toward her own body and was in response to a threat to her chastity. These images reinforce the notion that women could not effectively act in the public sphere and that the greatest challenge to which they could rise was the control of their sexuality. The images also reinforce the stereotypes of women as masochistic, passive, and essentially victims. Such implications are made even more strongly by the inclusion of Virginia in the ranks of the worthy women (cat. IA). This young girl did not commit suicide but, perhaps worse, was killed by her father in order to keep her from surrendering her chastity to a tyrant king. The perfect example of the heroine as passive victim, Virginia never speaks or even thinks about her dilemma, and yet in written sources she is considered equal to Lucretia as a model to women.[31]

Comparable to these heroine/victims is Susanna, the Old Testament woman who was often held up as the ideally virtuous wife, particularly in the seventeenth century.[32] Her willingness to die when falsely accused made her especially appealing in the Counter-Reformation era. Even so, representations of her did not escape the ambivalence and the erotic suggestions seen in images of Lucretia.[33]

A devout and chaste wife, Susanna attracted the attentions of two unscrupulous elders of the community. Spying on her as she bathed alone in her garden, the elders accosted her, saying that if she did not satisfy their desires they would testify that they had found her with a young man. Although she knew that she could be condemned to death if she were found guilty of adultery because of the elders' testimony, Susanna still refused to submit. The elders did falsely accuse her, and she was condemned, although at the last moment the young prophet Daniel protested and reopened the trial. The lies of the elders were then uncovered, and they, rather than Susanna, were put to death.

Susanna sometimes appears as one of the worthy women, and she is included in other series that compare her to women like Lucretia and Cleopatra. In one set of engravings Crispin de Passe brings these three women together with explanatory captions: Susanna is both "pious and chaste," Lucretia is "chaste but not pious" (presumably because she was pagan), and Cleopatra is "neither pious nor chaste."[34] Susanna is identified as a Christian (although she lived in pre-Christian times), which gives her greater esteem than Lucretia. She was also considered more virtuous than Lucretia, who committed suicide after yielding to her attacker, whereas Susanna was willing to suffer punishment without yielding at all.

Still, the most typical illustrations of Susanna, showing the scene in the garden, are very ambiguous. Susanna is depicted as a voluptuous nude, either fully displayed for the viewing pleasure of the elders (and viewers of the image) or in a pose that recalls the crouching Venus, an image of coy eroticism. Only rarely does she seem distressed. Sometimes she seems oblivious to the elders, and other times she gazes piously up to heaven.[35] Several examples show her looking beseechingly at the elders, implying that Susanna was the one who was tempted. Annibale Carracci's influential engraving shows her in this manner (cat. 18).[36]

Most of these images were made by men, for a largely male audience—men who had more in common with the voyeurs than with the victim. And it is likely that Susanna's reputation for chastity added to the erotic appeal of the prints. Rubens, for example, while pointing to the chastity of Susanna in the inscription for one of the engravings he designed, nevertheless referred to the same image as a "galanteria" in writing to a male correspondent about it. For his part, the receiver of the letter had hoped that Rubens' *Susanna* would be "beautiful enough to enamour even old men."[37] For Susanna, as for Lucretia, chastity makes the heroine even more enticing, and the image of virtue easily becomes an object of lust. Similar ideas were surely in the minds of other artists as well. Another example is found in Agostino Carracci's engraving of *Susanna and the Elders,* which formed part of a pornographic series that circulated widely, if surreptitiously, in the late sixteenth century.[38]

Another type of heroine frequently depicted in Renaissance and baroque prints is not a passive victim but an active, aggressive woman who makes a man her victim. The best known of these is Judith, the young widow renowned for her brutal slaying of Holofernes in order to save the Hebrews.[39] Her image appeared in all media in the visual arts, and her story inspired many literary works.[40] In the middle ages two interpretations of Judith were common: she was depicted as a parallel to the Virgin Mary overcoming the devil; or standing over Holofernes' body as a symbol of the struggle between virtue and vice, in which she might represent humility or chastity while Holofernes represented pride or lust.[41] These traditions continued into the Renaissance when indeed Judith and Holofernes could stand for almost any adversarial relationship. Catholic writers turned the story into an allegory of the Church in its battle against the Turks, while Martin Luther preferred to see Judith as a symbol of strength received directly from God, which was used to battle the tyrannical church of Rome.[42] Judith's image, paired with that of David slaying Goliath and placed in public settings, took on political

meanings—a representation of the people overcoming tyranny, or of the city overcoming a more powerful enemy. In this way she could stand for justice, and her image was even confused with the personification of justice, a young woman holding a sword and sometimes the head of a tyrant.[43]

Static images of Judith that resemble personifications of justice or other virtues do occur in Renaissance prints, although less frequently than one might expect. In Jacopo de' Barbari's *Judith* (cat. 20) and its companion *Saint Catherine* (fig. 20a) each woman simply holds her respective identifying attribute; all narrative elements are eliminated. The similarities suggest that both women share qualities of saintliness or courage.

Several of the German prints in the exhibition draw on this tradition, but with an extraordinary twist—Judith is completely naked. Although it is not uncommon to see personifications nude, the intention in the prints by Hans Sebald Beham and his brother Barthel (cats. 25–28) seems to have been to present the heroine as a sex object.[44] The implication is that Judith brought Holofernes down by being sexually irresistible. This interpretation, it should be noted, goes against the apocryphal text, which makes it clear that Judith, dressed in her finest clothes, was chaste when she entered Holofernes' tent and chaste when she left with his head in her sack. The transformation of Judith into an object of sexual delight may have been more appealing to the men who purchased such prints. At the same time, the message changed from setting up Judith as a model of courage to showing her as an example of the power that women have to make fools of men. Judith becomes the seductive *femme fatale,* toying with the head of Holofernes (cat. 28). An even more striking transformation overtakes the heroine Jael, whose story in many ways parallels Judith's.[45] Although she sometimes appears as one of the nine worthy women (cat. 1B), she more often takes her place in the "Power of Women" series, a negative tradition of images in which women use their sexual charms to vanquish wise or strong men.[46]

Renaissance artists, in prints as well as in other media, often depicted Judith accompanied by her maid after the decapitation. This allowed the artist to avoid the gruesome act itself and to focus on Judith's other qualities. The heroine's beauty could be pointed up by comparing it with the homeliness of the maid—typically the servant is shown as a coarse-featured old or black woman, stooped in contrast with Judith's upright bearing. The artist might also emphasize the cunning of the two women, who conspire to outwit their more powerful enemy. Judith and her maid had gone to the Assyrian camp claiming to have deserted the Hebrews and offering to betray valuable secrets. They were allowed to keep the religious customs of their people, however, to bring in their own food in a sack and to go outside the camp to pray every night just before dawn. Holofernes, quite taken by the heroine's beauty,

invited Judith to his tent with the hope of seducing her, but passed out from too much drink before he could do anything. Judith seized her chance and using his own sword, cut off his head, which she placed in the sack. She and her maid, carrying their sack as usual, then left the camp for their daily prayers; the Assyrians suspected nothing until they saw the head of Holofernes displayed above the walls of the Hebrew town. Such cunning was thought to be typical of women, and, like their sexuality, it could be used as a powerful weapon against men. These two powers are often linked in images of Judith and her servant (cat. 26).

Although active representations of Judith appeared in the second half of the sixteenth century, it is only in seventeenth-century prints that the story of Judith becomes a real drama. An engraving after Rubens (cat. 32) shows dramatic nocturnal lighting, which is also seen in an etching by Tempesta (cat. 30), although the moods are very different. Figures in the engraving express a full range of emotion, from the wide-eyed apprehension of the maid, to the determination of Judith, to the agony and rage of Holofernes as the sword slices through his neck. Sensuality is evident in the satiny sheets and Holofernes' nudity, but Judith is not simply a sexual presence. She is finally an active heroine, performing a perilous deed to save her people.

In all of these examples the varying interpretations given to the image of the heroine can be seen as a manifestation of the conflict between female virtue and heroic action. The story of another heroine, however, does not seem to involve this conflict. Esther, unlike Lucretia and Judith, performed no act of violence, nor does her action suggest the seduction of a man other than her husband. She was famous for her humility, and was in fact made queen precisely for this virtue. King Ahasuerus' first wife, Vashti, had been deposed for her insolence in refusing to come at the king's command; Esther, in contrast, submitted meekly to him. Esther was also beautiful, but she used her beauty only to influence her husband to spare the Hebrews from destruction. Even though she did not tell her husband of her own Jewish faith until the plot against her people was revealed, sixteenth- and seventeenth-century images do not show her as a treacherous woman. She is instead presented as an intercessor, sweetly shy (cat. 15) or fainting in fear of her husband.[47] Esther's power resulted from her submission and her chaste beauty. She accomplished her great deed by means of the virtues of the ideal woman, not in spite of them. Although Esther seems not to have been plagued with the kind of seductive images that were associated with other heroines,[48] it was only in the hands of an artist as sensitive as Rembrandt (cat. 16) that she was presented as a heroine who is strong and quietly determined in her task.[49] This is finally an image of a heroic woman whose power is much more than sexual.

The hero and the heroine are both exceptions in society, but the effort to make the heroine display the virtues expected in ordinary women led to continued conflict that is reflected in the prints in this exhibition. Artists chose to depict mythical women whose actions exemplified that most important of female virtues, chastity, yet they still transformed the women into sensuous objects, suggesting that even these paragons could be overcome by the right man. Society did not value power and aggressiveness in women, and artists often turned the heroine who displayed such traits into a *femme fatale* (wielding the power of sex) or into an Amazon (outside society and its norms).[50] At the opposite end of the spectrum, artists treated women who conformed to the ideals of humility, silence, obedience, and chastity with more respect (but perhaps with less sustained interest). Only rarely do artists emphasize courage and determination without malicious connotations. These prints can be given other interpretations as well: as political or religious allegories, as explorations of dramatic content, or as studies of ideal form. But even those purposes presuppose ideas about women that reflect their power (or lack of it), or that are governed by positive or negative stereotypes. The ambiguity toward the heroine so often seen in these prints relates directly to the ambiguity felt in the society toward strong women.

1. For definitions of the Renaissance hero, see Starn 1986, 75–77; and Mommsen 1959, 150 and 173. Mommsen notes that Petrarch clearly defined an illustrious man as a "great man of action," either a political or military leader, and specifically excluded other notable men like philosophers and poets, as well as men who had become famous through the workings of fortune rather than virtue. Later cycles, however, especially in Italy, also included "cultural heroes" such as Dante and Giotto.
2. Kelso 1956, 24–29; and Dunn 1977, 17. For other examples, see Los Angeles 1976, 22–23; and Kaufman 1978, 893–895.
3. Several women renowned for their military leadership are listed in Power 1975, 45. The most famous example is Joan of Arc; the very interesting history of her imagery is told in Warner 1981. It seems that female rulers in the Renaissance had to search for appropriate images to convey power along with female virtue. See ffolliott 1986, 231; and Marrow 1982, 55–57.
4. The catalogue of the British Library lists fifteen editions of Boccaccio's *De claris mulieribus*, in five languages, before 1566.
5. Boccaccio 1963 ed., xxxiii–xxxix. See also Jordan 1986, 243–244. Fahy 1956, 35 and 40, notes a similar avoidance of contemporary women in other Renaissance collections of lives of famous women.
6. For this and the following, see Jordan 1987, 25–47; the quoted line is on page 27.
7. An indication of this kind of use is seen in the painting *A Lady as Lucretia* by Lorenzo Lotto, in which a woman holds an image of Lucretia. This seems to be a drawing, but it is similar to Marcantonio's and Francia's engravings of Lucretia. See Hazard 1979, 25.
8. The iconographic tradition of the nine worthies has been traced in Wyss 1957, 73–89; Schroeder 1971; and Rorimer and Freeman 1948–1949. Additional bibliography can be found in Joost-Gaugier 1980, 312 n. 10. The related Italian tradition of illustrious men and wo-

men is discussed in Mommsen 1959, 95–116; Joost-Gaugier 1980, 311–318; and Creighton Gilbert, "On Castagno's Nine Famous Men and Women," in *Life and Death in Fifteenth-Century Florence*, ed. M. Tetel, R. G. Witt, and R. Goffen (Durham and London, 1989), 174–192.
9. For examples, see Schroeder 1971, plates 2 and 4.
10. Lucretia's story is part of the half-legendary history of the founding of the Roman republic (sixth century B.C.). The first surviving record of it was written five centuries later by Livy, *De urbe condita* 1.57.6–1.59.13. The historical validity of the story and the other classical sources for it are discussed by Donaldson 1982, 5–8; and Young 1964, 71–74.
11. The disgrace was compounded because of the Roman taboo of sexual relations between citizens and slaves. See Pomeroy 1975, 160–161.
12. Donaldson 1982, 11, discusses the fact that a rape was considered a defilement of the husband's property in Roman law.
13. Translation by B. O. Foster in Livy, *De urbe condita*, Loeb Classical Library (London and Cambridge, Mass., 1939), 1:203.
14. The story of Lucretia is seen on Florentine *cassoni* panels from the second half of the fifteenth century. In many examples the central scene is Brutus' oath over the body of Lucretia. See Walton 1965, 185–186; and Callmann 1979, 84.
15. Hazard 1979, 25–27; Young 1964, 74–76, 88–89.
16. Augustine, *City of God*, bk. 1, chaps. 16–19; see also Donaldson 1982, 29–39.
17. In *The City of Ladies* written in 1405, Christine de Pisan uses the example of Lucretia to reject the idea that women secretly like to be raped, their protestations notwithstanding (2:44.1). She also uses Lucretia's example to show that it is virtue, more than beauty, that attracts men (2:64.1). For surveys of the use of the Lucretia theme in literature, see Hartmann 1973; Galinsky 1932; Croce 1953, 1:400–410. Donaldson 1982, 83–100, discusses comic inversions of the legend. The question of Lucretia's consent is still an issue today. See Bryson 1986, 152–173; and the review by Susanne Kappeler in *Art History* 11 (1988): 118–123.
18. Machiavelli 1985 ed. For other examples and discussion, see Donaldson 1982, chap. 5.
19. Stechow 1951, 118–124. The statue, known only through early descriptions, probably lacked head and arms. Wendy Steadman Sheard has attempted to reconstruct its appearance. See Northampton, Mass., 1978, no. 102. The Italian engravings probably reflect the appearance of the statue most closely, while the Northern prints may be based on verbal reports. Only recently have Etruscan, not Roman, reliefs been found that may represent the story of Lucretia. See Small 1976, 349–360.
20. Examples include the engraving by Enea Vico after a design by Parmigianino (Bartsch 17) and a woodcut by Hans Sebald Beham (Pauli 1911a, no. 912).
21. Examples that show Tarquin fully clothed are illustrated in Donaldson 1982, plates 1 (Titian), 2, 4, 13 (Tiepolo), and 14 (Artemisia Gentileschi).
22. A good example that shows Lucretia fully displayed is Goltzius' *Rape of Lucretia*, c. 1578 (Bartsch 106), but it does not include the servant. The servant is most voyeuristic in Master LD's print (fig. 1 here); he is also seen in an engraving by Giorgio Ghisi after Giulio Romano (Bartsch 27).
23. Rome 1985, no. 8. First state dated 1523, second state dated 1524. This may have been based on a design by Raphael, but it was reworked by Enea Vico. Donaldson 1982 reproduces Thomas Rowlandson's version of the print in his fig. 3.

24. Most versions that show Tarquin nude are prints, a more private medium than painting. Other examples include two variations by Aldegrever (Bartsch 63 and 64). The only painted examples that I know are based upon Tintoretto's painting in the Art Institute in Chicago (another version is in Cologne, and a variation attributed to Domenico Tintoretto is in the Prado). See R. Pallucchini and P. Rossi, *Tintoretto: Le opere sacre e profane* (Milan, 1982), nos. 450, 451, and A59.

25. The literary evidence for ideas about women's responses to dying are explored by Joyce Van Dyke in an unpublished paper presented at the Folger Institute in Washington, D.C.: "Dying Like a Woman: Cleopatra's Art and Renaissance Convention."

26. Veldman 1986, 123. Cleopatra's story is told (with much disapproval) in Boccaccio 1963 ed., 192–197.

27. Barthel's prints are very similar in size and format, and it is likely that they were meant to be seen together. A similar pairing in engravings by Jan Muller shows both of the women dramatically killing themselves on their beds (Bartsch 8 and 9). Cleopatra is typically depicted in a languid pose, less often in a passionate one. See Guillaume 1972, 185–194; and Garrard 1989, 244–277.

28. Boccaccio 1963 ed., 86–92.

29. Virgil, *Aeneid* 1.335–756, 4.1–705, and 6.450–476.

30. Garrard 1989, 212–214, provides an excellent discussion of the contrast between representations of male and female suicides.

31. See cats. 3 and 13 for a fuller discussion of this myth. See cat. 13 n. 2, for a comparison of Virginia to Lucretia.

32. Susanna's story is told in the Book of Susanna and Daniel in the Apocrypha of the Old Testament. On Susanna as a model for women, see Kelso 1956, 24 and n. 35. For plays and other literary works based on the story of Susanna, see Casey 1976, 25–29 and chap. 2.

33. A good survey of the iconographic tradition of Susanna and seventeenth-century variations of it is found in Garrard 1989, chap. 3. See also Rearick 1978, 2:331–343.

34. The prints are Hollstein 38, 372, and 373, dated c. 1601–1602. Veldman 1986, 122–123.

35. For examples, see Garrard 1982, 148–154. Also see the prints by Jan Saenredam after Goltzius and after Cornelisz (Bartsch 42 and 36); and another by Claes or Nicolas Breau after Jacob Matham (Bartsch 5). The eroticized theme of Susanna in her bath is most frequent in the sixteenth and seventeenth centuries. See Réau 1955–1959, vol. 2, pt. 1, pp. 395–396. Garrard notes how Artemisia Gentileschi's painting of *Susanna* departs from this tradition, showing fear and a feeling of entrapment that the artist must have felt from the harrassment that preceded her own rape.

36. Such an interpretation is supported by religious works that set Susanna as a parallel to Eve, implying that Susanna was tempted in a similar fashion. See Leach 1976, 124–125; and Garrard 1989, 193–194.

37. McGrath 1984, 81–84, 89, nn. 72 and 75. The print in question is Vorsterman's engraving of *Susanna and the Elders,* which in its first version was dedicated to Anna Roemer Visscher and included the inscription referring to chastity, making it seem that Visscher's virtue was equal to Susanna's. The letters of Rubens and Dudley Carleton are in Rooses and Ruelens 1887–1909, 2:150 and 165.

38. Bohlin 1979, 289–291. There is some debate about whether the Susanna engraving and another showing Bathsheba belong in the series, because the others are mythological scenes, but the sexual content and the format of the prints make it seem likely that they were.

39. Judith's story is told in the apocryphal Book of Judith.

40. For literary works in northern Europe, see Purdie 1927. Purdie has found examples from as early as the ninth century, and she lists over forty literary works from the fifteenth through seventeenth cen-

turies that deal with the theme of Judith and Holofernes. For Italian dramatic works on the theme, see Frank Capozzi, "The Evolution and Transformation of the Judith and Holofernes Theme in Italian Drama and Art before 1627" (Ph.D. diss., University of Wisconsin–Madison, 1975).

41. Judith, along with Tomyris and Jael, is equated with the Virgin in chapter 30 of the *Speculum humanae salvationis,* a popular religious book that drew parallels between the Old and New Testaments. See Wilson and Wilson 1984. On the psychomachia, that is, the struggle of virtue and vice, see Katzenellenbogen 1964, 1–13. In the Renaissance, Donatello's bronze *Judith* draws on this tradition. See Wind 1937, 62–63; Von Erffa 1969, 460–465; and Herzner 1980, 139–142.

42. Purdie 1927, 41–42.

43. Herzner 1980, 170; and Warner 1985, 155, discussing Ambrogio Lorenzetti's personification of justice. Titian's *Judith* for the Fondaco dei Tedeschi in Venice, as well as Donatello's *Judith,* probably had such a political meaning. See Bialostocki 1988, 119; Serena Romano, "Giuditta e il Fondaco dei Tedeschi," and Stefano Coltellacci, Ilma Reho, and Marco Lattanzi, "Problemi di iconologia nelle immagini sacre—Venezia c. 1490–1510," in *Giorgione e la cultura veneta tra '400 e '500, Mito, Allegoria, Analisi iconologia* (Rome, 1981).

44. The engravings of the Behams that show Judith completely nude are dated form around 1525 onward. Earlier examples of nude Judiths include an engraving by Nicoletto da Modena, c. 1510–1515 (Bartsch 2), and an alabaster sculpture by Konrad Meit, c. 1512–1514. Contemporary with the earliest examples by the Behams is Hans Baldung Grien's painting in Nuremberg. For the German works, see Adelheid Straten, *Das Judith-Thema in Deutchland im 16. Jahrhundert: Studien zur Ikonographie* (Munich, 1983), 30–33. Eugene A. Carroll has published an extraordinary drawing by Rosso Fiorentino, which shows both Judith and her haggardly old maid totally nude except for turbans on their heads (Carroll 1978, 25–49). Carroll suggests that the drawing may have been intended as a model for printmakers.

45. See note 38 above, and cat. 1B.

46. See the section in this exhibition on the Power of Women. Judith is found in these series as well, but much less commonly. See Smith 1978, 278–279. For further examples of Judith as *femme fatale,* see Garrard 1989, 299–301.

47. Positive interpretations of Esther were surely encouraged by her close association with the Virgin Mary in the middle ages and Renaissance. In her role as intercessor she was seen as a parallel to the Virgin Mary in chapter 39 of the *Speculum humanae salvationis.* See Wilson and Wilson 1984, 201–203. Her coronation was also seen as a prefiguration of the Virgin's. See Avril Henry, *Biblia pauperum* (Ithaca, N.Y., 1988), 119. For the scholarly literature dealing with the iconography of Esther, see the notes to cats. 15 and 16.

48. Such images do occur in the nineteenth century. An example is Théodore Chassériau's *Toilet of Esther,* 1841, now in the Louvre.

49. Rembrandt's images of women are not always positive. See Mieke Bal, review of S. Alpers, *Rembrandt's Enterprise,* in *Art Bulletin* 72 (1990): 141 n. 17.

50. The Amazons have their own interesting and ambiguous history, which is not reflected in prints available for this exhibition. The range of interpretations given to them is discussed in Kleinbaum 1983.

1
Hans Burgkmair

Lucretia, Veturia, and Virginia
(from *The Eighteen Worthies* series)
Woodcut, 1519
194 x 130 (7⅞ x 5⅜)
Hollstein 252
Rosenwald Collection 1944.8.52

Esther, Judith, and Jael
(from *The Eighteen Worthies* series)
Woodcut, 1519
201 x 137 (7⅝ x 5⅛)
Hollstein 250
Rosenwald Collection 1944.8.51

Saint Helen, Saint Bridget, and Saint Elizabeth
(from *The Eighteen Worthies* series)
Woodcut, 1519
195 x 131 (7¹¹⁄₁₆ x 5⅛)
Hollstein 248
Rosenwald Collection 1944.8.50

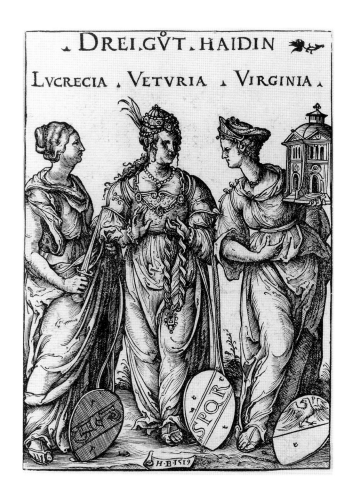

The late medieval love of chivalry lies behind the tradition of the nine worthies, three groups of three men representing the heroes of classical antiquity, of the Old Testament, and of the Christian era. By the early fourteenth century the list of male worthies was established, and very little variation is seen through the Renaissance. Hector, Alexander the Great, and Julius Caesar represent the pagans; Joshua, David, and Judas Maccabaeus, the Jews; and Charlemagne, Godfrey of Bouillon, and King Arthur, the Christians. A corresponding group of women worthies appeared by the end of the century, but the three-by-three structure was not given to this group. Instead the worthy women were most often represented by nine female warriors, particularly Amazons.[1]

Burgkmair follows the traditional scheme for his series of engravings of the male worthies (figs. 1a-c), but he seems to be the first artist to adopt the three-by-three grouping for the female worthies and to select them from similar categories.[2] It has been suggested that this reflects a reevaluation of women on the part of Burgkmair himself or of the humanist circle in Augsberg,[3] and yet a closer examination of the series reveals that the "female" virtues held up as ideals are very traditional.

While each of the pagan women that Burgkmair represents had an effect on the political affairs of the Romans, they were better known in the sixteenth century as examples of the most important of all female virtues: chastity. It is very likely

that the round temple held by Virginia represents the temple of Vesta, a clear reference to this virtue.[4] The three Roman women also represent the three states of women with regard to men: dutiful daughter (Virginia), the loyal and self-sacrificing wife (Lucretia), and the honorable widow who commands the respect of her son (Veturia).[5]

Esther, Judith, and Jael are the worthy women of the Old Testament.[6] All three played decisive roles in saving the Hebrews from imminent destruction, and they can be seen as symbols of female courage, but their stories carry other connotations that find expression in the visual arts. While Esther is almost always seen in a positive light—either as an intercessor like the Virgin Mary, or as a model of another great female virtue, humility—Judith and Jael's heroism is a result of their gruesome murder of men. As a result, the images used

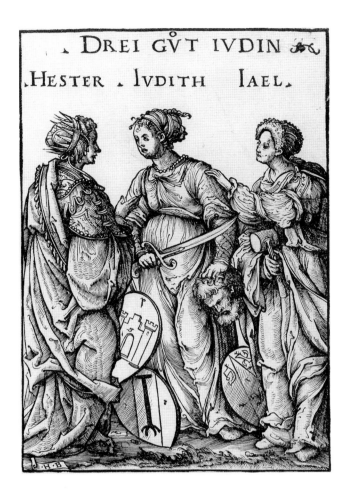

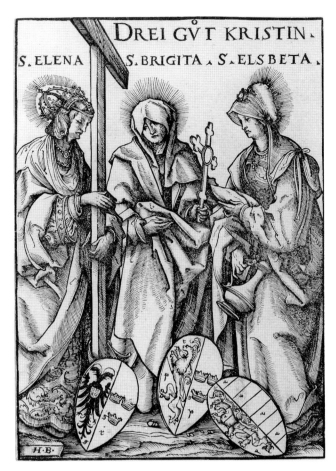

to portray them are much more ambiguous and sometimes quite negative in their meaning.

Burgkmair carefully portrays the three worthy women of the Old Testament to take the emphasis away from the violence and put it on more becoming female virtues. Judith is the figure that shows the most aggression, carrying the head of Holofernes in one hand, and holding her sword in a menacing fashion in the other, while her face seems to convey the kind of determination that a true hero must possess to carry out his or her actions. Jael, on the other hand, holds her mallet and tent peg like simple attributes, with no indication that she intends to us them. Esther holds no attribute, but her gesture is clearly one of intercession—she is in her most familiar role, convincing another to do right. Here, however, she pleads not with her husband to stop the killing, but rather

with Judith—presumably to stop her violent ways. Even Jael steps in to restrain Judith with the touch of her hand. This group can be compared with Burgkmair's three pagan men (fig. 1a), who are fully decked out in armor and whose gestures are decisive (Hector) and supportive (Caesar), not restraining. If the three women are being celebrated for their virtue, it seems the most worthy of the virtues are the womanly ones that Esther displays—humility and peacemaking—for she is in the position of honor, first in the group. The virtues of the hero—fortitude, strength, and aggressiveness—are clearly secondary.

For his Christian women, Burgkmair presents the saints Helen, Bridget, and Elizabeth of Hungary, among the most popular saints in Germany at the time.[7] The three saints can be seen as symbols of virtues: Elizabeth's life was seen as an

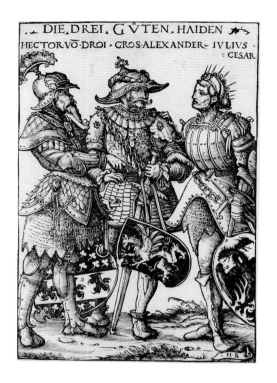

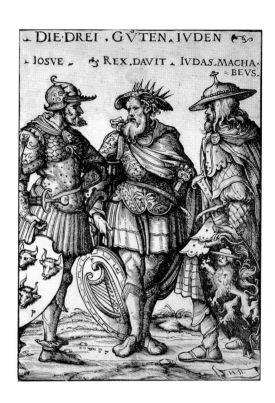

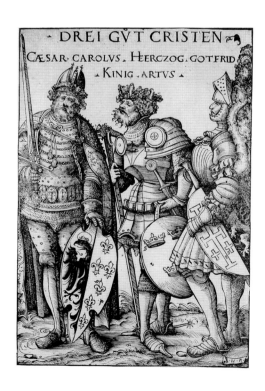

fig. 1a–c. Hans Burgkmair, *Three Good Pagan Men: Hector, Alexander the Great, and Julius Caesar; Three Good Jewish Men: Joshua, David, and Judas Maccabeus;* and *Three Good Christian Men: Charlemagne, Godfrey of Bouillion, and King Arthur,* 1516, woodcuts, 195 x 132 (7¹¹/₁₆ x 5³/₁₆); 196 x 131 (7¹¹/₁₆ x 5³/₁₆); and 195 x 132 (7¹¹/₁₆ x 5³/₁₆), National Gallery of Art, Washington, Rosenwald Collection 1944.8.49,48,47 (Hollstein 251, 249, 247).

example of the seven acts of mercy, and she carries the loaf and pitcher that symbolize her charity; Bridget, dressed in the habit of an abbess, may represent faith; while Helen, in her search for the True Cross, might represent the other theological virtue, hope. But perhaps more important than this reference to the theological virtues is the fact that the three were models for women of Burgkmair's time. All three of these women were married and maintained their sanctity before marriage as virgins, through marriage and motherhood, and after marriage as widows.[8] Yet they can hardly be thought of as heroines. No conquests are associated with them, and their actions did not have political consequences. Burgkmair's representation of them emphasizes something quite different from the active life of the worthy man: all look downward, withdrawn from the world and each other. It is worth noting that this is the only one of Burgkmair's groups in which there is no suggestion of conversation—and so the entire group represents the other great virtue of the ideal woman: silence.

Burgkmair's choices of women worthies may have been inspired by his patron Maximilian I, who traced his ancestry to the three worthy Christian men and to Saint Elizabeth. This then becomes a series of prints extolling the virtues of the emperor-elect's family.[9] But they also are images that persuade women to seek their glory in ways far different from those of men—through piety, humility, and chastity.

1. On the iconography of the nine worthies, see Wyss 1957, 73–89; Schroeder 1971, 79–81; Rorimer and Freeman 1948–1949, 243–260. An example of a worthies series that includes Amazon women is in the Castello della Manta in Salluzo, c. 1420 (see D'Ancona 1905, 94–106).
2. Burgkmair is often credited with inventing the three-by-three grouping of the worthy women, but Schroeder 1971, 174, has pointed out their occurrence in this format in a German manuscript on heraldry, now in Nuremburg at the Germanischen Nationalmuseum (Pap.-HS. 6599). The codex is dated to the sixteenth century (not 1470, as Schroeder states) and may follow Burgkmair's group. I have not yet seen this book, so I cannot speculate further on the possibility of a visual source. For a general discussion of the series, see Stuttgart 1973, nos. 106–111. The series was evidently designed in 1516 since an impression of the pagan women bears that date; this particular series, and all others, are dated 1519. The prints were very influential, inspiring copies in prints, paintings, and decorative arts (see Wyss 1957, plates 30 and 32).
 The coats of arms held by the male worthies are traditional; those held by the women worthies show a variety that corresponds to the lack of a firm tradition in the selection of the women. The Christian women hold the arms of their family or country. Some of the others hold arms with symbolic images (such as the dove on Virginia's), while others remain unidentifiable (for example, what seems to be an inscription on Lucretia's is indecipherable). See Schroeder 1971, chap. 5. Pamela Askew has suggested that the form on Judith's shield may stand for a menorah or a Jewish ritual vessel; (cf. E. R. Goodenough, *Jewish Symbols in the Greco-Roman Period*, abridged ed. [Princeton, 1988], fig. 47).
3. Stuttgart 1973, no. III.
4. A similar round temple is seen in the background of Georg Pencz'

engraving, *The Triumph of Chastity* (Bartsch 118). I have not been able to identify this building with any in Germany or elsewhere, and it is likely an imaginative reconstruction of the Roman temple of Vesta based upon written descriptions, such as the one in Ovid's *Fasti*, 6:282. I would like to thank Elisa R. Barsoum for her assistance with this problem.
5. Lucretia killed herself to preserve the honor of her husband after she was forced to submit to rape; as a result of the outrage her family felt, the tyrannical regime of the Tarquins was overthrown (see Livy 1:57.6–59.13). Virginia was killed by her father in order to prevent her losing her virginity to the tyrant Appius Claudius; this also led to the overthrow of the tyrants (see Livy 3:44–48). Veturia convinced her exiled son Coriolanus not to attack the Romans, who were in fact his family; her story is told in Livy 2:40, Dionysius of Halicarnassus 8:39–54, and Valerius Maximus 1:8,4; 4:3,4; and 5:2,1. Veturia is also an example of the queenly virtue of magnificence, which is perhaps symbolized in this engraving by her jewels. See Boccaccio 1963 ed., 120–121; on magnificence, see Marrow 1982, 58. Virginia and Lucretia are linked as examples of chastity in Livy and in the popular collection by Valerius Maximus (6:i.1 and 2); Vives, in his *Institutio*, emphasized the chastity of Veturia (quoted in Veldman 1986, 121).
6. The story of Jael is told in Judges 4. She was the wife of Heber, leader of the Kenite tribe, who had a truce with Sisera's people. When Sisera, the enemy of the Hebrews, came to her tent thinking they were allies, she welcomed him like an honored guest, but when he fell asleep she drove a tent peg through his skull. Esther and Judith are treated in their own books in the Old Testament and the Apocrypha; for Esther, see cats. 15 and 16; and for Judith, see the introductory essay to this section.
7. Réau 1957–1958, vol. 3, pt. 1, pp. 246–248 (Bridget), 417–421 (Elizabeth); and pt. 2, pp. 633–636 (Helen); LCK, vol. 5, cols. 400–403; vol. 6, cols. 133–140, and 485–491. Saint Bridget is the author of the *Revelations* that were enormously popular in Germany, especially after they were published in 1492. On Saint Bridget, see Nordenfalk 1961, 371–393.
8. Jacobus de Voragine, in the *Golden Legend*, the most popular Renaissance collection of lives of the saints, makes this point clearly with regard to Saint Elizabeth.
9. On Maximilian's genealogy, see Gerhild S. Williams, "The Arthurian Model in Emperor Maximilian's Autobiographic Writings, *Weisskunig* and *Theuerdank*," *Sixteenth Century Journal* 11 (1980): 3. On Habsburg connections with Elizabeth, see LCK, vol. 6, col. 138. The other Christian women may also be associated with Maximilian's family or his interests. Helen, for example, was the mother of the Emperor Constantine, and her coat of arms displays the double eagle of the Habsburg family, drawing a connection between the founding of a Christian empire under Constantine and the Holy Roman Empire headed by Maximilian. Bridget was associated with the pilgrimage to Jerusalem, which can be connected to Maximilian's interest in the crusades.

2

Israhel van Meckenem

The Death of Lucretia
Engraving, c. 1500/1503
270 x 183 (10⅝ x 7³⁄₁₆)
Lehrs 516
Rosenwald Collection 1943.3.165

Israhel van Meckenem's engraving is closely tied to the medieval tradition of book illustration.[1] The classical story is depicted as though it were a late medieval event; the costume and the castle setting give no suggestion that this is a Roman legend. The rape and the scene of Lucretia telling her father are depicted in small background scenes, while the central scene is devoted to Lucretia's dramatic suicide before her husband, her father, and their attendants. She swoons into the arms of her maids as she falls on an enormous sword, while the men look upward toward the rape, cementing the cause

and effect relationship between the two scenes. The barking dog adds drama to the scene, but is also a symbol of marital fidelity and obedience.[2]

Van Meckenem's engraving focuses on the grief of Lucretia's family and attendants, underscoring the fact that she died to preserve the honor of her father and her husband, a motive that was given great emphasis in classical sources.[3] Later prints would focus on the erotic elements of the story, the actual rape or the suicide of the partially clad woman. The inscription here, in Latin, also points out Lucretia's role as a model of female virtue: "Truly the modesty of Lucretia is an ornament in a woman, and when that has been torn away through an evil deed, she is fouled."[4] The inscription and the image itself make it clear that it was Lucretia's virtue and her self-destruction when her virtue was compromised, not the political consequences of her deed, that made her an exemplary person.

Although van Meckenem rarely engraved original designs, no model for this print is known.[5] Its medieval elements mark it as the end of a tradition, soon to be replaced by more classically inspired images of Lucretia.

1. An example of an illuminated manuscript showing the Lucretia theme can be found in a translation of Valerius Maximus by Simon de Hesdin and Nicolle de Gonesse (1469), Bibliothèque Nationale, Paris; reproduced in Young 1964, frontispiece. Even closer to van Meckenem's depiction, but only showing the central scene, is a page from an illuminated manuscript (c. 1470–1483) in the British Library, London; reproduced in Garrard 1989, fig. 180. The story of Lucretia is also presented as a continuous narrative on fifteenth-century Italian *cassoni*; compare Walton 1965, figs. 1–6.
2. Power 1975, 16.
3. See Judith P. Hallett, *Fathers and Daughters in Roman Society* (Princeton, 1984), 116–117.
4. The Latin reads: "Pro vere Lucretie pudor est decus in muliere / Quo malo convulso fetet pro minime grato." I am grateful to Robert Ulery for his assistance with this and other Latin translations.
5. Geisberg 1930, 236–237.

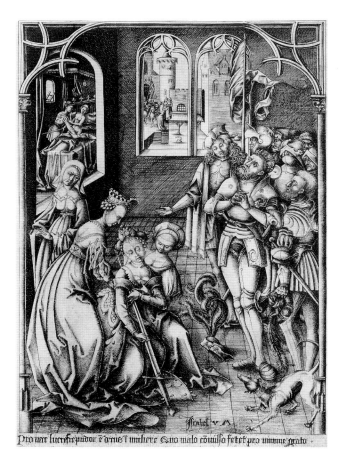

3
Anonymous Italian, sixteenth century

The Death of Virginia
Engraving, c. 1500/1510
242 x 301 (9¹/₂ x 11¹³/₁₆)
Hind 15
Rosenwald Collection 1953.14.1

The story of Virginia's death is so similar to the legend of Lucretia it may be a reworking of it.[1] Appius Claudius, one of the decemvirs of Rome, devised a plot so that he might take possession of Virginia. He had one of his men claim her as a slave stolen from his household, while Appius himself acted as judge. The judgment, of course, was in favor of Appius' man, but before he could take her and hand her over to Appius himself, Virginius, the girl's father, stabbed her to death to preserve her virginity. Virginia is really a passive victim, but just as Lucretia inspired the Romans to revolt, so did Virginia's death cause such outrage that the tyrannical Decemvirate was overthrown.

Images of the death of Virginia tend to stay closer to the textual sources, without the erotic or satirical elements sometimes seen in images of the suicide of Lucretia. This engraving is unusual in showing the scene taking place outdoors. More typically it is represented as if it were a tribunal with Appius

enthroned in judgment (see cat. 13). Here, Appius is designated by his wreathlike crown; he steps forward as if to stop the killing, but is restrained by one of his own men. Other gestures, such as Virginius' finger pointing at Appius, and the soldier (perhaps Virginia's fiancé) in the background pointing up toward to heaven, make very clear who is to blame and who is the virtuous one.

The dense modeling and strong contrasts, as well as the specific forms given to the trees, have been associated with the style of the school of Bologna, although the print has not yet been attributed to a particular artist.[2]

1. Donaldson 1982, 7.
2. Washington 1973, no. 190.

4
Jacopo Francia

Lucretia
Engraving, c. 1510
260 x 176 (10¹/₄ x 6¹⁵/₁₆)
Hind 4 2/3
Rosenwald Collection 1943.3.4367

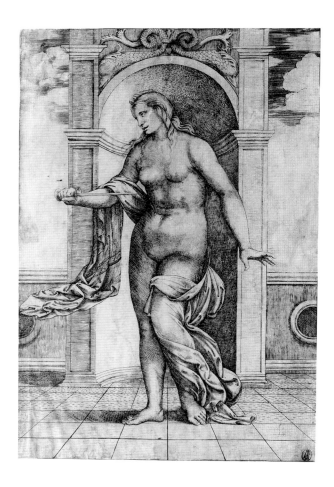

Francia's *Lucretia* is an example of the type based on a frag-
mentary classical statue of a partially draped woman, which
was identified as Lucretia even though it probably lacked
both head and arms.[1] The statue, now lost, seems to have ex-
hibited strong contrapposto, with sufficient rotation in the
neck to suggest the turned head mentioned in early descrip-
tions. Artists varied the arms depending on the amount of
drama or restraint they wanted to express. The pose that
Francia gives Lucretia has enough movement to communicate
a sense of tension, but still retains classical decorum. The
robust figure is set before a niche, which further emphasizes
its sculptural qualities.

The idea that Lucretia was depicted nude by the artists of
classical antiquity carried great weight in the minds of Renais-
sance artists. But the new popularity of the nude Lucretia
cannot have been simply a result of a love for ancient Rome,
since the written Roman sources say explicitly that she was
modestly dressed. The type was clearly more sensuous and
dramatic than earlier representations of Lucretia; later ver-
sions give even greater emphasis to her voluptuousness while
still paying lip service to her virtuous chastity.

1. For a general discussion of the print and its sources, see Washing-
ton 1973, no. 180. The Roman statue is discussed in Northhampton,
Mass., 1978, no. 102, and in Stechow 1951, 116–124.

5
Marcantonio Raimondi, after Raphael

Dido
Engraving, c. 1510
160 x 127 (6⁵/₁₆ x 5)
Bartsch 187
Gift of W. G. Russell Allen 1941.1.60

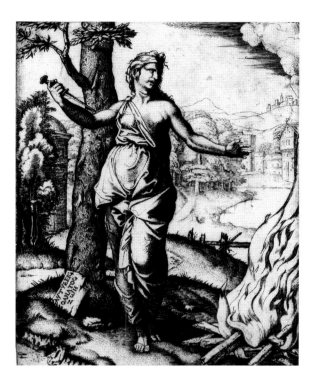

The suicide of a beautiful woman was a theme that combined passion, violence, and sensuality, and linked images of Lucretia and Dido even if the details surrounding their deaths were very different. Marcantonio used essentially the same pose for his prints of the two heroines, and these may be based on Raphael's similar variation of the Lucretia pose for a painting or drawing of Dido.¹ A similar reworking of a Lucretia type is seen in an engraving of Dido by Altdorfer (cat. 8).

Two stories of Dido's suicide were in circulation in the Renaissance. One derived from the fourth book of Virgil's *Aeneid*, which says that Dido killed herself when she was deserted by her lover Aeneas. This version, retold in popular sources like *The Romance of the Rose*, made Dido seem the epitome of women who lose control of themselves through love. The other version of the story, told in sources like Boccaccio's *De claris mulieribus*, held that the widowed queen of Carthage killed herself to avoid being married to a barbarian king, making her another example of chastity.²

Dido is seen less often than Lucretia in the visual arts, perhaps because she was less clearly an example of virtue. The inscriptions on Marcantonio's prints seem to emphasize this point. For Dido, the inscription speaks only of her fame—"A famous death lives on"—whereas for Lucretia (cat. 6), the inscription gives high praise: "It is better to die than to live in dishonor."³

1. Thomas 1969, 394–396, with bibliography. The print is discussed in Rome 1985, no. 1; and Lawrence 1981, no. 18. Marcantonio's *Dido* is usually thought to be earlier than his *Lucretia* (see cat. 6). The background landscapes for the *Dido* engraving are derived from prints by Dürer (*The Small Courier*, Bartsch 80, c. 1496, for the trees on the left) and by Lucas van Leyden (*The Holy Family*, Bartsch 85, c. 1505–1508, for the scene on the right).
2. Boccaccio 1963 ed., 86–92.
3. Translations in Lawrence 1981, 88, 94. Enea Vico's version of Marcantonio's *Dido* (second state dated 1580) bears the following inscription: "Hospes abit, sed ut est extinta." An anonymous copy shown in the *Illustrated Bartsch* 187A-1 (153) continues this inscription: "sed ut est extincta Pudoris honestas, me ferro extinctam cogit inire locos." The entire inscription may be translated: "The guest departs, but when the honor of modesty has been extinguished, honor forces me to enter the underworld, killed by the sword." Another anonymous copy, not mentioned in Bartsch, is inscribed in Italian, "Ecco di Castità l'Effetto Vero" (Here is the true result of chastity).

6

Marcantonio Raimondi

Death of Lucretia
Engraving, c. 1511–1512
217 x 133 (8½ x 5¼)
Bartsch 192
Museum of Fine Arts, Boston,
Harvey D. Parker Collection

Marcantonio's engraving was among the best-known images of Lucretia in the Renaissance. Vasari writes that Marcantonio used a drawing by Raphael as his inspiration, and that when Raphael saw the engraved version, he was so impressed that he had Marcantonio make prints after several of his works.[1] Vasari's statement, as well as the probability that the pose of

Lucretia derives from an antique model, would seem to indicate that the *Lucretia* was done before the *Dido*. The *Lucretia* is a much better print, however, larger in format and more dramatically composed, with sharp contrasts of light and dark, and with the heroine's outstretched, nearly horizontal arms and sharply turned head adding greater tension to the figure.[2] This engraving is also technically more advanced than the *Dido*, with a more controlled and logical system of hatching and with stronger drawing.

Raphael's drawing and, in turn, Marcantonio's engraving were based on the same ancient Roman statue that inspired Francia's engraving of Lucretia (cat. 4). Marcantonio emphasizes the classical source of his image by setting Lucretia before a Corinthian column with indications of classical architecture seen through an arcade. But while paying tribute to the ancients, Marcantonio's pose for Lucretia may also draw on the Christian image of the Crucifixion, suggesting that Lucretia was a martyr for chastity.[3] To concentrate on the symbolism of the image, all the elements of the narrative attendant to the suicide have been removed. The rape is not indicated, there is no trace of Lucretia's anguish in telling her father and husband, and no revenge is suggested. There is only a Greek inscription that assumes the story is well known: "It is better to die than to live in dishonor."[4]

1. Vasari/Milanesi 5:411. The drawing by Raphael was thought to be lost, but a drawing of Lucretia in a private collection has recently been identified with Raphael's. See Stock 1984, 423–424. Marcantonio's print was copied by several artists. See Rome 1985, no. 2.
2. For further discussion of the relative dating of the prints, see Lawrence 1981, no. 20, with earlier references. Marcantonio's use of Lucas van Leyden's print of *Susanna* for the landscape background sets the date after 1508.
3. See Donaldson 1982, 27.
4. Translated in Lawrence 1981, no. 20.

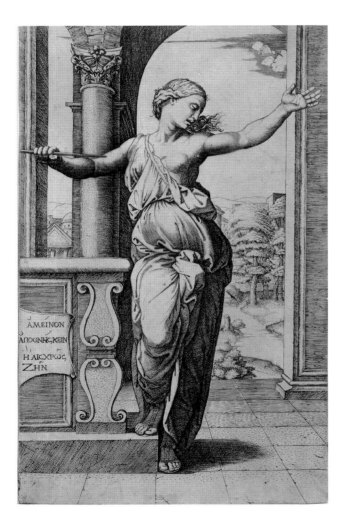

7
Master S

Lucretia
Engraving, c. 1505/1520
64 x 41 (2¹/₂ x 1⁵/₈) (diamond)
Hollstein 419
Rosenwald Collection 1943.3.5824

This tiny engraving is among the earliest Northern prints of a nude Lucretia, and it seems to depend on the same sculptural model that inspired Italian artists like Francia and Marcantonio. It is likely that either sketches or verbal descriptions of the antique statue had reached northern Europe very quickly, since a drawing by Dürer of Lucretia (fig. 7a) bears the date 1508 (two or three years before Marcantonio's engravings of the theme), and Lucas van Leyden's engraving of Lucretia's suicide is generally dated c. 1514.[1]

Master S shows Lucretia standing on a sphere, an attribute that is not usually associated with her. The sphere, a symbol of instability that is often used as an attribute of Fortune, may refer to the change in Lucretia's fortunes that led to her suicide. A dog, a symbol of faithfulness, stands by her side.[2] Another image of Lucretia by the same artist shows her standing on a skull (Hollstein 418).[3]

1. For Dürer's drawing, see Stechow 1951, 122–124. For Lucas' print, see Washington 1983, 134–135.
2. The dog also appears in Israhel van Meckenem's engraving of Lucretia (cat. 2).
3. The use of a globe in other erotic images is discussed in Silver and Smith 1978, 263–265. Altdorfer's image of Fortune, dated 1511 (Winzinger 1963, 113, illustrated in Silver and Smith 1978, fig. 31), is very similar to the *Lucretia* by Master S.

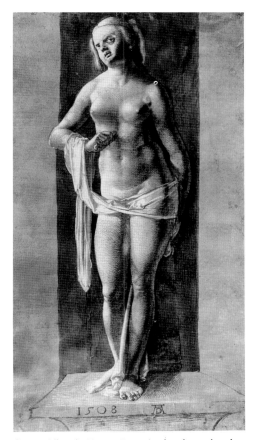

fig. 7a. Albrecht Dürer, *Lucretia*, dated 1508, brush heightened with white on green prepared paper, 422 x 226 (16⁵/₈ x 8⁷/₈), Albertina, Vienna.

8
Albrecht Altdorfer

The Suicide of Dido
Engraving, c. 1520/1530
65 x 38 (2⁹/₁₆ x 1¹/₂)
Winzinger 1963 159b
Rosenwald Collection 1943.3.410

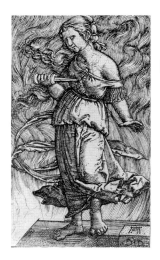

This small engraving shows again how artists adapted the
standard Lucretia pose to the image of Dido. The pose of
Altdorfer's Dido is almost identical to that of Francia's
Lucretia (cat. 4), which may have been his source.[1] The Dido
in Altdorfer's print, unlike the Lucretia in Francia's, is fully
dressed, which might suggest that he meant her to be seen as
the chaste queen of Carthage rather than the disappointed
lover of Aeneas. Yet signs of wild passion are also present: her
garment slips from her shoulder, her hair and drapery fly
about her, and she stands before a wall of flame—a much
more dramatic suggestion of the funeral pyre than the bonfire
seen in Marcantonio's engraving (cat. 5).

All of the prints in the series to which *The Suicide of Dido*
belongs are clearly related to stoicism in the face of danger or
pain: one depicts Horatius Cocles, another Mucius Scaevola,
both Roman heroes who endured great danger and pain in
their fight against the Etruscans.[2] A fourth engraving shows
Judith, unmoved as she displays the head of Holofernes on
the point of a sword (see cat. 24). In keeping with this theme,
Altdorfer has given Dido a facial expression that conveys a
quiet sadness in striking contrast to the suggestions of less
restrained emotion seen in the other details of the print.

1. Winzinger says that the source for this and Altdorfer's *Judith* is a
print by Zoan Andrea after Mantegna, but the similarity is rather gen-
eral (Winzinger 1963, 110, and appendix 15).
2. Winzinger 1963, nos. 156, 157.

9
Barthel Beham

Cleopatra
Engraving, 1524
59 x 41 (2⁵/₁₆ x 1⁵/₈)
Pauli 1911, no. 23 3/6
Rosenwald Collection 1943.3.888

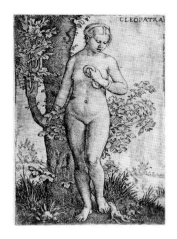

10
Barthel Beham

Lucretia Standing at a Column
Engraving, c. 1524
62 x 45 (2⁷/₁₆ x 1³/₄)
Pauli 1911, no. 21 2/2
Rosenwald Collection 1943.3.884

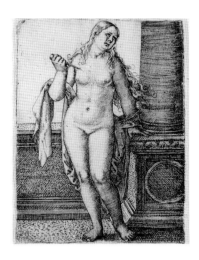

In the 1520s Barthel Beham made several small-scale engrav-
ings of Cleopatra, Lucretia, and other famous women. The
women are shown nude, and this, as well as Barthel's idealiz-
ing style, suggests that the subjects were simply opportunities
for the artist to display his knowledge of the classical nude.[1]
The full proportions, the contrapposto, and the turned head
suggest that Barthel's source may have been the statue of
Lucretia found in Rome in the first decade of the sixteenth
century (see cat. 4 and note). The classicism is accented in
Barthel's *Lucretia* by placing the figure beside a column, or in
the case of another version done about three years later, in a
niche. But Barthel's image of Lucretia is more restrained than
many others based on the same source, including variations
by his brother, Hans Sebald, or by the Italian printmakers. It
is likely that Barthel's *Lucretia* refers more directly to North-
ern models, such as paintings and drawings by Lucas Cranach
and Albrecht Dürer (see fig. 7a).[2] Such images were probably
inspired by verbal descriptions of the statue, but they show a
more controlled Lucretia, her arms held close to her body,
the dagger held with bent arm close to or even entering her
breast.

The same restrained pose is used by Barthel in his
Cleopatra, except that it is her left arm that is bent and
brought across her breast holding the asp. Cleopatra is shown
standing before a tree in a gardenlike setting, suggesting an
image of Eve, another "fallen" woman. But Cleopatra's calm
gives no hint of passion or torment—if anything she seems
more idealized than Barthel's Lucretia. This is an example of
the way in which Lucretia's suicide could be paired with
others like Cleopatra's or Dido's without a clear distinction
made with regard to their virtue.[3]

1. In addition to the two exhibited engravings, Barthel Beham did
two other engravings of Lucretia: one seated (Pauli 1911, no. 20, dated
1522), and another standing (Pauli 1911, no. 22, c. 1527). On the date of
the former, see Muller 1958, 12. The engravings of Judith are also very
similar to these (see cats. 27, 28).
2. Two drawings by Cranach are illustrated in Donaldson 1982,
figs. 5, 6.
3. The same pose was used by Georg Pencz for Dido (Bartsch 85). For
further comparisons of Lucretia and Cleopatra, see Garrard 1989, 210–
211, 244–247.

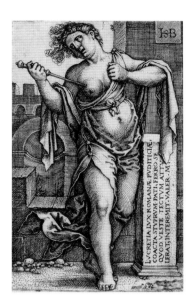

11
Hans Sebald Beham

Lucretia Standing
Engraving, c. 1541/1545
74 x 47 (2⅞ x 1¹³/₁₆)
Pauli 1911a, no. 83 3/4
Rosenwald Collection 1943.3.1229

Lucretia's suicide was a theme treated often in prints by the Beham brothers and by their contemporary Georg Pencz. These are very small prints, and they must have been collected avidly since many survive in today's print collections.[1] Often there are other prints of a similar size and composition showing the related themes of the suicides of Cleopatra and of Dido. Hans Sebald Beham produced the first of these prints, with an early version of the death of Lucretia dated 1519 (fig. 11a) that is clearly based on the famous engraving by Marcantonio Raimondi (cat. 6). In Beham's version Lucretia is seated, but the upper part of her body is a mirror image of Marcantonio's heroine.

In the exhibited print, produced more than twenty years after the first, the artist emphasizes the maenad-like quality of a woman driven to suicide—a woman crazed by emotion rather than responding with reasoned deliberation to her situation.[2] Her hair flies wildly, she pulls her garment from her breast and strides forward, one leg exposed, the other wrapped in clinging drapery that flutters in the wind. The dramatic passion is similar to that seen in Altdorfer's *Dido*

(cat. 8), but here Lucretia's bared leg suggests even more strongly the sexual reason for her distress and may even imply that her wantonness provoked the rape.[3]

The Latin inscription indicates the artist's source as Valerius Maximus, who summarized classical stories in a popular collection called *Memorable Sayings and Deeds* (*Factorum et dictorum memorabilium*), written in the first century C.E. and published in at least seventy-eight editions in the fifteenth and sixteenth centuries.[4] Translated, the inscription reads: "Lucretia, the light of Roman chastity who was forced to endure rape, killed herself with the dagger that she had brought concealed in her dress. Valerius M[aximus]."[5] While the inscription emphasizes Lucretia's virtue, the image points to less worthy characteristics that were thought to be typical of women: their tendency to madness and their lack of control, especially in matters of love.

1. On the popularity of the "Little Masters" prints by these artists, see Lawrence 1988, 18–23.
2. At least five copies were made of this design: two are dated 1573; another bears the date 1534, which is probably a mistake for 1543. The artist also did a larger woodcut (1530), showing the suicide of Lucretia in front of the bed (Geisberg 1974, 1: 218).
3. Bialostocki 1981, 211–226, discusses similar innuendos with regard to Judith's bared leg.
4. Faranda 1971, 35–37.
5. "LVCRETIA LVX ROMANAE PVDITICIAE, / COACTA STVPRVM PATI, FERRO SE / QVOD VESTE TECTVM ATTV / LERAT, INTEREMIT VALER M."

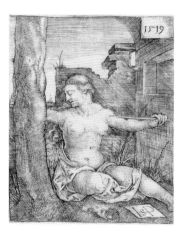

fig. 11a. Hans Sebald Beham, *Lucretia*, dated 1519, engraving, 58 x 44 (2⁵/₁₆ x 1³/₄), British Museum, London (Pauli 1911a, no. 82).

12
Hans Sebald Beham

Dido
Engraving, dated 1520
117 x 90 (4⁹/₁₆ x 3¹/₂)
Pauli 1911a, no. 84 2/2
Rosenwald Collection 1943.3.1230

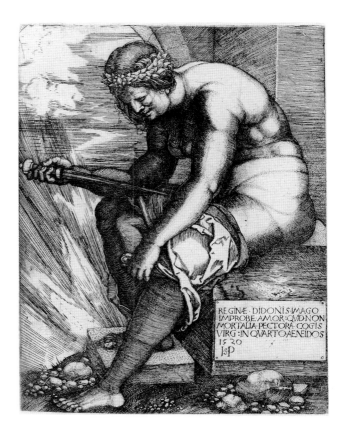

This is perhaps the most striking image of Dido in the exhibition, and it is unusual in that it does not draw on the standing Lucretia type seen in the prints by Marcantonio and Altdorfer. Instead the source of the image is another engraving by Marcantonio, the *Bathing Venus*, c. 1511 (Bartsch 297).[1] Dido here wears a wreathlike crown referring to her royalty, while the flames of the pyre shoot up behind her, more like an aureole than a fire. These details seem to point up her glory, all the more poignant in comparison to her pose of absolute dejection. She is nearly nude, but she is not the idealized nude seen in most other prints of female suicide. Instead it seems her clothing has fallen from neglect. Her face appears old and heavy, her body thick and slumping over the knife. This is not an image of a woman who is a symbol of chastity, but rather of a woman destroyed by passion, and it is not surprising that the artist gives his source as the fourth book of Virgil's *Aeneid*, adding the following inscription: "This is the image of Queen Dido. O Evil Love, what do you not force mortal hearts to do?"[2]

1. A small undated engraving of a woman stabbing herself in a similar pose, usually attributed to Altdorfer, also derives from Marcantonio's *Venus*. This is generally considered an image of Lucretia, and if so, it would be another example of the transference of imagery between Dido and Lucretia. Reproduced in Winzinger 1963, 134, appendix 26.
2. "REGINAE DIDONIS IMAGO / IMPROBE AMOR: QVID NON MORTALIA PECTORA COGIS / VIRG: IN QVARTO AENEIDOS / 1520 / HSP." The second line is a precise quotation from the *Aeneid*. Translation adapted from Mandelbaum 1982, 97.

13
Georg Pencz

Virginius Killing His Daughter
Engraving, c. 1546/1547
117 x 77 (4⁹/₁₆ x 3)
Bartsch 84
Rosenwald Collection 1943.3.6716

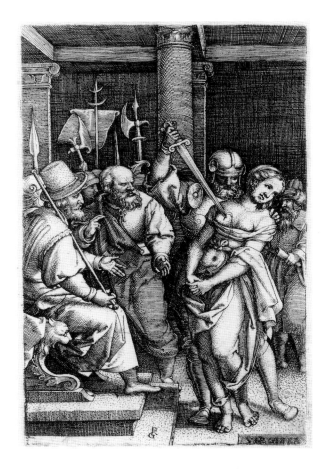

Pencz made this print of the death of Virginia and another of the rape of Lucretia at the same time, late in his career.[1] Although *Virginius Killing His Daughter* cannot be considered a pendant to Pencz' *Rape of Lucretia*, which is somewhat larger and was paired with his *Death of Lucretia*, nevertheless the styles of the two engravings are very similar, and it would not be surprising if one theme suggested the other. The stories of Lucretia and Virginia were often paired in literary sources, and they are seen together in Italian domestic paintings of the fifteenth century.[2] Both women valued their chastity more than life, with Lucretia preferring death to the dishonor of being a defiled wife, and Virginia dying at her father's hand rather than surrender her virginity to the tyrant Appius Claudius. Virginia is here shown standing before Appius, who is enthroned as a judge. Her father, Virginius, in his centurion's helmet, begins to plunge his sword into Virginia's bared breast. The man standing between them is Appius' accomplice, who tried to wrest Virginia away from her fiancé and her father by claiming her as a slave who had been stolen from him.

Impressions of Pencz' engraving of Virginia are relatively rare. In fact the theme was much less popular in prints than images of Lucretia, even though the story was told in popular sources such as Boccaccio's *De claris mulieribus* and Chaucer's *Canterbury Tales*.[3] The images that do exist of Virginia retain their narrative quality, and the figure of Virginia never becomes canonical like Marcantonio's *Lucretia*. Pencz' *Virginius Killing His Daughter* is as much an illustration of the story told in Livy as the anonymous Italian print done some forty years earlier (cat. 3), but there is no reason to think that the Italian print was an influence.

1. Landau 1978, 66, 68.
2. For examples, see Walton 1965, 177–179; and Lightbown 1978, 2: 101–106.
3. Boccaccio 1963 ed., 128–130. Chaucer's version is part of the *Physician's Tale*. Other sources for the story are discussed in Shannon 1941, 398–408.

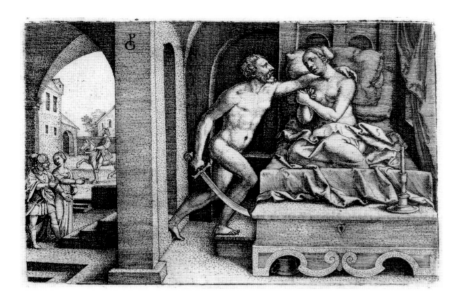

14
Georg Pencz

Tarquin and Lucretia
(from *The Stories of Roman History (II)* series)
Engraving, c. 1546–1547
109 x 147 (4¼ x 5¾)
Bartsch 78
Gift of Dr. Paul Sachs 1941.2.15

Although it was quite common to show Lucretia partly clad or completely nude in both paintings and prints, Tarquin was rarely depicted so. A number of engravings from the first half of the sixteenth century, however, do present a naked Tarquin. The earliest seems to derive from a design by Raphael or his school; it was engraved by Agostino Veneziano in 1523 with a second state dated 1524 (fig. 14a).[1] Sexual titillation seems to have been the primary purpose of that engraving, an aim reinforced by a pair of copulating dogs in the lower right corner. Even more sexually explicit is Heinrich Aldegrever's engraving dated 1539, with Lucretia's genitalia fully exposed as she tries to defend herself against Tarquin (fig. 14b).[2] Aldegrever was evidently using a design by Georg Pencz in this print, for Pencz' monogram appears just above the the date. If the exhibited engraving was Aldegrever's source, it must be dated earlier (before 1539) than the 1546–1547 suggested by its style. There are some similarities between the two prints, particularly the form of the pedestal for the bed, Tarquin's striding pose, and the general appearance of Tarquin's head.

Pencz' engraving, however, is much more discreet than Aldegrever's: the lower part of Lucretia's body is covered with the bedclothes and she folds her arms in a gesture of pleading. An alternative explanation that would preserve the traditional dating of Pencz' engraving is that Aldegrever used a lost drawing by Pencz as his inspiration; this might also explain the discrepancies between the two prints.[3]

In spite of its greater modesty in comparison with Aldegrever's print, Pencz' engraving has an ambiguity that allows it to be read as sexually provocative. The image is strangely lacking in violence, for instance. Lucretia pleads with Tarquin in a gesture that can be read as longing rather than fearful, while Tarquin, holding his sword down at his side, places his arm around her shoulder. Outside the bedroom a man and a woman point to the rape, observing it, but not taking any action; another figure in the background rides by on horseback, evidently oblivious to any offense. However one interprets these minor characters—as voyeurs, as rhetorical figures simply calling our attention to the scene, or as an indication that such events have little effect on most of the world—the presence of the nude Tarquin implies that the sexual act is imminent. Pencz' purpose may have been to record the history of the Romans, but in this particular episode he reflects the kind of ambivalence that was often voiced regarding Lucretia's own consent to and enjoyment of the rape.

By turning to subjects such as the death of Virginia or the rape of Lucretia, Pencz may have been trying to rekindle his old political ideals. He had always been sympathetic to the

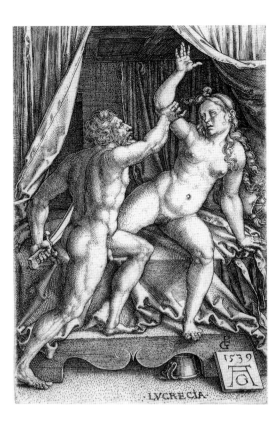

fig. 14a. Agostino Veneziano de' Musi, after Raphael, *Lucretia and Tarquin*, dated 1524, engraving, 253 x 401 (10 x 15³/₄), Albertina, Vienna (Bartsch 208).

right: fig. 14b. Heinrich Aldegrever, *Tarquin and Lucretia*, dated 1539, engraving, 127 x 77 (5 x 3¹/₁₆), Staatliche Graphische Sammlung, Munich (Bartsch 63).

lower classes, and these two heroines are both associated with popular uprisings.[4] His cool treatment of both subjects, however, seems at odds with a political intent; the style has been associated instead with the artist's psychological withdrawal in the face of uncertain political events.[5] It may also reflect Pencz' own ambivalent feelings toward women. One of the few details known about Pencz' personal life has to do with the suspicion he felt toward his wife at the time of his death. With this in mind, it is not surprising that images of women, not all complimentary, predominate in his late work.[6]

1. See the introduction to this section for further discussion.
2. Another version of this scene by Aldegrever is dated 1553 (Bartsch 64). It also shows Tarquin nude but is somewhat closer to the Pencz engraving in this exhibition in depicting Lucretia with her hands folded as if in prayer, although her legs are still spread and genitalia exposed. Jaffé and Groen 1987, 162–164, suggest that Aldegrever's print may be the source for Titian's painting, *Tarquin and Lucretia* (1568–1571), in the Fitzwilliam Museum, probably by way of the engraving by Master L.D. in which Tarquin is again shown clothed. Aldegrever's print may have also inspired Georg Pencz' engraving, *Joseph and Potiphar's Wife*, 1544 (Pauli 15), which reverses the position of Lucretia relative to Tarquin in keeping with the idea of the woman as sexual aggressor. See Janey L. Levy's essay in Lawrence 1988, 48–49.

3. Landau 1978, 66, 68, argues for the later dating. In a personal correspondence Landau affirmed his dating and offered the explanation involving a lost drawing by Pencz; Aldegrever is known to have used other drawings by Pencz as inspiration—in the four evangelists, for example (Bartsch 57–60). This print is paired with the engraving *Colatinus with the Dying Lucretia* (Bartsch 79). In the latter engraving, Lucretia is shown after stabbing herself and (unlike most scenes of the suicide) collapsing into the arms of her husband, surrounded by other members of her family. Two other engravings are similar in format, in size, and in subject matter drawn from Roman history: *Horatius Cocles Defending the Sublician Bridge* (Bartsch 80) and *Porsenna Receiving the News of Cloelia's Escape* (Bartsch 81). All four prints may have been part of the same series; none bears a date, although Landau 1978, nos. 88 and 89, assigns a date of c. 1537 to the Horatius Cocles and Porsenna engravings.
4. Landau 1978, 38–40, 56.
5. Landau 1978, 68–72.
6. Landau 1978, 72–74.

15
Lucas van Leyden

Esther before Ahasuerus
Engraving, dated 1518
274 x 203 (10¾ x 8)
Hollstein 31 1/3
Rosenwald Collection 1943.3.5622

Esther was a Jewish woman, chosen by the Persian king Ahasuerus to be his queen because of her great beauty and her humble submission to him. She did not tell him of her Jewish heritage until a plot devised by his minister Haman had been set in motion to have the whole Jewish population destroyed. She then presented herself before her husband, waiting silently until he touched her with his scepter, and pleaded with him to stop the plot, revealing herself as one of those destined for destruction.[1] Ahasuerus was again touched by her beauty and humility. He not only informed the Hebrews of the plot so that they could take the offensive but he had Haman hung on the scaffold meant for Mordecai, Esther's cousin, who had refused to bow down before Haman.

Of the several episodes in the story, the most frequently depicted in the sixteenth century was Esther before Ahasuerus, a scene that emphasized Esther's humility and her powers of intercession.[2] This was also the scene that had the longest history, appearing in medieval devotional books alongside the Virgin Mary interceding for mankind.[3] Such typological depictions placed Esther in an unquestionably positive light. She was humble and beautiful, but she was also a peacemaker, one of the most important roles that women could have in the political sphere.

Lucas van Leyden's illustration of this scene is a marvelous study of tenderness between the shy queen and her husband, whose compassion is almost mournful as he bids her, with his scepter, to rise from her knees.[4] Although placed in the foreground, Esther and her maids are small figures. The contrast between the standing men—particularly Haman, who holds the edict in his clenched fist—and the kneeling women is a sharp one, and one that could be seen as another way of showing the subjugation of women. But it seems Lucas' depiction of the women is more positive. They are the ones with the purposeful glances as they approach the king; the men behind them seem bewildered. And the king himself is shown in a half-kneeling pose that connects him more with the women before him than with the men in the background.

1. Esther 2:15–9:10.
2. On the iconographic tradition, see Réau 1957–1958, vol. 2, pt. 1, pp. 335–341; Ehrenstein 1923, 335–341; and the LCK, vol. 1, cols. 684–687.
3. Wilson and Wilson 1984, 203.
4. The engraving is discussed in Washington 1983, no. 68.

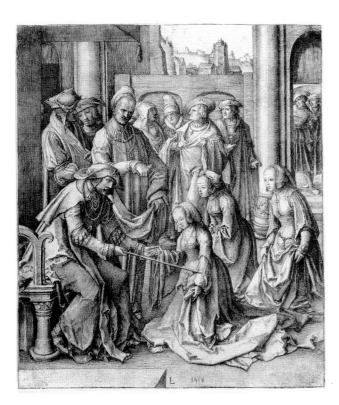

16
Rembrandt van Rijn

The Great Jewish Bride
Etching, with some drypoint and burin, 1635
219 x 168 (8⁹/₁₆ x 6⁵/₈)
White and Boon 340 5/5
Rosenwald Collection 1943.3.7098

This beautiful etching, one of Rembrandt's most striking representations of a woman, has been interpreted by Madlyn Kahr as a depiction of Esther.[1] Although it is not common to find such a contemplative image of Esther, holding the decree in which Ahasuerus ordered the death of the Jews, Kahr argues that a renewed interest in the subject by the Dutch people in the early seventeenth century, as well as Rembrandt's own personal reading of the Old Testament, can explain this unique image. The Dutch saw the story of Esther, with its triumph of humility and piety over pride and tyranny, as a parallel to their own liberation from Spanish rule.[2] Artists and writers began to look more closely at the Old Testament story, emphasizing unusual details or giving a more dramatic cast to the story.

fig. 16a. Rembrandt, *Esther Preparing to Intercede with Ahasuerus*, 1633(?), oil on canvas, 109.0 x 93.0 (43 x 36⅝), National Gallery of Canada, Ottawa.

Rembrandt's use of themes from the Book of Esther is most often seen in his late work, but a number of his paintings and prints from the 1630s and 1640s are also known to deal with Esther and Mordecai.[3] A painting in Ottawa, identified by Kahr and others as the "Toilet of Esther," bears the date 1633 (the date is often misread as 1632) (fig. 16a). It is of special interest because it shows a young woman having her hair combed by a servant, with a stack of documents in the background. If the interpretation is correct, this painting would depict Esther as a representative of a people threatened by great danger, not in her traditional posture of supplication. Rembrandt's selection of this episode would correspond in a much more positive way to the political symbolism that the story held for the Dutch.[4]

The exhibited etching, popularly known as "The Great Jewish Bride," is quite similar to the Ottawa painting.[5] A seated young woman (in both cases the model was probably Rembrandt's wife, Saskia) holds a document in her hand; her long hair flows loosely on her shoulders as if it had just been combed. The etching, like the painting, would represent

Esther preparing to go before her husband, after having been shown a copy of the decree condemning the Jews (Esther 4:8–5:1). She had dressed herself in garments of mourning, covered her head with ashes, and fasted for three days, asking God's help before going to her husband unsummoned, an action that could be punished with death. After this, she put on her royal garments and made herself beautiful in preparation for meeting her husband. Rembrandt shows her at this point.[6] The woman has a look of determination that fits well with this interpretation: she is a woman preparing to risk her own life in order to save her people. If this interpretation is correct, the etching is a rare image of a heroine as a person of dignity and strength. Although Esther used her beauty to aid her in her task, Rembrandt does not exaggerate this fact into a suggestion that her power is merely a by-product of her sexuality.

1. Kahr 1966, 228–244.
2. Kahr 1966, 228; Lurie 1965, 94–100.
3. Rotermund 1969, 105, sees the interest in Esther as a phenomenon of the last decade of Rembrandt's life. For a list of Rembrandt's works dealing with Esther (including earlier works like the *Triumph of Mordecai*, c. 1641), see Kahr 1966, 229.
4. Kahr 1966, 235.
5. The title of the etching goes back to the eighteenth century (see Kahr 1966, 242–243). Traditionally, it has been seen as an image of a woman dressed for her wedding—her thin coronet, the suggestion of a veil (visible falling over the arm of her chair), and the long loose hair all are in keeping with sixteenth-century Jewish traditions. If she is a Jewish bride, the scroll that she holds would be the written statement of the groom, promising his care for her during marriage and his provisions for her if he should die (Landsberger 1946, 74–78, citing earlier bibliography). Other more esoteric interpretations have been given to the etching: for example, that she represents Minerva or a sibyl. It should be noted that Kahr 1966, 242, and fig. 7, reads the date on the etching as 1637.
6. Kahr 1966, 243–244, also notes that the books seen behind the woman are seen in other representations of Esther. The open book probably represents the Bible, a sign of Esther's faith.

17
Heinrich Aldegrever

Susanna Surprised by the Two Elders
(from *The Story of Susanna* series)
Etching, dated 1555
113 x 82 (4^7/$_{16}$ x 3^3/$_{16}$)
Bartsch 30 2/3
Rosenwald Collection 1943.3.223

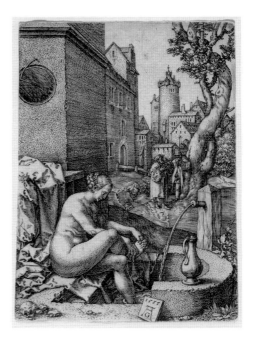

Aldegrever's small etching of Susanna in her bath is unusual
in that is part of a series that focuses primarily on the trial of
the elders.[1] Susanna herself appears in only two of the prints:
this one, which shows her bathing while the elders watch
from a distance; and the second in the series, which shows the
elders before the young judge Daniel, as Susanna watches de-
murely. Her own trial is not shown, nor is her condemna-
tion. The last two prints in the series show the elders being
convicted and stoned to death. There is an interesting use of
nudity in this series. Susanna, of course, is completely nude
in her bath, while the distant elders are dressed in elaborate
robes. At their trial, though, they are dressed in loosely
draped sheets. And they are completely nude at their execu-
tion. This pattern seems to suggest that nudity signifies
vulnerability.

This series, dated 1555, comes from the last year of Alde-
grever's activity as an artist. That same year he did a similar se-
ries of prints showing the story of Lot. Both series deal with
potentially lascivious subjects but are treated with modesty.
The source for Susanna's pose in the exhibited etching is Mar-
cantonio's *Bathing Venus* (Bartsch 297), which had been used
by Northern artists since the 1520s.

1. See also Bartsch 31–33. Images of the trial and the stoning of the el-
ders are much less common than those of Susanna at her bath. See
Garrard 1982, 153 and n. 20; and Garrard 1989, 187, 529–530 n. 14, where
the author points out examples of extended Susanna cycles, including
one by Pinturicchio in the Borgia Apartments (1494) and another
from the early seventeenth century by Baldassare Croce in S. Susanna
in Rome. Aldegrever's series is discussed in Zschelletzschky 1974,
140–141.

18
Annibale Carracci

Susanna and the Elders
Etching and engraving, c. 1590/1595
345 x 312 (13⅝ x 12¼)
Bohlin 14 1/4
Andrew W. Mellon Fund 1976.48.1

The story of Susanna and the elders was a popular subject in the later sixteenth and seventeenth centuries, especially in northern Italy.[1] In this print, as in many contemporary examples of the theme, Susanna is shown as a voluptuous nude, posed like the crouching Venus, a well-known classical figure full of erotic implications. The garden setting, while authorized by the apocryphal account, serves to heighten the eroticism of the image: the bath is not just a basin but a fountain of love, decorated with carvings of a male nude and a putto who rather testily rides a tortoise, a symbol of the good wife who stays home and is silent.[2] Although Susanna reaches for a piece of drapery to cover herself, her gesture does not reject the elder's advances, and her glance almost conveys longing. There is also an implication of ulterior motives, as one of the elders points to a castle on the hill as if trying to seduce Susanna with the temptation of wealth since he might not succeed with his physical charms. As in most representations of the theme, there is no sense that Susanna is afraid of the two men or that she abhors their advances. Instead the theme, which should celebrate female chastity, becomes a vehicle to study the nude and suggests that Susanna welcomed the advances of the old men.

This print was done around the same time as Agostino Carracci's version of *Susanna and the Elders* (Bohlin 176), which is generally thought to belong to the pornographic *Lascivi* series. Agostino's engraving is, however, much smaller and less technically advanced than Annibale's, probably because Agostino's was circulated in a clandestine manner.

1. On the iconographic tradition of Susanna and the elders, see Garrard 1989, 185–189. See also Rearick 1978, 2, 331–343, on the renewed interest in the theme during the Counter-Reformation. The most thorough discussion of this engraving, with further references, is in Bohlin 1979, 444. The second state adds an inscription, ''Ariminae Gentis decus, et sacra gloria Gualde, / Prisca vetustatis quem monumenta iuvant: / Accipe tentatae Exemplar sine labe Susannae, / Signet avita fides quam sit avitus amor.'' The first line refers to Francesco Gualdo, whose coat of arms also appears within the border of the second state. The inscription may be translated as follows: ''The honor and the sacred glory of the people of Rimini, Gualdo, you who enjoy the monuments of antiquity: Take the example of Susanna, tested without falling. Let ancestral faith signify what ancestral love is.''
2. See Garrard 1982, 148–149. An even more explicit fountain of this type is shown in the print by Jan Saenredam after Cornelisz (Bartsch 36), where Susanna looks longingly at a naked putto sitting on top of the fountain and holding the neck of a swan between his legs. On the symbolism of the tortoise, see William S. Heckscher, ''Aphrodite as a Nun,'' in *Art and Literature: Studies in Relationship*, ed. Egon Verheyen (Durham, N.C., 1985), 97–117 (originally published in *The Phoenix: The Journal of the Classical Association of Canada* 7 [1953]: 105–117).

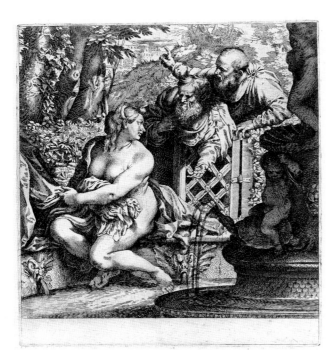

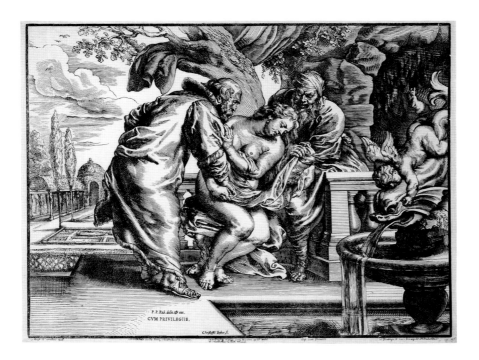

19
Christoffel Jegher, after Peter Paul Rubens

Susanna Surprised by the Two Elders
Woodcut on heavy laid paper, c. 1632/1636
460 x 592 (18⅛ x 23¼)
Hollstein 1 1/2
Ailsa Mellon Bruce Fund 1986.48.1

The theme of Susanna and the elders was one that Rubens treated several times in his career. At least five painted variations have been attributed to Rubens, although some may be works of his shop.[1] Jegher's woodcut repeats in reverse the composition of a painting in the Hermitage in Leningrad, which has been identified with one that Rubens describes in a letter of 1618.[2] The woodcut would have been done somewhat later, since Jegher worked with Rubens during the 1630s.[3]

Rubens began painting and designing works using the theme of Susanna shortly after he returned from Italy in 1608, and his interpretations depend heavily on Italian models. Jegher's woodcut shows this Italian influence in its fountain, which can be compared to the one in Annibale Carracci's engraving (cat. 18). The motif of the elder on the right climbing over the balustrade is found in another Italian *Susanna*, the painting by Domenichino of 1603.[4]

Jegher's garden is Italianate, too, with its cyprus trees and formal plan, although the direct inspiration for it may have been northern European prints such as an engraving by Georg Pencz (Bartsch 26) or one by Hans Collaert after Maarten de Vos (fig. 19a).[5] The composition of Jegher's woodcut is similar to the compositions of these other two prints, especially Collaert's: all have the horizontal format, with the garden area in the background to one side, while Susanna, facing forward and covered only by a piece of drapery in her lap, is set between the two elders on the other side.

In this woodcut, Susanna is again a voluptous nude, but she is not shown in a pose derived from either the crouching or the bathing Venus. Instead she seems to react in a way that shows genuine aversion, pushing away one of the elders and looking away from both. The elders are portrayed as unattractive old men (true to the apocryphal source, although not always so in the artistic tradition); the one on the right is even given a demonic aspect. All this does not quite negate the erotic elements of the image: one of the old men reaches down into Susanna's lap, and the other has a hand moving in the same direction. Even the accessories in the scene point up their lascivious intentions: a piece of drapery flies through the forked branches of the tree behind Susanna, while the putto straddling the fish on the fountain, with its gushing mouth, can hardly be seen as anything other than a sexual metaphor.

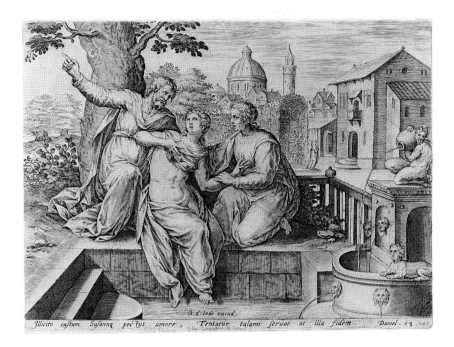

Jllicito castum Susanna pectus amore, Tentatur talami seruat at illa fidem. Daniel. 13.

G. de Iode excud.

1. Della Pergola 1967, 7–14, with further references.

2. Della Pergola 1967, 12–14; Leach 1976, 122 n. 10, and fig. 5. If this identification is correct, the Hermitage painting was done by a student of Rubens and retouched by the master himself. See also Myers 1966, 15–16.

3. A good discussion of Jegher's work for Rubens is Myers 1966, 7–23.

4. Reproduced in Garrard 1989, fig. 160; the painting is discussed in Richard E. Spear, *Domenichino* (New Haven and London, 1982), 1:130–131.

5. Leach 1976, 122 n. 10, has suggested that the source for Rubens' design is Pencz' engraving of *Susanna and the Elders* (Bartsch 26). The engraving by Collaert after de Vos (Hollstein 9) is reproduced without making this connection, in Dunand 1972, fig. 6.

fig. 19a. Hans Collaert, after Maerten de Vos, *Susanna and the Elders*, before 1628, engraving, 194 x 260 (7⅝ x 10¼), The Harvard University Art Museums, Cambridge (Hollstein 9).

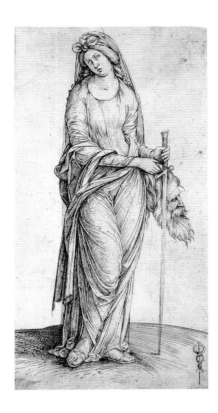

Jacopo's image of Judith is similar to the well-known painting by Giorgione (now in the State Hermitage Museum, Leningrad), although in Giorgione's work Holofernes' head is on the ground and Judith places her left foot on it. Since her left leg is bared to midthigh, the implication is very strong that it was Judith's sexuality that caused Holofernes' downfall. Jacopo's engraving, which is assigned a date contemporary to Giorgione's painting (neither one is firmly dated), avoids such suggestions—Judith's legs are covered (even though the drapery clings to them), the head is not on the ground, and Judith avoids looking at it.

1. There are three other paired sets in Jacopo's oeuvre: the *Woman with a Distaff* and the *Man with a Cradle; Satyr's Family* and *Two Fauns;* and *Apollo and Diana* and *Three Captives.* The prints in each pair are nearly identical in size, and they may have been done on either side of the same copperplate. The first two pairs are clearly related in subject matter as well. See Washington 1973, 364. The source for Jacopo's *Judith* may be a series of saints by Schongauer, especially his *Saint Catherine* (Lehrs 70). Judith and Saint Catherine, copied from Jacopo's prints, are shown together in a single print by Hieronymus Hopfer (Bartsch 20). Lucas Cranach used Giorgione's *Judith* as the basis for his painting of Saint Catherine (see Wilde 1981, 85). For other examples of Judith as a personification of virtue, and of her association with saints (one engraving even labels her "St. Judith"), see Bialostocki 1981, 195–196, 205.
2. See Warner 1985, 159.

20
Jacopo de' Barbari
Judith Holding the Head of Holofernes
Engraving, c. 1501/1503
185 x 95 (7¹/₄ x 3³/₄)
Hind 7
Rosenwald Collection 1943.3.944

This rather conservative image of Judith shows her holding the head of Holofernes and the sword as if they were attributes and she a saint. In fact, Jacopo may have intended just this association, since the engraving is very similar in size and appearance to his *Saint Catherine* (fig. 20a).[1] The two form a symmetrical pair when placed side by side, both women holding swords and turning their heads in the opposite direction. Seen in this manner, it was probably also to be understood that the two women shared qualities of saintliness and chastity, and that both were willing to die for their faith. The two also shared a strength that was not usually thought of as typical of women—Catherine outreasoned the philosophers of Alexandria, a "conquest" that might be thought of as equivalent to the decapitation of Holofernes.[2]

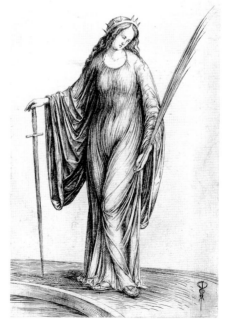

fig. 20a. Jacopo de' Barbari, *Saint Catherine,* c. 1501/1503, engraving, 186 x 117 (7⁵/₁₆ x 4⁵/₈), British Museum, London (Hind 8).

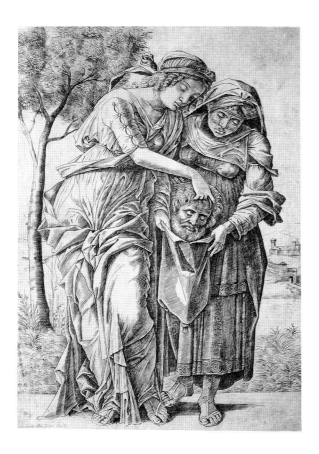

21

Girolamo Mocetto, after Andrea Mantegna

Judith with the Head of Holofernes
Engraving, c. 1500–1505
309 x 209 (12¹/₈ x 8³/₁₆)
Hind 10 2/2
Print Purchase Fund (Rosenwald Collection) 1968.14.1

This print is an example of the type that shows Judith with
her maid, putting Holofernes' head in the sack that they will
then carry back to the Hebrews. Representations of this type
often show Judith looking upward as though she were acting
out God's will rather than her own, or they show her express-
ing feelings of fear or guilt as the two women look furtively
for Holofernes' men (cf. cat. 26). Here, however, there is a
feeling of quiet, almost of sadness, as both women look down
at the head, which also seems mournful. While this might in-
dicate that Judith felt some tenderness for Holofernes, the
image does not present Judith as a seductress. The maid, who
is often presented as a foil for Judith's beauty, seems in this

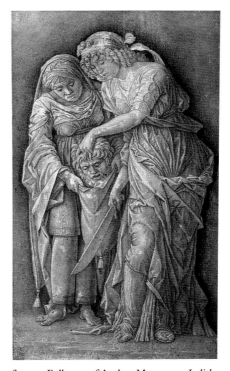

fig. 21a. Follower of Andrea Mantegna, *Judith
with the Head of Holofernes*, c. 1480, pen and ink
with chalk and white heightening on olive-
brown prepared paper, 348 x 202 (13⅛ x 7⅞),
National Gallery of Art, Washington, Samuel
H. Kress Collection 1939.1.178.

print to be used to emphasize the unity of purpose that the two women shared.[1]

A group of drawings, paintings, and prints, including this one, derive from designs by Andrea Mantegna.[2] All concentrate attention on the figures of Judith and her servant, who stand in the foreground, sometimes framed by Holofernes' tent.[3] Mocetto's engraving is closest to a drawing (fig. 21a) closely copied by a follower of Mantegna after a lost work by Mantegna himself.[4] Mocetto, however, makes a significant change in this design, eliminating the sword and having Judith help her servant hold the sack. The awkwardness in the drawing of Judith's left hand and its similarity to the maid's hand in the drawing suggest that Mocetto may have simply misunderstood his source, but the changes contribute to a mood of quiet and a lack of violence that is remarkable in images of Judith. All references to the corpse are avoided, and the head is held in such a way that the severed neck is hidden. The event seems to have taken place outside the walls of a town, in a landscape that Mocetto may have added later (the first state does not include the landscape)—in contrast to the dark, claustrophobic setting so often suggested in such images.

The figure of Judith is modeled after an antique statue of Venus, which was well known in the Renaissance and which now stands in the Cortile della Pigna in the Vatican.[5] But Mantegna, and Mocetto following him, shows Judith fully clothed rather than half-draped like the statue. This is in accord with the apocryphal account of how Judith dressed in her finery before approaching the tent of Holofernes, a detail of the text that later artists often ignored.

1. See Mantegna's *Judith and Holofernes,* c. 1495, oil on wood, National Gallery of Art, Washington. On the traditional contrast between Judith and her maid, see Garrard 1989, 291.
2. See the illustrations in Lightbown 1986, figs. 120, 141, 142, 157, 186, and 246; Lightbown lists other examples on p. 474.
3. The painting is generally dated to the 1490s, although some scholars have proposed dates as early as c. 1464 or c. 1475. For a summary of the literature, see Lightbown 1986, 435.
4. See Lightbown 1986, 474, for a summary of opinions on this lost painting; it has been assigned dates ranging from 1490 to 1506.
5. Washington 1973, 388.

22
Parmigianino

Judith
Etching, c. 1526
154 x 91 (6¹/₁₆ x 3⁹/₁₆)
Bartsch 1
Print Purchase Fund (Rosenwald Collection) 1980.14.10

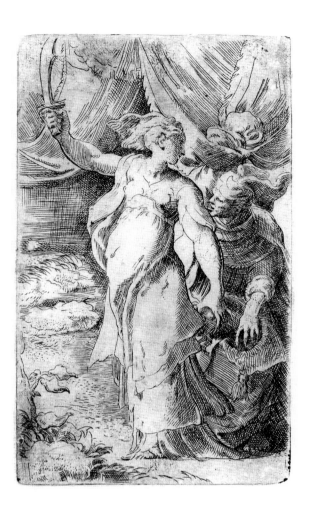

Although Parmigianino was not the first Italian artist to use the etching technique, he was the first to exploit its potential for creating images that have the spontaneity of drawings.[1] The technique used in the *Judith* captures the energy of Parmigianino's best drawings, and at the same time gives an extraordinary forcefulness to this image of the heroine. The sweeping lines of the tent, the facelike knot of drapery, and the headpiece of the maid all echo the line of the Judith's right arm as she boldly lifts the sword before her.[2] Yet there is also a sinister side to Parmigianino's image: Judith's face is in shadow as she turns to hand her maid the head of Holofernes with a nearly hidden, backhand gesture.

Parmigianino here seems to combine two of the best-known images of Judith by Italian artists, those by Mantegna and by Michelangelo. From Mantegna, he takes the image of the maid as a black woman, holding the sack as she looks up at Judith.[3] From Michelangelo's *Judith*, painted in one of the corner pendentives of the Sistine Chapel, he borrows the concept of Judith turning her head to look back at the body of Holofernes, hiding her face in a manner that suggests shamefulness. But Parmigianino's energetic portrayal of Judith goes beyond the images of either of these masters, presenting her as an active and proud figure, even if the image is not without negative overtones.

1. Popham 1971, 1:14; Boston 1989, xxii.
2. Copertini 1932, no. 118, sees the influence of Roman art in the triumphant gesture of Judith. The form above the head of the maid is clearly a knot of drapery in a preparatory drawing for this etching (Popham 1971, no. 204). Another drawing related to this etching is discussed in Harprath 1974, 373–375.
3. See cat. 21 for Mantegna's images of Judith. Parmigianino's maid is especially close to the maid in a drawing by (or after) Mantegna in the Uffizi, Gabinetto dei Disegni, no. 404 (see Lightbown 1986, no. 188, and fig. 15).

23
Barthel Beham

Judith with the Head of Holofernes
Engraving, 1525/1527
84 x 67 (3⁵/₁₆ x 2⁵/₈)
Pauli 1911, no. 4
Rosenwald Collection 1943.3.885

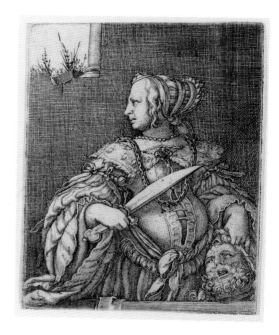

This image of Judith is faithful to the apocryphal account in showing the heroine in the sumptuous dress and jewelry that she put on to make herself more attractive to Holofernes.[1] An example of a "good Judith," she is shown as a strong, virtuous woman. The blank wall behind her is broken only by a small window with a column suggesting fortitude, a virtue often associated with this heroine.[2] Some small grasses growing in the opening seem to be causing the wall to crumble, perhaps alluding to the frail young woman who was able to fell a powerful male enemy. The face of Holofernes has an agonized expression, as if he were still alive and begging for mercy. Judith looks sharply in the opposite direction—a majestic image of female power.

The references to the virtue of Judith seen in this engraving must have been clear to Beham's contemporaries. In 1528 the image was transformed into a personification of fortitude in an engraving by Heinrich Aldegrever (fig. 23a).[3] Aldegrever's Fortitude turns her head in the same direction as her body, and so does not show the same tension as Barthel's Judith, but the background is similar, and the figure holds a large broken column that is the attribute of the virtue.

1. Apocryphal Book of Judith 10:3–5.
2. Coltellacci 1981, 104.
3. This engraving belongs to a series that also includes images of Faith and Intemperance (Hollstein 62 and 63). A similar image of Judith in profile, also by Aldegrever (Hollstein 18), may belong to the same series. If so, it is unclear whether she is associated with positive or negative Virtues, since two of the others are positive and one negative. Jacob Bink engraved a copy of Barthel's *Judith* in reverse, which is also dated 1528 (Bartsch 7).

fig. 23a. Heinrich Aldegrever, *Fortitude*, dated 1528, etching, 81 x 56 (3³/₁₆ x 2¹/₄), National Gallery of Art, Washington, Rosenwald Collection 1945.5.14 (Bartsch 133).

24
Albrecht Altdorfer

Judith with the Head of Holofernes
Engraving, c. 1520/1530
64 x 40 (2¹/₂ x 1⁹/₁₆)
Winzinger 158a
Rosenwald Collection 1943.3.398

Altdorfer presents Judith in an exceptionally brutal stance, with the head of Holofernes held up on a sword, stabbed through the eye. Judith herself seems unmoved by the gruesomeness, a reflection of the idea that part of her heroism lay in her ability to suppress her emotions in order to kill her enemy. This is one of a series of four prints dealing with the theme of stoicism (see cat. 8). In all four engravings, Altdorfer gives the subject a grim facial expression, in contrast to the more dramatic details in the gestures, costumes, or background elements.

Judith's dress in this engraving, as it slips off one shoulder, is comparable to the dress of his Dido (cat. 8), which in turn was derived from Italian images of Dido or Lucretia (see cats. 5, 6). But given the savage gesture of Judith, the image of an Amazon also comes to mind, with the connotations of fierceness and a wild "otherness" that set them apart from the norms of society.[1] This was one way to deal with the violence in the story of Judith and Holofernes. If Judith was depicted as a woman fundamentally unlike women living in the artist's time, her violence would not be in conflict with the ideal of meekness set for ordinary women.

The erotic element in the story of Judith, while not dominant in this engraving, is nevertheless suggested by the heroine's bared left leg.[2] In this, the engraving bears a striking resemblance to Giorgione's painting of Judith in the Hermitage. Altdorfer had traveled to Italy, and Giorgione's painting was reproduced in prints soon after it was made, so it is possible that Altdorfer knew it either in the original or in reproduction.[3]

1. Warner 1985, 278–282.
2. Bialostocki 1981, 211–219.
3. On Altdorfer's journey to Italy, see Winzinger 1975, 9.

25
Hans Sebald Beham

Judith and Her Servant Standing
Engraving, c. 1526/1530
109 x 70 (4¼ x 2¾)
Pauli 1911a, no. 11
Rosenwald Collection 1943.8.1163

26
Hans Sebald Beham

Judith Walking to the Left, and Her Servant
Engraving, c. 1531/1535
106 x 72 (4³/₁₆ x 2¹³/₁₆)
Pauli 1911a, no. 12
Rosenwald Collection 1943.3.1164

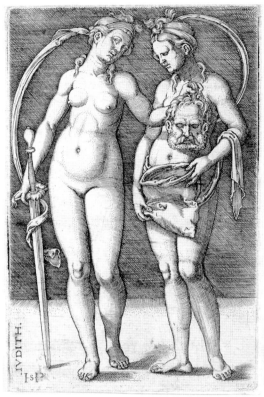

25

In images dealing with the story of Judith, the inclusion of the maid with her sack emphasizes Judith's deception of the Assyrians, since the maid had carried the sack full of food into the camp regularly until the two had gained the trust of the enemy. She then used the same sack to carry Holofernes' head out of the camp undetected. The maid often appears in paintings and in prints, but usually she is shown as an old (sometimes black) woman who serves as a foil to Judith's youth and beauty.[1]

In the two engravings exhibited here, Sebald Beham departs from the tradition, depicting the maid as someone very much like Judith in appearance. In the earlier of the two prints (cat. 25) both are youthful, and both are completely nude except for a token piece of drapery that wraps around the maid's body and falls over her arm. Her nudity is partly hidden, however, behind the sack and the head of Holofernes, so there can be no doubt of the power of Judith's more forthright display of her sexuality. Judith also looks upward, a symbol perhaps of the divine inspiration for her actions, while the maid looks downward, her eyes shadowed. The image is rather static; movement seems to be arrested (a ribbonlike arc of cloth hovers around the figures) and there is little sense of psychological interaction between the two women.[2]

In the second engraving, however, all this has changed. The stealth and the conspiratorial closeness of the two women are emphasized, with both looking in the same direction and the maid scowling, half-hidden by Judith's arm. Judith is shown completely nude, and her servant is dressed in a clinging garment, again pointing up the power of the sexuality of women in general, but making it clear that Judith is the active party. She strides forward as she turns back to look at the

scene of the murder or to make certain that the two have not been discovered. She holds the sword firmly, and its position against the maid's body gives it a phallic appearance, which, along with the nudity, only reinforces the idea that Judith seduced Holofernes in order to overpower him. Judith wears a wreath like a victor, and carries Holofernes' head like a prize.

1. Several examples are illustrated in Garrard 1989, 284–312. Artemisia Gentileschi, the subject of Garrard's study, presented the maid as a young woman in all four versions of the subject that she painted (Naples, the Palazzo Pitti in Florence, the Uffizi, and Detroit; see Garrard 1989, figs. 272, 278, 287, and 291). So did her father, Orazio Gentileschi, in his *Judith and Holofernes* in Hartford (Garrard 1989, fig. 277). All of these are from the first quarter of the seventeeth century. The two prints by Sebald Beham are the only sixteenth-century examples of such a representation of which I am aware.
2. A similar image of Judith, completely nude and with a looping piece of drapery over her head, is seen in an engraving by Nicoletto da Modena, 1510/1515 (Bartsch 2).

26

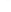

27

Barthel Beham

Judith Seated on the Body of Holofernes
Engraving, 1525
54 x 37 (2¹/₈ x 1⁷/₁₆)
Pauli 1911, no. 3
Rosenwald Collection 1943.3.886

This is one of three versions of Judith by Barthel.[1] In all three, the violent deed has been done and Judith holds the head of Holofernes at her side. She is always shown as a sensuous woman, and in two versions, including this one, she is completely nude. The sexuality of Judith is heightened in this engraving by having her sit on top of Holofernes' nude body. Her right hand still grips the sword, and she looks sharply over her shoulder, her eyes in shadow. While a female standing or sitting over the body of a male might suggest the medieval psychomachia tradition where virtue conquers vice, here Judith's glowering expression gives her a more sinister air.

1. The other two are Pauli 1911, nos. 2 and 4. This engraving was copied in reverse by Master R.B. with the date of 1530.

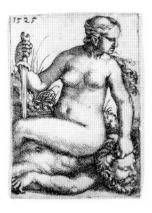

28
Hans Sebald Beham

Judith Sitting in a Window
Engraving, dated 1547
75 x 50 (2¹⁵/₁₆ x 2)
Pauli 1911a, no. 13 1/4
Rosenwald Collection 1943.3.1165

The figure of Judith here is copied in reverse from Barthel Beham's engraving dated 1523 (Pauli 1911, no. 2). Sebald also adds the arched window and the inscription.[1] Judith is shown in a contemplative mood very different from other versions that Sebald designed himself (see cat. 26). As she looks downward, it seems as if her gaze meets that of Holofernes, suggesting remorse or even longing—again there is the implication that Judith was as interested in Holofernes as he was in her. The inscription emphasizes Judith's passiveness, the notion that she is merely the agent of a higher power: ''The Lord has taken away the head of Holofernes by the hand of Judith.''[2]

1. Sebald Beham's print is discussed by Janey L. Levy in Lawrence 1988, no. 28.
2. ''HOLOFERNI CAPUT DOMINUS / ABSTULIT PER MANUM IUDITH.''

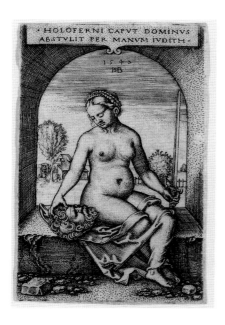

29
Georg Pencz

Tomyris with the Head of Cyrus
(from *The Fables* series)
Engraving, c. 1539
118 x 73 (4⁵/₈ x 2⁷/₈).
Bartsch 70
Rosenwald Collection 1943.3.6719

The story of Tomyris and Cyrus is told by the ancient Greek historian Herodotus (*History* 1.205-214). Tomyris was the widowed queen of the uncivilized Massagetae, whose land bordered Persia, then ruled by Cyrus the Great. After conquering vast territories in the Near East, Cyrus decided to acquire the Massagetae lands, which had been peaceful up to that point. Cyrus first offered to marry Tomyris, but when he was refused, he entered her territory by force. Although Tomyris tried to reason with him, he continued to plan his offensive. He would send the weakest third of his troops into the Massagetae territory to set up camp and to lay out a sumptuous feast. The Massagetae easily defeated this group, as Cyrus planned, but then they fell asleep after feasting on the meal that had been set for them. This allowed the remaining Persian troops to overcome the Massagetae. During this rout, Cyrus took Tomyris' son captive. Tomyris, who in Herodotus' version is always reasonable and chivalrous, reproached Cyrus for his trickery and asked for the release of her son. In the meantime, however, her son had killed himself out of humiliation for being taken captive. After another fierce battle, Cyrus' troops were finally defeated and he himself killed. When his body was brought to Tomyris, she cut off his head and plunged it into a bucket of blood, saying that now he would have his fill of blood.

Because of its Greek origin, the story of Tomyris was somewhat less accessible in the middle ages than those of the Roman heroines.[1] Still, the story was told, often in diluted form, and it was used for a variety of purposes. For example, Tomyris was brought together with Judith and Jael as forerunners of the Virgin, who ultimately conquered the Devil.[2] The story was also used as a moralizing exemplum warning against drunkenness, and it was retold in books that dealt with military strategies, although often Herodotus' meaning was inverted so that it was Tomyris' treachery that led to the defeat of Cyrus.[3] Whether it is called treachery or cunning, it was Tomyris' mental abilities—her strategies—that led to the defeat of the most powerful man in her time. Christine de Pisan (who transforms Tomyris into a queen of the Amazons) has her allow Cyrus' army to enter her land unopposed, only to ambush them in the rough terrain. Boccaccio describes her

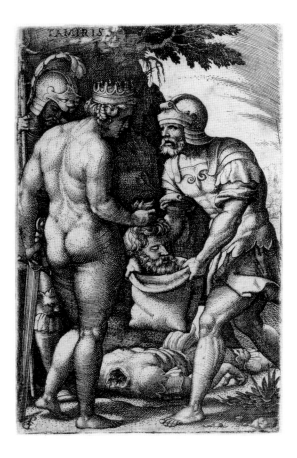

tuous wife of Cephalus, was accidentally killed by him while he was hunting). This kind of random grouping of women was typical in collections of lives of famous women, where the virtuous and the infamous were set side by side. Pencz has, in a sense, equalized these women by showing all of them nude, taking attention from the narrative and placing it on the study of the female form.

1. See Young 1964, 10–42, for summaries of the medieval versions of the story.
2. The four are brought together in chapter 30 of the *Speculum humanae salvationis*. A woodcut example published in 1476 is shown in the *Illustrated Bartsch* 81:50, no. 1476/199.
3. Young 1964, 16, 36–37, citing the *Gesta romanorum*, no. 88.
4. Christine de Pisan, *City of Ladies,* 1.17.1–3; Boccaccio 1963 ed., 104–106. See also Kleinbaum 1983, 65–66.
5. Examples of works showing the bucket are illustrated in Young 1964, facing pages 17 and 32. See also the woodcut mentioned in note 2 above.
6. Landau 1978, 48; and Lawrence 1988, 93.
7. Bartsch 71–73.

strategies as inversions of Cyrus', so that he is defeated because he is deprived of supplies in Tomyris' barren lands.[4]

Georg Pencz' image of Tomyris emphasizes the power of the woman, but gives no indication that her power is intellectual rather than physical. She wears nothing but a crown as she lowers Cyrus' head into a sack (rather than the bucket that is usually depicted).[5] This last detail strengthens the analogy to images of Judith putting Holofernes' head in a sack, with the decapitated body in the background. Pencz' source may in fact have been a drawing of Judith by Mantegna or a print based upon it (see cat. 21).[6] Here, however, the servant is a male soldier who looks up at Tomyris with a hint of fear, while another is hidden in darkness.

This is one of a series of four famous women—the others are Medea, Oenone, and Procris.[7] The women have little in common. One is a warrior, the other three are lovers, each with very different relationships to their men (Oenone was abandoned by Paris; Medea aided Jason with her magic but then turned against him after their divorce; Procris, the vir-

30

Antonio Tempesta

Holofernes is Killed by Judith
(from *The Biblical Battles* series)
Etching, dated 1613
210 x 289 (8¼ x 11⅜)
Bartsch 258 1/2
Ailsa Mellon Bruce Fund 1974.55.40

Tempesta's great specialty was the etching of battle scenes, and in this series he illustrated twenty-four battles from the Old Testament and Apocrypha.[1] The series was dedicated to the duke of Florence, Cosimo II, and the frontispiece (Bartsch 235) makes it clear that the victories of the Hebrews were meant to be seen as a parallel to Cosimo's own conquests.[2] With this identification in mind, it is of some interest that the story of Judith is included in the group at all, since it is the only one in the series that focuses on a female. It also conveys a feeling of quietude that is different from the suspense or the active warfare seen in the other etchings in the series.[3] The violence of Judith's act is given less emphasis than usual—she only directs our attention to the head that is being covered by her maid, while the sword leans against a stool within Holofernes' tent. Holofernes' army sleeps unaware of the murder of their leader (the poses of the soldiers closest to the tent remind one of a similar lack of watchfulness in scenes of the Agony in the Garden).[4] Judith's face is covered in shadow, which suggests that Tempesta knew Parmigianino's etching of the subject (cat. 22), but the effect in this print is more mysterious, revealing the eerie effects of moonlight. The inscription makes it clear that the warning this image contains has as much to do with drunkenness and the lack of attentiveness that it brings as with the wiles of women: ''Here where the foul canopies are made red, sprinkled with gore, you, the leader, lie slain, overpowered by the art of a woman. That beauty had adorned itself to bring about your ruin, but you hasten death in the night by your drunkenness.''[5]

1. For an overview of Tempesta's work, with further references, see Boston 1989, 217–221.
2. Stanford 1978, 57–58.
3. The extensive view of the Assyrian camp does fit in well with the other works in the series. Such views are not common in the iconographic tradition of Judith and Holofernes, but there are some examples, such as Hans Burgkmair's woodcut, c. 1515 (Burkhard 1932, no. 43), and a woodcut by Christoffel van Sichem II, after a drawing by Goltzius, c. 1630 (Strauss 1973, 322).
4. See, for example, the paintings by Mantegna (Lightbown 1986, pl. 2, and fig. 38).
5. ''Hic ubi foeda rubent co[n]spersa conopea tabo / Obrute foeminea Ductor ab arte iaces. / Exitio forma illa tuo se compserat at tu / Nocturnam properas ebrietate necem.''

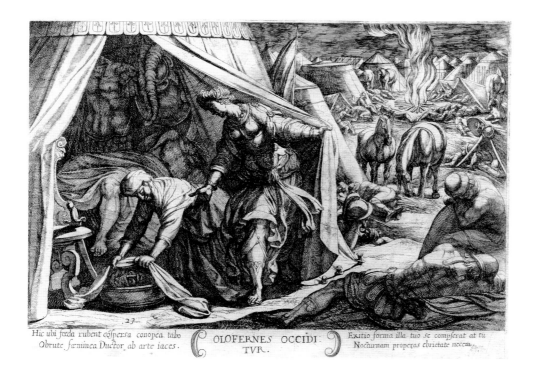

Hic ubi foeda rubent cõspersa conopea tabo Obrute fœminea Ductor ab arte iaces. OLOFERNES OCCIDITVR. *Exitio forma illa tuo se compserat at tu Nocturnam properas ebrietate necem.*

Infirma mundi elegit Deus, ut confundat fortia. 1. Cor.1.
Dieu choisit la foiblesse du monde, pour en confondre la force.
Israel ex. cum privil. Regis.

31
Jacques Callot

Judith with the Head of Holofernes
Etching, c. 1627
100 x 71 (3¹⁵/₁₆ x 2¹³/₁₆)
Lieure 674 2/2
Rudolf L. Baumfeld Collection 1969.15.112

There are few images from the Old Testament in Callot's
graphic oeuvre, and it is likely that the motivation behind this
image has more to do with technique than with the subject it-
self.[1] The etching is done in the *gravée au pointillé* technique,
a meticulous method of creating a dotted surface with the
point of a needle. The etching bears a strong resemblance to
the central scene in the *Judith and Holofernes* by Tempesta
(cat. 30), the artist with whom Callot worked as a young man
and from whom he most likely learned the art of etching.[2]
The two artists worked together in Florence on the funeral
book of Margherita of Austria from 1611 to 1612. Tempesta
then returned to Rome, but Callot continued to work for the
Medici in Florence. Tempesta's series, which includes the
Judith etching, was published in Rome the next year; Callot

could have known the composition before it was published,
or afterward since it surely was sent to Duke Cosimo II of Flo-
rence. These coincidences, as well as the use of a new tech-
nique, suggest that Callot was using Tempesta's composition
as the basis for his experimentation, perhaps in an attempt to
improve on the nocturnal mood of the image.

The similarities to Tempesta's design are numerous: the
tent with Holofernes' armor hung inside and the propped-up
body of Holofernes are much the same in both etchings, al-
though Callot reverses the composition. Judith is also shown
in a pose similar to the one in Tempesta's etching, with one
hand holding the tent open, as she leans toward her servant
and the body of Holofernes. Callot varies Tempesta's design,
however, in having Judith hold her sword in one hand, while
she sets the head in a tray held by her servant. These changes,
as well as the elimination of the camp scene, place Callot's
etching more clearly within the earlier tradition, which
emphasizes Judith's violent action within the confines of the
tent. The inscription, added to the second state, also gives a
more traditional meaning to the etching: "God chooses the
weak of the world to confound the strong."[3]

1. On Callot's religious images, see Washington 1975, 155–206.
2. Callot is known to have copied Tempesta's etchings (see Oberhu-
ber 1963, 118–119). On Tempesta's relationship to Callot, see Lieure
1929, 1:22–37.
3. The inscription is in both Latin and French and, as noted on the
print, is a quotation of 1 Corinthians 1:27: "Infirma mundi elegit
Deus, ut confundat fortia. 1.Cor.1 / Dieu choisit la foiblesse du
monde, pour en confondre la force."

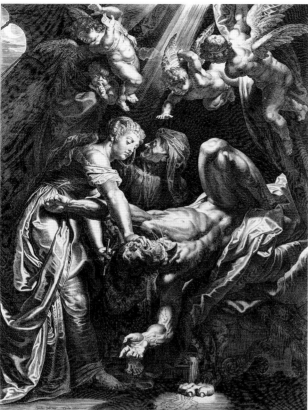

Cedite Romani ductores, cedite Graij;
Obſtruxit veſtris femina luminibus.
Veſtra fuit magna victoria parta virûm vi,
Et cedit laudis pars bona militibus;
Barbarus vnius dextrâ cadit Induperator,
Defendit patriæ perniciem vna manus.

Clariſſ. et amiciſſimo viro D. IOANNI WOVERIO paginam hanc auſpicalem primamque ſuorum operum
typis æneis expreſſam PETRVS PAVLLVS RVBENIVS promiſſi iam olim Virtute a ſe facti memor DAT DICAT.

32

Cornelis Galle the Elder, after
Peter Paul Rubens

Judith Beheading Holofernes
Engraving, c. 1610
550 x 380 (21⅝ x 15)
Hollstein 31 2/2
Andrew W. Mellon Purchase Fund 1978.29.3

The "Great Judith," as this engraving is popularly known, was the first reproductive print that Rubens commissioned; it is based on one of his paintings that is now known only through copies.[1] The print was commissioned shortly after Rubens' return to Antwerp from Italy, and the composition shows a clear Italian influence. It is especially close to Caravaggio's *Judith*, painted in the 1590s and now in the collection of the Palazzo Barberini in Rome (fig. 32a). In both, Holofernes is still quite alive as Judith slices through his neck, and he turns his half-severed head to look at her.[2] In both, the maid's haggard face is seen in profile next to Judith's face, a sharp contrast that serves to emphasize the loveliness of the heroine. Caravaggio's painting and Galle's engraving also share the dark setting with dramatic lighting from above, although Galle (presumably following Rubens' design) adds more specificity by showing details of Holofernes' bed and the doorway of the tent, set at a vertiginous angle in the upper left corner. Indeed, Rubens' image is more explicit overall than Caravaggio's. It is more gruesome with its spurting blood, and the angels above make the divine inspiration of Judith's action more clearly visible, although their presence (particularly the gesture of the angel with his finger to his lips) detracts from the serious impression that the rest of the image gives.

Rubens also gives more emphasis to Holofernes' body than Caravaggio does, showing him dramatically sprawled across the bed, his powerful torso fully visible, with one leg sharply bent and his arms extended and tense. The immediate source for this image was a painting by Adam Elsheimer of the same theme, done less than ten years earlier. Rubens greatly admired Elsheimer and owned this very painting (now in the Wellington Museum, Apsley House, London).[3] But whereas Elsheimer's Holofernes sprawls in a way that suggests a lack of control, Rubens gives him an exceptionally heroic presentation. His muscular body recalls classical sculpture like the Laocoön, and a similar image of a nude man struggling against overwhelming forces occurs again in Rubens' *Prometheus*, c. 1611.[4] While this may be seen as a glorification of Holofernes—a phenomenon that occurs frequently in works of art and literature—Rubens here depicts Judith firmly in control of

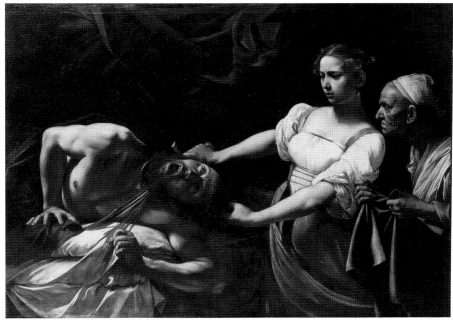

fig. 32a. Caravaggio, *Judith Beheading Holofernes*, 1598–1599, oil on canvas, 145.0 x 195.0 (57¹/₈ x 76¹/₂), Galleria Nazionale d'Arte Antica, Palazzo Barberini, Rome.

this powerful man. Her face shows cool determination. She does not grimace, or even seem to mind that her fingers enter Holofernes' open mouth.

The inscriptions on the engraving include a dedication to the Flemish humanist Jan Wouver or Woverius, along with the following verse: "Surrender, O Roman leaders; surrender, O Greeks: A woman has blocked your eyes. Yours was a great victory, brought forth by force of men, and a good part of your glory to the soldiers yielded: A hardened foreigner falls by one right hand, one hand wards off the danger to the fatherland."[5]

1. Rome 1977, no. 9; Pohlen 1985, 17, 40–44; Hofrichter 1980, 9–15.
2. See Garrard 1989, 290–291, for a discussion of Caravaggio's *Judith* within the iconographic tradition of the theme.
3. Andrews 1977, cat. 12, cited by Garrard 1989, 307, and 554 n. 86.
4. Rome 1977, no. 9, points out the similarity of Holofernes' body to that of the father in the Laocoön group, which Rubens clearly admired and made drawings of while in Italy.
5. "Cedite Romani ductores, cedite Graij: / Obstruxit vestris femina luminibus / Vestra fuit magna victoria parta virum vi, / et cessit laudis pars bona militibus: / Barbarus unius dextra cadit Indurator, / Defendit patriae perniciem una manus."

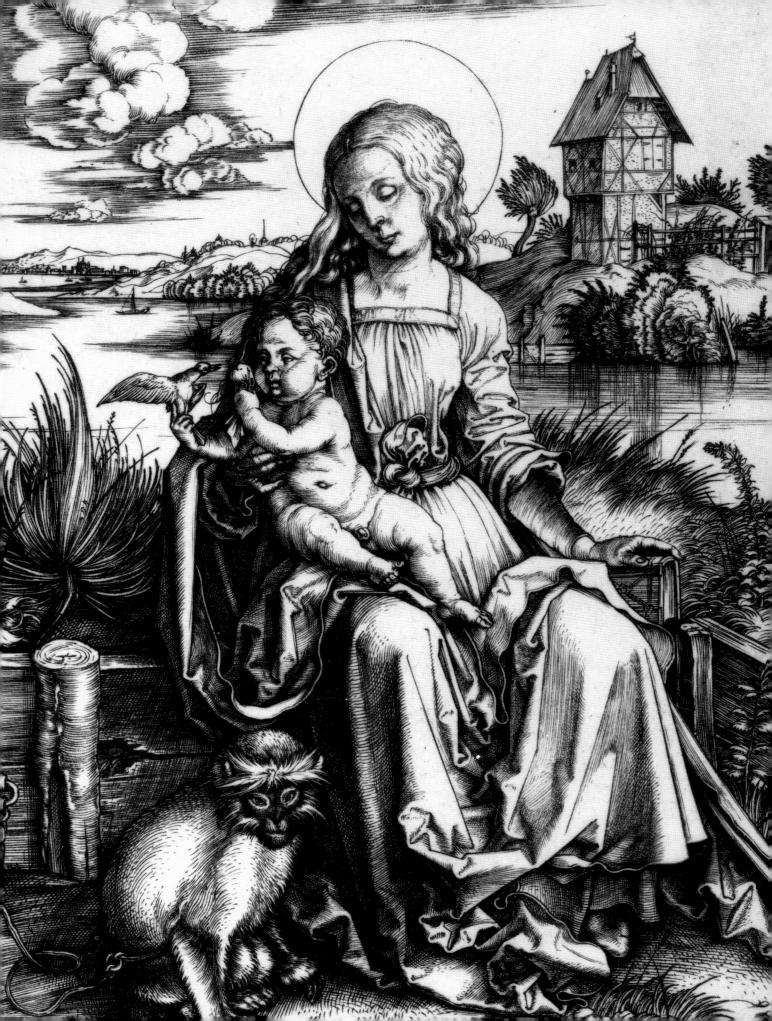

II
THE VIRGIN AND SAINTS

H. Diane Russell

The Virgin is little mentioned in the Bible, and the worship of her by members of the Roman Catholic Church first appeared strongly in the fifth century C.E.[1] As the cult of the Virgin grew, reaching its apex in the high middle ages, the events of her life received increasing attention in religious writings of multiple kinds.[2] When we encounter her here, in images of the Renaissance and baroque periods, we meet a figure whose representation, to a great extent, has been conventionalized. This is especially true of the narrative "events" of her life. These begin here with a scene by Dürer of her birth (cat. 33), and continue with the announcement to Mary by the angel Gabriel that God has chosen her to be the vessel for Christ's birth (cat. 36). She is present at Christ's Crucifixion (cat. 40), where she is depicted as having collapsed with grief at the foot of the cross. Scenes follow of her own death, attended by the apostles (cats. 41–42), as well as of her bodily assumption to heaven (cats. 43–45). After her Assumption, she is shown enthroned with God (cat. 46).

There are many non-narrative images shown here, too, depicting the Virgin herself. In some of these, she holds the Christ Child tenderly and often has a somber expression that indicates her awareness of the pain he will suffer for humankind (cat. 48). Two prints are representative of particular devotions to the Virgin. Altdorfer's *Beautiful Virgin of Regensburg* (cat. 53) is based on a thirteenth-century Italo-Byzantine icon in the town church, which drew thousands of pilgrims in the early sixteenth century (see fig. 53a). The second work (cat. 47) shows the Virgin and Child surrounded by rosary beads. Confraternities of the Rosary were founded in the last quarter of the fifteenth century and quickly became widespread. This print, in fact, joins two types of images: the Virgin of the Rosary and the Virgin in the Sun (that is, she is shown usually standing on a crescent surrounded by an aureole of light). The Virgin in the Sun had come to represent two important beliefs. One was a belief in Mary's pure and perpetual virginity, accepted since early Christian times. The other, a controversial belief, was in the Immaculate Conception (that the Virgin was born without sin). If the rosary was recited in front of the Virgin of the Rosary, or certain approved prayers said in front of the Immaculata, the persons

saying them would receive "munificent indulgences."[3] It is certain that Pope Sixtus IV conceded indulgences to members of the Brotherhood of the Rosary in 1478, and Ringbom has proposed that the pope also granted indulgences for devotions to the Immaculata.[4] In any case, images of these two subjects reflect their enormous popularity in the late fifteenth and early sixteenth centuries. They are especially common in prints and manuscripts of the time.

It is impossible, of course, to deal with all of the aspects of Mariology specifically represented in the prints assembled or with the Virgin as she was thought about and understood in the Renaissance and baroque periods. The catalogue entries do focus on the particular subject matter of the individual images. Some very important matters, nevertheless, must be touched on. The availability of images of the Virgin in prints, especially where the images were linked with indulgences, would have further encouraged devotions to her, and hence would have encouraged further images. There is no doubt that the Virgin was deeply venerated in the fifteenth century and into the sixteenth, prior to the Protestant Reformation. Moreover, although she was a unique, perfect woman, she possessed qualities that could be—or should be, ideally—emulated. She was obedient to God, she respected and trusted her earthly husband, she tenderly cared for and nurtured her child, she was part of a warm, caring family unit. The Virgin suffered for the sake of others (through Christ's death for humankind), and she offered her considerable power to help others (in her role as mediatrix with God for humankind). These are all qualities that might appeal to and be admired by both men and women.

Devotion to the Virgin during the late middle ages and the earlier Renaissance also generated interest in her own (presumed) family, especially in her mother, Anne (see cats. 38, 52).[5] Images of Saint Anne in various contexts proliferated. She was often shown with Virgin and Child or with her large, extended family; from 1100 on, she had been thought to have married three times and produced children by each marriage. The veneration of Saint Anne greatly intensified toward the end of the fifteenth century, especially in northern Europe, in part owing to the efforts of two clerics, Jan van Denemarken, a northern Netherlandish priest, and Pieter Dorlant, a Car-

thusian monk from Zelem near Diest, both of whom wrote about Anne. A Brotherhood of Saint Anne was founded at Frankfurt about 1479, where it met in a Carmelite monastery. Foreign merchants from Switzerland, France, and the Low Countries belonged to it.[6] As Ton Brandenbarg has emphasized, Anne appealed to extremely diverse groups of people, from married couples to monks and nuns, from intellectuals to those who were illiterate. She "was patron of housewives, married couples, mothers, mothers-to-be and widows, although she was also the guardian of celibates, whom she supported in their attempts at sexual abstinence."[7]

The veneration of the Virgin, Saint Anne, and numerous male and female saints came to a thundering halt with the advent of the Protestant Reformation. The reformers saw much corruption in the Roman clergy and in practices and beliefs that had been permitted to grow and flourish in the Church. They were deeply concerned by the cult of the saints and especially by what they considered to be flagrantly excessive veneration of the Virgin, "Mariolatry," as it came to be known.[8] In essence, the saints were banished by the Protestant sects. By contrast, the Roman Catholic Church, during its own ensuing reformation, reaffirmed the Virgin's theological importance and newly encouraged her veneration.[9] It was asserted ever more strongly that she was assumed body and soul into heaven immediately after her death, there to act as intercessor with God on behalf of humankind. The Church also re-emphasized that Mary was born without the sin of Adam and Eve that all other people carry from birth; that she miraculously conceived Christ—that is, without physical sexual intercourse; and that in giving birth to Christ in the usual human fashion, she nevertheless remained a virgin, utterly pure.

Protestantism became, basically, a religion of the word, whether written or spoken; and images, if they appeared at all, usually appeared in printed books.[10] Catholicism, on the other hand, continued to embrace images as a powerful means to worship, while forbidding, as it always had, the idolatry of images.[11] Hence religious images continued to be produced by Catholic artists for Catholic viewers, not least in the print media. Indeed, new devotions were promoted through images, among them a renewed emphasis on the Holy Family, now as almost always constituted solely of the Virgin, Child, and Saint Joseph, whose cult grew rapidly (cat. 39).[12] The importance of other saints, too, was reaffirmed (see cat. 56), and Catholic Reformation martyrs, among others, were added to the calendar of saints and newly represented. As regards the power of images to promote and propagate religious faith, anyone who has seriously studied the matter may be inclined to think that the Roman Church made the wiser decision in retaining visual religious imagery and, moreover, in strengthening its role.[13]

There is another matter that ought to be addressed here. Apart from religious doctrines and theological justifications, why was it apparently so important for Mary to have been uniquely virgin?[14] The question arises because women as a gender group, apart from the virginal saints, were considered to be far more lustful than were men as a group. A single but trenchant example of this attitude is found in the work of Jacobus Sprenger, the Dominican inquisitor who was co-author (with Heinrich Kramer) of the treatise on witchcraft, the *Malleus Maleficarum* (c. 1486). The treatise is infamous for its stress on women as witches, and the idea that woman's carnal lust is the root of all witchcraft; it is arguably one of the most misogynistic tracts ever published. Yet Sprenger, together with Alain de la Roche, was greatly devoted to the Virgin and founded many confraternities devoted to her worship through the rosary (see cat. 47 and fig. 47a). In other words, men worshiped the Virgin and were simultaneously ever on guard against the depravity of "normal" women. The latter attitude is especially clear in images of Eve (see cats. 62–75), the first mother, whose concupiscence was thought by many to have caused the expulsion of herself and Adam from Paradise. It is seen, as well, in many of the other images exhibited here. Woman uses her sexual wiles in various ways to entrap man and to achieve the upper hand in relations with him (for example, cats. 87, 99). In some instances, she causes his death, either directly or indirectly (cats. 92, 94).

In a recent study of the cult of the Virgin, Michael Carroll has focused on Mary's uniqueness as mother *and* virgin (his italics) and on the *origins* of the cult (my italics).[15] As he points out, her worship has rarely been approached from this standpoint. In so doing, he reviews the principal earlier studies and discusses the ideas and beliefs about earlier pagan goddesses who might be thought to have been "models" for the Virgin. He also focuses on the hypothesis that a Marian sect developed during the first four centuries of Christianity and was assimilated by the main Church in the fifth century.[16] Acknowledging that all of these ideas are problematic, Carroll himself stresses the *kind* of societies that would be likely to embrace the worship of a powerful female figure. He concludes that there are two types. First, a society in which a "client/patron" relationship exists, which is to say that one person does not have direct access to centers of power and thus needs another person to act as mediator.[17] The other is an agricultural society.[18] As Carroll points out, neither of these hypotheses explains the Virgin's complete disassociation from sexual intercourse.[19]

In the end, Carroll's principal explanation for belief in Mary's total virginity is rooted in classical Freudian psychoanalytic theory. For men, he sees devotion to the Marian cult in its strongest forms in families where the father is absent. He posits that there is strong sexual desire for the mother (uncon-

scious) on the part of the son, and that the desire is necessarily repressed. Incest, of course, is consciously unacceptable in virtually all "civilized" societies. The psychic energy required by this repression is "discharged through some activity that represents the disguised fulfillment of that unconscious desire," in this case, the worship of a virginal figure.[20] This does not account for the worship of the Virgin by women, and to explain that, Carroll suggests that women, in being encouraged to emulate the Virgin's qualities are unconsciously enabled "to experience vicariously the fulfillment of their desire for sexual contact with, and a baby from, their fathers."[21]

Psychoanalytically oriented scholars have moved far away from this kind of Freudian analysis; not surprisingly, Carroll's views have been controversial. They nevertheless provide a base study from which other, more subtle but also more probing views may be brought forth. It is almost undoubtedly true that the extraordinary figure of the Virgin, as well as the worship of her and of the virginial saints who occupied an important role in the Roman Church, arises out of the deepest part of the human unconscious. In his study of men, women, and sexual renunciation in early Christianity, Peter Brown has illuminated the struggle of early Christians with the corporeal body.[22] In concluding his story, he remarks that "the sudden rise of the cult of the Virgin offered the luminous inversion of the dark myth of shared, fallen flesh."[23] In looking at sixth-century icons of the Virgin with the Child held in her lap, the Christian could see the physical bonds between humans "at their most sweet, at their most harmonious, and at their most cohesive because effectively disconnected in the believer's mind, from the black shadow of the sexual act that lay at the root of normal, physical society."[24]

Early Christian and medieval societies are not, of course, identical to Renaissance and baroque societies. Indeed Brown himself has cautioned the reader that it is very difficult for us to understand early Christian people. Nevertheless, it is evident that the body, its desires and demands, has been and will be with people throughout human history, a matter of often deep and troubled concern. How one behaves, what the norms of society are, and what society will tolerate are issues quite alive and of a contentious nature today.

The Virgin was indeed worshiped by both men and women, and it may be useful to speculate on how each gender group responded to her. Some of the Virgin's surely admirable qualities have been mentioned above: obedience, the capacity for a nurturing love, selflessness. In a fascinating study, Caroline Walker Bynum has called attention to the use of maternal imagery in the writings of some medieval Cistercian theologians, especially Bernard of Clairvaux (1090?–1153).[25] Her investigation is focused on "the idea of God as mother" as it appeared in writings by men. She stresses "that many

male figures are referred to as mother, or described as nursing, conceiving, and giving birth."[26] The men so described are authority figures: bishops and abbots, leaders and teachers of the Old Testament, the apostles Peter and Paul. She further points out that this imagery rests on consistent sexual stereotypes. "Throughout contemporary sermons and treatises, gentleness, compassion, tenderness, emotionality and love, nurturing and security are labeled 'female' or 'maternal'; authority, judgment, command, strictness, and discipline are labeled 'male' or 'paternal'; instruction, fertility, and engendering are associated with both sexes (either as begetting or as conceiving)."[27] In other words, certain female and male characteristics are considered desirable as components of a male personality, as in the case of clerics who preside over religious communities of men.

Bynum emphasizes that while these writers valued these female traits, they were men "who had renounced the family and the company of women."[28] Their view of God as loving and approachable (maternal), or of leaders as tender and nurturing, had no carryover in terms of how they viewed ordinary women, including their own mothers. Bynum's study demonstrates that men could and did separate out affective qualities deemed positive from the female gender, while still regarding worldly women as dangerous. It is not surprising that during this twelfth-century period devotion both to the Virgin and to female saints increased greatly.[29]

It has long been observed that representations of God, Christ, and the Virgin, in particular, may be more or less authoritarian. A favorite comparison has been between the stern figures of God in Romanesque sculpture and the more humanized holy figures of Gothic sculpture. Images of the Virgin have undergone similar kinds of changes, for example, from the Virgin as Queen of Heaven to the Virgin as a figure of humility (compare cats. 46 and 48). How did men respond to images of the Virgin and women saints that emphasized not their humility or nurturing qualities but rather their status as figures of authority and power? Men were almost always those who commissioned and paid for paintings and sculptures, including the numberless images of the Virgin.[30] In regard to fourteenth-century Tuscan paintings of the Virgin and female saints, which depict them as powerful women, Margaret Miles has suggested that the imaging itself permitted men to spiritualize the women and to distance them.[31] Decades ago, the psychoanalyst Karen Horney focused on men's dread of women.[32] She proposed that men denied this dread even to themselves and that they sought to overcome it by objectifying it in artistic and scientific work. "We may conjecture that even his [the male's] glorification of women has its source not only in the cravings of love, but also in his desire to give the lie to his dread."[33] Whatever the deep roots are that prompt or compel men to create or to pay for images of

women, there are also more apparent and practical reasons. In the case of patrons, for example, some men may have felt that honoring the Virgin in images would be helpful later in seeking her help as mediatrix with God. Men of different classes and occupations, moreover, probably had different motivations and emphases in their worship of the Virgin—as, for example, a cloistered, chaste monk versus a worldly merchant who was also a husband and a father.

The same variety of motivations and satisfactions would seem to apply to women who were especially devoted to the Virgin and female saints. Miles has astutely emphasized that images may be interpreted differently by different persons within the same culture. She has also proposed, however, that medieval women did receive a particular message from images of the Virgin, namely that "the power of the Virgin came from her virginity as surely as it came from her motherhood."[34] During the Renaissance and baroque periods, many women would have regarded freedom from frequent childbirth as a highly desirable state. While the Virgin was a model mother, she was also markedly an individual who was free from the constraints of ordinary marriage and daily life.

Women who took religious vows or who otherwise chose a life of virginity or chastity, following the model of the Virgin and virginal saints, lifted themselves out of stereotypical female patterns. In the case of Catherine of Siena, the fourteenth-century Italian mystic who later became one of the two women Doctors of the Church, Rudolph Bell has proposed that the spiritual life permitted her "to be the servant of no man."[35] In adolescence, Catherine began to eschew worldly pleasures and embarked on a life of severe physical deprivation. She increasingly practiced self-starvation and eventually died from it. Among the physical effects that arise from starvation are the abatement of sexual desires and, for a length of time, extraordinary periods of energetic activity. By rejecting the demands of the flesh in all respects, Catherine took exceptional control of her life and achieved worldly religious goals quite beyond the expectations of other women and of many men. No earthly bride, she chose to become the bride of Christ and believed that Christ and the Virgin placed a marriage ring on her finger (fig. 58a). While her life was an unusual one, it was not unique among a group of religious women whom Bell has called "holy anorexics." All of these women manifested extreme behavior, but their lives, nevertheless, can offer insights into the lives of "normal" women.[36]

1. On Mary in the Gospels and the Apocrypha, see Warner 1976, 3–33. Mary's status as *Theotokos*—"God-bearer" or "mother of God"—was confirmed at the Council of Ephesus in 431. All orthodox Fathers of the Church believed that Christ was conceived by a virgin.
2. See especially Mâle 1984.
3. See Ringbom 1962, and on devotions to the rosary, Wilkins 1969.
4. Ringbom 1962, 326.
5. See especially Brandenbarg 1987.
6. Brandenbarg 1987, 113–116, on the Brotherhood of Saint Anne; 105–111, on Denemarken; and 111–113, on Dorlant.
7. Brandenbarg 1987, 124.
8. See especially Mâle 1951, 19–107.
9. Mâle 1951, 29–48, and 229–295.
10. See the interesting discussion in Miles 1985, 95–125. There were, of course, Protestant artists who executed religious paintings and independent prints, the most notable example being Rembrandt.
11. See Mâle 1951. A stimulating discussion of idolatry and iconoclasm is found in Freedberg 1989, 378–428.
12. In earlier art, Joseph was sometimes represented as a crude and simple-minded figure, as in the Master of the Housebook's drypoint of the *Holy Family*, c. 1500 (Lehrs 28). That work as well as many relevant paintings are illustrated in Cuttler 1968, for example.
13. Freedberg 1989 is especially relevant in this connection. See also the fascinating account of uses of sacred images by Richard Trexler, "Florentine Religious Experience: The Sacred Image," *Studies in the Renaissance* 19 (1972): 7–41.
14. Church dogma in fact lagged much behind theological thought on the Virgin. While the Virgin was often represented as the Immaculata during the Renaissance and baroque eras, the Immaculate Conception was not declared a dogma of the Church (that is, a mandatory belief for all Roman Catholics) until 1854. On the vicissitudes of the doctrine, see Warner 1976, 236–254. For a discussion of virginity generally as a cultural category, see Anton Blok, "Notes on the Concept of Virginity in Mediterranean Societies," in Schulte van Kessel 1986, 27–33. For a consideration of virginity from a psychological point of view, as seen by a pupil of Jung's, see M. Esther Harding, *Woman's Mysteries Ancient and Modern: Myth, Story, and Dreams* (New York and Hagerstown, 1971).
15. Carroll 1986.
16. Carroll 1986, 40–48, examines in particular the earlier work of Geoffrey Ashe, *The Virgin* (London, 1976), in which that author linked the Virgin to a group called the Collyridians, drawing on the supposed evidence of Epiphanius, later fourth-century bishop of Salamis in Cyprus.
17. Carroll 1986, 22–32.
18. Carroll 1986, 32–41. In reaching both of these conclusions, Carroll is also probing the ideas of earlier scholars. Following the suggestions of Lewis Richard Farnell in *The Cults of the Greek States* (Oxford, 1907), Carroll does find a classical goddess whose worship may have prepared the way for the worship of Mary. This is Cybele, who was a virgin mother and who was also sometimes associated with agricultural fecundity. For this discussion, see Carroll 1986, 90–112.
19. Carroll 1986, 48.
20. Carroll 1986, 49–74. Carroll points out a number of times in his book that the cult of the Virgin is especially strong in southern Italy and Spain, and he stresses that those societies frequently have absent fathers, are agricultural, and so on.
21. Carroll 1986, 59.
22. See Brown 1988.
23. Brown 1988, 445.
24. Brown 1988, 446.

25. See Bynum 1982.

26. Bynum 1982, 147. Bynum also discusses women mystics but strongly stresses (p. 140) that ''it was not women who originated the female image of God.''

27. Bynum 1988, 148.

28. Bynum 1988, 144.

29. Bynum 1988, 137, points out that 9.8 percent of all recognized saints were women in the second half of the eleventh century, and that by the first half of the fifteenth century, 29 percent were women. Bynum also notes the great popularity of Mary Magdalene in the twelfth and thirteenth centuries.

30. Men individually and in organizations to which they belonged simply had more access to money than did women. Nevertheless, there were women patrons, and research is being carried out at present on a number of them. A notable study already published is Marrow 1982. See also the interesting article by Elisja Schulte van Kessel, ''Gender and Spirit, Pietas et Contemptus Mundi: Matron-Patrons in Early Modern Rome,'' in Schulte van Kessel 1986, 47–68.

31. Miles 1985, 63–93.

32. See Horney 1932, 348–360. Horney's work is being newly studied by feminists, who tend to regard it favorably.

33. Horney 1932, 350.

34. Miles 1985, 89.

35. See Bell 1985, 20, and 22–53, for the extended treatment of Catherine.

36. Among the other ''holy anorexics'' discussed in Bell 1985 are Veronica Giuliani, who lived in the seventeenth century, and Angela of Foligno, who lived in the thirteenth. Bell's view of these women as anorexics has created some controversy, but his book is a fascinating and informative one.

33
Albrecht Dürer

The Birth of the Virgin
(from *The Life of the Virgin* series)
Woodcut, c. 1503/1504
296 x 208 (11⅝ x 8³/₁₆)
Meder/Hollstein 192
Rosenwald Collection 1943.3.3577

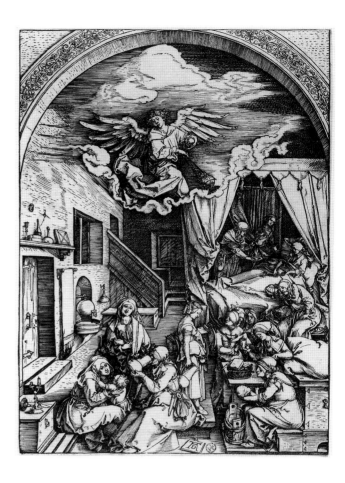

In the Gospels of the New Testament, the Virgin is rarely and only scantily mentioned, but through the centuries leading up to the Renaissance period, events in her life, from birth to her Assumption and coronation as Queen of Heaven (cat. 46), were the subject of myriad and varied writings.[1] These texts focused on many matters, including the Virgin's parents, Joachim and Anne, her presumed siblings (cat. 38), her marriage to Joseph (cats. 34, 35), and her death (cats. 41, 42). By the time Dürer began composing his *Life of the Virgin* se-

fig. 33a. Albrecht Dürer, *The Madonna on the Crescent*, title page from *The Life of the Virgin*, 1510–1511, woodcut, 203 x 196 (8 x 7³/₄), National Gallery of Art, Washington, Gift of W. G. Russell Allen 1941.1.27 (Meder/Hollstein 188).

ries around 1501, representations of the Virgin were legion, and the main events through which to illustrate her life were fairly standardized.

Dürer's series is, nevertheless, an especially elaborate one, being composed of nineteen scenes plus a title page (fig. 33a). It was first published in book form in 1511, but it is generally agreed that seventeen of the prints had been completed by 1505, when the artist departed for Venice for a second time.[2] Modern scholars, while acknowledging that a number of the scenes provide lively narrative elements, have been particularly interested in the architectural settings Dürer created through his manifest mastery of mathematical perspective.[3] It is important, however, to keep in mind that Dürer was personally devoted to the Virgin, continuing to create images of her after the onset of the Protestant Reformation in Nuremberg (see, for example, cat. 51). The formal devices he employed in this series enhance the narrative clarity and dignity of what is depicted.

The scene of the Virgin's birth takes place in a large, spacious room filled with women. Saint Anne, seemingly fatigued, is shown in bed in the background, attended by two women who bring her nourishment. In the foreground are several other women. The one at the right holds the infant Virgin and is bathing her, or about to bathe her, with water from the bucket on the ground. At the left, an older child is held by a woman, while the person next to her, perhaps a midwife, drinks from a large stein. Standing in the center of the scene is a young woman with a stein or pitcher carried in one hand and what is probably a birthing stool under her left arm. Two women seated at the right, behind the infant Virgin, are distinguished from the others by the garments they wear; they have headdresses and dresses common to women of the German merchant class, which contrast with the simpler garments worn by the others.

What Dürer has created here is a scene depicting the events that might have surrounded an actual birth in Nuremberg or other German cities during the Renaissance.[4] A baby was delivered by a midwife, who might bring with her an apprentice. The mother was placed on a birthing stool for delivery, and afterward was given broth, wine, and other drinks prepared by female relatives and friends who were present at the birth. The midwife was admonished not to drink before the birth, but was to be offered food and drink afterward. The newborn infant was usually given a warm herb bath. During the birthing process, the husband was not permitted to be present. The entire ritual and midwifery as a profession were strictly governed by city ordinances. Midwives, moreover, were supposed to follow manuals that instructed them in gently caring for mother and child.[5] In their work, they were overseen by patrician women, or the wives and widows of craftsmen—*Ehrbare Frauen* ("honorable women"), as they were sometimes called—appointed by the city, a regulation that began in Nuremberg in 1463.

Dürer has here effectively captured the sense of activity and *Gemütlichkeit* that attended successful births. The angel above, keeping watch and swinging a censer, immediately tells the viewer that this birth has momentous significance.

1. For a convenient résumé of the Virgin as mentioned in the Gospels and in the Apocrypha, see Warner 1976, 3–33. The number of writings is, of course, countless.
2. At the time of book publication, Latin texts by Benedictus Chelidonius were added. *The Life of the Virgin,* the *Large Passion,* and the *Apocalypse,* all with texts by Chelidonius, were sometimes bound together. See Washington 1971, cat. 134.
3. Panofsky's discussion of the series, part of a chapter entitled "Five Years of Rational Synthesis, 1500–1505," has been extremely influential in this respect. See Panofsky 1971, 95–104.
4. The material on midwifery and birth that follows is taken from the excellent and illuminating study of German working women in the Renaissance, Wiesner 1986, 55–73.

5. Wiesner 1986, 65–67, emphasizes the importance of a manual published in 1513 in Strasbourg by Eucharius Roesslin, *The Rosegarden for Midwives and Pregnant Women (Den swageren frauen and hebammen Roszgarten),* and subsequently translated into "all the western European languages. Much of the information contained in the *Roszgarten* came from classical authors, and much of it was wrong or useless, but it was accepted by university physicians and midwives alike."

34
Israhel van Meckenem, after Hans Holbein the Elder

The Marriage of the Virgin
(from *The Life of the Virgin* series)
Engraving, c. 1490/1500
264 x 181 (10³/₈ x 7¹/₈)
Lehrs 53
Rosenwald Collection 1943.3.107

Meckenem's *Life of the Virgin* series consists of twelve engravings, beginning with *Joachim's Sacrifice* and culminating in the *Coronation of the Virgin*.[1] The prints are characterized by having two scenes represented on each plate, one in the foreground and one in the background. The latter scene sometimes chronologically precedes and sometimes follows the principal scene. In the present instance, the *Marriage* is in the foreground, while an earlier event in the background shows the "bachelors of Judah"—the eligible men—who have been summoned to the temple by the high priest so that he can select a suitable husband for the young Mary. The priest is to look for the flowering of one of the rods carried by the men as they walk around the altar; at the right, Joseph's rod indeed has miraculously flowered, and he will be chosen.

The story of the Virgin's marriage had existed since the early Christian era, when apocryphal events of her life began to be written. These accounts were numerous and varied, but Christiane Klapisch-Zuber has pointed to the text of the proto-Matthew, dating from the seventh or eighth century, as "the most direct source for representations of the *Sposalizio* in the West."[2] By Meckenem's time, the theme had certain visual conventions, but it could also inspire considerable variations. Meckenem followed convention in representing Joseph as an older man. Later, in the seventeenth century, it became usual to depict him as younger and physically able-bodied, the better to serve as protector of the Virgin and Child.[3] It was also common to show the ceremony taking place in front of a building representing the temple, as the artist has done here. In virtually all representations of the marriage, a high priest joins the right hands of the couple to signify their consent to marry, but this figure's blessing gesture is often omitted, as in Dürer's version (cat. 35). Witnesses and onlookers are also always present, and, as here, some are often in rather nondescript "biblical" or "historical" dress, while others are dressed in contemporary costumes. The woman at the right, holding a rosary, may be an anachronistic detail or a deliberate portent of the Virgin's joys, sorrows, and glory to come as mother of Christ and venerated saint. The subject became especially popular in the fifteenth and

sixteenth centuries, for a number of reasons, but the relationship between it and actual marriage contracts and rituals is extremely complex.[4] In part this complexity is due to the fact that what constituted marriage rituals varied enormously from one geographical region to another, as well as from one class to another. The Roman Church itself encouraged the faithful to follow local customs. The most important fact about marriage was that while it was and is a sacrament, it was not necessary to have a religious ceremony to marry in the eyes of the Church. The crucial requirement was that the two would-be spouses were eligible to marry and freely gave their consent to do so; the event could be witnessed by a person authorized to do so, most often a notary.[5] The blessing of the union by a priest was subject to the wishes of the couple and their families and varied according to locale.[6]

Klapisch-Zuber has emphasized, however, that the visual representations of the Virgin's marriage, with the inclusion of a religious figure between the Virgin and Joseph, is evidence of the Church's wish to bring this sacrament more closely under the control of the Church, which was and is greatly concerned that the man and woman involved each consent to the union. Obviously, the events in the life of the Virgin, and not least her marriage to Joseph, with its aura of chastity and caretaking, were held up as exempla of Christian conduct to the faithful.

1. For Meckenem's series, see Washington 1967, cats. 216–227. Shestack, at the beginning of the entries, discusses the vexing matter of the relationship between Meckenem's prints and paintings by Hans Holbein the Elder.
2. Klapisch-Zuber 1985, 198.
3. See Mâle 1951, 315–316, The cult of Saint Joseph grew strongly in the Catholic Reform period. His feast day became obligatory in 1621.
4. An excellent source, directed toward Italian Renaissance painting and Tuscan and Roman customs, is Klapisch-Zuber 1985, 178–212; also 213–246, which discusses the issues of dowries and Marco Antonio Altieri's dialogue, *Li nuptiali* (c. 1500), which relates to marriage customs in Rome at that time. Because the author is an art historian as well as an historian, her research is often of particular relevance to students of art.
5. A work of art of peculiar interest and importance in this regard is Jan van Eyck's *Giovanni Arnolfini and His Wife* of 1434 (National Gallery, London). Several recent articles have been published on it (the classic account is Panofsky's of decades ago), all debating its meaning in great detail. See especially Bedaux 1986, 5–28. Presumably van Eyck painted the work as witness to the marriage of the two, who join hands in a domestic bedchamber. The artist's prominent signature reads: "Jan van Eyck was here, 1434."
6. Following marriage in Rome, the husband would meet his bride at a church as part of the ritual in which she left her house to go to the house of her groom. They would hear Mass and be blessed by the priest. This was part of the "public" marriage ritual taking place outside the homes of the couple. See Klapisch-Zuber 1985, 186–187.

35
Albrecht Dürer

The Betrothal of the Virgin
(from *The Life of the Virgin* series)
Woodcut, c. 1504/1505
294 x 206 (11⁹/₁₆ x 8¹/₈)
Meder/Hollstein 194
Gift of W. G. Russell Allen 1941.1.32

Dürer's print is part of his *Life of the Virgin* series (see cat. 33). Like Meckenem (cat. 34), Dürer has focused attention here on the high priest joining the hands of the Virgin and Joseph. The crowd of witnesses and onlookers, as in Meckenem's engraving, includes figures in contemporary dress. The woman at the right, in pleated dress and elaborate headpiece, is taken from one of Dürer's watercolors of about 1500; on it, he wrote, "so does one dress for church in Nuremberg."[1] Following convention, Dürer shows Mary and Joseph in front of a sanctuary, which, like Meckenem's building, is defined by the religious objects in it as a Jewish temple. Dürer, however, chose to define the synagogue with Romanesque architectural elements, as Panofsky pointed out, rather than the Gothic forms used by Meckenem.[2] The heavy forms and dark interior of the temple contrast with the brightly lit area of the marriage group, suggesting a contrast between the old order of Judaism and the new order of Christianity. This kind of distinction was commonly made in early Netherlandish painting.[3]

Erwin Panofsky proposed that the combat between armed men on unicorns and women on lions seen on the inner molding of the great doorway symbolizes "the conquest of sensuality by innocence." The owl, a nocturnal bird with traditionally evil connotations, is said to represent the synagogue and to refer to "the benightedness of the Jewish religion."[4] In any case, it is evident that Dürer used architecture carefully and effectively, in both aesthetic and symbolic ways, to provide impressive and meaningful settings for the individual scenes in the series. For other comments on the iconography of the subject, see cat. 34.

1. Pointed out in Washington 1971, cat. 141.
2. See the discussion in Panofsky 1971, 102–103.
3. Panofsky 1971, 102, mentions in particular the works of the Master of Flémalle and the brothers van Eyck.
4. Both quotations are from Panofsky 1971, 103.

36
Federico Barocci

The Annunciation
Etching and drypoint, c. 1584/1588
441 x 315 (17³/₈ x 12³/₈)
Bartsch 1
Ailsa Mellon Bruce Fund 1972.71.1

Barocci made only four prints—two large, of which *The Annunciation* is one; and two small—and all of them reproduce his own paintings. Nevertheless, the technique of etching and engraving that he employed proved to be very influential, and the prints have been admired as well for their affective qualities, which he successfully carried over from his paintings.[1] The print of *The Annunciation,* in fact, now communicates his conception of the subject much better than does the painting, which has suffered damage.[2]

The Annunciation is a drama enacted between two personages: the angel Gabriel is sent from God to give a message to the Virgin, who lives in Nazareth and is betrothed to a man named Joseph.

> And he came to her and said, "Hail, O favored one, the Lord is with you!" But she was greatly troubled at the saying, and considered in her mind what sort of greeting this might be. And the angel said to her, "Do not be afraid, Mary, for you have found favor with God. And behold, you will conceive in your womb and bear a son, and you shall call him Jesus." . . . And Mary said to the angel, "How shall this be, since I have no husband?" And the angel said to her, "The Holy Spirit will come upon you, and the power of the Most High will overshadow you; therefore the child to be born will be called holy, the Son of God." . . . And Mary said, "Behold, I am the handmaid of the Lord; let it be to me according to your word." (Luke 1:28–31, 34–35, 38)

For artists who considered the rendering of "the human figure in significant action" to be the most important object of art, as generations of Italian artists did, the Annunciation could thus offer an especially challenging subject.[3] Barocci's painting of *The Annunciation* received high praise from the seventeenth-century Italian biographer and art critic Giovanni Pietro Bellori, a vigorous and influential supporter of the classicistic theory of painting. As Edmund P. Pillsbury has emphasized, for Bellori "Barocci's art possessed the rare quality of decorum: that is to say the gestures and actions of the figures in his paintings expressed the most elevated human emotions and evoked an appropriate response from the viewer; for example, his religious subjects inspired feelings of piety and devotion."[4]

In Barocci's print of *The Annunciation*, Gabriel has descended into the Virgin's chamber from the right, his great wings and rumpled garment still suggesting his flight. Kneeling, in his left hand he holds a lily, symbol of the Virgin's purity, and with his right, palm upward, he gestures toward her. With her left hand, she puts on a table a still-open prayer book she has been reading, and with her raised right hand, she reacts to the unexpected interruption. Her thumb pointed toward herself, she seems to ask if it is really she that Gabriel is seeking. Yet her kneeling figure, on a dais and thus raised some distance above the angel, conveys a solemn and calm dignity, an equanimity, as does her facial expression. She is prepared, it seems, to be the handmaid of the Lord. The darkness of the chamber is illuminated by a divine light from above, which also seems to radiate from the figures, and it is contrasted with the daylight of the city scene visible through the window. At the lower left, a cat sleeps, conveying a kind of simple innocence that may be contrasted with the perceptions of the participants in this portentous event, and with our own reactions as viewers.

Barocci's image, still widely admired, is a fine example of religious painting and printmaking at its most moving and satisfying level.

1. For an illuminating discussion of Barocci's prints, see Cleveland 1978, 93–109.
2. On Barocci's paintings, see Harald Olsen, *Federico Barocci* (Copenhagen, 1962), especially cat. 37, and pl. 56, for *The Annunciation* (now in the Pinacoteca, Vatican, Rome), which was commissioned by Barocci's principal patron, the duke of Urbino, in 1582 for the ducal chapel of the basilica in Loreto.
3. For a discussion of the theory of history painting, see Lee 1967.
4. Cleveland 1978, 7, and 11–24, where Bellori's life of Barocci is translated into English, with extensive editorial notes.

37
Bartolomeo Biscaino

The Holy Family Adored by Angels (The Large Nativity)
Etching on laid paper, c. 1651/1657
395 x 280 (15¹/₂ x 11)
Bartsch 7 2/3
Ailsa Mellon Bruce Fund 1985.54.1

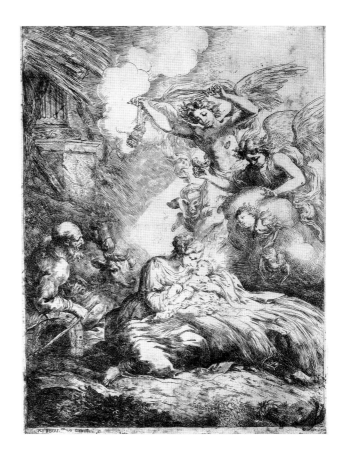

Biscaino was a Genoese painter and printmaker who died at the age of twenty-five from the plague. As Sue Welsh Reed has pointed out, most of his prints were small in scale, but "*The Nativity* is one of his largest and most ambitious plates."[1] Early impressions of the etching show that Biscaino purposely left a great deal of ink on the plate so that it would print tonally and create richly atmospheric effects. The image itself is a variant of an "Adoration of the Child," the Virgin kneeling and holding the infant Christ, and angels hovering above, a subject that ultimately derives from visions recorded by the medieval Swedish mystic, Saint Bridget, in her *Revelations*.[2] The billowing clouds and strong chiaroscuro effects of this print greatly contribute to its visionary quality.

1. Boston 1989, 272. The impression of *The Nativity* reproduced there is even more brilliantly contrasting in tone than the present impression.
2. For a fifteenth-century depiction of the Virgin kneeling before the Child in adoration, accompanied by a kneeling Saint Bridget, see Washington 1965, cat. 174.

38
Lucas Cranach the Elder

The Holy Kinship
Woodcut, c. 1509
227 x 333 (8¹⁵/₁₆ x 13⅛)
Hollstein 71
Rosenwald Collection 1943.3.2878

The cult of Saint Anne, mother of the Virgin, reached its height in the fifteenth century and continued into the middle of the sixteenth. With the advent of the Protestant Reformation in the early sixteenth century, veneration of Saint Anne became a particular focus of attack by the reformers because she is not mentioned in the Bible. Yet stories about her life had become prodigious, and her cult had spread widely. Visual representations abounded, too, in sculpture, painting, and graphic arts.[1]

Most often, as here, Saint Anne is depicted with the Virgin and Child (see also cat. 52). Anne and the Virgin are about the same size and hold the Child between them, a composition that John Hand has called the "trinitarian arrangement." Sometimes the Trinity is actually shown. The other typical composition has the Virgin and Child seated on Anne's lap, which Hand calls "hieratic," for the saint in this case is hieratically enlarged.[2]

By the end of the fifteenth century, Saint Anne's supposed genealogy had become quite elaborate, and it is this that is illustrated in the print by Cranach. The chart reproduced here (fig. 38a) indicates Anne's large family, her parents being Stollanus and Emerentiana, who supposedly also had another daughter, Hysmeria.[3] In Cranach's woodcut, the Virgin,

Anne, and the Child are in the center of the print. It is probably Joseph, hat in hand, who approaches them from the left. The two women seated on the floor, at left and right, must be Anne's daughters by the two subsequent marriages she was thought to have made following the death of the Virgin's father, Joachim. These unions were to Cleophas, which produced Mary Cleophas, presumably the figure at the left (note the four children); and to Salomas, which produced Mary Salomas, who had two children, and is presumably the figure at the right. The men in each case would be their respective husbands. The three male figures at the upper right are probably intended to represent Anne's three husbands, although each of them died before she married the next one. It is important to the story that Joachim was the first husband, for it was said that Anne was an older and barren woman before God sent an angel to both Joachim and Anne to tell them they were to be the parents of the Virgin.[4]

A considerable amount of religious writing was devoted to Saint Anne, her parents, her sister, husbands, children, and grandchildren during the late fifteenth and early sixteenth centuries. This large family was used as an exemplum of the purposes of marriage: to be obedient, to refrain from lust, to procreate, and to raise good, Christian children. When her third husband died, Anne, who was no longer fertile, remained a widow and thus exemplified the virtue of chastity. Anne, in short, became "the ideal model of a spouse, mother and widow."[5] Brandenbarg has connected the veneration of Anne in this respect with ideals of the urban middle class in the Low Countries and the Rhineland (where her cult was especially popular), in particular with respect to the place of women in the family, and concepts of morality.[6] It has also been stressed that the cult of Saint Anne grew as debate increased

fig. 38a. Genealogy of Saint Anne.

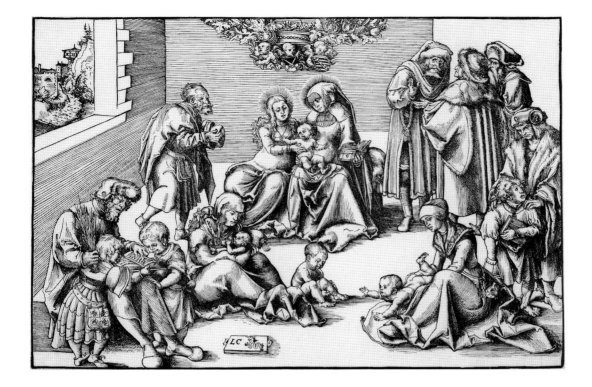

about the Virgin's freedom from Original Sin. Hand has pointed out that the doctrine of the Immaculate Conception "may be said to have been legitimized in 1480 when Pope Sixtus IV approved the addition to the liturgy of a special office and Mass of the Immaculate Conception."[7] Whether one thought that Mary was cleansed in her mother's womb or was without sin from the moment of conception, it was compelling to establish her mother's utmost probity.[8]

1. See the excellent article, with many illustrations, in Brandenbarg 1987, 101–127.
2. Hand 1982, 49. Perhaps the most famous instance of this type is Leonardo da Vinci's cartoon and painting of Saint Anne, the Virgin, and Child (National Gallery, London; and Louvre, Paris, respectively). Leonardo was dealing, however, with making the two women the same size, which created an aesthetic challenge that has been frequently discussed.
3. The genealogy and the spellings of the names are taken from Brandenbarg 1987, 125 n. 12.
4. "The Annunciation to Joachim," as it might be called, was included by both Israhel van Meckenem and Dürer in their series on *The Life of the Virgin*. Events of Saint Anne's life are sometimes closely related to those in the Virgin's life, the latter presenting a convenient but also iconographically signficant model.
5. Brandenbarg 1987, 121.
6. Brandenbarg 1987, especially 120–122.

7. Hand 1982, 49.
8. Brandenbarg pointed out that the "maculists," most prominently the Dominican Order, thought the Virgin was cleansed in Anne's womb, while the "immaculists," especially the Franciscans, Carmelites, and Carthusians, thought she was without sin from the moment of conception. See Brandenbarg 1987, 107. The Immaculate Conception was proclaimed a dogma of the Roman church only in 1854.

39
Jacques Callot

The Holy Family at Table
Etching and engraving, c. 1628
191 x 171 (7¹/₂ x 6¹¹/₁₆)
Lieure 595 3/4
R. L. Baumfeld Collection 1969.15.106

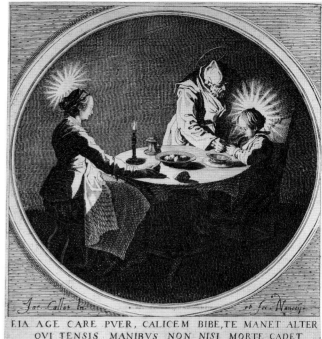

EIA AGE CARE PVER, CALICEM BIBE,TE MANET ALTER
QVI TENSIS MANIBVS NON NISI MORTE CADET

In this image, Callot portrayed an intimate and gentle family
scene of the Virgin, Joseph, and Child that became typical of
a stream of seventeenth-century images of the Holy Family.[1]
In helping the Child drink, Joseph is given new prominence
that accords with a post-Tridentine emphasis upon his close
paternal connection with the Christ Child. While he is men-
tioned several times in the Gospels as Christ's foster father
and the protector of both Virgin and Child, he became seri-
ously venerated only around this time. In medieval visual and
literary representations, Joseph was treated almost as an ob-
ject of derision. In the fifteenth century, his virtues began to
be extolled, and during the sixteenth century, his cause was
promoted by such religious thinkers as Teresa of Avila and
Francis de Sales. Only in 1621, however, did his feast day be-
come obligatory.[2]

The occasion depicted here is a somber one, as is empha-
sized in the inscription below the image: "Come, dear boy,
drink the cup, another cup awaits you that will not fall from
your hands except with death." This cup thus alludes to the
Eucharistic cup of the Last Supper, the proffered cup of
Christ on the Mount of Olives, and the sponge of vinegar of-
fered Christ on the cross (Mark 14:23–25, 36, and 15:36). Solem-
nity is further enhanced by the effect of a night scene from
which details beyond the figures and the table are omitted.
The black background also permitted the artist to stress the
brilliant, radiating light of the haloes around the heads of
Virgin and Child and to distinguish it from the lesser light of
Joseph's halo and the candle on the table.

Although Callot is perhaps best known as the creator of fes-
tival prints and Commedia dell'Arte figures, a great part of his
corpus of work was devoted to religious subjects, reflecting
the demand for such imagery in his native Lorraine and
elsewhere.[3]

1. Among these are paintings by Callot's contemporary and fellow
countryman, Georges de La Tour (1593–1652), notably the nocturne
Christ in the Carpenter's Shop (Louvre, Paris), where the Child
watches Joseph at his work. Joseph is drilling holes in a plank of
wood, presaging the cross of Christ's Crucifixion.
2. See Mâle 1951, 313–325, for the new devotions to Joseph, with
illustrations of a number of works.
3. On Callot's religious prints and drawings, see Washington 1975,
155–206.

40
Master I.A.M. of Zwolle

The Mount of Calvary
Engraving, c. 1480
357 X 247 (14 X 9¹¹/₁₆)
Lehrs 6 3/3
Rosenwald Collection 1943.3.5837

Alan Shestack has stressed this artist's "preference for the animated, dramatic, and the unexpected,"[1] qualities that are in evidence in this image. The two quiescent figures are Christ on the cross and the Virgin at the lower left, who has collapsed and is supported by John and a female figure, perhaps Mary, wife of Cleophas.[2] The others present are mostly shown in active poses, including the two crucified thieves who flank Christ. Their bodies face in various directions, creating a rather frenetic scene.

The linking of Christ and the Virgin is expressive of the mother's overwhelming grief at her son's death and also, in all likelihood, carries theological significance. In the fifteenth century, as Otto von Simson has pointed out, the Virgin was regarded as *co-redemptrix* and *co-salvatrix* with Christ by virtue of her *compassio* during the Crucifixion.[3] While the Virgin's thoughts under the cross had been "the object of meditation and pious speculation" from the time of the early Christian era, they became newly significant in the twelfth century and afterward, culminating in the writings of Denis the Carthusian (died 1471). Denis referred to the Virgin as *Salvatrix Mundi* and stressed her overwhelming sorrow, "even expressing the conviction that she herself was near death when Christ gave up his spirit."[4] Thomas à Kempis (died 1471, in Zwolle) urged the faithful to participate in the Virgin's compassion "as the indispensable means to Salvation."[5]

The extraordinarily lofty place accorded the Virgin in such thought did not survive the Protestant Reformation and the Catholic Reform, although the Roman Church was to continue and indeed renew devotion to her.[6] Nevertheless, her role as mediator in the salvation of humankind has continued to receive theological attention. On March 25, 1987, this "maternal mediation" was discussed in the encyclical *Redemptoris Mater* by Pope John Paul II, who lauded her but emphasized that her authority is derived from Christ and is subordinate to his power.

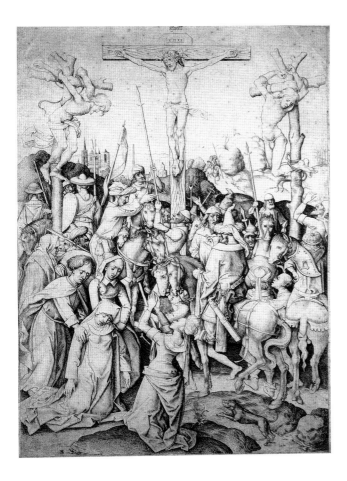

1. See Washington 1967, the biographical information preceding cat. 134. The print itself is discussed under cat. 134.
2. It is most likely that the woman kneeling in prayer in front of the cross is Mary Magdalene. See John 19:25–27, where the presence of the Virgin at the Crucifixion is emphasized.
3. Von Simson 1953, 9–16.
4. Von Simson 1953, 14.
5. Von Simson 1953, 16.
6. On the Virgin in the post-Tridentine period, see Mâle 1951, especially 29–48.

41

Anonymous German, fifteenth century, School of Peter Maler or Ulm

The Death of the Virgin
Woodcut, hand-colored in light orange-red, green, yellow, and brown, 1465/1470
197 X 272 (7³/₄ X 10¹¹/₁₆)
Schreiber 708
Rosenwald Collection 1943.3.519

The Virgin's death, like so many of the events of her life that came to be written about in literature and theology and depicted in the visual arts, is not discussed in the Gospels. By the middle ages, however, visual renderings of her death and her subsequent assumption into heaven were fairly common. A splendid example is the Coronation tympanum at Chartres Cathedral, the North Portal, dating from about 1205–1210. In the left lintel, she is shown on her deathbed surrounded by the apostles while her soul is held by Christ. In the right lintel, angels are preparing to resurrect her body, and in the field above the lintels, the Virgin is shown enthroned with Christ.[1]

The woodcut shown here is similar to such works: the Virgin is lying in bed surrounded by the apostles, while her soul, depicted as a young girl, is already held by Christ.[2] Among the written sources for such images is *The Golden Legend,* where it is told that the apostles, who were preaching the

word of God in scattered geographical areas, were miraculously transported to the Virgin's chamber as her death approached. During the night of their vigil, Christ appeared and ''Mary's soul went forth out of her body and flew upward in the arms of her Son,'' and he directed that her body be laid in a tomb in the valley of Josaphat. Three days later, Christ appeared again before the apostles at the Virgin's tomb, her soul was reunited with her body, and she was assumed into heaven.[3]

There are innumerable depictions of the Virgin's death, carried out in various media during the Renaissance and baroque periods. In prints, three well-known images are by Israhel van Meckenem, Schongauer, and Dürer.[4] Meckenem's engraving includes, in the background, the Virgin's coffin being carried to burial by the apostles. All three works depict the apostles attending the dying Virgin and performing priestly functions, but the convention of showing Christ with her soul has been dropped. The popularity of the subject undoubtedly arose from its manifest relevance to Christian belief in an afterlife, which included bodily resurrection. As is the case, nevertheless, with nearly all important aspects of her life, the Virgin exists in a special position between Christ and humankind. Theologians of the Catholic Reformation, such as the notable Cardinal Cesare Baronius, reaffirmed that the Virgin had died a mortal death, like Christ, and that she was then resurrected in body and soul, like Christ.[5] Because she was born free from Original Sin, her body was incorruptible, un-

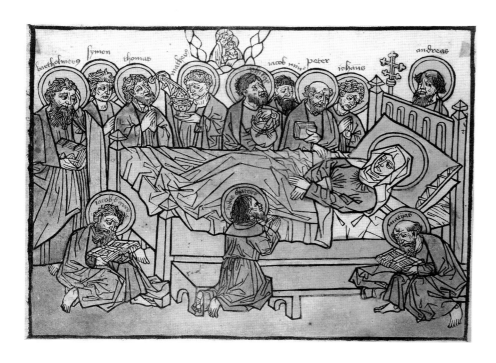

like those of ordinary humans, who die and whose possible resurrection to heaven must await the Last Judgment. These deeply held Catholic beliefs were, however, not declared dogma by the Roman Church until the modern era.[6]

In the woodcut shown here, the "identifications" of the apostles through pen and ink inscriptions (in an old hand) above their heads seem to be arbitrary in terms of the particular figures, except for Peter and the youthful John, both close to the Virgin's head. Paul is not named, for reasons that are not clear.

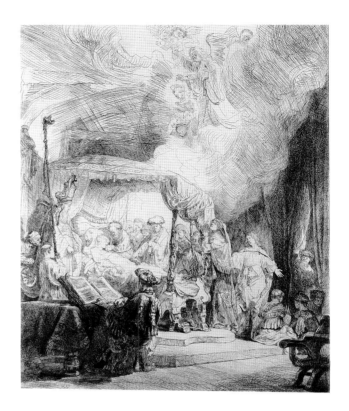

1. For reproductions, see Katzenellenbogen 1959, plates 43–44, 47.
2. See also Field's discussion of the print in Washington 1965, cat. 105.
3. Jacobus de Voragine 1969, 449–465 (451 for the quotation).
4. For reproductions of Schongauer's and Meckenem's prints, see Washington 1967, cats. 41, 226. For Dürer's woodcut, see Washington 1971, cat. 152. Both Meckenem's and Dürer's works are part of series devoted to the life of the Virgin; the two series are reproduced in their entirety in the sources cited.
5. Mâle 1951, 359–365, discusses the death and assumption of the Virgin. I have profited from Pamela Askew's text for a lecture on Caravaggio's *Death of the Virgin* (now in the Louvre, Paris), given at The Frick Collection, New York, in April 1985. Her book on the subject will be published by Princeton University Press this year.
6. The Immaculate Conception, proclaiming the Virgin's freedom from Original Sin, was declared a dogma in a bull by Pope Pius IX on December 8, 1854. On the long evolution of the idea and its vicissitudes, see, for example, Warner 1976, 236–254. The Assumption of the Virgin was declared a dogma by Pope Pius XII in a bull of November 1, 1950.

42
Rembrandt van Rijn

The Death of the Virgin
Etching and drypoint, dated 1639
408 X 317 (16 X 12⁷/₁₆)
White/Boon 99 3/3
Rosenwald Collection 1943.3.7171

Rembrandt's print is characteristic of his earlier phase of handling religious imagery in the dramatic style of some Italian baroque painters, a style that he learned at least in part from his teacher, the Amsterdam artist Pieter Lastman, who was strongly influenced by Caravaggio's works. The remarkable contrasts of light and dark, which create an almost breathable atmosphere and suggest the convergence of heavenly and earthly realms, are even more pronounced in some earlier impressions of this etching.

Light is, of course, used symbolically, its greatest intensity being on the dying Virgin and on the angels above. It acts, moreover, as an agent that seems to dissolve the Virgin's flesh and bones and thereby release her spirit upward. The costumes worn by some of the apostles(?) and other men and women who attend the event are also typical of the exotic and sometimes fanciful garments that Rembrandt featured in his early religious paintings as well as in early "portraits" of models that he dressed up. For comments on the iconography of the Virgin's death, see cat. 41, above.

43

Domenico Campagnola

The Assumption of the Virgin
Engraving, dated 1517
287 X 197 (11⁵/₁₆ X 7³/₄)
Hind 3 3/3
Rosenwald Collection 1943.3.2692

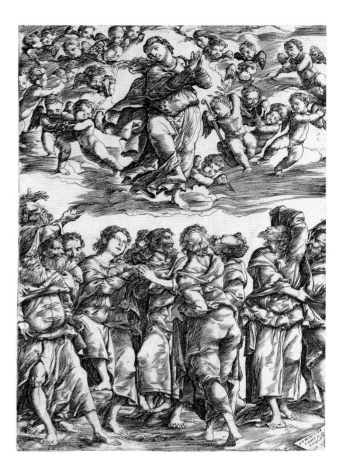

As is well known, Campagnola executed this print while
Titian was engaged in painting his famous *Assumption of the
Virgin* for the Church of the Frari in Venice (begun 1516,
completed 1518). There is a similarity between the two works,
above all in the energetic animation of the figures, both the
apostles on the ground level and the ascending Virgin and an-
gels in the next register. Titian's huge painting (over twenty-
two feet high), however, has a third register that shows the
floating figure of God the Father, an angel to either side,
ready to receive the Virgin and to place a crown on her head.
And as David Rosand has pointed out, the architectural frame
for the altarpiece has a sculpted figure of the resurrected
Christ on its top and a small relief of the dead Christ with two
angels at the center of the bottom cornice, paralleling the Vir-
gin's Assumption and Christ's Resurrection in their triumph
over death.[1]

Domenico was the adopted son of the Paduan-born artist,
Giulio Campagnola, and although trained by his father, he
may also have studied with Titian for a time. He was a painter
but is now best known for his prints. A number of drawings
exist that have been assigned to Domenico or to Titian by var-
ious scholars, and there is still debate as to correct attribu-
tions.[2] The style of this engraving, however, as well as of a
number of his other prints, is quite different from Titian's.
Domenico has created a kind of frenzied composition in
which space is radically compressed, and the various figures
compete, as it were, for the viewer's attention. The tomb of
the Virgin is not visible, being presumably walled-off by the
turning, twisting, and gesticulating apostles. These elements,
together with almost flashing effects of light and dark, give
the image a distinctly visionary power.

The Assumption was depicted countless times (here, see
also cats. 44–45), although it was not proclaimed a dogma by
the Roman Church until 1950.[3]

1. See David Rosand, *Painting in Cinquecento Venice: Titian, Ver-
onese, Tintoretto* (New Haven and London, 1982), 51–58, and color-
plate 2. Konrad Oberhuber, in Washington 1973, cat. 152, stressed
that Campagnola's print also has similarities with Palma Vecchio's
Assumption, now in the Accademia, Venice.
2. Washington 1973, 414–417.
3. For further comments on the subject of the Assumption and the
inextricably related Death of the Virgin, see cat. 41.

44
Albrecht Dürer

The Assumption and Coronation of the Virgin
(from *The Life of the Virgin* series)
Woodcut, dated 1510
291 x 206 (11⁷/₁₆ x 8¹/₈)
Meder/Hollstein 206
Rosenwald Collection 1943.3.3630

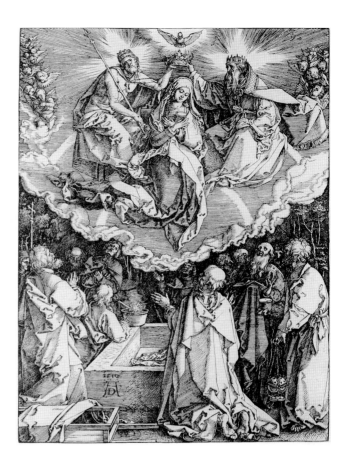

This is one of two narrative woodcuts that Dürer added to his
elaborate series, *The Life of the Virgin,* before its publication
in 1511 and after his return to Nuremberg from a second trip to
Italy (see cat. 33). As has often been observed, this print and
The Death of the Virgin, also dated 1510, demonstrate an "in-
crease in compositional unity and spatial clarity" when com-
pared with earlier scenes in the series.[1]

The print is nearly identical in subject and form with the
central panel of the Heller Altarpiece, begun about 1503 for
the Frankfurt merchant Jacob Heller, and sent to him by the
end of August 1509. Heller had commissioned the triptych for
the local Dominican church. Dürer himself painted only the
central panel, which was sold in 1615 to Maximilian I, elector
of Bavaria, and was destroyed by fire in 1729. It is known to-
day through an old copy.[2]

Both the woodcut and the painting combine the themes of
the Assumption and Coronation of the Virgin. In each, she is
crowned by the Holy Trinity. In both, as well, the apostles
surround her vacant tomb, and some of them see the miracu-
lous event in heaven: the Virgin, having ascended and now
kneeling below God the Father, Son, and Holy Spirit, is
made Queen of Heaven. This is an iconographically innova-
tive image that, as Panofsky pointed out, draws together Ger-
man, Netherlandish, and Italian pictorial sources.[3] Dürer's
figures are well formed and stately, and space is carefully and
rationally articulated so that the resulting image is impres-
sively clear visually and didactically.

1. Washington 1971, cat. 153.
2. On the Heller Altarpiece, see Panofsky 1971, 122–125 (fig. 168 for the
painted copy).
3. Panofsky 1971, 123–125.

45
Schelte Adams Bolswert,
after Peter Paul Rubens

The Assumption of the Virgin
Engraving, c. 1633(?)
634 x 433 (25 x 17)
Hollstein 35
Ailsa Mellon Bruce Fund 1975.23.5

It is generally agreed that Rubens executed only one print himself, an etching depicting Saint Catherine of Alexandria, c. 1620 (Hollstein 1). He was deeply involved with printmaking, however, from the creating of designs to be engraved, to his employment of artists to reproduce his paintings in various media (see the woodcut by Jegher, cat. 19). Like Raphael before him, Rubens was well aware of the power of prints to disseminate his visual imagery. He directly supervised a number of these artists, sometimes to the point of correcting proof impressions of their work. Schelte Adams Bolswert, one of Rubens' finest interpreters in engraving, worked for him from about 1633 until Rubens died in 1640, and afterward continued to reproduce his paintings.

This *Assumption* is based on an oil sketch (now in the Mauritshuis, The Hague) for Rubens' large altarpiece (490 x 325 cm) for Antwerp Cathedral, put in place in 1626. Another oil sketch, very close to the Mauritshuis work (see fig. 45a), is

fig. 45a. Peter Paul Rubens, *The Assumption of the Virgin*, c. 1626, oil on wood, 125.4 x 94.2 (49³/₈ x 37¹/₈), National Gallery of Art, Washington, Samuel H. Kress Collection 1961.9.32.

thought by Eisler, Freedberg, and others to be a copy by an unknown artist after Bolswert's engraving.[1]

In the period from 1611 to about 1637, Rubens executed about eight paintings of the Assumption, sometimes combined with the subject of the Coronation. Freedberg has pointed out that most of these Assumptions, and a number of other large religious altarpieces, were commissions to replace works in churches depleted of art by the iconoclasts. Roman Catholicism itself had been firmly reestablished in the southern Netherlands in 1609 by Archdukes Albert and Isabella.[2] Rubens' Marian subjects also reflect the renewed emphasis placed on the Virgin by the reformed Roman Church.

Despite many attempts by theologians at the Council of Trent (1545–1563) and afterward to discourage or forbid artists from using such popular and imaginative sources as *The Golden Legend,* they often continued to do so, and Rubens was no exception.[3] Freedberg has suggested that a principal literary source for Rubens' Assumptions may have been a book by the Jesuit Jerome Nadal, *Evangelicae historiae imagines,* republished in Antwerp in 1607 by the Plantin-Moretus Press. There he would have found texts, illustrations, and implications for the presence of the apostles at the Virgin's tomb, the angels who accompany her to heaven, and the women who are among the witnesses to

her ascent; the latter were said to have prepared her for burial but are unusual in depictions of the Assumption.[4]

The Antwerp Cathedral Altarpiece was originally placed in an elaborate architectural frame: above the Virgin was a sculpted figure of Christ holding the crown to be placed on her head, and above Christ was the dove of the Holy Spirit and God the Father.[5] Hence, as in Titian's Frari *Assumption* (which Rubens knew), the Virgin's ascent was even more forcefully and didactically emphasized than it was in the modello or in this print.[6]

Rubens' exuberant figures, dynamic compositions, and strong, bright colors—all elements nicely translated in the present instance by Bolswert—coalesced into a remarkably triumphant imagery that well suited and served the Roman Church during this period. His depictions of the Virgin, whatever the particular subject, show her as young, vibrant, and beautiful, a positive and presumably effective means of propagating her veneration.

1. Freedberg 1984, cat. 43b; and see cats. 43, 43a, for the Antwerp and The Hague paintings. On Rubens' Assumptions, see also Thomas L. Glen, *Rubens and the Counter Reformation: Studies in His Religious Paintings between 1609 and 1620* (New York and London, 1977), 143–159.
2. For a general discussion of the Assumptions, from which these comments are drawn, see Freedberg 1984, 138–143.
3. See Mâle 1951, 359–365. See also the account of the Council of Trent by Anthony Blunt, *Artistic Theory in Italy 1450–1600* (Oxford, 1956), 103–136.
4. Freedberg 1984, 139; see also 140 and individual entries on particular works, for several important visual sources for details in various Assumptions, including especially Lodovico Carracci's 1601 painting of the subject in Corpus Domini in Bologna.
5. See Freedberg 1984, fig. 111, for an engraving showing the entire high altar.
6. For comments on Titian's *Assumption,* see cat. 43, above.

46
Martin Schongauer

Triumph of the Virgin (Mary-Ecclesia)
Engraving, c. 1480/1490
162 x 154 (6³/₈ x 6¹/₁₆)
Lehrs 18
Rosenwald Collection 1943.3.36

The cult of the Virgin reached its apex, in thought and substance, on the portals of those Gothic cathedrals where the Virgin is shown crowned and seated in heaven next to her son. She shares his throne, she rules with him forever,

and she acts as intercessor with him for humankind.[1] In her triumph, Mary allegorically typifies the Church, which is also Virgin and Mother, and Bride of Christ as the Virgin was Bride of God.[2]

Schongauer's image, including the angels who pay homage to the Virgin,[3] clearly recollects the Triumphs of high medieval churches not only in its content but also in the sculpturelike clarity of its composition and drawing.[4] Executed sometime toward the end of Schongauer's short but highly influential artistic career, the *Triumph* sounds an exalted and serene note soon to be shattered by the attacks of reformers on the felt excesses of worshipers of the Virgin.

1. See the excellent historical and iconographical summary of the theme in Katzenellenbogen 1959, 56–59.
2. Katzenellenbogen 1959, 59–65.
3. Katzenellenbogen 1959, 59, notes that the angels in the archivolts who surround the Triumphs at Senlis and Chartres-North are drawn from the Pseudo-Jerome's letter, which reads in part: "Mary was worthy to be exalted over the choirs of angels."
4. Alan Shestack in Washington 1967, preceding cat. 34, discusses stylistic influences on Schongauer (but not that of medieval sculpture). He notes the enormous influence of Schongauer's own designs on the German sculpture of the period.

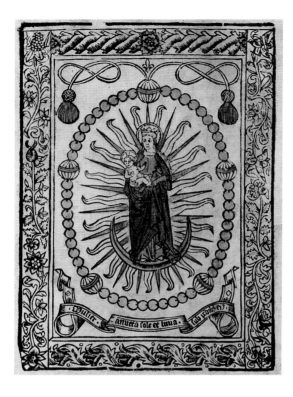

47
Anonymous French, fifteenth century, Savoy School(?)

The Virgin and Child in a Rosary
Woodcut, hand-colored in brown, red, and green, c. 1490
255 x 178 (10 x 7)
Schreiber 1130b
Rosenwald Collection 1943.3.565

Several woodcuts in the Rosenwald Collection focus on the Virgin and Child surrounded by a rosary, as here, or by a wreath of roses (see fig. 47a). These works principally date from the later fifteenth century, when devotion to the rosary was given great emphasis by two Dominican priests, Alan de la Roche and Jacob Sprenger, each of whom founded Confraternities of the Rosary. As an object, the rosary is composed of five large single beads alternating with five groups of ten small beads. In saying an "ordinary" rosary, the worshiper would recite five prayers beginning "Our Father," one each on the large beads, and follow with ten prayers beginning "Hail Mary" on each of the five decades of small beads. A "complete" rosary had 150 Hail Marys and fifteen Our Fathers.[1] Included in recitations of the rosary were medita-

tions, known as mysteries, on particular events in Mary's life or Christ's Passion. The rosary was considered an aid to prayer and a safeguard against heresy and sin. Its name derives from *rosarium,* meaning rose garden, and it had long been associated with the Virgin, who was considered the "rose without thorn."[2] According to a tradition traceable to Alan de la Roche, the Virgin appeared to Saint Dominic, founder of the Dominican Order, in the thirteenth century, to give him a rosary as an aid in his work among the Albigensian heretics.[3]

In this print, the Virgin is represented as the apocalyptic woman of the Book of Revelations, surrounded by rays of the sun and standing on the half moon, as the inscription below her states. Like a number of woodcuts in the Rosenwald Collection and elsewhere, this print was discovered pasted into the lid of a strong box, which helped to preserve it.[4] An impression still contained in such a box was published in a recent catalogue of prints (see fig. 47b).[5]

1. The terms "ordinary" and "complete" are used in Panofsky 1971, 110.
2. For résumés of devotion to the rosary among Roman Catholics, see Wilkins 1969; Warner 1976, 305–310; and *New Catholic Encyclopedia,* 12:667–670.
3. Caravaggio memorably depicted Dominic with the rosary, looking at the Virgin and Child, with the faithful kneeling in front of him, c. 1606–1607 (illustrated in Friedlaender 1955, pl. 39).
4. See Washington 1965, no. 170.
5. Arsène Bonafous-Murat, *Estampes 1490–1989* (Paris, 1989), no. 1, where it is noted that the best public collection of such boxes is that of the Bibliothèque Nationale, Paris, which has fourteen objects.

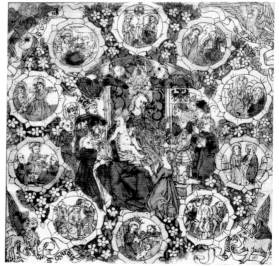

fig. 47a. Anonymous German, *Virgin with the Rosary* (detail), 1485, hand-colored woodcut, National Gallery of Art, Washington, Rosenwald Collection 1943.3.564 (Schreiber 1129).

The artist has emphasized the tender love of the Virgin as mother for her child. Her embrace and her somber expression make one think of how she will again hold her son at the end of his earthly life, when his broken body is removed from the cross (see cat. 54). The image is made forceful through its simplicity: no setting is indicated except for the ground line and the parallel strokes that surround the two figures. Mantegna's print was adapted by Rembrandt for one of his own prints, which depicts a tender scene of the Virgin, Child, and Joseph (see cat. 49).

Mantegna is generally acknowledged to have executed only seven prints himself, although his inventions and engraving style were further disseminated through prints by his followers. Most extant impressions, like the present work, are late impressions pulled from worn plates; the images, nevertheless, remain remarkably powerful and memorable.[3]

1. For a thorough discussion of the type, see Meiss 1978, 132–156. As Meiss explains, theologians had long considered the root of "humilitas" to be "humus," although the Virgin so seated did not appear in the arts until the trecento. Humility was considered a Christian virtue essential to the attainment of other virtues.
2. Washington 1973, 194.
3. On the prints of Mantegna and his followers, see Washington 1973, 165–233; and for a superb first state of this print, figs. 8–17. The haloes seen here were added in the second state.

fig. 47b. Anonymous French, *The Madonna and Child in a Rosary*, c. 1490, hand-colored woodcut pasted into lid of box, 222 x 158 (8¾ x 6⁵⁄₁₆), Arsène Bonafous-Murat, Paris.

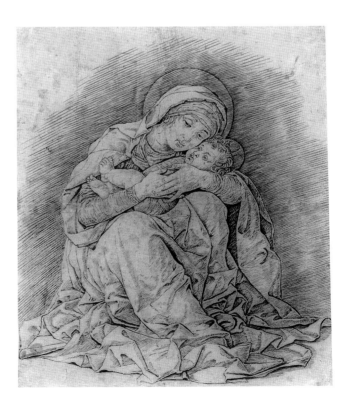

48
Andrea Mantegna

The Virgin and Child
Engraving, c. 1485/1491
241 x 205 (9½ x 8¹⁄₁₆)
Hind 1 2/2
Rosenwald Collection 1943.3.5772

The Virgin in this print, seated on the ground and holding the Christ Child, her cheek touching his, is a combination of two types of image. One is the Madonna of Humility, characterized by the placement of the figure, an invention of Sienese painters of the fourteenth century.[1] The other is the *Glykophilousa,* meaning sweetly or tenderly loving, which was derived from Byzantine icons.[2]

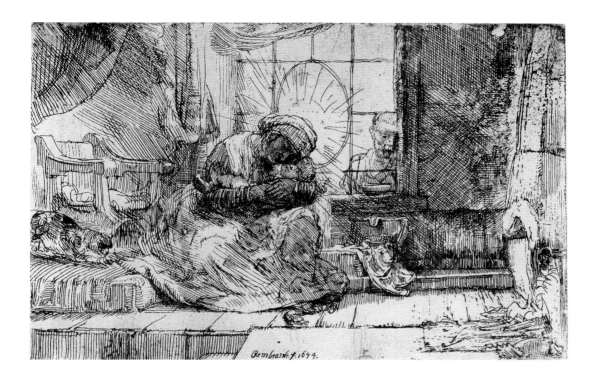

49

Rembrandt van Rijn

The Virgin and Child with the Cat and Snake
Etching, dated 1654
95 x 145 (3³/₄ x 5¹¹/₁₆)
White/Boon 63 1/2
Rosenwald Collection 1943.3.9112

That Rembrandt was acquainted with Mantegna's engraving, *The Virgin and Child* (cat. 48), and that he used the poses and attitudes of the two figures in this print is well known. He has, however, given the tenderly depicted figures a setting: a cozy domestic interior warmed by the fireplace at the right, with a cat playing on a raised platform in front of a chair at the left, a small, open chest of clothing, and a large window through which a gentle Joseph looks in. The large halo that encompasses the heads of both mother and child, and the curious detail of the snake that emerges from under the woman's garment, are the two elements that clearly mark the scene as a religious one.

Jakob Rosenberg, among other authors, emphasizes that the large portion of work Rembrandt devoted to religious subjects (in all media) was unusual in Calvinist Holland. He further stresses that, above all, the artist depended on his own reading of the Scriptures, and that his dominant focus was on

the life of Christ.[1] During the 1650s, the artist rendered the Holy Family a number of times, and a painting in Kassel from this period is rather close in composition and spirit to this print.[2] The hallmark of these works is the warm affection they convey among the principals and the careful tending of the infant Christ by the Virgin and sometimes also by Joseph.

As an inclusion in this image, the snake must be counted significant; the Virgin's foot seems to rest on it. As the tempter of the first Eve in the garden of Eden, the snake had long symbolized sin. By the seventeenth century, it could also be understood as an emblem of heresy. Most important, the Roman Church stoutly defended the role of the Virgin in overcoming both sin and heresy, while the Protestants denied her role.[3] Rembrandt must have been familiar with some of the many images in which the Virgin, usually with the infant or young Christ, vigorously crushed the serpent.[4] He, no doubt, understood the meaning of the motif and did her a kind of honor in adapting it here.

Rembrandt's personal religious views are unknown, in spite of some attempts by scholars to tie him to particular Protestant sects in Holland.[5] And while the Calvinists were quite strong in Holland, the country was, in fact, heterodox in terms of religion.[6] Perhaps one comes closest to the spirit of Rembrandt's religious imagery by emphasizing its accent on earthly events and its easy accessibility, which obviously distinguish it from doctrinal approaches.

1. On Rembrandt's biblical subjects, see Rosenberg 1968, 169–234. The first edition of this book was published in 1948. Rosenberg's evident admiration for the artist and his works can be viewed as verging on a kind of hagiographic approach. It should now be weighed against more recent accounts, especially by Horst Gerson in *Rembrandt Paintings* (Amsterdam, 1968); and Gary Schwartz, *Rembrandt, His Life, His Paintings* (Viking, 1985).

2. Rosenberg 1968, fig. 166.

3. See Mâle 1951, 29–42.

4. Perhaps the best known of these today is Caravaggio's *Madonna del Serpe* (showing the Virgin, Child, and Saint Anne), made for the Society of the Palafrenieri and now in the Borghese Gallery, Rome (see Friedlaender 1955, 191–195, and pl. 37). For the Roman Church, Pope Paul V (whose pontificate was 1605–1621) declared in a papal bull on the rosary that both the Virgin and Christ had crushed the head of the serpent.

5. Scholars have particularly focused on Rembrandt's possible ties with the Mennonites, but the evidence remains inconclusive.

6. See, for example, Schama 1988, especially 51–125.

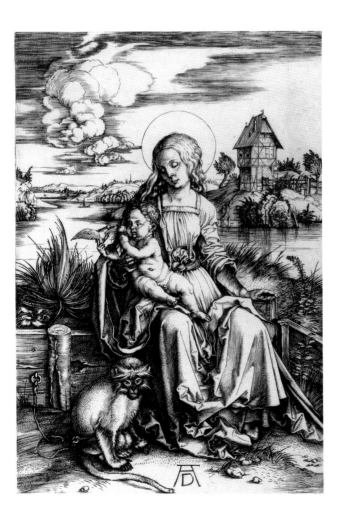

50
Albrecht Dürer

The Virgin and Child with the Monkey
Engraving, c. 1498
190 x 123 (7⁷/₁₆ x 4¹³/₁₆)
Meder/Hollstein 30
Gift of R. Horace Gallatin 1949.1.20

There are some twenty-two years between this print and the one following (cat. 51), also by Dürer. Not surprisingly, one finds changes in style and in the treatment of the subject matter, but the two works also indicate Dürer's lifelong devotion to the Virgin—this despite the fact that Willibald Pirkheimer wrote that the artist died a good Lutheran.[1]

In this earlier engraving, the proportions of the Virgin are almost willowy, and the landscape setting is elaborately detailed.[2] The Virgin sits on a grassy mound, made benchlike by boards that abut it. A monkey is chained to a board at the left, while the Christ Child, who sits on his mother's lap, holds a bird in his hand. Panofsky noted that the monkey was associated with the synagogue and with Eve; here it is under the control of the new Eve, the Virgin.[3] Horst Woldemar Janson further commented that "Dürer must also have intended to contrast the monkey, as the prisoner of bodily pleasures, with the bird in the hand of the Infant Christ, i.e., the soul as the voluntary captive of the Saviour."[4]

The beauty of the natural setting is thoroughly appropriate for the Virgin, who was often depicted outdoors and was known by such epithets as "the rose without thorns" and "the enclosed garden."[5] Her expression, however, is a solemn one as she looks at the Child, who must ultimately die for humankind.

Iconographically and artistically, the engraving exerted a considerable influence on other artists, who reflected it not only in prints but in other media as well.[6] The impression exhibited here is a very rich, fresh one, and it clearly conveys Dürer's technical expertise in rendering various kinds of textures and substances.

1. Panofsky 1971, 199.
2. The background is taken from a well-known watercolor by Dürer, now in the British Museum (Washington 1971, cat. 14).
3. Panofsky 1971, 67.
4. Janson 1952, 151.
5. On garden and flower imagery in relation to the Virgin and the saints, see Washington 1990, 15–41, and especially 23–24.
6. Janson 1952, 151, 161 n. 25.

51
Albrecht Dürer

The Virgin with the Swaddled Child
Engraving, dated 1520
142 x 96 (5⁹/₁₆ x 3³/₄)
Meder 40
Rosenwald Collection 1943.3.3545

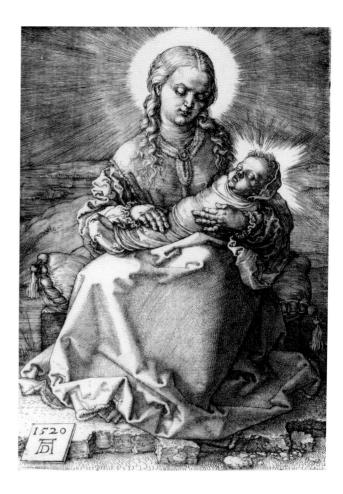

In contrast to the preceding work (cat. 50), the Virgin hold-
ing the Child here is a stocky figure who sits on a stone para-
pet covered with a cushion. Indeed, Panofsky has referred to
the entire image as "stony,"[1] and the scale of the Virgin in
relation to the format has been called "colossal."[2] The Vir-
gin's drapery is greatly simplified by comparison with the ear-
lier work, and the setting has become exceedingly austere.
Rather than day, it is night that hovers here. The Virgin's ex-
pression is even more grave, and she holds not an alert and
upright boy but a child who is tightly swaddled and sleeps,
resting across her lap. As Panofsky pointed out, "In many
theological texts relating to the Passion of Christ a tragic com-
parison was drawn between the sleep of childhood and the
sleep of death, and the *corporale* (that is, the cloth spread over
the altar for the Host to rest upon) is still interpreted both as
a symbol of Christ's swaddling cloth and of His shroud."[3]

The scene receives its illumination from the brilliance of the
haloes around the heads of Mother and Child, the Child's
distinguished by being crosslike in shape. The Virgin's halo
radiates out in linear streaks into the darkness, reaching the
farthest shores and sea in the background; hence it tightly ties
together the figures and setting. Among the many epithets
used for the Virgin, this feature recalls those that refer to her
as "the morning star" or "the star of the sea," which were
intended to indicate that she brings eternal light.[4]

The engraving is characteristic of Dürer's late style, not
only in prints but in paintings as well, a kind of "no frills" re-
ligious imagery that some scholars have linked to the impact
of Protestantism.

1. Panofsky 1971, 150.
2. Washington 1971, cat. 72.
3. Panofsky 1971, 40. Gilbert 1952, 206–207, took issue with this kind
of iconographical approach, specifically suggesting that the sleeping
infant Christ is not always intended to allude to the Pietà, but he
might agree that in this image there is such an allusion. Certainly the
facial expression of the Infant suggests it.
4. See the discussion in Mâle 1986, 195–203, where the author points
out that such metaphors were especially common in sixteenth-
century missals.

52
Lucas Cranach the Elder

Saint Anne and the Virgin with the Child
Woodcut, c. 1513
247 x 171 (9¹¹/₁₆ x 6¹¹/₁₆)
Hollstein 75
Rosenwald Collection 1943.3.2849

Cranach presents here a kind of visionary scene, as Saint Anne
and the Virgin worshipfully hold the Child between them.
God the Father and the Holy Spirit, above, together with the
Child, signify the Holy Trinity. The ground beneath Anne
and Mary is indicated with simplified strokes, but there is no
background detail to distract from the image. The clouds and
infant angels shown on either side of the group further inten-
sify the sense of a special, otherworldly devotional image.

The print clearly conveys the highly important place in the
religious hierarchy occupied at this time by Saint Anne,
mother of the Virgin. For comments on her cult, see cat. 38.

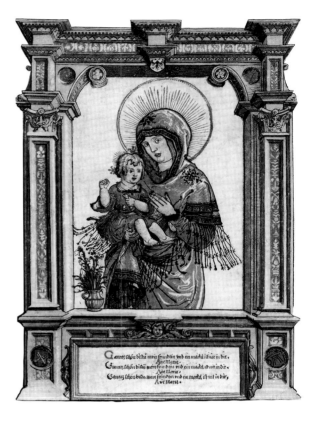

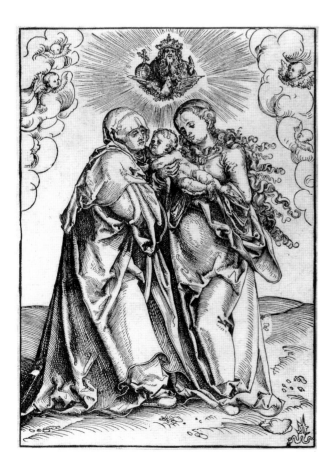

53
Albrecht Altdorfer

The Beautiful Virgin of Regensburg
Woodcut printed from six blocks in red, green, blue,
light orange, brown, and black, c. 1519/1520
339 x 246 (13³/₈ x 9¹¹/₁₆)
Winzinger 89 I
Rosenwald Collection 1962.5.1

The Virgin in this woodcut is one of a number of images
devoted to the "Beautiful Virgin" (*Schöne Maria*) of
Regensburg. She is identified by the garment she wears: a
hood with star and decorative border, and sleeves with bor-
ders and fringe. The type was based on a thirteenth-century
Italo-Byzantine icon in the church at Regensburg, and the
print itself derives from a painting by Altdorfer that once
graced the same church.[1]

Devotions to the Beautiful Virgin gave rise to a fervent
cult. The emotional behavior of its adherents was recorded in
a print by Michael Ostendorfer (fig. 53a). Throngs of pilgrims
are lined up to enter the church; the icon can be seen through

fig. 53a. Michael Ostendorfer, *Pilgrimage to the Church of the Beautiful Virgin in Regensburg*, c. 1520, woodcut, 580 x 391 (22⁷/₈ x 15³/₈), Kupferstichkabinett of the Kunstsammlungen der Veste Coburg.

1. New Haven 1969, 47–48. For an illustration of the painting and information on it, see Winzinger 1975, 93–94 and pl. 41.

2. Detroit 1983, 323–325, points out that this was a financial bonanza to church and town.

3. Detroit 1983, 325. Despite the fact that his native town, Nuremberg, became Protestant and that he himself supported Luther, Dürer remained devoted to the Virgin and continued to represent her in his later prints; see, for example, cat. 51.

4. The translation is from New Haven 1969, 48, where the similarity to the Song of Solomon 4:7 is mentioned. On the influence of this text, see, for example, Warner 1976, 121–133.

the doorway. On the bell tower is a banner with another image of the *Schöne Maria* painted by Altdorfer, and in the right foreground, pilgrims are shown in ecstatic fits around a sculpture of the Virgin and Child. Huge numbers of pilgrims flocked to Regensburg. In 1520, on two different days, 27,000 and 50,000 persons were recorded.[2]

It was this kind of image worship that became a focal point for Protestant reformers and led many to hold an iconoclastic attitude toward religious images. Dürer owned an impression of Ostendorfer's print and wrote the following inscription on it: "This spectre has arisen against the Holy Scripture in Regensburg and is permitted by the bishop because it is useful for now. God help us that we do not dishonor the worthy mother of Christ in this way but [honor] her in his name, Amen."[3]

This is the only woodcut that Altdorfer printed in color. The inscription below the image, repeated three times, reads in translation: "Of perfect beauty are you, my love, and there is no blemish in you. Ave Maria." The phrase derives from the Song of Solomon, an important source for medieval interpretations of the Virgin and her role in Christianity.[4]

54
Anonymous German, fifteenth century, Basel School

The Lamentation
Traveling altar with a woodcut printed on parchment in black and hand-colored in blue, green, brown, tan, orange, and red; set between two panels of printed text to form a triptych; housed in a slipcase with an embroidered Crucifixion scene on the front and backed in leather; in turn housed in a velvet, silk, and linen box, strengthened with layers of parchment from an account book, with ornamental tassels at each corner, c. 1490
127 x 127 (5 x 5) (woodcut)
[Schreiber IX.506aa]
Rosenwald Collection 1959.16.15

This woodcut, together with its container, is one of the great treasures of the Rosenwald Collection and, indeed, an object of greatest rarity among extant fifteenth-century prints. A traveling altarpiece, it has been thoroughly described by Richard Field, following research by Edmund Schilling.[1] The central scene, the *Lamentation,* showing the Virgin with the crucified Christ, Saint John, and the Magdalene, is flanked by texts printed on the same piece of parchment, to form a triptych. The woodcut fitted into a slipcase embroidered with the Crucifixion, and this in turn fitted into a velvet box. From a letter that survived the centuries in the cover of the box, we know that this devotional object belonged to Apollonia von Freyberg, a nun in the Convent of Saint Clara in Mülhausen (Alsace, near Basel). Apollonia is likely to have done the embroidery work and decorated the box. Adding to the remarkable documentation is the small helmet at the lower right of the image. This is the printer's mark of Lienhart Ysenhut, active in Basel.

The image itself, with the column and switches of Christ's Flagellation, the crown of thorns, the spear and sponge of the Crucifixion, and, of course, the cross itself, is an *Andachtsbild,* an image for meditation and devotion, rather than a narrative event. The manner in which Christ's body is presented, poignantly angular and lying across the Virgin's lap, is related to the stream of images of the Pietà in German late medieval sculpture.[2]

1. Washington 1965, no. 78.
2. See the classic article by Erwin Panofsky, "Imago Pietatis," *Festschrift für Max J. Friedländer zum 60. Geburtstage* (Leipzig, 1927). Field pointed out that the immediate source for this image is an engraving by the Master E. S.; see the reproduction in Philadelphia 1967, no. 18.

55
Martin Schongauer

Christ Appearing to Mary Magdalene (Noli me tangere)
Engraving, c. 1480/1490
160 x 158 (6⁵/₁₆ x 6³/₁₆)
Lehrs 15
Rosenwald Collection 1961.17.65

Mary Magdalene, who became one of the most popular of medieval saints, is associated with or thought to come from Magdala on the Sea of Galilee. She is specifically mentioned several times in the Gospels, beginning with Luke 8:1–2, where Christ is said to have healed her of seven demons. She was present at the Crucifixion and, with two other women, went to Christ's tomb and found it empty. In both Mark 16:9 and John 20:11–18, it is written that she was the first person to whom Christ appeared after his Resurrection, the scene that Schongauer has depicted in this print. John writes that at the tomb, she mistook Christ for a gardener and asked him where her Lord's body had been taken.

> He then said: ''Mary.'' She turned and said to him in Hebrew, ''Rab-bo'ni!'' (which means Teacher). Jesus said to her, ''Do not hold me, for I have not yet ascended to the Father; but go to my brethren and say to them, I am ascending to my Father, to my God and your God.'' Mary Magdalene went and said to the disciples,

''I have seen the Lord''; and she told them that he had said these things to her.

At the same time, other unidentified women in the Gospels were conflated with the Magdalene, including especially the woman of Luke 7:36–50, who bathed Christ's feet with her tears when he came to dine at the house of a Pharisee, dried his feet with her hair, and was forgiven her sins.[1] A number of such stories about her are told in *The Golden Legend* as well as numerous other writings, and many legendary scenes were depicted by artists.[2] She was thought to have been born to rich parents and consequently was often shown in the visual arts wearing resplendent garments. Said to have been very beautiful, she was described as having thoroughly indulged herself in sexual pleasures before repenting.

In the present work, Schongauer has emphasized the moment when the Magdalene recognizes Christ and reaches toward him. Her hand and his overlap on the vertical axis formed by their gestures, her ointment jar, and the barren tree above, but their hands are, of course, spatially and expressively, even poignantly, separated.

1. Malvern 1975 traces the fortunes of the Magdalene from the Gospels to the twentieth century, illustrates a number of visual works depicting her, and provides a useful bibliography. On the confusing mentions of various Marys in the Gospels, see, for example, Warner 1976, 344–345.
2. See particularly Jacobus de Voragine 1969, 355–364.

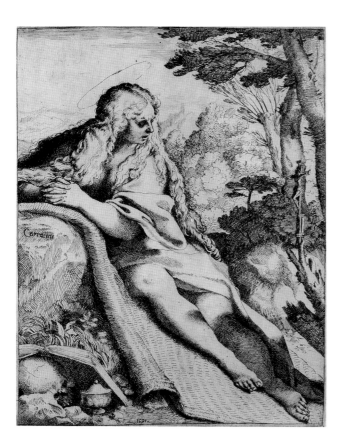

56
Annibale Carracci

Mary Magdalene in the Wilderness
Etching and engraving, dated 1591
223 x 169 (8¾ x 6¹¹/₁₆)
Bohlin 12 I/4
Ailsa Mellon Bruce Fund 1972.65.17

Legends grew up about the Magdalene's activities after the Ascension of Christ, richly relating tales of her supposed later life. According to *The Golden Legend,* for example, she, like Christ's apostles and other disciples, "went out into the divers regions of the earth to sow the word of God."[1] She preached, performed miracles, and converted people to Christianity. Later, wishing to devote herself to contemplation, she "retired to a mountain cave which the hands of angels had made ready for her, and there she dwelt for thirty years, unknown to anyone."[2] Hence, as in this print, she was sometimes depicted as a penitent saint in the wilderness.

Diane DeGrazia Bohlin has suggested that Annibale's etching, *Saint Jerome in the Wilderness,* might have formed a pendant to the present work. At the same time, she notes that a painting of the penitent Magdalene (collection of Sir Denis Mahon, London), where the figure is also shown facing right, presumably predates the print. There is also a preparatory drawing for the print, with the figure reversed (Louvre, Paris).[3] The ointment jar at the lower left, from which the Magdalene was said to have anointed Christ's body "with sweet spices after His death,"[4] became her attribute.

1. Jacobus de Voragine 1969, 357.
2. Jacobus de Voragine 1969, 360.
3. See Bohlin 1979, 440–443, and figs. 12a, 12b.
4. Jacobus de Voragine 1969, 356.

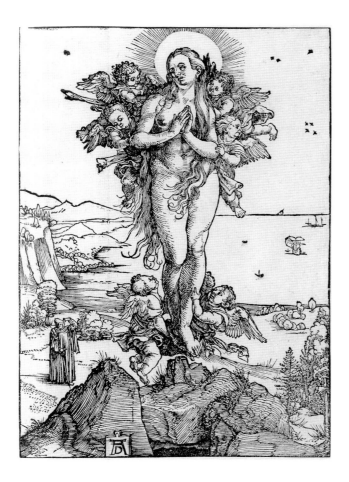

The Magdalene dies, her soul goes to heaven, and her body is buried "with great pomp" by the bishop.[1] The Magdalene's story in *The Golden Legend* concludes with the relation of various miracles she performed for those who prayed for her help after her death.

Mary Magdalene, having been a prostitute, was the quintessential "fallen woman."[2] Her "elevation" therefore both literally and metaphorically conveys her redemption from sin. Dürer's depiction of her here as a nude figure whose long hair discreetly covers her genitalia is no doubt ultimately derived from the story of another saint, Mary of Egypt, with whom the Magdalene became partially conflated during the middle ages. Mary of Egypt, an Alexandrian prostitute, was said to have lived for forty-seven years in the wilderness as a penitent; with her clothes rotted away, her long hair covered her. Like the Magdalene, she received communion from a bishop, promptly died, and was buried by him.[3]

Unlike the three essentially decorous depictions of the Magdalene shown here (cats. 55–57), other images during the Renaissance period often showed her as physically alluring, whether clothed or not (see, for example, Titian's half-length nude Magdalene, a painting in the Palazzo Pitti, Florence). Hence her repentance and chastity were contradicted, much as was the chastity of a heroine like Lucretia.[4]

1. Jacobus de Voragine 1969, 360–362.
2. For depictions of fallen women in nineteenth-century art, see Linda Nochlin, "Lost and *Found*: Once More the Fallen Woman," in Broude and Garrard 1982, 220–245. Her discussion is focused on Dante Gabriel Rossetti's painting, *Found*.
3. On Mary of Egypt, see Jacobus de Voragine 1969, 228–230, and Réau 1955–1959, vol. 3, pt. 2, pp. 884–888. For another well-known depiction of the Elevation of the Magdalene, with elements from the story of the Egyptian, see Tilman Riemenschneider's high altar for Münnerstadt, 1490–1492 (now in the Bayerischen Nationalmuseum, Munich). Two reliefs for the altar depict the Magdalene receiving communion and being buried.
4. On ambivalent treatments of Lucretia, see the first section of the catalogue.

57
Albrecht Dürer

The Elevation of Saint Mary Magdalene
Woodcut, c. 1504/1505
216 x 147 (8½ x 5⅝)
Meder/Hollstein 237
Rosenwald Collection 1943.3.3598

Having become a hermit in the wilderness (see cat. 56), the Magdalene was said to have been bodily borne aloft seven times every day at the canonical hours. The chant of the heavenly hosts sustained her, and she needed no earthly food. In Dürer's print, as she is carried upward, she is observed by a priest, to whom, as the story goes, she reveals her identity. She then sends the priest to tell the bishop Maximinus that on the day of the Resurrection he should go to his oratory, where he will find her with angels. Maximinus does so, and he, the priest, and other clergy administer holy communion.

58
Anonymous German, fifteenth century, or Master with the Mountain-Like Clouds

The Virgin Enthroned with Eighteen Holy Women
Metalcut, hand-colored in green, yellow, and red,
c. 1480/1490
325 x 252 (12¹³/₁₆ x 9¹⁵/₁₆)
Schreiber 2519m
Rosenwald Collection 1943.3.704

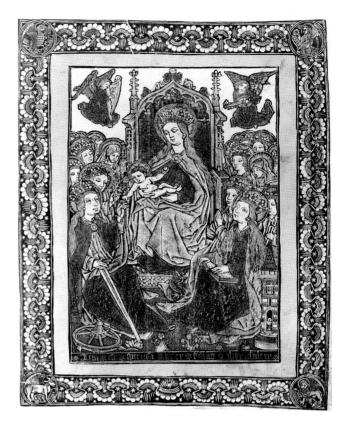

In this large and imposing metalcut, the crowned Virgin and
Child sit enthroned and surrounded by female saints. The
two most prominent saints, placed at the left and right of the
Virgin, are Catherine of Alexandria, identified by her attri-
butes of the wheel and sword, and Barbara, identified by the
tower (see cat. 61). Field has pointed out that a few others
may be identified: behind Catherine is perhaps Saint Doro-
thy, holding a flower, and behind Barbara, Saint Apollonia
with her tongs. The inscription below the figures reads: "She
is beautiful among the daughters of Jerusalem."[1]

The attributes of saints were, of course, related to some
part of their stories, and not infrequently to their torments or
deaths. In the story of Catherine, one long version of which is
in *The Golden Legend*, the emperor ordered that she be placed

fig. 58a. Carlo Maratti, *The Mystic Marriage of
Saint Catherine*, etching, 180 x 134 (7¹/₁₆ x 5¹/₄), Na-
tional Gallery of Art, Washington, Ailsa Mellon
Bruce Fund 1985.54.2 (Bartsch 10).

between four wheels "studded with iron saws and sharp
nails," two of which were to move in one direction and the
other two in the opposite direction, "so that grinding and
drawing her at once, they might crush and devour her."[2] But
Catherine prayed to God, and an angel broke the wheels
apart. Eventually, the emperor had her beheaded. "And
when her head was cut off, milk gushed forth from her body
instead of blood. Angels then bore her body from that place
to Mount Sinai, a journey of more than twenty days, and
there gave it honourable burial."[3]

Both Catherine and Barbara were thought to be virgin
saints of the first century. Virginity was considered to be the
highest expression of chastity, and chastity was, for Chris-
tians, a prime virtue, and, in fact, the most desirable state in
which to live. Donald Weinstein and Rudolph Bell have
pointed out that most saints were thought to have preserved
their virginity and that, indeed, in the stories of many saints,
"lust, virginity, and chastity were central issues."[4] The most
perfect of the saints was the Virgin Mary, who before and af-
ter the birth of Christ remained a virgin, as the Council of
Trent in the sixteenth century was to reaffirm.[5]

The ring that Catherine holds up with her left hand is the ring of her mystical marriage to Christ, itself a subject represented innumerable times in the visual arts of this period (fig. 58a).

1. Washington 1965, cat. 346. Field says that the phrase may be adapted from the apocryphal book of Judith 15:10, and that it is also found in the Second Vespers for Holy Women. On the technique of metalcuts, a medium primarily in use in the second half of the fifteenth century, see Washington 1965, the discussion preceding cat. 296.
2. Jacobus de Voragine 1969, 713.
3. Jacobus de Voragine 1969, 714–715. Gory and sadomasochistic accounts of the torture and martyrdom of female and male saints on the part of hagiographers are fairly common, and visual representations of such scenes were newly emphasized in the era following the Protestant Reformation and Catholic Reform.
4. Weinstein and Bell 1982, 74.
5. For a very brief résumé of what was and remains a rather vexing issue for the Roman Church, see Warner 1976, 34–49.

59
Martin Schongauer

Saint Catherine of Alexandria
Engraving, c. 1480/1490
99 x 55 (3¹⁵/₁₆ x 2¹/₈)
Lehrs 69
Rosenwald Collection 1943.3.69

Shestack has suggested that this small engraving and another, *Saint Barbara* (cat. 61), similar in size and style, were probably intended to be part of a series of saints that Schongauer never completed.[1] In any case, these prints must reflect a demand for such images at the same time that printmaking in the fifteenth century further encouraged the growth of the cult of saints by making it possible for many people to own comparatively inexpensive representations of saints to whom they were especially devoted. Certainly the first century of printmaking saw a remarkable number of depictions of both male and female saints, those who were legendary, as in the present case, and those who were historically well documented.

Catherine is shown here with the attributes of her torture and martyrdom, the wheel and the sword (see cat. 58), and with a book, symbolic of her learning. In many respects, she is a typical saint of the early Church, when most saints were martyred for adhering to the Christian faith.[2] Through the period of the middle ages, as Weinstein and Bell have pointed out, the majority of saints came from the upper classes, and Catherine was said to be the daughter of a king.[3] Female martyrs, moreover, were extolled by such early Christian thinkers as John Chrysostom and Jerome, who otherwise are noted for a virulent misogyny. As Elizabeth Clark has emphasized, however, these male authors saw female martyrs and, a little later, female ascetics as having overcome the negative qualities of women (vanity, frivolity, lack of intelligence). "As Jerome phrased it, once a woman prefers Jesus Christ to a husband and babies, 'she will cease to be a woman and will be called a man.'"[4] Chrysostom called female martyrs "virile" and full of "manly spirit."[5]

Catherine also shares the characteristics of female ascetics in terms of her learning (she is the patron saint of philosophers, among other specialities). According to *The Golden Legend,* she disputed with fifty learned orators who had been brought together by the emperor in order to confound her, "refuting them with the clearest reasonings."[6] The orators then announced that they were converted to a belief in Christ, and the emperor had them martyred. While the Church Fathers usually condemned women to silence in public, Jerome, for example, had a circle of scholarly female friends and called one of them "the foremost student of the Scripture in Rome"

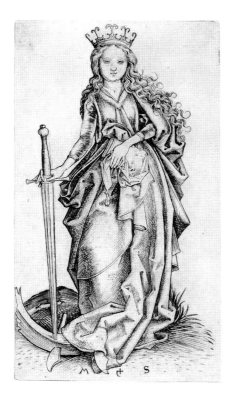

9. The original Doctors of the Church were: in the West, Ambrose, Augustine, Jerome, and Gregory the Great; and in the East, John Chrysostom, Basil the Great, Gregory of Nazianus, and Athanasius. The first addition to this list came in 1568 (Thomas Aquinas). Pope Paul VI so designated Catherine of Siena (1347–1380) and Teresa of Avila (1515–1582) in the autumn of 1970. See the *New Catholic Encyclopedia*, 4:938–939.

after he had himself left the city; some of these women engaged in public debate.[7]

Yet the Roman Church continued to be markedly patriarchal in its development, and during the Catholic Reform, even the numbers of female saints greatly diminished.[8] Today women continue to be banned from the priesthood, and it was only in 1970 that any woman was proclaimed by the pope or an ecumenical council a "Doctor of the Church," a title conferred on a canonized saint of "great sanctity and eminent learning."[9]

1. Washington 1967, cat. 85.
2. "In the early church saintliness was synonymous with martyrdom; saints were those who gave their lives in witness to the true faith of Christ. The church perpetuated that recognition in the liturgy of the mass, while Pope Urban VIII's decrees formalized martyrdom as a distinct type requiring no additional proofs of sanctity." Weinstein and Bell 1982, 160.
3. See Weinstein and Bell 1982, 194–219, on "class."
4. Clark 1986, 43.
5. Clark 1986, 44.
6. Jacobus de Voragine 1969, 711.
7. Clark 1986, 47.
8. Weinstein and Bell 1982, 225–227.

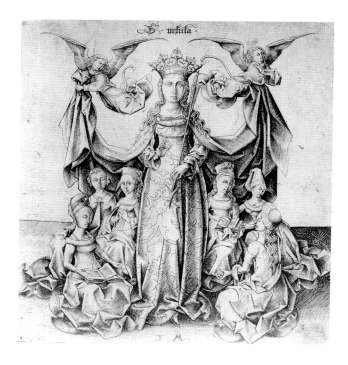

Ursula was the last to survive the attack, was offered marriage by the leader of the Huns, refused, and was killed by him with an arrow through her heart. The arrow became her attribute, and she is shown with it in Meckenem's engraving. Like a Madonna of Mercy, she is also shown here shielding other virgins beneath her mantle, which is held up at the corners by angels.[2]

Ursula's cult was especially venerated in Cologne, where her presumed relics were found in 1155. She, like a number of other early saints, was especially popular in the fifteenth century, but the Order of Saint Ursula was founded in 1535 in Brescia by Saint Angela Meriei and dedicated to the care of the sick and needy as well as the education of girls.[3]

Meckenem, from the east Netherlandish town of Bocholt, was the most prolific printmaker of the fifteenth century. Over 620 works have been attributed to him.[4]

1. See Jacobus de Voragine 1969, 627–631.
2. Ursula is also shown standing, holding an arrow, and shielding her followers in Hans Memling's reliquary *Shrine of Saint Ursula* in the Saint John's Hospital, Bruges, which was installed in 1489. In addition to narrative scenes of her life on the sides of the object, one end shows Ursula as described and the other shows the standing Virgin holding the Child with the two female donors of the work kneeling on either side of her. For reproductions of this important work, see, for example, Max J. Friedländer, *Early Netherlandish Painting*, vol. 6, *Hans Memlinc and Gerard David* (New York and Washington, 1971), pt. 1, plates 68–77.
3. See *New Catholic Encyclopedia*, 14:491–495, on the Order and its spread to the present day.
4. See Washington 1967, essay preceding cat. 154, on Meckenem's life and activities; and cat. 182, for this print.

60
Israhel van Meckenem

Saint Ursula and Her Maidens
Engraving, c. 1475/1480
158 x 148 (6³/₁₆ x 5¹³/₁₆)
Lehrs 412 4/4
Rosenwald Collections 1943.3.150

Ursula is another virgin martyr of the early Christian Church. She may have lived in the fourth century, but the origins of her legend are unknown, and the story of her life is highly conflated. One source is Geoffrey of Monmouth's *Historia Regum Britanniae* (first appeared c. 1139), but the account in *The Golden Legend* is probably the one most used by visual artists.[1]

Like many other female saints and martyrs, Ursula was said to be from the aristocratic class, in this case the daughter of a Christian king of Britain, and, again following convention, she was said to have been very beautiful. The most signal part of her story begins when, having arrived in Cologne with eleven thousand virgins that she had converted, she was directed by an angel to go to Rome on a pilgrimage. Returning from Rome with the virgins, accompanied by various male ecclesiastical followers and her own betrothed, she and the group were attacked by Huns in Cologne and massacred.

61
Martin Schongauer

Saint Barbara
Engraving, c. 1480/1490
100 x 61 (3¹⁵/₁₆ x 2³/₈)
Lehrs 68
Rosenwald Collection 1943.3.68

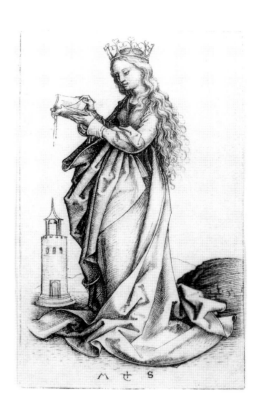

This small engraving may have been one of a projected but
never completed series of saints (see cat. 59). Barbara was a vir-
gin saint and martyr who was regarded as the patron of those
exposed to sudden death. Her legend may be of Egyptian
origin and first became popular in the seventh century. Sup-
posedly, her wealthy pagan father, Dioscorus, kept her locked
in a tower to preserve her purity, but she arranged to be vis-
ited by a Christian disciple who converted her to the faith and
baptized her. Discovering this, her father had her condemned
to death by a local official and then beheaded her himself, af-
ter which he was suddenly consumed by fire. Her popularity
was at its height in the fifteenth century, when there were nu-
merous depictions of her in the visual arts; she is almost al-
ways identified by the tower as her attribute.[1]

1. See Washington 1967, cat. 86; Réau vol. 3, pt. 1, pp. 169–177; and
the *New Catholic Encyclopedia*, 2:86–87.

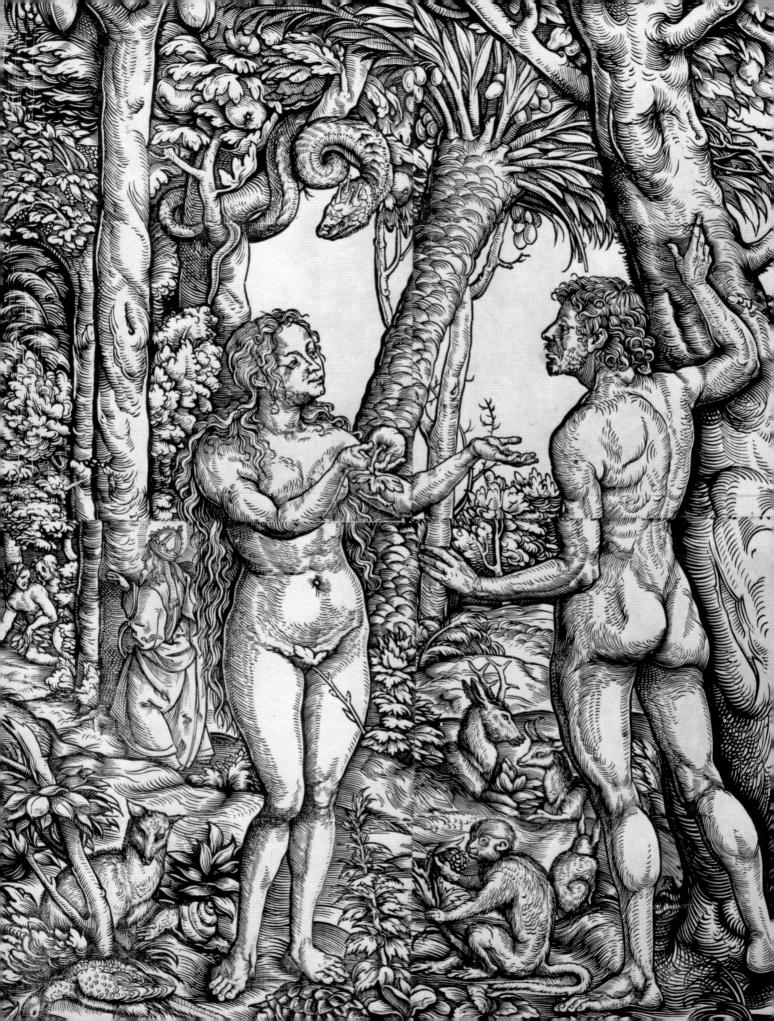

III
EVE

Who tempted whom in the Garden of Eden, and what was the nature of that temptation? These are questions that have reverberated for centuries. Was the sin for which God expelled Adam and Eve from Paradise sexual, or was it something else? The Fall of Man has been depicted countless times in Christian art, of course, and we may note that it was an especially favorite subject in the early centuries of printmaking, to which the prints exhibited here attest (cats. 62–72).[1] In Dürer's famous engraving (cat. 63), Adam and Eve still occupy the Garden, although, as often noted in the scholarly literature, there is a foreshadowing of the Fall in the tenseness of both humans and animals. In Baldung Grien's prints, Adam and Eve respond to each other with evident sexual awareness (cats. 71–72), and Eve is given the distinct role of seductress.

The early Church Fathers were much concerned with the text in Genesis that relates the story of Adam and Eve. They argued among themselves as to its meanings, but it was Augustine's readings of Genesis that prevailed in the Roman Church. These were that Adam and Eve's sin was a sin of the *will* in disobeying God's commandment not to eat of the Tree of the Knowledge of Good and Evil.[2] For Augustine, that sin then gave rise to various consequences, the most critical being the inability of humans to control sexual desire, the necessity of man to labor and woman to suffer the pains of childbirth and to be subject to her husband's rule; and finally, and most dire, death itself. According to Augustine, moreover, because of Adam and Eve, every human born afterward was born with that Original Sin.[3] These are indeed heavy burdens to be carried by the descendants of the first man and the first woman.

Augustine assumed that man and woman did have sexual relations before the Fall, but he considered those relations to be under the control of reason in Eden. A view contrary to this tradition of thought surfaced in the early sixteenth century, formulated by Heinrich Cornelis Agrippa, a German writer, soldier, and physician. His views are expressed in his *De originali peccato,* known as early as 1518 and published in Antwerp in 1529 and in Cologne in 1532. In it, he suggests that sexual intercourse itself was the cause of the Fall and that the serpent, the third participant in the Paradise drama, more than simply gaining control of the male sex organ *was* the sex organ.[4] The serpent had usually been associated with the Devil. Eve was tempted, in short, by male sexuality, and she

fig. 1. Hans Sebald Beham, *Adam and Eve*, 1543, engraving, 82 x 56(3¼ x 2¼), The Harvard University Art Museums, Cambridge, Gift of Mrs. Frederic T. Lewis in memory of Dr. Frederic T. Lewis (Pauli 1911a, no. 7).

then persuaded Adam "to exercise this sexuality as the *officim* of the Serpent."[5] A. Kent Hieatt sees this expressed, above all, in Hans Baldung's painting, *Adam, Eve, and the Serpent,* now in the National Gallery of Canada, Ottawa (fig. 70a).

Whether or not one finds Agrippa's treatise of likely importance for Baldung and other artists, many of the visual images of Adam and Eve produced during the earlier sixteenth century do indeed emphasize lustful attitudes on the part of both. Others especially stress Eve's seductiveness in persuading Adam to eat the fruit. This is to say, that with or without a text on the subject, the images focus on sexuality either as a cause or as a result of the Fall. In a very real sense, cause and result are simply collapsed into each other in the images of the time. Eve, moreover, is the one who almost always proffers the forbidden fruit, and her role as perhaps the quintessential *femme fatale* comes to the fore. Adam, who was always the

one thought to have the faculty of superior reason, however that was defined by theologians, is sometimes shown almost as an innocent victim (cat. 66).

That the outcome of the Fall is death is particularly clearly expressed in an engraving by Hans Sebald Beham (fig. 1). The serpent twists around a tree that is in fact a skeletal figure of death. Lust in particular but also sexuality in general have come to be thought of as intrinsically and inextricably connected with death.

1. Many images of Adam, Eve, and the Fall, as well as other events in the lives of the first humans are illustrated in Frye 1978; and Phillips 1984.
2. On Augustine's views, see especially Brown 1988, 387–427; and Pagels 1988, 98–150. Both scholars also discuss the views of many other important early Christian thinkers, including Jerome.
3. See Pagels 1988, especially 109.
4. See Hieatt 1980, especially 223.
5. Hieatt 1980, 223.

62
Jean Duvet

The Marriage of Adam and Eve
Engraving, 1540/1555?
301 x 214 (11¹³/₁₆ x 8⁷/₁₆) (lunette)
Eisler 35 2/2
Rosenwald Collection 1954.12.245

While visual representations of Adam and Eve marrying are known from the eleventh through the sixteenth centuries, the subject is, nevertheless, a rare one. Louis Réau has stressed that it is to be understood as meaning the institution of marriage as a sacrament and, in addition, as the prefiguration of the union of Christ and the Church.[1] The latter meaning is clearly evident in illustrations in a French thirteenth-century *Bible moralisée,* where the marriage of Adam and Eve is placed directly above the marriage of the heavenly Sponsus and Sponsa (see fig. 62a). As in the miniature painting, Duvet's engraving shows the figure of God the Father joining the hands of Adam and Eve,[2] and in the print, as in some other examples, these three figures are surrounded by the heavenly host.

Duvet's inscription on the print reads: "The marriage of Adam and Eve and their blessing from God and other mysteries here contained are taken for the most part from the first chapter of Genesis."[3] Colin Eisler has noted that this is a paraphrase of Genesis 1:28, where God blesses the couple and tells them "Be fruitful and multiply."[4] In terms of the institution of marriage, it is also related to Genesis 2:24. God has created Eve from Adam's rib and brought her to him, and Adam has called her "flesh of my flesh." "Therefore a man leaves his father and his mother and cleaves to his wife, and they become one flesh." Genesis 2:25 concludes the chapter thus: "And the man and his wife were both naked, and were not ashamed." Verses 24–25 are interpreted in the New Oxford Annotated Bible (1977) as meaning that Adam and Eve had a sexual relationship prior to the *Fall,* that it was not evil but rather a God-given impulse, and that their relationship to each other and to God was guiltless. These issues, of course, have been among the most debated across centuries of Christian thought.

Eisler has suggested that Duvet's image is in essence a *re-marriage* of Adam and Eve, pointing out that the "major participants and heavenly witnesses carry branches or banners of the cross, symbolizing the victory of Christ and the resulting state of peace and grace."[5] The arched format of the print relates it to the tablets of Moses, which Duvet used in his famous *Apocalypse* series, first published in 1561, and sometimes in doubled tablet form as a device to contain his signature.

fig. 62a. *The Marriage of Adam and Eve*, and *The Marriage of Sponsus and Sponsa*, Bodleian Library, Oxford, ms. Bodl. 2706, fol. 6.

Eisler thinks that Duvet regarded the tablets "as signs of the word from God, to be communicated by reproduction."[6]

Caught in the religious conflicts of the Reformation and Counter-Reformation era, Duvet worked almost alternately in France and Geneva, and each environment was turbulent. He was a Calvinist, but like some other French Protestant artists, he worked also for Catholics in order to make a living. It may be significant in regard to the present image that the Reformers, including Luther, Bucer, and Calvin, all strongly and vociferously extolled marriage as a desirable estate for clergy and lay people, and sometimes made specific reference to the union of Adam and Eve.[7]

Duvet's serene and idealized Adam and Eve are closely related to Dürer's famous engraving of the two (see cat. 63). In Duvet's print, they stand out against a background so detailed and spatially compressed as to suggest a kind of *horror vacuui* on the artist's part. This is also characteristic of his *Apocalypse* series. Despite Eisler's excellent monograph on the artist, Duvet and his visually eccentric and iconographically complex works retain enigmatic qualities.

1. Réau 1955–1959, vol. 2, pt. 1, pp. 81–82, with examples of visual works.
2. In both miniature paintings and in Duvet's print, the traditional *dextrarum iunctio,* supposedly essential to a sacramental marriage, is shown as a left-handed *iunctio*. That the left-handed gesture was perfectly acceptable according to secular law and in church marriages is proved by Bedaux 1986, especially 8–10.
3. The translation is in Eisler 1979, 238 n. 1.
4. Eisler 1979, 238 n. 1.
5. Eisler 1979, 238.
6. Eisler 1979, 75, but also 74–75, for a longer discussion of the meaning of tablets for Duvet.
7. See especially Chrisman 1972, 147–150 and n. 18; and Roelker 1972, 190–192.

63
Albrecht Dürer

Adam and Eve
Engraving, dated 1504
249 x 193 (9¹³/₁₆ x 7⁹/₁₆)
Meder/Hollstein 1 4/5
Gift of R. Horace Gallatin 1949.1.18

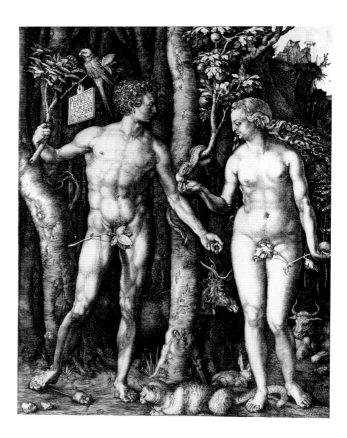

Connoisseurs and scholars have long acclaimed this work for its brilliant engraving technique. It has also been admired as the outcome of Dürer's intense study of ideal proportions for the human figure, greatly stimulated by his direct contact with Italian Renaissance art during an initial trip to Venice in 1494–1495. Two antique sculptures were important prototypes: the *Apollo Belvedere* (Vatican, Rome) for Adam; and the *Medici Venus* (Uffizi, Florence) for Eve. Panofsky suggested that the artist originally intended the two figures to represent mythological beings and to be rendered on separate sheets.[1] In settling on the biblical couple, however, Dürer then drew on a well-known Scholastic doctrine, that of the "Four Humors," represented here by the elk (melancholic), the rabbit (sanguine), the cat (choleric), and the ox (phlegmatic). Before the Fall of Man, these humors or bodily fluids were held in balance in both man and beast, but after the Fall, all became subject to the vices intrinsic to the humors: despair, avarice, pride, wrath, gluttony, sloth, and lechery.[2]

While the image has been seen as portraying the state of equilibrium before the Fall, a certain tension has been noted as well. Adam holds onto a mountain ash, representing the Tree of Life, while he reaches out for the forbidden fruit. Eve takes the fruit from the serpent in a fig tree, the latter representing the Tree of the Knowledge of Good and Evil. This tension has been seen as mirrored in the still quiescent but soon to be antagonistic cat and mouse in the foreground.[3]

Dürer has long been extolled for his openness to the classical ideal, for his rational approach to artistic form and theory, and for his evident desire to intellectualize art and to raise the status of artists in northern Europe. Yet, as has been acknowledged, after completing this engraving, he turned away from Vitruvian proportions for his nudes. Panofsky proposed that he responded to other standards of beauty during a second trip to Venice (1505–1507).[4] Even here, however, in these idealized figures, there are elements that subvert that idealization. Adam and Eve appear frozen, lifeless, and marmoreal, for reasons not depending on their sculptured sources. One feels a deep-seated—it is tempting to say, primordial—distrust of the flesh. This is especially evident in the figure of Eve, above all in her fa-

cial morphology. Her features are neither classically constructed nor distinctly alluring, as in the case of such northern European types as Cranach's or Baldung Grien's (see cats. 76, 70–71). She is surprisingly particularized in the direction of a plain German *hausfrau*, her head being similar to that in his earlier work, *Nemesis* (cat. 139).

The dichotomous elements of the image have been noted by others. Craig Harbison, for example, writes that "while it presents a subtle and discerning picture of the human psyche in harmony, the real conflict between inner and outer man, spirit and flesh, is even more strikingly demonstrated in this engraving."[5] Larry Silver and Susan Smith read it otherwise: as "a type of beauty which is apprehended intellectually" and "radically subordinates the flesh to mentally imposed forms, consistent with Dürer's conception of the originally noble, spiritual nature of man."[6] But they also draw attention to other disquieting elements, including the dark grove of trees behind the figures, which creates an inhospitable setting.[7]

It seems, in short, that the print demands to be read in a more open way than it has been and that, indeed, so do many other of this artist's works.

1. Panofsky 1971, 86.
2. Panofsky 1971, 85; and Princeton 1969, 16–17.
3. Panofsky 1971, 84–85.
4. Panofsky 1971, 264–265.
5. Princeton 1969, 17.
6. Silver and Smith 1978, 246.
7. Silver and Smith 1978, 284 n. 30, drawing in part on observations made by Charles Minott.

64
Lucas van Leyden

The First Prohibition
(from *The Story of Adam and Eve* series)
Engraving, dated 1529
165 x 118 (6¹/₂ x 4⁵/₈)
Hollstein 2 1/3
Rosenwald Collection 1943.3.5668

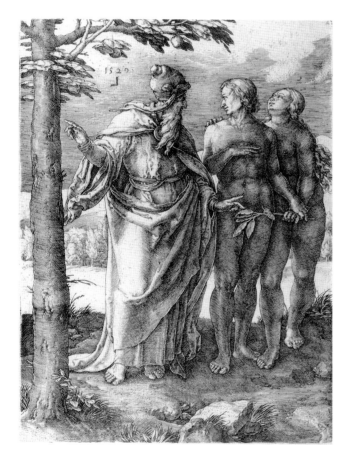

Lucas dealt with episodes from the story of Adam and Eve a number of times during his career, in both the engraving and woodcut media. The earliest print included here, the expelled Adam and Eve (cat. 65), is dated 1510, and the latest is a Temptation (cat. 68) of c. 1530. The present work, dated 1529, is characteristic of his later works in terms of the treatment of the figures. In their proportions and the careful modeling of their forms, the figures display his study and absorption of classical Renaissance canons.

This print is the second of a series of six engravings devoted to the story of Adam and Eve. The series begins with the creation of Eve as she is pulled by God from the sleeping Adam's side. The remaining subjects are: the Expulsion; Adam and Eve after the Expulsion; Cain murdering Abel; and last, Adam and Eve lamenting over Abel's body.

As Silver and Smith have stressed: "The first four subjects provide an expanded account of original sin with emphasis on Eve's leading role."[1] In the creation scene, Eve looks raptly at Adam and reaches toward him, hence implying "that her inclination from the beginning was to turn away from the spiritual."[2] Here, as God gestures toward the Tree of Knowledge, Eve gazes intently at the fruit, while Adam looks over his shoulder at the paradisiacal landscape. The Fall, and Eve's role in it, is alluded to through the hand she places on Adam's shoulder and the leafed branch with which she covers his genitalia. The admonitory gesture of God's left hand further emphasizes the nature of the sin so often connected with the Fall. As Silver and Smith point out, Lucas seems to have been aware of theological views that saw woman and her sensuality as being responsible for the Fall.

1. Silver and Smith 1978, 255.
2. Silver and Smith 1978, 256.

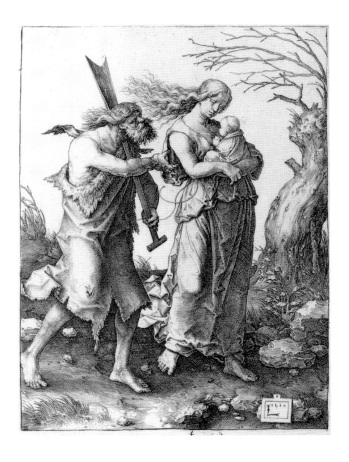

65

Lucas van Leyden

Adam and Eve after Their Expulsion from Paradise
Engraving, dated 1510
187 x 143 (7³/₈ x 5⁵/₈)
Hollstein 11
Rosenwald Collection 1946.11.94

In this early print, as Ellen Jacobowitz and Stephanie Loeb Stepanek have pointed out, Lucas telescoped the narrative from different parts of Genesis.[1] He shows Adam with his spade and Eve with their firstborn, Cain, striding through the barren and rocky countryside to which they have been banished from Eden. As punishment for having disobeyed their Creator, Adam must struggle to make a living from the soil, and Eve is condemned to pain in childbirth and to being ruled by her husband, until their deaths.

The figures are typical of the artist's early figure types: idiosyncratic in anatomy and morphology, indeed quite far removed from the classical canon Lucas later learned and adopted (see cat. 64). In such early works, however, he created strikingly vivid and memorable images that clearly convey their meaning. He was, in short, an excellent storyteller.

It is well known that early and high quality impressions of Lucas' engravings are quite rare. The present impression is perhaps better than average, but certainly not brilliant. Only in the best impressions, of course, can one fully appreciate his expertise in the medium and gauge the pungent power of his images.[2]

1. Washington 1983, 86.
2. See Washington 1983, 87, for a very fine early impression of this work, but also throughout that catalogue for impressions of remarkable quality.

66
Lucas van Leyden

Adam and Eve
(from *The Small Power of Women* series)
Woodcut, 1516/1519
242 x 172 (9¹/₂ x 6³/₄)
Hollstein 2 1/2
Rosenwald Collection 1943.3.5699

Lucas van Leyden created two series of woodcuts devoted to the Power of Women theme. They are distinguished by the sizes of their formats, one being known as *The Large Power of Women* series and the other as *The Small Power of Women*. The theme, which originated in decorative arts of the middle ages, focused on an array of clever and deceitful women, who, through their sexual allurements, duped presumably strong and sometimes heroic men into foolish or disastrous actions. The theme is discussed more fully in the subsequent section

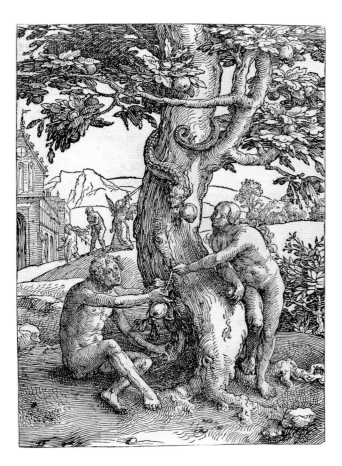

of this catalogue entitled "The Power of Women."[1] Here, we are concerned to point out that Lucas began each of the series with a depiction of Adam and Eve, a unique inclusion in such a pictorial cycle.[2]

Lucas' inclusion of Adam and Eve is in fact readily understandable, for as Silver and Smith have stressed, "The temptations of the flesh which all women represent to all men have the Fall as their cause and prototype."[3] Each of the several times that Lucas created images of the Temptation, he managed to create a fresh composition and to give the actors' actions differing inflections, but it is always clear that Eve is the protagonist in bringing about the Fall.

In the present image, Eve leans against the twisted tree, echoing in her own pose its serpentine trunk and indeed the serpent itself, who is wrapped around the trunk. This visual grouping forms a kind of convex unit that tilts toward Adam and seems, by its pressure, to create the concavity of his torso. Seated on the ground, Adam reaches for the fruit that Eve holds out for him, but apparently he does not see her. His expression is one of a thoroughly dazed person, one who acts but does not think. In this way, Adam seems to mirror a major interpretation by exegetes of Genesis: Eve's successful temptation of her mate represents a triumph of the flesh or passion over the mind or rationality.[4] At the left of the image, in the distance, Adam and Eve are expelled from Paradise by an angel with sword.

The six woodcuts that constitute *The Small Power of Women* series were probably first issued as individual sheets. A second printing, dating about 1520–1530, was produced with elaborate enframements around each image and with tablets at the lower center of the enframements that carried inscriptions in Latin or Dutch.[5] It is generally agreed that Lucas designed some one hundred woodcuts but that, like most painters of the time, he did not actually cut the woodblocks himself. This may explain why none of these prints, including the present one, bears his monogram.[6]

1. See cat. 87 and others that follow. The principal source on the Power of Women topos is Smith 1978.
2. For the Adam and Eve in *The Large Power of Women* series, see Washington 1983, no. 33, and for a discussion of each series, see pp. 102–106, 164–167.
3. Silver and Smith 1978, 253.
4. See Phillips 1984, 61, where he designates Philo as the originator of this influential idea in both Judaism and Christianity. See also Pagels 1988, especially 110–112, on Augustine's discussion of the will and passion.
5. For illustrations, see Washington 1983, figs. 23a–f.
6. Washington 1983, 27.

67
Lucas Cranach the Elder

Adam and Eve
Woodcut, dated 1509
338 x 230 (13¹/₄ x 9¹/₁₆)
Hollstein 1
Rosenwald Collection 1943.3.2884

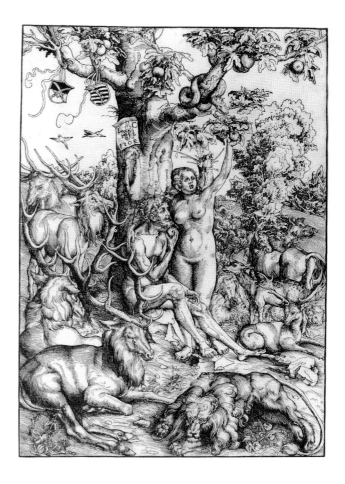

Cranach was to become a master of the seductive female nude (see, for example, fig. 76a). In this early woodcut, however, the impact of Dürer's classically inspired *Adam and Eve* (cat. 63) is apparent, and that print may also account for the many still peacefully co-existing animals who surround the figures. There is, nevertheless, a sensual detail in the juxtaposition of Adam's mouth and Eve's breast. Common to many depictions of the subject, Eve purposefully reaches for the fruit, while Adam passively sits beside her standing figure.

Cranach is typical of certain artists of the time who lived what might be considered a contradictory existence. He was a close friend and supporter of Martin Luther, and he co-founded a publishing firm devoted to Reformation literature. Yet he also carried out a number of commissions from Cardinal Albrecht of Brandenburg, Luther's enemy, and from other prominent Catholics. As court painter to successive dukes of Saxony, moreover, he catered to a sophisticated and worldly taste for depictions of erotic female nudes. On the other hand, the dukes themselves were supporters of Luther.[1]

1. On Cranach and some of his important prints, including three portraits of Luther, see Detroit 1983, 215–237. This excellent book concerns prints, drawings, and books from two collections in Coburg. Through the works of art and interpretive essays, it provides a rich compendium of information and thought on "the age of Luther."

68
Lucas van Leyden

The Fall of Man
Engraving, c. 1530
190 x 247 (7⁷/₁₆ x 9¹¹/₁₆)
Hollstein 10 I/4
Rosenwald Collection 1943.3.5611

Silver and Smith have focused on Lucas van Leyden's late Italianate nudes and their "emphatic physicality," maintaining that "their beauty is quintessentially that of the flesh, not the spirit."[1] The artist, turning once again to the subject of Adam and Eve, boldly places the two seated, monumental, and well-modeled nudes to the left and right sides of the horizontal format and strongly contrasts their poses. Eve's is dynamically frontal and open, her right and left arms stretched out to either side of her body and her legs opened provoca-

tively. Her genitalia are covered by a small, leafy branch, but it is attached to a larger branch that juts forward toward Adam powerfully and suggestively. Adam's pose is more equivocal and conveys his hesitancy to take the forbidden fruit. He leans back, legs pressed discreetly together, but he simultaneously reaches his arm out toward the proffered fruit.

Adam's and Eve's hands nearly meet at the center of the print, a point that becomes supercharged by their gestures. While the background appears to be sunlit and bordered by leafy trees, the foreground, where the two sit, is a shaded area defined by tree trunks with short, bare branches and massive barren rocks. It clearly evokes the harsh physical environment the two had to live in after their expulsion from Eden.[2]

1. Silver and Smith 1978, 250.
2. On Lucas' gift for pictorial narration, see the illuminating article by Peter Parshall, "Lucas van Leyden's Narrative Style," *Nederlands Kunsthistorisch Jaarboek* 29 (1978): 185–237. On this image, see also Washington 1983, 242–243.

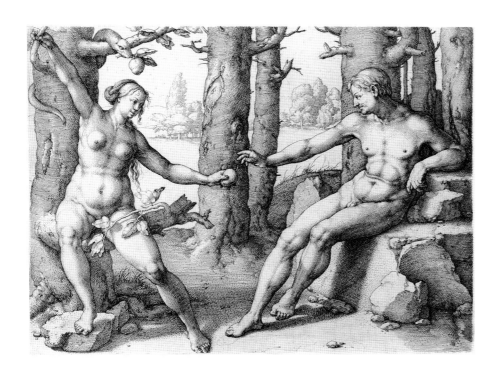

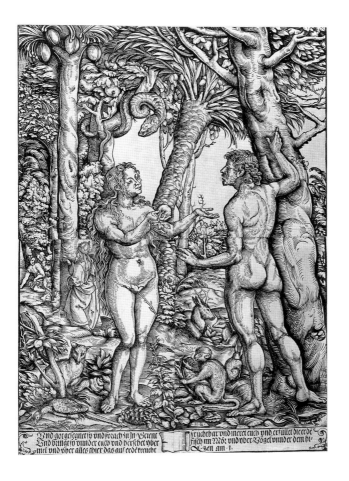

69

After Hans Burgkmair

Adam and Eve
Woodcut
933 x 653 (36³/₄ x 25³/₄)
Hollstein 1 (copy)
Rosenwald Collection 1946.21.203

This very large woodcut was made on several blocks. As can readily be seen, the sheets composing the image were joined together after they were printed from the blocks.

The print is, in fact, a close copy of the equally large, original woodcut by Hans Burgkmair, the most prominent artist in Augsburg in the early sixteenth century. Burgkmair's principal patron was the Emperor Maximilian, for whom he executed many prints as well as paintings. Characteristic of Burgkmair's style are the well-modeled and gracefully posed figures of Adam and Eve; the artist was very responsive to Italian Renaissance forms in art. At the same time, the setting here is highly detailed, the forms of trees and foliage almost ornamentally treated, as they convey the extraordinary lushness of Eden.

In the left background, Adam and Eve attempt to hide their shame from God, who is shown approaching them. The monkey, prominently placed in the foreground, is a well-known symbol of evil.

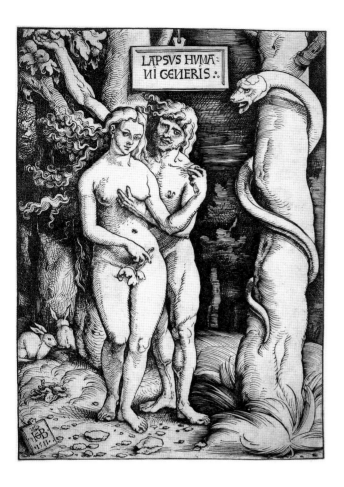

70
Hans Baldung Grien

Adam and Eve
Woodcut, dated 1511
375 x 257 (14³/₄ x 10¹/₈)
Hollstein 3
Rosenwald Collection 1950.17.7

Baldung's images are among the most compelling, disturbing, and often mysterious images of his time. Many involve women, including such holy figures as the Virgin and saints; but perhaps more famous are the depictions of Eve and of witches (see, for example, cat. 105 and fig. 70a). In both prints and paintings that depict Eve, Baldung consistently stressed her sensuality. Having spent time in Dürer's workshop (probably

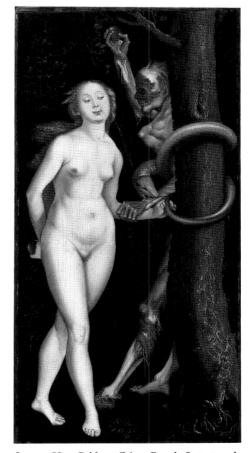

fig. 70a. Hans Baldung Grien, *Eve, the Serpent, and Death*, c. 1510–1515, oil on wood, 64.0 x 32.5 (25¹/₄ x 12³/₄), National Gallery of Canada, Ottawa.

around 1503), Baldung was well acquainted with Dürer's interest in idealized antique and Italian Renaissance art. He, too, could create well-proportioned and solidly modeled figures. But in doing so, he simultaneously subverted the classical ideal to other ends. The body was not to be admired for its abstract and perfect beauty, its "wholesomeness," as it were. Rather, Baldung's figures strike us in their carnal reality.

The Adam and Eve in the present print have often been compared with those in Dürer's famous engraving (cat. 63), whom they both resemble and diverge from in significant ways. As Thomas DaCosta Kaufmann has stressed, in this and in a number of other works, Baldung carried out a "negative transformation of Dürer"; "Dürer's forms are recast in a context where they have become problematic and, finally, terrifying."[1] Baldung's Eve stands in front of Adam, their bodies touching. This may suggest that they will copulate like animals.[2] Eve looks out at the spectator suggestively, as she holds a leaf in front of her genitalia with one hand and the forbidden fruit with the other. Adam, in turn, reaches for fruit from the tree with one hand and with the other fondles her breast—"the well-known breast-fruit metaphor."[3] The forest setting itself is dark and bleak, and the serpent is prominently and energetically twisted around a tree trunk, staring at its prey. The animals present in Dürer's and many other Edenic scenes have been reduced to two rabbits, creatures widely known for their rampant reproduction. Finally, the tablet in the upper center of the print is inscribed "The Fall of Mankind," leading most scholars to write that Baldung reasoned lust as the cause of the Fall.[4]

This work was also printed as a chiaroscuro woodcut. A version with a tan tone block is exhibited here (cat. 71).

1. Kaufmann 1985, 31, 33. This is a highly perceptive study of how Dürer's works were interpreted, and sometimes willfully changed, by younger artists.
2. See Washington 1981, 122, 123 n. 7.
3. Washington 1981, 121.
4. See the discussion in the introductory essay above.

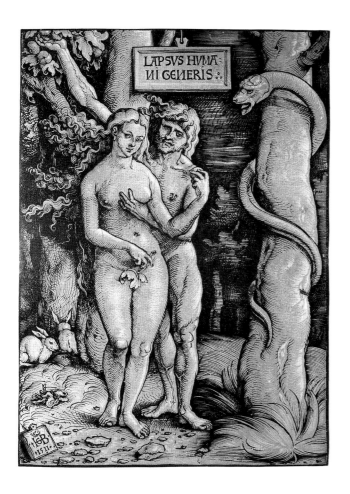

LAPSVS HVMA
NI GENERIS ∴

71
Hans Baldung Grien

Adam and Eve
Chiaroscuro woodcut, dated 1511
377 X 257 (14⁷/₈ x 10¹/₈)
Hollstein 3
Rosenwald Collection 1943.3.907

Baldung's treatment of this subject is discussed in the entry above (cat. 70). That image is printed from the "key block," and the outlines of the forms were inked black, as was the usual custom with woodcuts. The present image shows the addition of a tonal block, in this case inked in a tan color. These color woodcuts are known as *chiaroscuri* (plural, meaning light/dark in Italian), a method invented in the earlier sixteenth century and subsequently quite popular with Italian as well as northern European artists. Several tonal blocks were sometimes used. By contrast, woodcuts with color in the fifteenth century, a few of which are exhibited in the section "The Virgin and Saints," were colored by hand after having been printed.

72
Hans Baldung Grien

Adam and Eve
Woodcut, dated 1519
258 x 101 (10¹/₈ x 3¹⁵/₁₆)
Hollstein 2
Rosenwald Collection 1943.3.925

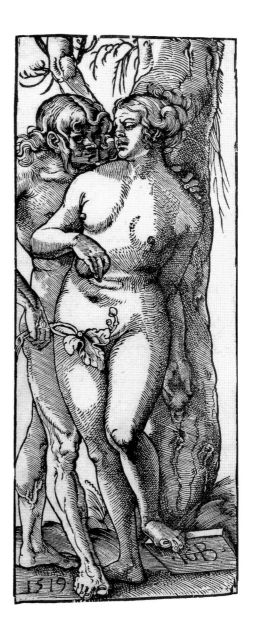

Adam, with a dark and brutish countenance, approaches Eve from behind and leans ominously against her, his right foot aggressively placed in front of her's. Rather than being represented as seductive, this Eve has an expression that conveys distress at Adam's act, and perhaps distaste for it. One scholar has suggested that what is represented here is not the Temptation or Fall but rather the impact of the Fall.[1] The attitudes of the two figures, the narrow format of the print, and the omission of a setting except for the tree, work together to create a highly intense, almost claustrophobic image. The placement of the leafy branch, which Adam holds, and the two buds that turn up from it onto Eve's abdomen, suggest sexual penetration and conception.

It has been pointed out that Baldung was the only male member of his family who was not educated at university. His father, for example, was an attorney, and an uncle was a physician. Having grown up among intellectuals, it was extremely unusual that he chose to become an artist.[2] However one may interpret his background, one must consider it important when evaluating his many works that emphasize not only lust but also demonic forces and certain religious images that convey a pronounced mystical quality.[3]

1. Washington 1981, 243.
2. Washington 1981, 4–5.
3. See, for example, a woodcut of c. 1515–1517, in which the dead Christ is carried feet first by angels to Heaven, where God the Father is surrounded by an enormous aureole of seemingly brilliant light. Washington 1981, cat. 50.

73
Rembrandt van Rijn

Adam and Eve
Etching, dated 1638
160 x 117 (6⁵/₁₆ x 4⁹/₁₆)
White/Boon 28 2/2
Rosenwald Collection 1943.3.7102

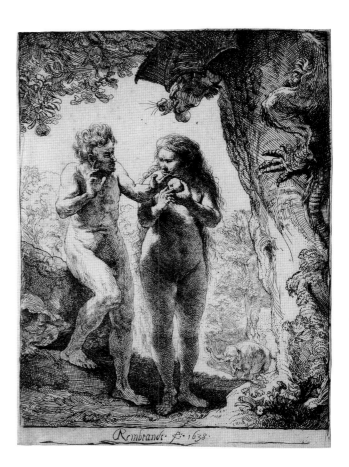

This is one of the most atavistic images of Adam and Eve ever created, the two figures appearing almost simian. The great dragonlike serpent, cast in shadow and clutching the tree trunk with its huge claws, adds a further primeval note. It is perhaps to be contrasted with the trumpeting elephant in the sunlit landscape of the background (based on life drawings Rembrandt had made), one of the "beasts of the field" God created so that man would not be alone (Genesis 2:18–20).[1]

Christopher White has pointed out that Rembrandt changed the way in which Eve holds the apple through two preparatory drawings for the etching. In the earliest sheet, Eve aggressively tempts Adam with the fruit. In the completed etching, "the focus was Adam's guilty participation."[2] Adam stares intently at the apple, stretching out his left hand toward it; but his right hand, fingers splayed, and his bent right leg, suggest a momentary but portentous hesitation.

While a number of Rembrandt's earlier works, as here, show both male and female forms conceived with what White calls "shock realism," the artist could and did create conventionally graceful nudes. An example is his *Danae* painting of 1636 (The State Hermitage Museum, Leningrad).[3]

Old and New Testament subjects remained a continuing part of Rembrandt's oeuvre throughout his career. This constancy and quantity were unusual for an artist of the time in the Calvinist Netherlands. As has been suggested by a number of scholars of his art, Rembrandt was intrigued by and increasingly focused on the complex psychological reactions of participants in biblical stories.

1. The nearly ape-like appearance of Adam and Eve here recalls that apes are sometimes among the animals in depictions of the Fall of Man, where they are generally understood to refer to sexual desire. See, for example, Burgkmair's *Adam and Eve* (cat. 69). For a full discussion of "The Ape and the Fall of Man," see Janson 1952, 107–144, plates 12–19.
2. White 1969, 43, figs. 36–37.
3. White 1969, 177.

74
Cristofano Robetta

Adam and Eve with the Infants Cain and Abel
Engraving
257 X 178 (10⅛ X 7)
Hind 9 1/2
Rosenwald Collection 1946.21.321

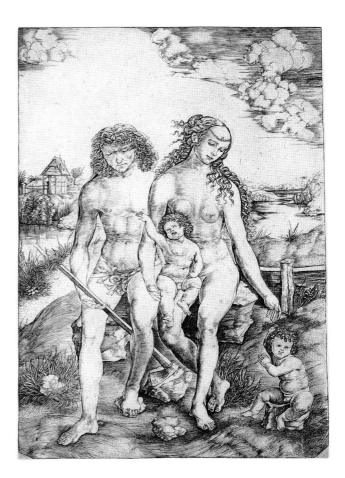

Jay Levenson has defined Robetta as "a *pasticheur,* working from a stock of motifs borrowed from various Italian and northern sources and combining them at will to create his compositions."[1] Most striking here is his use of Dürer's landscape background from a depiction of the Virgin and Child (cat. 50). Levenson has suggested, moreover, that Robetta may have consciously intended that the family of Adam be understood as an Old Testament typological prefiguration of the New Testament's Holy Family (Joseph, the Virgin, the Christ Child, often shown with the young or infant John the Baptist), represented countless times in Christian art.[2]

Robetta's prints are most commonly known in late impressions, such as the one here, which have lost the subtle linear definition and tonal nuances that convincingly model the figures and create a sense of atmosphere in corresponding early impressions.[3]

1. Washington 1973, 290–291.
2. Washington 1973, 304.
3. For a rare early impression of this print, see Washington 1973, fig. 14-2, from the Museum of Fine Arts, Boston.

75
Andrea Andreani, after Domenico Beccafumi

Eve
Chiaroscuro woodcut, dated 1586
460 x 313 (18¹/₈ x 12⁵/₁₆)
Bartsch 1
Andrew W. Mellon Fund 1975.110.1

This scene reproduces, in reverse, one of the segments of the bands of pavement at the right side of the main altar of the Duomo, Siena, which were designed by Domenico Becca-fumi, a leading Sienese painter of the early sixteenth century. If the subject is correctly identified as Eve, the representation is unusual, a figure kneeling in the wilderness most commonly being a penitent saint (see, for example, cat. 56). Nevertheless, the artistic context would seem to support this identification. Other segments represent Old Testament scenes and figures, including prophets, and there are sibyls as well. One marble of a kneeling male figure has been tentatively identified as Adam and corresponds in size to Eve.[1] Finally, the tree in the print and in the segment is almost certainly a fig tree; its leaves and fruit correspond to the fig tree next to Eve in Dürer's influential *Adam and Eve* (cat. 63). Andreani is one of the best-known chiaroscuro printmakers of the period.[2]

1. See Donato Sanminiatelli, *Domenico Beccafumi* (Milan, 1967), 118, 204–205 n. 67, and plates 69–69a.
2. On Andreani, see Ercolano Marani and Chiara Perina, *Mantova: Le Arti* (Mantua, 1965), 3: 679–681. P. Askew called this to my attention. See also Maria Elena Boscarelli, "New Documents on Andrea Andreani," *Print Quarterly* 1, no. 3 (1984): 187–188.

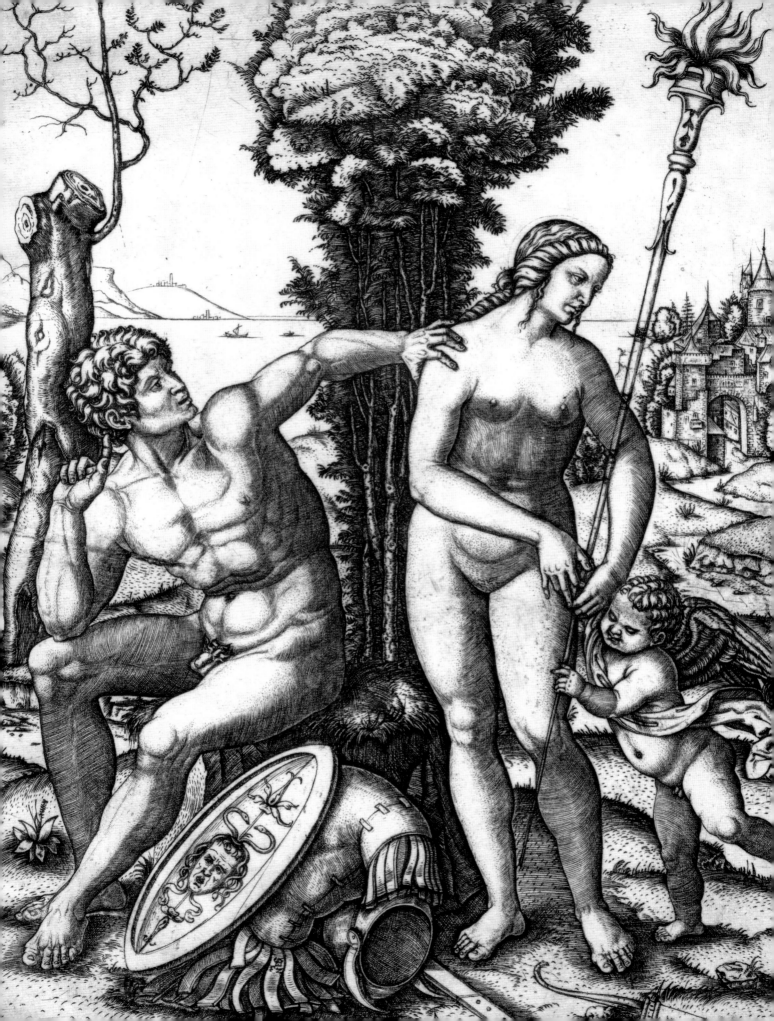

IV
VENUS

With the ancient pagan goddess Venus, we enter a rather different realm in terms of the guises in which woman was represented during the Renaissance and baroque periods. Venus, goddess of love, beauty, and fertility, was frequently depicted in the art of the time, and she tends to embody what is acceptable and desirable in the flesh, as opposed to what is dangerous in the flesh as represented by Eve. She has been perceived as infinitely sensual and arousing. As a figure who symbolizes the pleasures of earthly love and procreation, she touches on matters intrinsic to earthly life. Images of Venus became apodictic symbols for the fertility of married couples. Among the best-known and most striking examples are the figures of Venus depicted on marriage chests (*cassoni*), which were talismanic gifts to brides and grooms.[1]

Excepting Marcantonio's *Judgment of Paris* (cat. 77), the images of Venus exhibited here are all figures that focus on earthly love. They relate most closely to the conflated and web-like tales of mythology that came from antiquity to the Renaissance period. In myth, Venus was renowned for her seductiveness, had many lovers and a number of children, and was the only goddess to have committed adultery, promiscuity being otherwise the preserve of the male gods.[2] She was the wife of Vulcan, god of fire, who discovered her in their marriage bed with Mars, god of war (cats. 82, 84). By Mars, she was said to be the mother of Cupid (or the more powerful Eros) and of Harmony (cat. 81). By the mortal Anchises, she was also the mother of Aeneas, regarded as the founder of Rome. Venus was said to have fallen in love with another mortal, the handsome young Adonis, who eventually left her for the pleasures of the hunt and was killed by a boar (fig. 1). Both Venus with Mars and Venus with Adonis became favorite subjects of Renaissance and baroque artists and were rendered many times, including by Botticelli, Veronese (cat. 86), Marcantonio (cat. 79), and Rubens.

Greek philosophers expounded another tradition, in addition to mythology, that involved Venus. That tradition needs to be explicated because artists of the period sometimes drew upon it, and it has figured prominently in art historical discussions of images depicting Venus. In antiquity, the Roman "Venus," who was originally a minor fertility goddess, came to be identified with the powerful Greek "Aphrodite," one of the six major goddesses. From early on, there were three principal identities in which Venus presented herself and performed, as it were, specialized functions. As Venus Genetrix or Nymphia, she protected human love and marriage. In a second role, she was concerned with the vulgar passions or lusts and was the patron of prostitutes. Her most exalted role was as the celestial Venus, goddess and symbol of chaste, ideal love.[3] This role is notably explicated in Plato's *Symposium*, one of the most famous dialogues on love ever written. In it, the protagonists focus on the celestial and earthly aspects of the goddess, and the corresponding kinds of love. While earthly love can encompass the physical, it must be through the controlling of "our lusts and pleasures." And, of course, Socrates eventually leads the discussion away from matters of the flesh altogether, to the contemplation of the soul and of universal beauty, to enlightened, celestial love.[4]

The "Twin Venuses" of Plato's writings became a renewed focus for some Renaissance philosophers, notably for the fifteenth-century Florentines, Marsilio Ficino and Pico della Mirandola. Conversant with Plato's thought through the works of his followers, the two men wanted to fuse pagan and Christian thought. In so doing, Ficino regarded love as "the motive power which causes God—or rather by which God causes Himself—to effuse his Essence into the world, and which, inversely, causes his creatures to seek reunion with

fig. 1. Titian, *Venus and Adonis*, c. 1560, oil on canvas, 106.8 x 136.0 (42 x 53½), National Gallery of Art, Washington, Widener Collection 1942.9.84.

Him.''[5] Each Venus and Eros is praiseworthy, but the celestial Venus and Eros impel man, through Mind or Intellect, to the contemplation of Divine Beauty.[6]

This kind of Neoplatonic thought has been considered by such art historians as Panofsky, Edgar Wind, and E. H. Gombrich, among others, to be of formative importance in a number of now famous Renaissance paintings, especially Titian's *Sacred and Profane Love* (Galleria Borghese, Rome). It has also been drawn on by Theodore Reff in an analysis of Titian's *Venus of Urbino* (fig. 2).[7] The latter painting, as well as its model, Giorgione's *Sleeping Venus* (fig. 80a), are of interest here, especially in relation to Domenico Campagnola's print (cat. 80), and his father's earlier reclining nude (fig. 80b). Giorgione's painting and perhaps related drawings, now lost, are directly or indirectly the source for the innumerable depictions of nude females in landscapes that so proliferated in the sixteenth and into the seventeenth centuries (see fig. 76a for example).[8]

Lofty Neoplatonic interpretations of these nude women have been vigorously challenged in recent years. Some scholars have emphasized the eroticism of Giorgione's and Titian's pictures of Venus. It is now generally agreed that Giorgione's Dresden painting is a marriage picture, a most suitable use for a Venus in her role as goddess of marriage and fertility.[9] Rona Goffen has stressed, moreover, that Venus' gesture—resting her hand on her genital area—may reflect the advice of medical doctors to husbands to caress their wives in this way in order to facilitate the simultaneous orgasm of the couple and hence ensure procreation.[10]

Giorgione's female is certainly a Venus, for there is a Cupid at her feet, overpainted in the nineteenth century but visible in x-radiography. Titian's *Venus of Urbino*, however, is thought by some scholars not to be a Venus at all; some propose that she represents a prostitute of the time.[11] It may be that she is a portrait of a courtesan in the guise of Venus. In any case, her pose, her frank look at the viewer, and her suggestively crumpled bedsheets all emphasize her sensual qualities. While she is exceedingly beautiful, it is surely not a chaste, celestial beauty that is extolled in the image.

In comparing the two Campagnolas' prints with these two paintings, one is led to the idea that the Campagnolas' figures are probably not, in fact, meant to depict Venus. Certainly, they have no attributes to suggest that they represent the goddess. They would seem instead to be women who, in lying outdoors, are allied with the earth, as women have been so widely seen over history (Mother Earth, *Natura*).[12] They thereby become images of a natural sensuality and fertility, the nature nymphs that frequently appear in such ancient literature as Ovid's *Metamorphoses*. They bespeak an interest in and desire for a sensuous pastoralism that was evident in Venetian culture of the time.[13]

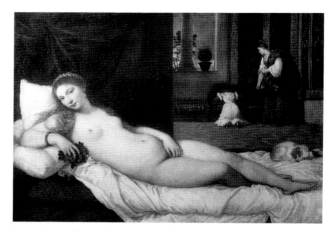

fig. 2. Titian, *Venus of Urbino*, 1538, oil on canvas, 119.3 x 165.1 (47 x 65), Uffizi, Florence.

Depictions of female nudes, whatever their particular identity is determined to be, have also come under the intense scrutiny of feminist scholars in recent years. Feminists have argued that images of the female nude were almost always made for the delectation of male viewers. This has given rise to discussion of "the male gaze," as it has come to be known.[14] Objections to the male gaze rest, of course, on what is perceived to be the exploitation of women's bodies. Freedberg, in his recent discussion of sexual arousal by image, which he considers to be an overwhelmingly male response, will have added fuel to these objections.[15] More traditional art historians, male and female, continue to argue that many beautiful female nudes are, in essence, apotheosized beyond their merely sensual appeal.[16]

1. See Brucia Witthoft, "Marriage Rituals and Marriage Chests in Quattrocento Florence," *Artibus et Historiae* 3/5 (1982): 43–59; as well as Callmann 1979.
2. See Tripp 1974, under "Aphrodite." For an interesting discussion of the gods and goddesses in antiquity, see Pomeroy 1975, 1–15 (includes Venus).
3. Panofsky 1962, 129–148. Lust was often not considered to be under the aegis of Venus or her agent, Cupid or Eros.
4. See *The Collected Dialogues of Plato, Including the Letters*, ed. Edith Hamilton and Huntington Cairns, Bollingen Series 71 (New York, 1961), 526–574.
5. Panofsky 1962, 141.
6. Panofsky 1962, 142–143. Much important material on love in ancient and Neoplatonic thought is also discussed in Wind 1968, 128–170.
7. The literature on the *Sacred and Profane Love* is vast, but see Panofsky 1969, especially 109–119. According to him, the nude figure in the painting is the celestial Venus and the clothed figure is the terrestial Venus. Hope 1980, among others, has challenged this view.

Agreeing with Panofsky that it is a marriage picture, Hope proposes that the clothed woman represents the bride, Laura Bagarotto. On the *Venus of Urbino,* see Reff 1963.

8. Some of these are illustrated in Lawner 1987. A number of the paintings are by Titian himself, other Venetians, and by the young Nicolas Poussin.

9. See the important article on the painting in Anderson 1980.

10. See Goffen 1987, 699. She makes clear that she does not consider Giorgione's painting "to illustrate a presumed gynecological fact," but rather, that both patron and painter must have been cognizant of biological assumptions about female sexuality.

11. Lawner 1987, 138, and Hope 1980, for example, see the "Venus" as a courtesan, while Goffen 1987, and Rosand 1980, maintain that she is indeed Venus.

12. On the identification of woman with nature, see the interesting discussion in Merchant 1980, 1–41. Both Merchant and Ortner 1974 see this identification as injurious to both woman and nature, because, they propose, men identified themselves with culture. According to this view, men have been zealous in their desire to control both.

13. In antiquity, nymphs were minor female divinities known for their youth, beauty, and amorous qualities. The word "nymph" itself means "young woman." See Tripp 1974, 399. The nostalgia for the pastoral world is seen in both the visual arts and literature of the time. See, for example, Robert C. Cafritz, Lawrence Gowing, David Rosand, *Places of Delight: The Pastoral Landscape* [exh. cat., National Gallery of Art] (Washington, 1988).

14. Nochlin, for example, in Brooklyn 1988, 36–37, asks if women, in viewing female nudes, are to respond as "one of the boys" and enjoy the image as erotic stimulation, or as "one of the girls." The latter, she suggests, can involve two different reactions: the female viewer can reject the image as oppressive, or she can give up her privileged status as viewer and identify with the body in the image. Snow 1989, suggests that the cliché of the male gaze deserves to be reexamined, for it tends to exclude a range of possible reactions on the part of male viewers to many images. His own focus is on the *Rokeby Venus* (National Gallery, London) by Velázquez.

15. See Freedberg 1989, especially 317–344, and 13–18, where author also specifically discusses the nudes by Giorgione and Titian.

16. This approach is seen at its most sophisticated and elegant, perhaps, in Kenneth Clark, *The Nude: A Study in Ideal Form,* Bollingen Series 35 (Washington, 1956).

76
Lucas Cranach the Elder

Venus and Cupid
Woodcut, dated 1506
287 x 202 (11⁵/₁₆ x 7⁵/₁₆)
Hollstein 105 2/2
Rosenwald Collection 1954.12.227

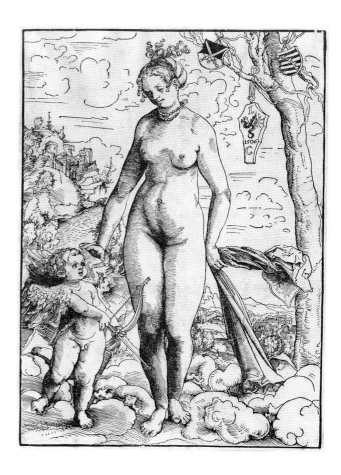

Cranach produced some of the most straightforwardly seduc-
tive female nudes found in Renaissance art, especially in paint-
ing (see fig. 76a). At their most characteristic, these women—
who may represent Venus, Lucretia, Judith, or others—
convey their sexuality through their sinuous outlines, small
waists, manipulated poses, and narrowed, slanting eyes that
usually stare provocatively at the viewer. Often they wear just
a bit of clothing, as seen in this early woodcut—a hat some-
times, or a pearl necklace—and they may hold a transparent
veil. As such, they seem to conform to male fantasies and ex-
ist for the male gaze. Quite far from any classical ideal of fe-
male beauty, Cranach's nudes have a startlingly feline quality,
at once suggesting the energetic physical grace of big cats and
their potentially threatening and dangerous behavior.

The Venus exhibited here is less exaggerated in pose and
bodily conformation than Cranach's nudes were to become.
The print is also known in chiaroscuro impressions.[1]

1. See Basel 1974, 2:641–659 and no. 555, with illustrations, for a long
discussion of Cranach's images of Venus, including the present print,
and his depictions of Adam and Eve.

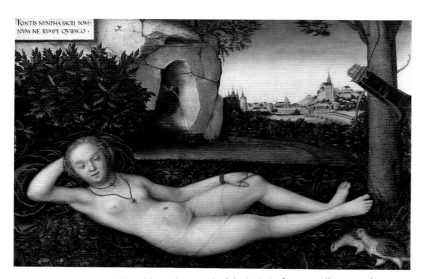

fig. 76a. Lucas Cranach the Elder, *The Nymph of the Spring*, after 1537, oil on wood, 48.5 x
72.9 (19 x 28⁵/₈), National Gallery of Art, Washington, Gift of Clarence Y. Palitz 1957.12.1.

77
Marcantonio Raimondi, after Raphael

The Judgment of Paris
Engraving, c. 1517/1520
292 x 434 (11¹/₂ x 17¹/₈)
Bartsch 245
Gift of W. G. Russell Allen 1941.1.63

Marcantonio's *Judgment,* based on drawings by Raphael, has been called "one of the most influential images in the history of art."[1] It conveys Raphael's full absorption of classical antiquity and his transformation of it into his own crystalline classical style. Raphael's vision, moreover, is well served by Marcantonio's mature handling of the engraving technique.

The story of Paris and the three goddesses, Minerva, Juno, and Venus, is one of the best known of all myths. Briefly recounted, the goddess Eris (or Strife) threw a golden apple marked "for the fairest" into a throng of guests at the wedding of Peleus and Thetis. Since Minerva, Juno, and Venus all claimed the apple, Jupiter elected Paris to decide among them. Hoping to win, Minerva offered him victory in war, Juno offered to make him ruler of the world, and Venus offered him the love of the most beautiful woman in the world. He of course chose Venus, under whose protection he was led to Helen of Sparta; his subsequent abduction of her precipitated the Trojan War.

Visual representations of the story are legion, especially in the Renaissance and baroque periods.[2] It is noteworthy that the goddesses are depicted nude here, for which there are few precedents in art and literature.[3] Subsequently, they were often shown this way.

Drawn from several ancient literary sources, the Judgment of Paris came to be much discussed in later exegetical literature, notably by Fulgentius, as well as in the Moralized Ovid and Neoplatonic writings. The goddesses came to be regarded as personifying the three courses of life: the contemplative (Minerva as goddess of wisdom), the active (Juno), and the sensual (Venus). Disquisitions on Paris' choice of Venus abounded, many of them of considerable complexity. In terms of Raphael's *concetto* as shown in Marcantonio's print, Wind proposed an elevated allegorical reading: namely that what is represented here symbolizes "the supreme moment in which Beauty transfigures the world of the senses."[4] Similarly lofty philosophical readings by Wind, Panofsky, and other traditional art historians have been given a number of Titian's images of Venus.

1. Lawrence 1981, 146–147, for a discussion of the drawings and visual sources for the image.
2. Pigler 1974, 2:195–201.
3. Lawrence 1981, 146–147.
4. Wind 1968, 271.

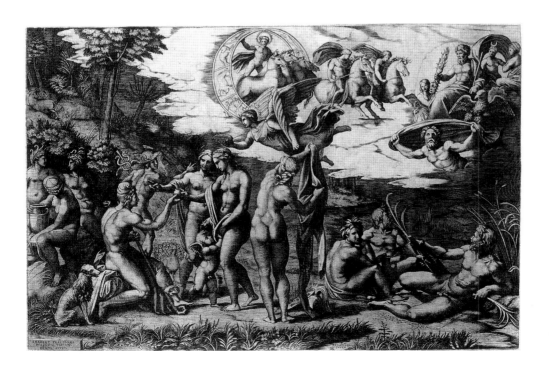

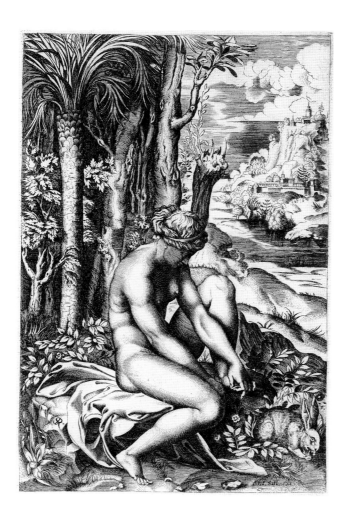

78

Marco Dente, after Raphael

Venus Extracting a Thorn from Her Foot
Engraving, c. 1516
263 x 170 (10⁵/₁₆ x 6¹¹/₁₆)
Bartsch 321 1/2
Rosenwald Collection 1964.8.612

This print reproduces one of eight wall paintings in fresco that form part of the decoration of Cardinal Bibbiena's Stuffetta (bathroom) in his apartments in the Vatican, Rome. With subjects drawn primarily from Ovid's *Metamorphoses,* the project was carried out by two of Raphael's pupils, Giovanni Francesco Penni and Giulio Romano, perhaps after cursory sketches by the master.[1] Six of the scenes, including the present one, were subsequently engraved by members of Marcantonio Raimondi's workshop.[2] The images, some more sexually explicit than others, are an important example of Renaissance erotica and notable for having been commissioned by a high cleric.[3]

The incident depicted here shows Venus removing a rose thorn from her foot. The blood from the prick was said to have turned a white rose red. The rabbit (looking rather crazed) is usually a symbol of fertility and hence an appropriate companion for Venus.[4]

1. Dussler 1971, 92–93. One of the paintings has been destroyed.
2. Three of these, including the present impression, are reproduced and discussed in Lawrence 1981, 184–189.
3. Lawrence 1988, 41.
4. Paul Barolsky, *Infinite Jest: Wit and Humor in Italian Renaissance Art* (Columbia, Mo., 1978), 45–46, has pointed out that the Latin word for rabbit, *cuniculus,* was often used in the Renaissance as a pun on the female pudenda, *cunnus.*

79
Marcantonio Raimondi

Mars, Venus, and Cupid
Engraving, dated 1508
303 x 214 (11¹⁵/₁₆ x 8⁷/₁₆)
Bartsch 345
Gift of W. G. Russell Allen 1941.1.68

There are probably two states of this print, rather than three, as has sometimes been thought. In any case, this is the final state, in which a number of details earlier omitted have been added. The most important of these are the large torch with flame that Cupid seems just to have given Venus and the Medusa's head that decorates Mars' shield.[1]

From antiquity onward, and especially in the Renaissance, the union of Mars, god of war, and Venus, goddess of love, was interpreted as the concord produced by the union of discordant or contrary parts (*discordia concors*). The idea was made manifest in the daughter, Harmony, said to have been born of the union. In Renaissance images, Mars is often shown sleeping while Venus either puts on his armor or permits cupids and infant satyrs to play with it; an example is Botticelli's well-known painting in the National Gallery, London. Wind has emphasized that such scenes convey the message that Love is more powerful than Strife.[2] In Marcantonio's print, although Mars has removed his armor, concord has yet to be achieved. Wind has suggested that Mars is here attempting to forestall Venus from setting fire to his shield and cuirass.[3] We might read the image, further, as a metaphor for Venus preparing to ignite Mars' passion, and the verdant trees placed in the center behind the two figures may signify the fruitfulness of the impending union.

At the same time, the twentieth-century viewer recognizes the sexual and psychological meanings of the Medusa's head on Mars' shield, with its manifold forms, from having read Freud and others.[4] It is true that such shields, used for tournaments and parades, were fairly common in the fifteenth and sixteenth centuries, and the Medusa's head continued to carry one of its mythological attributes: that it protected the warrior against his male enemies by turning them into stone when they looked at it.[5] Yet in the present context, it seems as if the Medusa's sexual power reinforces the strength of Venus over Mars, and indeed, the image communicates, intentionally or not, the *frisson* of Mars' sexual entanglement.

1. See Lawrence 1981, 76–79, with illustrations.
2. Wind 1968, 89–90.
3. Wind 1968, 96 n. 48.
4. See Laurie Schneider, "Donatello and Caravaggio: The Iconography of Decapitation," *American Imago* 33, no. 1 (Spring 1976): 84–91, and the bibliographic references.
5. Friedlaender 1955, 87–89. Medusa, one of three monsters known as the Gorgons, was beheaded by Perseus with the help of Athena, according to Hesiod's *Theogony*.

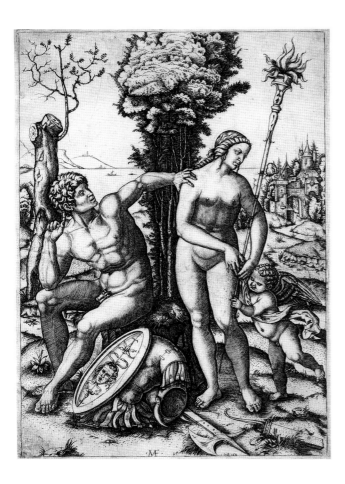

80
Domenico Campagnola

Venus Reclining in a Landscape
Engraving, dated 1517
96 x 134 (3³/₄ x 5¹/₄)
Hind 13
Rosenwald Collection 1943.3.2700

This arresting image of a female nude reclining in a landscape presents several art historical problems. It is rather closely related to a drawing in the British Museum (the images are in reverse of each other), which has been attributed to Giulio Campagnola by some scholars and to his adoptive son, Domenico, the present artist, by others. While the subject recalls Giorgione's famous *Sleeping Venus* (fig. 80a), it has been suggested that the more immediate source for the image, in terms of the sensuous treatment of the figure, is in works by

Palma Vecchio. The latter, however, are usually dated later than the print, which is signed and inscribed 1517.[1]

Like Palma's paintings in Dresden and Cambridge, this reclining nude is awake, and as in the Dresden work, she lacks any attributes that would either strongly suggest or firmly identify her as Venus.[2] Firm identification, in fact, would rest on the presence of Cupid. (A cupid in Giorgione's painting was overpainted but is known through x-radiography.) In her waking state, and in the provocative gesture of resting her fingers below her right breast, the figure raises questions about the purpose of the print. The image suggests that this female is "no goddess, and indeed no lady."[3] The same might be said of Giulio's earlier print (fig. 80b), again a work traditionally called a "Venus."

1. For more complete information and an illustration of the drawing, see Washington 1973, no. 151, fig. 20-4.
2. On Palma's paintings, see Mariacher 1968, 76–77, figs. 53–54.
3. The phrase is from Goffen 1987, 695, on Titian's *Venus of Urbino*.

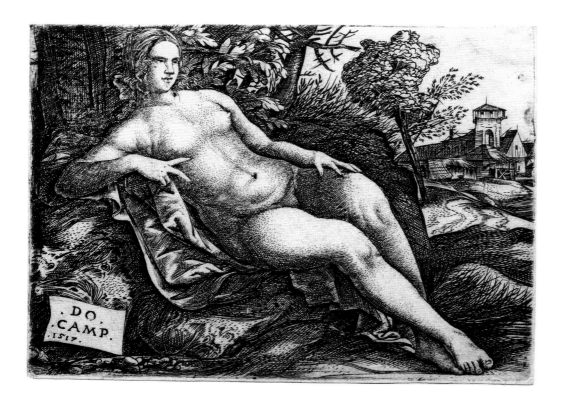

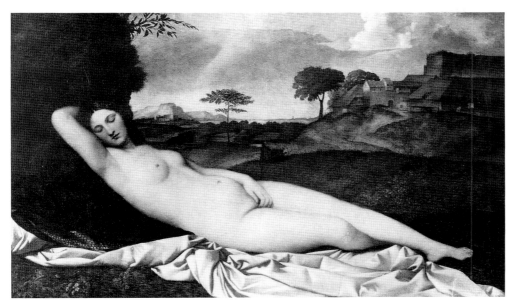

fig. 80a. Giorgione, *Sleeping Venus*, c. 1508, oil on canvas, 108.0 x 175.0 (42¹/₂ x 68¹/₄), Gemäldegalerie, Dresden.

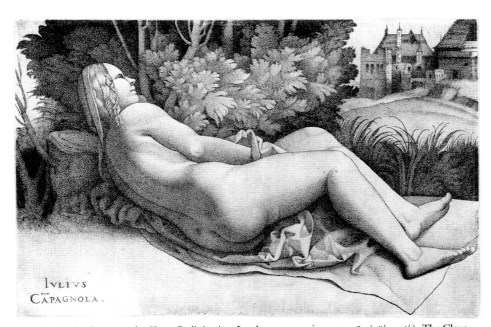

IVLIVS
CĀPAGNOLA.

fig. 80b. Giulio Campagnola, *Venus Reclining in a Landscape*, engraving, 119 x 184 (4¹¹/₁₆ x 7¹/₂), The Cleveland Museum of Art, Gift of The Print Club of Cleveland (Hind 13).

81
Niccolò Boldrini, after Titian

Venus and Cupid
Woodcut, dated 1566
312 x 234 (12¹/₄ x 9³/₁₆)
Bartsch 29
Rosenwald Collection 1943.3.934

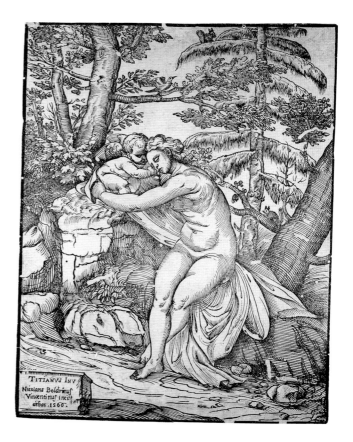

Despite the inscription on the woodblock, David Rosand and
Michelangelo Muraro find only a loose connection between
this image and Titian's own art, concluding that, at most,
Titian might have supplied Boldrini with a drawing of the fig-
ure group. The printmaker would have devised the landscape
himself.[1] The print exists in impressions of solely the key
block as well as, more rarely, in a chiaroscuro version.[2] The
present impression is a late one, showing as it does white
spots that were caused by wormholes in the block.

 Venus is depicted here, unusually, in a moment of intimate
and loving affection with her son, Cupid, a kind of expression
readily found in images of the Virgin and Child (see especially
Cranach's print, cat. 52). It is tempting to think of this as the
Venus who protects marriage and childbirth.

1. Washington 1976, 243.
2. Washington 1976, nos. 72A and 72B, illustrated.

82

Enea Vico, after Parmigianino

Mars and Venus Embracing with Vulcan at His Forge
Engraving, dated 1543
236 x 352 (9¼ x 13⅞)
Bartsch 27 1/3
Ailsa Mellon Bruce Fund 1972.34.5

83

Enea Vico, after Parmigianino

Venus Reclining with Vulcan at His Forge
Engraving, dated 1543
235 x 348 (9¼ x 13¾)
Bartsch 27 3/3
Ailsa Mellon Bruce Fund 1972.34.6

Two states of this print are exhibited here, the first state and
the third. In the first image, Venus and Mars are shown in
bed, while Venus' husband, Vulcan, god of fire, works at his
forge, apparently oblivious to their betrayal. Yet Vulcan
seems to be shaping a net of "fine links of bronze," which he
made after having seen "the shame of Mars and Venus." Ac-

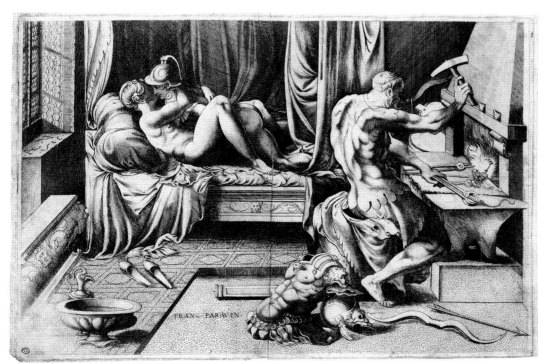

82

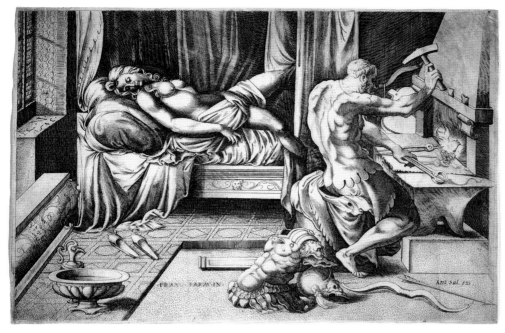

83

cording to Ovid's *Metamorphoses,* he placed the net on the couch, and when Mars and Venus lay on it again, they were caught in it. Vulcan then invited the other gods into the chamber. "The gods laughed, and for a long time this story was the talk of heaven."[1]

Freedberg has pointed out that this image, like many prints in the later sixteenth century, was censored by reworking the plate. In the second state, the figures of Mars and Venus were burnished out, and the area simply printed as white, and so untidily that the censor must have pulled impressions to see how well he had done his work. In the third state (cat. 83), Venus has been redrawn, the lower part of her body draped, and Mars is no longer to be seen.[2]

Paintings and sculpture were also censored during this period of Tridentine reform. One of the most famous examples is the prolonged criticism of the "indecent" nudes in Michelangelo's *Last Judgment.* The fresco was nearly destroyed but survived with overpaintings of the figures' genitalia. Freedberg has suggested that since prints could be easily and widely circulated, they were especially subject to censorship. "The issue is at least as much social control as sexual control."[3]

1. Ovid 1976 ed., 4:167–189.
2. Freedberg 1989, 361–368, figs. 172–174.
3. Freedberg 1989, 368, where the author deals throughout the chapter with the subject of censorship.

84

Georges Reverdy

Mars and Venus Surprised by Vulcan
Engraving
120 x 274 (4¹¹/₁₆ x 10³/₄)
Bartsch 19
Andrew W. Mellon Fund 1976.79.14

Mars and Venus are discovered here *in flagrante delicto* by
Vulcan, who has with him the bronze net he has made to
catch them in. For the mythological story and another visual
moment of it, see cat. 82.

Reverdy is one of the lesser-known French printmakers of
the sixteenth century. He seems to have been in Italy around
1530, and afterward, he worked in Lyons, where he specialized
in mythological subjects and scenes of peasant life, and made
woodcuts for book illustrations.[1]

1. See Jean Adhémar, *Bibliothèque Nationale, Inventaire du Fond
Français: Graveurs du seizième siècle* (Paris, 1938), 2:79–88.

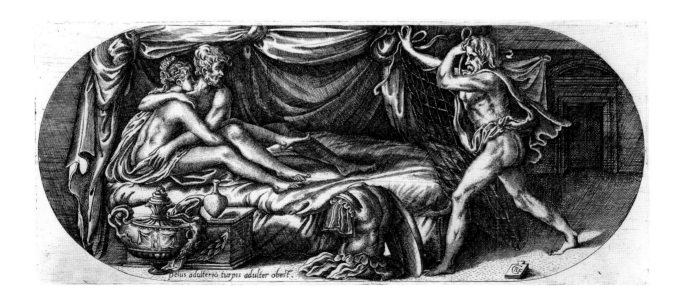

85
Pietro Testa

Venus in a Garden with Cupids
Etching, c. 1632
350 x 409 (13¾ x 16⅛)
Bartsch 26, Bellini 12 2/4
Ailsa Mellon Bruce Fund 1972.66.50

This print is a large and complex early work by Pietro Testa. Decorously reclining, Venus gazes directly at the viewer, and with her open-armed gesture invites one to observe the animated activities of the charming *erotes* who are playing in her garden, the garden of love. As Paul Watson has made clear, the garden of love became an especially important theme in the development of secular art around the turn of the fifteenth century, continuing into the seventeenth and eighteenth centuries.[1] Testa's immediate visual and intellectual sources for his image in the works of his contemporaries, Nicolas Poussin and François Duquesnoy, have been identified by Elizabeth Cropper. In turn, those artists and Testa himself reflect their direct acquaintance with Titian's painting, the *Worship of Venus* (Madrid, Prado), one of the Venetian artist's famed *Bacchanals,* which were then in Rome.[2] Cropper has stressed, moreover, the interest of all three later artists in "the capacity of Titian's cupids to evoke responses of tenderness in the spectator because of their softness and innocence."[3] At the same time, the children's love games evoke the more emotionally serious love games of adults, and indeed adult love is adumbrated by the leering statue of Pan, the male and female figures to the right of Venus, and the dancing satyrs (known as quintessentially lustful creatures) at the right of the cupid with bow and arrow.

1. Watson 1979, 17–24.
2. Philadelphia 1988, 22–27.
3. Philadelphia 1988, 23, quoting Bellori.

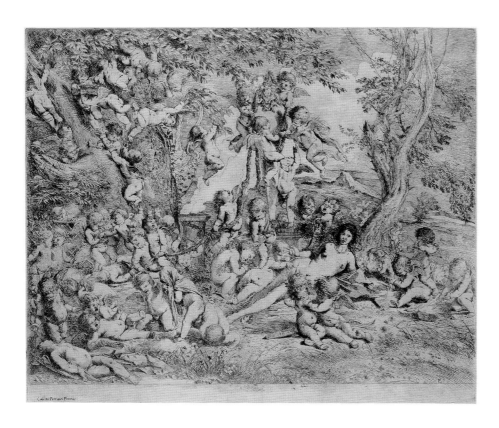

86
Simone Cantarini, after Veronese

Mars, Venus, and Cupid
Etching, c. 1637/1639
263 x 197 (10⁵/₁₆ x 7³/₄)
Bartsch 32, Bellini 9 1/2
Ailsa Mellon Bruce Fund 1971.37.37

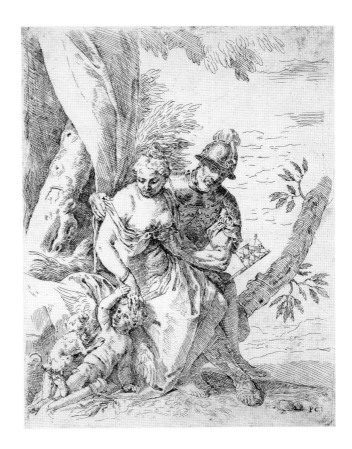

This print records, in reverse, a painting now in the National
Galleries of Scotland, Edinburgh, which Roger Rearick attrib-
utes to Paolo Veronese's son Carletto. That work, in turn,
as well as another repetition by Paolo's son Gabriele, are
thought to derive from a drawing and now lost painting by
Paolo.[1]

In Cantarini's translation of the image into etching, Venus'
clothing has acquired a disheveled appearance and suggests,
not that Mars pulls the bodice down to reveal her breasts, but
that it has slumped from her shoulders. Mars himself looks
old, largely because his beard is read as being white. Hence
the etched image (unintentionally, one suspects) evokes an al-
most poignant response to aging lovers.

By contrast, in Veronese's many depictions of the subject,
Venus is youthfully voluptuous, Mars is vigorously muscular,
and the images seem to radiate with the sensual heat of their
relationship. Terisio Pignatti thinks that such erotic subjects
were demanded of the artist by certain collectors, especially
following the death of Titian.[2]

Veronese made no prints himself, but his works were fre-
quently replicated by various printmakers from the sixteenth
into the nineteenth centuries.[3]

1. Washington 1988, 136–137, fig. 44.
2. Washington 1988, 15.
3. See, for example, *Paolo Veronese e i suoi incisori* [exh. cat., Museo
Correr] (Venice, 1977).

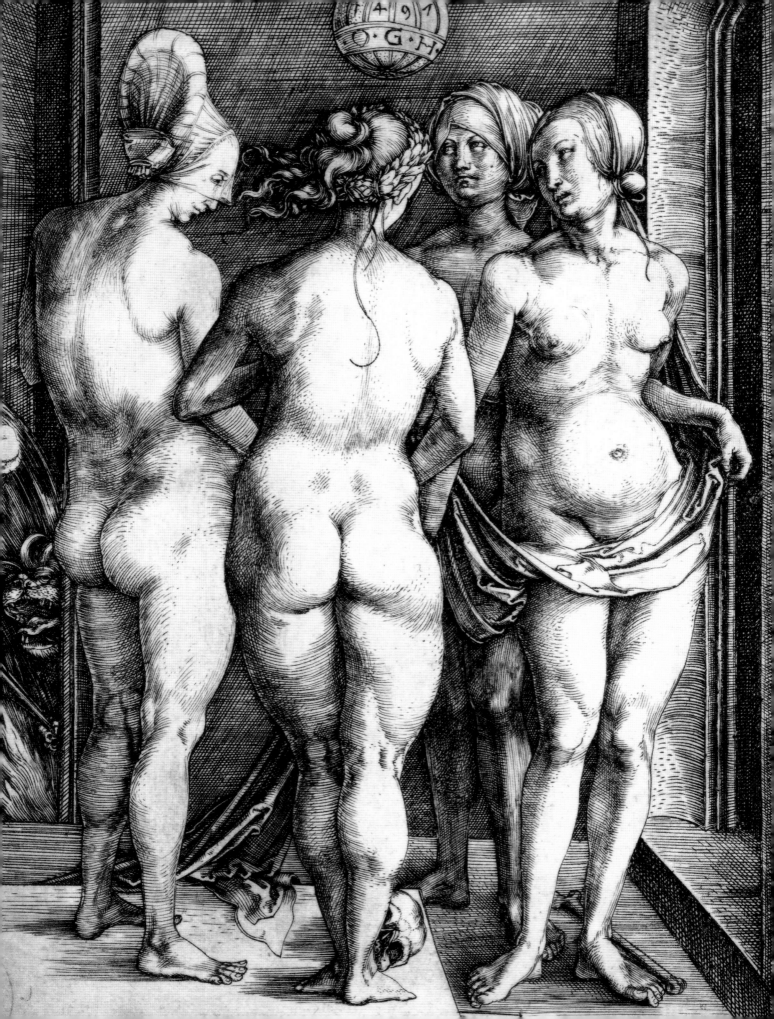

V
THE POWER OF WOMEN

The "Power of Women" topos refers to a group of themes, in literature and the fine arts, that focused on women who used their feminine wiles to triumph over men. Some stories were frequently represented, some less often, but the thrust of each was that women overcame men who were prominent, accomplished, or heroic (see cat. 87).[1] Sometimes the man was subjected to the ridicule of others. Such was the case when the famed Virgil, trying to reach a woman's room by being pulled up to it in a basket, was left by her to dangle helplessly. The next morning, a crowd gathered and made fun of his plight (cat. 96). The consequences could be much more serious, however. The influence of Herodias and her daughter Salome upon Herod resulted in the decapitation of John the Baptist (cats. 88, 89). In a similar way, Samson was lured by the sexual appeal of Delilah to drink too much and to reveal to her that the secret of his vaunted physical strength was his hair. When he fell asleep in her lap, she cut his hair off, and he was captured by his enemies, the Philistines, who had paid her to entrap him (cat. 94). In most of these stories, the women tempt the men with their sexual attractiveness in order to triumph over them.

In many respects, one might propose that the majority of prints in the exhibition demonstrate men's vision of women's power, whether it is a power used for good or for evil. The Virgin, empowered by God, uses her role as mediatrix with God for the benefit of humankind. Other women, like the goddesses Venus and Fortuna, may benefit humans as well, but not necessarily and certainly not consistently. Still other women marshall their power to nefarious ends. Among the latter are witches (cats. 103–105).

Witches were considered patently evil during the Renaissance and baroque periods, or until about 1630. They were thought to be empowered by Satan to act as his agents, and hence they were strikingly dangerous adversaries of humans. While men could be witches and sometimes were indeed put on trial for being witches, women increasingly outnumbered them in this capacity during this period. At the end of the greatest period of persecution of witches, women accounted for about eighty percent of those accused. There were a number of reasons for this, but the most important was the belief that women were sexually insatiable and that Satan seduced them to his cause. Devils appeared to women as incubi to copulate with them (devils in female form, succubi, sup-

posedly seduced the less-willing men). In many images of witches, especially those by Hans Baldung Grien, there are numerous phallic symbols as well as poses and gestures of the figures that are sexual in character (see fig. 103a).[2]

In a study of witches in Gascony, Emmanuel Le Roy Ladurie pointed to four principal "crimes" for which witches were held to be responsible. They could take away the strength of young men and sometimes went on to kill them. They could make men impotent, and hence they struck at the ability of humans to reproduce. They could destroy the crops of farmers by conjuring up such harmful natural phenomena as hailstorms. Finally, they were thought to increase their own material wealth by striking at the holdings of others.[3] Witches were thought able to fly through the air in performing their evil acts; to achieve flight, they used unguents on themselves and their poles, ointments supposedly made of infants they had killed.

The persecution of witches began in the fifteenth century. Before that, sorcerers, as they would be more properly called, might be friendly or unfriendly, but they were not feared and hated. Even at the end of the sixteenth century, as Carlo Ginzburg has shown, there were friendly sorcerers in the Friuli region of Italy who were thought to fight bad sorcerers and thereby protect the fecundity of the soil. Yet these people themselves were eventually convinced by authorities that they were in fact witches.[4]

Many reasons have been proposed for the emergence of witchcraft as a phenomenon during the Renaissance and baroque periods. Among them are devastating crop failures, the bubonic plague, and syphilis.[5] Whatever the reasons, most scholars agree that the persecutors of witches were "sincerely" motivated. That is, they were not accusers, inquisitors, or judges who were deliberately looking for scapegoats, whatever particular incident of witchcraft might be involved. Rampant misogyny, nevertheless, was nearly constant, and a deep part of the craze for persecution.

In a study of Baldung's images of witches, Linda Hults has proposed that Baldung himself saw these women as deluded in the following ways: that they only imagined they could fly, that they attended sabbaths, and that they copulated with devils. In this way, she sees Baldung's visual images as connected with sermons by the preacher Johann Geiler von Kayserberg in Strasbourg, collected and published as *Die Emeis* (*The Ant-Heap*) in 1517. Hults emphasizes, however,

that both von Kayserberg and Baldung thought that witches were possessed by the Devil. A witch's "deluded state and real powerlessness in no way exonerated her, because it was her weak, corruptible will that made her susceptible to the devil's deception in the first place."[6]

Witchcraft was an extreme phenomenon of the European history of the time. The women who were thought to be witches, however, were different in degree but not in kind from women as a whole—that is, in terms of how they were regarded. In the case of witches, such female characteristics as lustfulness, gullibility, irrationality, deceitfulness, and the like are simply seen in their most extreme form.

As noted in the Introduction, the Power of Women topos originated in decorative arts objects of the middle ages and became newly popular at the end of the fifteenth century when it was picked up as a theme by printmakers. Images of witches, an essentially new theme at the end of the century, were likewise given wide circulation through the print media. Some of these prints appeared as illustrations to treatises on witchcraft, but many were single-sheet prints, often without text.[7] Witches were much less frequently depicted in other media, including painting. It is probably impossible to assess how much influence on popular opinion such images had, but it is almost certainly bound to have been greater than the rather ponderous tomes written about witchcraft. The latter had their greatest currency among those at "the top": that is, the clergy and civil authorities who were inquisitors, prosecutors, and judges.[8]

1. The key and comprehensive source on the Power of Women is Smith 1978.
2. See the discussions of Baldung's images of witches, and illustrations, in Washington 1981; and Hults 1987.
3. See Ladurie 1987, 25.
4. See Ginzburg 1985.
5. See the useful review of modern scholarship on witchcraft by E. William Monter, "The Historiography of European Witchcraft: Progress and Prospects," *Enforcing Morality in Early Modern Europe* (London, 1987), 435–451.
6. Hults 1987, 267.
7. Von Kayserberg's *Die Emeis,* for example, was illustrated with woodcuts that were formerly attributed to Baldung and that, in any case, reflect his style, as Hults has noted.
8. Klaits 1985, 3–4, has stressed the importance of the educated elite's views on witchcraft. They were the ones who joined together concepts of harmful magic and religious dissent and heresy. He also suggests that the interest of Renaissance humanists in ancient magic texts contributed to the stereotype of the witch.

87
Master MZ

Phyllis Riding Aristotle
Engraving, c. 1500
185 x 133 (7¼ x 5¼)
Lehrs 22
Museum of Fine Arts, Boston, William A. Sargent and
Stephen Bullard Memorial Fund

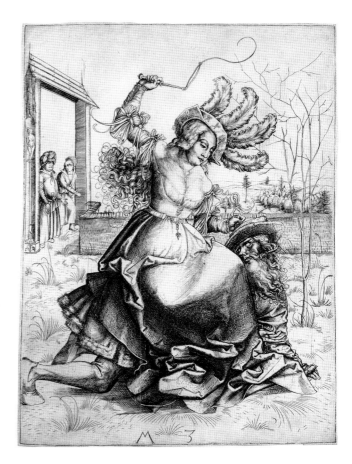

As Susan Smith has pointed out in her rich and comprehensive study, the Power of Women topos first came into existence in the visual arts during the late thirteenth century. It began to appear in various kinds of decorative arts objects, such as tapestries, ivory caskets, enamels, furniture, and the like. Such objects became an especially convenient source for printmakers who were interested in secular imagery.[1] The growing popularity of prints in the later fifteenth century, and their concomitantly increasing availability, in turn gave new life to the Power of Women subjects. These subjects could vary, even in series of prints, depending on the particular artist's preferences, but the underlying idea of the theme was to show women overwhelming prominent, accomplished, or heroic men by sexually beguiling them. Among the images exhibited here are prints not only by Master MZ but also by Lucas van Leyden, Baldung Grien, Altdorfer, and Burgkmair.

Of all of the many subjects that appeared as part of the topos in prints, the present one was among the most popular, and it is immediately revealing of the thrust of the imagery. Here the much venerated ancient philosopher, Aristotle, has succumbed to his lust for the beautiful Phyllis, usually said to be Alexander the Great's wife or mistress. According to a common version of the legend, Aristotle had earlier warned Alexander, his pupil, that the young man was paying too much attention to this woman. When the philosopher approached Phyllis with his own desires, she insisted, before she agreed to gratify them, that Aristotle put on a bridle and let her ride on his back around the garden. This he did, as shown in MZ's image, and, as in many other representations, Alexander and a companion look on. In the present print, Phyllis and Aristotle are elaborately dressed. In a woodcut of 1513 by Baldung Grien, they are both nude, although she wears a hat.[2] The basic moral of the story is quite clear: even so rational and learned a man as Aristotle can allow his desire for a woman to overcome his reason; he is thus reduced to behaving as beasts do.

One of the earliest depictions of the subject in prints is that by the Housebook Master, which dates no later than 1488. Jane Campbell Hutchison has discussed both *Phyllis and Aristotle* and its pendant, *Solomon Worshiping False Gods* (for

the subject, see cats. 99, 100),[3] also a popular part of the Power of Women theme. Solomon, the biblical sage, was induced by his pagan wives to turn away from the God of Israel and to worship idols (1 Kings 11:1–13). Thus, both he and Aristotle, the pagan sage, were duped by women into foolish acts. Hutchison has further connected the pairing of the two subjects with fifteenth-century theological and philosophical movements in Germany, the *Via Moderna* and the *Via Antiqua*. She suggests that the prints are a joke at the expense of adherents of the *Via Antiqua* because Aristotle and Solomon were greatly revered in antiquity but their follies are stressed here.[4]

Whether or not there might be such timely philosophical reflections in other Power of Women prints has not, it seems, been studied. It is interesting in this connection, nevertheless, to speculate on the meaning of murals depicting the theme that were planned or executed for several town halls. One of the most intriguing projects, never executed, is preserved in a watercolor by Dürer (Pierpont Morgan Library,

New York).[5] The design was commissioned from Dürer by the Nuremberg city council and intended for the main chamber of the Rathauss. The chamber was primarily used for official business, which men would attend to, but also occasionally for social events.[6] The murals must have been intended to entertain or amuse both men and women. The power of women could be seen as a counterfoil to the power that men were exercising in the chamber; whatever their public power, men were subject to beguilement by women. The women who came for social occasions, such as dances, on the other hand, might have found it pleasurable to have their own power acknowledged in the decorations.

The identity of the Master MZ remains a mystery. He is known to have worked in Munich and has sometimes been identified as the Munich goldsmith, Matthäus Zaisinger. MZ has a known corpus of twenty-two engravings, of which six are dated between 1500 and 1503. As Shestack has stressed, the artist's handling of the burin (the principal tool for engraving lines) is in the direction of soft, painterly effects, as seen here in Phyllis and Aristotle's physiognomy and costumes. This makes one think that he may also have been a painter.[7] In any case, the impression here is of exceptionally fine quality.

1. See Smith 1978.
2. For Baldung's print, see Washington 1981, cat. 37. For a drawing by Baldung and a woodcut by Lucas, see Washington 1983, cat. 49 and fig. 49b.
3. Hutchison 1966, 73–78.
4. Hutchison 1966, 77–78. The *Via Antiqua* was neo-Thomist, that is, composed of followers of the thirteenth-century Scholastic, Saint Thomas Aquinas, whose thought was deeply tied to Aristotle's. The *Via Moderna* was composed of what Hutchison has called "proto-humanists," who were adherents of the nominalist, William of Ockham (died c. 1349). Smith 1978, 296–299, however, disagrees that this is of relevance to the prints.
5. For the watercolor, see especially Washington 1971, cat. 29.
6. There were earlier Power of Women subjects in town halls, including those at Frankfurt and Cologne. See New York 1986, cat. 146.
7. Washington 1967, biographical information preceding cat. 143.

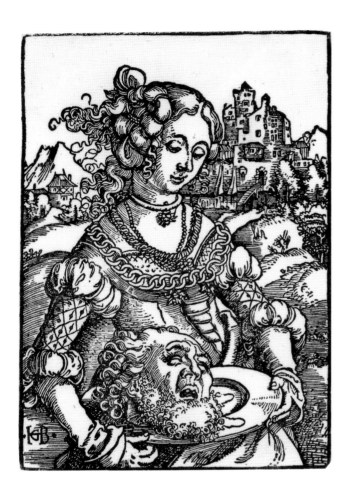

88
Hans Baldung Grien

Salome
Woodcut, c. 1511/1512
130 x 90 (5¹/₈ x 3¹/₂)
Hollstein 115
Rosenwald Collection, Print Purchase Fund 1987.33.1

John the Baptist had been imprisoned by King Herod for criticizing Herod's marriage to his brother's wife, Herodias. At a large birthday party that Herod gave for himself, Herodias' daughter Salome had danced for the guests, and she had done it so pleasingly that Herod promised her anything she wanted. At the suggestion of her mother, Salome said: "I want you to give me at once the head of John the Baptist on a platter." Herod, not wanting to go back on his word in front of so many important officials, immediately sent for the Baptist's head. A guard "went and beheaded him in prison, and brought his head on a platter, and gave it to the girl, and the girl gave it to her mother" (Mark 6:25, 27–28).

The latter part of the story is often depicted (see cats. 89, 90), showing Salome presenting the head to Herodias. But Baldung's print is obviously not a narrative scene. He shows Salome, elegantly dressed in German clothing of his own time, in about three-quarters length; she is outdoors, and a castle is shown in the background. While she looks down at the severed head in an almost bemused way, the head itself displays the agony of decapitation. The print is a kind of meditative image, and it has been linked as such to other small prints Baldung made at this time.[1]

The subject formed part of Lucas van Leyden's *Small* and *Large Power of Women* series (see cat. 90), and certainly it was a well-known example of the lethal possibilities of woman.[2] In several painted versions done in the seventeenth century, Salome herself is often omitted, and the viewer's attention is focused simply on the salver with John's head.[3] As has often been noted, John was Christ's precursor, and his martyrdom precedes and foretells Christ's Crucifixion. In this way, the severed head on a salver functions as a Eucharistic symbol.[4]

1. See Washington 1981, cat. 27.
2. See especially Washington 1983, cats. 36 and 66.
3. For earlier versions of the subject, see Isabel Combs Stuebe, "The *Johannisschüssel:* From Narrative to Reliquary to *Andachtsbild,*" *Marsyas* 14 (1968–1969): 1–16, with illustrations. A painting by the seventeenth-century Italian painter, Domenichino, for example, is in the Academia de San Fernando, Madrid.
4. Washington 1981, 148.

89
Israhel van Meckenem

The Dance at the Court of Herod
Engraving, c. 1500
214 x 316 (8⁷/₁₆ x 12⁷/₁₆)
Lehrs 367 2/4
Rosenwald Collection 1943.3.138

Meckenem has here used a compositional device that he employed in his *Passion* series and *The Life of the Virgin* series (see, for example, cat. 34), namely that of showing narrative scenes in the background that relate to the principal foreground scene. In the left background, John the Baptist has been decapitated, and his head is put on a salver held by Salome. At the right background, Salome presents the salver and head to her mother, Herodias (see cat. 88 for the biblical story). The foreground is taken up with a dance. Three musicians stand and play on a high dais in the center of the room, and below, numerous elegantly dressed couples are occupied with the dance and with each other.

Max Geisberg proposed that what is represented in the foreground is an actual event in Münster that Meckenem attended.[1] While this may or many not be true, the figures do wear fifteenth-century dress, albeit from slightly different

times. In any case, the dance is not simply an invention of Meckenem's. It relates to the biblical text of John's martyrdom, where Herod was said to have invited many officials to attend a birthday party that he gave in his own honor, at which Salome danced. The obliviousness of the guests to the cruel and portentous events taking place is likely to have been intended as a mildly didactic reminder of the inevitability of death and judgment for all.

1. As summarized by Shestack in Washington 1967, cat. 232, a discussion of this print.

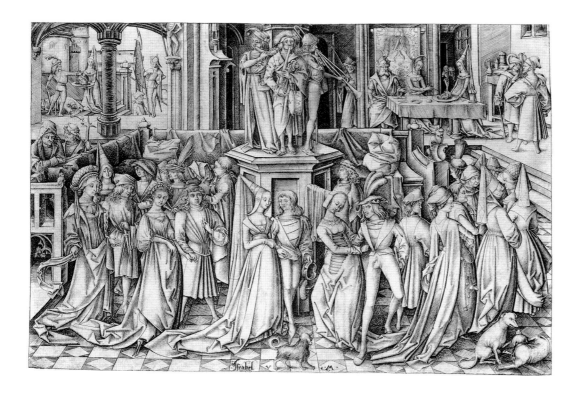

90

Lucas van Leyden

Herod and Herodias
(from *The Large Power of Women* series)
Woodcut, c. 1512
416 x 293 (16³/₈ x 11¹/₂)
Hollstein 21 1/2
Rosenwald Collection 1950.1.107

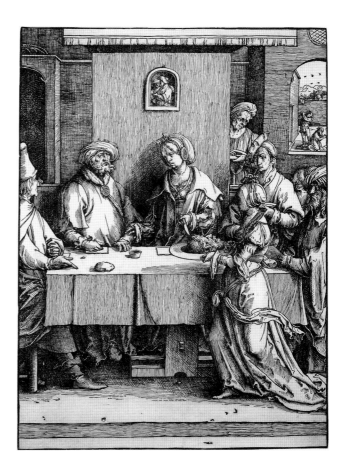

For the story of Herod and Herodias and the beheading of
John the Baptist, see cat. 88. In this print, Lucas has chosen
to focus on the king and his wife, as Salome glides in from the
right with the Baptist's severed head on a platter. While
Herod had imprisoned John for having preached that
Herod's marriage to Herodias was unlawful, he had not
bowed to his wife's desire that John be killed: "for Herod
feared John, knowing that he was a righteous and holy man,
and kept him safe" (Mark 6:20). Herodias, having finally en-
gineered the dreadful deed, now touches Herod's arm, and
turns toward him to call attention to John's head. With her
left hand, she holds a knife that serves both to emphasize the
head and to suggest her responsibility for the Baptist's death.
Herod appears transfixed by the sight, and his tension is man-
ifested in the way he splays the fingers of his left hand on the
tabletop. It has been suggested that the plaque above the fig-
ures, which shows two prophets, is intended to symbolize the
prophetic belief in John as a precursor of Christ.[1]

This print is part of the *Large Power of Women* woodcut
series by Lucas. Jacobowitz and Stepanek have pointed out
that no museum owns a uniform set of the series, that is, a set
of six that are printed on the same kind of paper, whether
they be early or late impressions. Because of this, they suggest
that the prints were probably sold singly, rather than as a set.[2]
Both of Lucas' *Power of Women* series begin with a print de-
picting Adam and Eve (here, see cat. 66). As Smith has writ-
ten, "alone among printmakers, he seems to have recognized
the special significance of this scene for the *topos* . . . ; had
Adam not succumbed to Eve's blandishments, the divinely
ordained relationship between man and woman, spirit and
flesh, would never have been overturned."[3] The images in
the *Large Power of Women* series are notable for the restraint
with which they are handled. The figures move very little, but
the gestures and glances are of distinct and memorable
significance.[4]

1. See Washington 1983, cat. 36.
2. Washington 1983, 105.
3. Smith 1978, 342.
4. Washington 1983, 105, where analogy is also made to the prints as
resembling a *tableau vivant*.

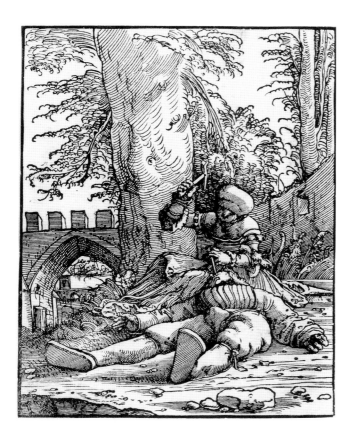

91
Albrecht Altdorfer

Jael and Sisera
Woodcut, c. 1523
121 x 94 (4³/₄ x 3¹¹/₁₆)
Winzinger 23
Gift of W. G. Russell Allen 1941.1.103

Jael, together with Judith and Esther, was considered a Jewish heroine. Sisera, the commander of an army fighting the Israelites, asked Jael for refuge in her tent, his tribe being at peace with that of her husband. She gave him milk to drink, covered him with a rug, and promised to stand guard against his enemies. Then, when he had fallen asleep, she killed him by driving a tent peg through his temple, and called the Israelites (see Judges 4:17–22).

As has been noted by several scholars, in the context of the Power of Women topos, Jael is not a heroine but rather a woman who commits deception and murder. Choosing to place the scene outdoors rather than in a tent, Altdorfer achieves irony in the contrast between the bucolic setting and the dastardly act taking place.

92
Lucas van Leyden

Jael Killing Sisera
(from *The Small Power of Women* series)
Woodcut, 1516/1519
243 x 182 (9⁹/₁₆ x 7¹/₈)
Hollstein 7 1/2
Rosenwald Collection 1943.3.5700

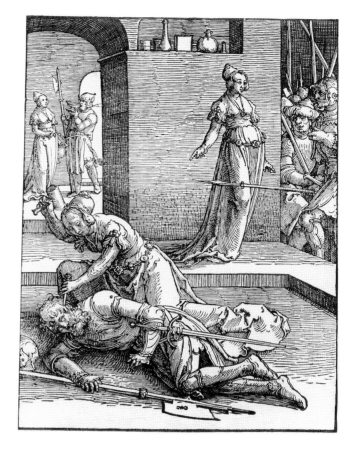

For the story of Jael and Sisera, see cat. 91. Lucas has here devised a continuous narrative: in the left background, Sisera arrives at Jael's door and is given milk to drink; in the foreground, Jael pounds a peg into Sisera's temple; and at the right, she invites the Israelites in to show them what she has done. She is depicted as a very different woman from the one who appeared in such famous books as the *Mirror of Human Salvation,* where she was presented as prefiguring the Virgin in her triumph over the Devil.[1] In being turned from a good model to a vicious one, she is rather similar to a woman like Judith. For example, Judith, also a Jewish heroine, was sometimes depicted as beheading Holofernes in a way that verges on sadism (see the first section of this catalogue).

The inclusion of the story of Jael and Sisera in a Power of Women series is unusual and dependent, it seems, on Lucas' own idiosyncratic thought. In later printings, the six woodcuts forming this series were joined with elaborate, architectural enframements and tablets containing Latin or Dutch biblical commentaries in the lower center. It remains uncertain whether or not Lucas chose these captions, but he is thought to have designed the enframements. In the present instance, the last line of the commentary is said to be from the apocryphal text, Ecclesiasticus (Sirach) and has been read: "Nothing is as evil as a woman's malice."[2]

1. Washington 1983, 172.
2. Washington 1983, 172, and cats. 61 and 62, for illustrations of both the first and second printings of the image.

93
Marcantonio Raimondi, after Raphael

Joseph and Potiphar's Wife
Engraving, c. 1517
208 x 246 (8³/₁₆ x 9¹¹/₁₆)
Bartsch 9
Rosenwald Collection 1943.3.7349

Like a great many of Marcantonio's prints, this subject and
composition were taken from a work by Raphael. In this case,
the source was one of three ceiling frescoes devoted to the life
of Joseph that are in a bay in the Vatican Logge. The other
two are *Joseph's Dream* and *Joseph Sold by His Brethren.* Marc-
antonio's engraving shows the action in the same direction as
the fresco.[1]

Potiphar's wife was an unscrupulous, vengeful, and power-
ful woman. According to the story related in Genesis 39:1–23,
Joseph had been bought and taken to Egypt by Potiphar, an
officer of the Pharaoh. Joseph found favor with his master,
but as he was "handsome and good-looking," he also at-
tracted the attention of Potiphar's wife, who made numerous
attempts to seduce him. A virtuous young man, Joseph re-
refused to sin against his master and against God. Potiphar's
wife made one last attempt when she and Joseph were alone
in the house, but he fled on her approach, leaving his gar-
ment in her grasping hand. She then, with his garment as evi-
dence, accused him before the men of the household and
before her husband of having tried to seduce her, and Pot-
iphar had him imprisoned. Joseph was later released by the
Pharaoh for interpreting a dream and placed over all others in
Pharaoh's court.

The story is an illustration of the dangers of a lustful
woman. It is effectively communicated through the simple
setting, with its focus on the bed, and through the gestures of
the two figures. There are numerous visual representations of
the subject during the periods under study here.

1. See Dussler 1971, 89, pl. 150. As Dussler points out, twelve of the
thirteen bays in the Logge, constructed by Raphael in his role as
Vatican architect, are devoted to Old Testament scenes.

94
Hans Burgkmair

Samson and Delilah
Woodcut, c. 1519
123 x 100 (4¹³/₁₆ x 3¹⁵/₁₆)
Hollstein 5
Rosenwald Collection 1943.3.2127

"Samson loved Delilah, she betrayed him, and what is worse, she did it for money."[1] The story of Delilah cutting off Samson's hair, which he finally revealed to her as the source of his enormous physical strength, is told in Judges 16:4–21. Most representations show Samson asleep on Delilah's lap, having been overcome by strong drink, as is the case here. Made groggy by the contents of the wine flagon seen to the left of the figures, he falls easy prey to Delilah's deception, for which she has been paid many pieces of silver by Samson's enemies, the Philistines. In the following print (cat. 95), the two are shown indoors, and the soldiers are entering the room.

In several later versions of the subject by Rubens, including a painting of c. 1610 (now in the National Gallery, London), Samson's youthful and powerfully muscular body is emphasized, making his "fall" more pronounced. In that work as

well, Delilah's breasts are bare, making explicit her sexual attraction for Samson, which became the critical weapon in his undoing. The Philistines gouged out his eyes after capturing him, and chained him to a millstone, making him grind flour. As Madlyn Kahr has noted, this was meant to be particularly humiliating because grinding flour was supposed to be a woman's work.[2] Samson, of course, eventually "triumphed" over his enemies. When his hair—and strength—grew back, he pulled down the Philistines' temple, killing thousands of them, but also himself.

The subject was often depicted as part of the Power of Women stories, which emphasized heroic or wise men who were overcome by woman's wiles (see cat. 87). This print is one of four woodcuts by Burgkmair in a series on the "Follies of Love," which includes *Bathsheba at Her Bath* (cat. 97).

1. The pithy phrase is Kahr's in Broude and Garrard 1982, 119.
2. Broude and Garrard 1982, 122. The essay by Kahr, 118–145, has numerous illustrations of visual works, many of them prints, and the theme is thoroughly discussed. She interestingly explains the ways in which Samson was considered to be a typological figure of Christ.

95
Hans Brosamer

Samson and Delilah
Engraving, dated 1545
81 x 98 (3³/₁₆ x 3⁷/₈)
Hollstein 2
Rosenwald Collection 1943.3.2112

For the story of Samson and Delilah, see cat. 94. It was
frequently used to illustrate the Power of Women topos (see
cat. 87).

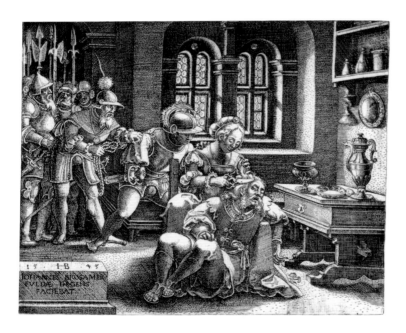

96
Lucas van Leyden

The Poet Virgil Suspended in a Basket
(from *The Large Power of Women* series)
Woodcut, c. 1512
412 x 286 (16¼ x 11¼)
Hollstein 89 2/2
Gift of W. G. Russell Allen 1941.1.170

The Roman poet Virgil, author of the *Aeneid, Eclogues,* and
Georgics, was well known in the middle ages, and many leg-
ends grew up around him, both as a famed pagan and as a
supposed magician. He was most famous for his Fourth
Eclogue, also known as the "Messianic Eclogue" (c. 41 B.C.),
in which he celebrated the birth of a boy who would bring
prosperity and peace to the world. By the Roman Church
Fathers, especially Jerome, this was taken to be a prediction of
the birth of Christ, and Virgil was called "a Christian without
Christ."[1]

The incident shown here, however, is very similar to the
story of Aristotle and Phyllis (cat. 87), in which another famed
pagan succumbed to the charms of a woman and made a fool
of himself. Virgil, according to this legend, became enamored
of the Roman emperor's daughter. She suggested that he
come to her room one night by getting into a basket and be-
ing pulled up the wall of the tower to her room. He tried
this, but she tricked him, stopping the basket halfway up the
wall and thereby subjecting him to ridicule the next morning
when people passed by. Lucas does not show the woman but
rather focuses on Virgil in the basket and the crowd below
him. The subject was a popular one, appearing in the prints
of a number of artists as well as in other media.[2]

This impression is a late one, as can be seen especially in the
evident cracks in the woodblock, which printed as white or
broken areas of black ink.[3] It is one of six woodcuts by Lucas
that compose his *Large Power of Women* series, others shown
in cats. 90, 92, and 100. On the Power of Women theme,
see cat. 87.

1. See R. D. Williams and T. S. Pattie, *Virgil: His Poetry through
the Ages* (London, 1982), especially 84–93.
2. See Marcello Fagiolo, *Virgilio nell'arte e nella cultura Europea*
[exh. cat., Biblioteca Nazionale Centrale] (Rome, 1981), 67–69, for a
brief discussion and several illustrations.
3. For reproductions of both a first and second state of the print, and
a discussion of it, see Washington 1983, cats. 37, 38.

David's other soldiers. The king tried to cover up the adultery by arranging for Uriah to return to his wife, but out of devotion to his comrades, Uriah refused. This led David surreptitiously to order Uriah's death in battle. After Uriah died, David and Bathsheba were married. Bal has referred to the narration as "a story of sex and war, concealment and murder, the use of a woman and the abuse of power."[2]

In various interpretations, it is Bathsheba who is blamed for what happens in the story.[3] An inscription on one depiction of Bathsheba bathing (one of several scenes on a tapestry of 1561) puts it very directly: "David would have remained unsullied, had Bathsheba covered her body."[4] It is woman who incites men to lust, and lust can cause perfidious acts. David, like Solomon, his (and Bathsheba's) son, was known for his great wisdom, but he was nevertheless led astray. He later repented and was held up as an exemplar of humility for rulers.

1. The other two prints are *Aristotle and Phyllis* and *Solomon's Idolatry*.
2. Bal 1987, 10. In her introduction to this fascinating and valuable study, Bal mentions literary theory, feminism, and narrative theory as the three discourses that meet in her study of biblical love stories. "It is my contention that, in spite of major differences in the innumerable readings of the Bible, there has been in Christian, Western culture a continuous line toward what I refer to as 'the dominant reading': a monolithically misogynist view of those biblical stories wherein female characters play a role, and a denial of the importance of women in the Bible as a whole."
3. See Bal 1987, 10–36.
4. Quoted by Smith 1978, 216. She mentions David and Bathsheba a number of times throughout her study.

97
Hans Burgkmair

Bathsheba at Her Bath
Woodcut, dated 1519
119 x 95 (4¹¹/₁₆ x 3³/₄)
Hollstein 2 1/3
Rosenwald Collection 1949.5.92

This is one of four small woodcuts by Burgkmair that formed a Power of Women set usually referred to in this instance as *Liebestorheiten* (Follies of Love). The set includes *Samson and Delilah* (cat. 94).[1]

In the story of David and Bathsheba, recounted in 2 Samuel 11, David is said to have remained at home without much to occupy him, while his army was away fighting. One afternoon, he looked out of a window in his tall house and saw a beautiful woman bathing, the scene shown in this print. He wanted her, and as Mieke Bal has remarked, because he was powerful, he had her. She became pregnant. But she was the wife of Uriah the Hittite, who was away waging war with

98
Allaert Claesz.

David and Bathsheba
Engraving, c. 1520–c. 1555
72 (2¹³/₁₆) (diameter)
Bartsch 9.121.9
Rosenwald Collection 1944.8.6

For the story of David and Bathsheba, see cat. 97. In contrast
to Burgkmair's version, Claesz.'s Bathsheba is fully clothed,
with only her feet in the bath, and her back is to David, as he
stares out the window toward her. The peacock included in
the image is probably a reference to vanity, presumably the
vanity of the beautiful Bathsheba.

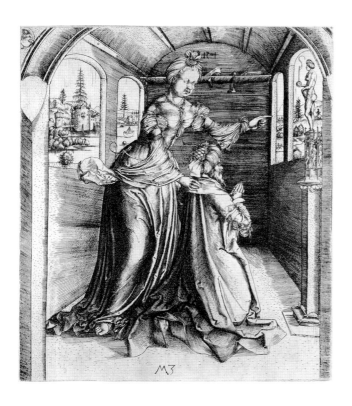

99
Master MZ

Solomon Worshiping False Gods
Engraving, dated 1501
185 x 157 (7¼ x 6³/₁₆)
Lehrs 1
Rosenwald Collection 1949.4.1

The subject of this print and of the following two (cats. 100 and 101) is derived from 1 Kings 11:1–13. It is there told how Solomon was induced by his pagan wives to give up the God of Israel and to worship instead false gods or pagan idols. It is not surprising that the subject was a popular one in the Power of Women topos (see cat. 87). Considered a biblical sage, Solomon permitted himself to be duped by women into sacrilegious behavior.

In the Master MZ's rendition of the story, Solomon kneels in front of the statue of a female nude who is supported by a stand that features other female nudes. In the context of the image, the nudes suggest that a reason for Solomon's turning away from the true God was the sexual influence of his wives. Here he is encouraged in his false worship by a single wife, who stands behind him, touching his shoulder with one hand and pointing to the statue with the other. Her huge size in relation to the room they are in serves to emphasize her powers of persuasion over him. Through the windows, one sees the calm countryside, which contrasts with the bareness and smallness of the room.

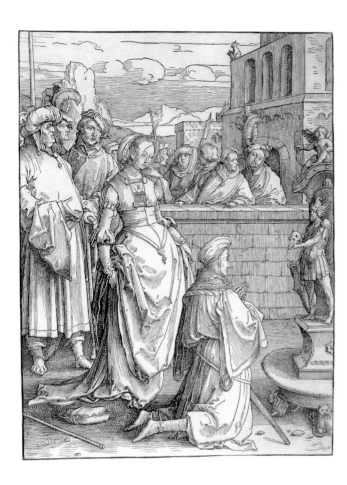

100
Lucas van Leyden

Solomon's Idolatry
(from *The Large Power of Women* series)
Woodcut, c. 1512
417 x 292 (16³/₈ x 11¹/₂)
Hollstein 8 1/3
Rosenwald Collection 1950.1.100

For the subject, see cat. 99. As Jacobowitz and Stepanek have pointed out, there are two especially important aspects to Lucas' rendering of this theme. First, he has placed a cupid above the statue of the "false god," thereby suggesting that it was love, false itself, which led Solomon to his idolatry. Second, in contrast to some versions of the subject, Solomon and his pagan wife are here surrounded by onlookers; this suggests that his idolatry is not simply a private matter but rather affected his people as well.[1]

The issue of religious images and of idolatry was to become a matter of intense debate during the Protestant Reformation and the Catholic Reform. Some Protestants (though not Luther, for example) took up firm iconoclastic views. The iconoclasts were to use Solomon's idolatry as an example of the deleterious effects of images on the faithful. Freedberg has pointed to another image by Lucas, his *Dance around the Golden Calf* of c. 1530 (Rijksmuseum, Amsterdam), as indicating the pronounced irony of looking at and admiring a work of art. Remarking that the painting's virtues are purely visual, not devotional, he notes that Lucas chose a subject "which proved how wrong it was to feast one's eyes on rich material idols."[2] Whether Lucas was already attuned in the present print to the burgeoning contemporary criticism of idolatry is impossible to know. Presumably the artists of the Reformation period would have maintained, necessarily and tenaciously, that it was indeed possible to separate the image as an inspiration to worship and thought from the worship of the image itself.[3]

1. See Washington 1983, cat. 35.
2. Freedberg 1989, 378–385, and fig. 177, for an illustration of Lucas' painting. He points out that the format for the painting is the triptych, traditional for religious images.
3. Cf. Washington 1983, 113 n. 3.

101
Albrecht Altdorfer

Solomon's Idolatry
Engraving, c. 1519
60 x 40 (2³/₈ x 1⁹/₁₆)
Winzinger 136b
Rosenwald Collection 1943.3.397

Altdorfer's version of this subject, in contrast to Master MZ's and Lucas van Leyden's (cats. 99, 100), depicts Solomon and one of his wives standing in front of a niche in which is placed an idol. Solomon has not yet given in to his wife's pleas to give up the God of Israel. As in the case of the Master MZ's print, the statue here is of a female, lending further emphasis to the fact that Solomon was tempted by women.

In the same year that this print was executed, Altdorfer made two etchings of the Regensburg synagogue, a medieval building with an interior of pointed arches and vaulted ceiling. The building here is similar to that in the etchings, but not identical.[1] Nevertheless, there may be some connection. In February of 1519, the city council, of which Altdorfer was a member, voted to expel all Jews from Regensburg, and the task was accomplished within a week. Almost immediately afterward, the synagogue and the entire Jewish quarter were destroyed. It is possible that Altdorfer meant to suggest that while Solomon worshiped false gods, so did all of the Jewish people.[2]

1. See Detroit 1983, cat. 100.
2. Winzinger made this proposal same years ago; see catalogue raisonné entry 136b.

102

Herman Jansz. Muller, after Maerten van Heemskerck

Judah Gives Tamar a Bracelet
(from the *History of Judah and Tamar* series)
Engraving, c. 1566
205 x 263 (8¹/₁₆ x 10⁵/₁₆)
Hollstein 31
Ailsa Mellon Bruce Fund 1974.33.53

The story of Judah and Tamar is told in Genesis 38. Judah chose Tamar to be the wife of his firstborn, Er, but Er was wicked, and the Lord slew him. Because Er died childless, Judah, according to the custom of levirate marriage, told his second son, Onan, to lie with Tamar so that his brother Er would have offspring. Onan deliberately spilled his seed, and the Lord slew him. Judah then told Tamar to return to her father's house until his third son, Shelah, grew up. Later, Tamar discovered that Shelah had grown up, but she had not been given to him in marriage. She then put on a veil to disguise herself and sat by a road where Judah would pass by. He took her for a harlot and had sex with her. He promised her a kid from his flock, and she took his signet, cord, and staff un-til the kid would be delivered to her. She subsequently could not be found, but later Judah was told that Tamar was pregnant from having played a harlot, and he ordered that she be burned. She then revealed to him by returning to him the signet, cord, and staff that it was he who had impregnated her. Judah admitted that Tamar was more righteous than he because he had not given her Shelah. Henceforth he respected her, and she gave birth to twins.

Bal has given this story an interesting interpretation. "*Discernment* is what she teaches him. Her action does not provide her with the husband that was her goal. But it does provide Judah with the offspring he was longing for. As in many biblical tales, the woman is used for her indispensable share in the course of history, as the sidestep that restores broken chronology. As is often the case, she is also used to teach man insight into his own paralyzing neuroses. . . . Overprotective fathers paralyze their sons and thus, by trying to remain the only subject, kill their own family and stop history."[1]

This is the first of four prints in the series, which culminates in the birth of the twins (Hollstein 31–34).

1. Bal 1987, 102, and 89–103, for her full treatment of the biblical narrative.

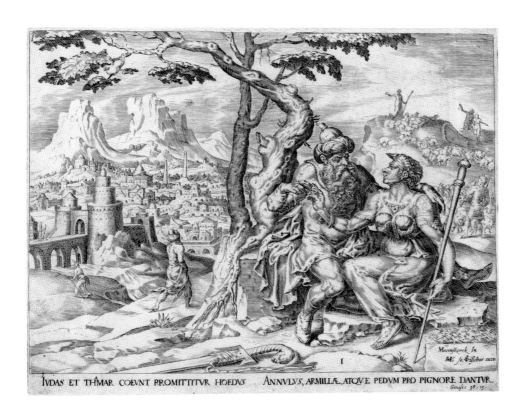

IVDAS ET THAMAR COEVNT PROMITTITVR HOEDVS ANNVLVS, ARMILLÆ, ATQVE PEDVM PRO PIGNORE DANTVR.
Genesis 38. 15.

103
Albrecht Dürer

Witch Riding on a Goat
Engraving, c. 1500–1501
115 x 72 (4¹/₂ x 2¹³/₁₆)
Meder/Hollstein 68
Rosenwald Collection 1943.3.3556

The persecution of witches began in the fifteenth century. Before that, these creatures were more correctly called sorceresses, and they were widely regarded as benign and sometimes even as helpful.[1] The artist who created more images of witches than any other during this period, in paintings, drawings, and prints, was Baldung Grien (see cat. 105 and fig. 103a). Dürer, by contrast, rarely depicted witches; this print and cat. 104 are his principal works dealing with the subject. He would have been familiar with the *Malleus Maleficarum,* the treatise on witchcraft published about 1486 and

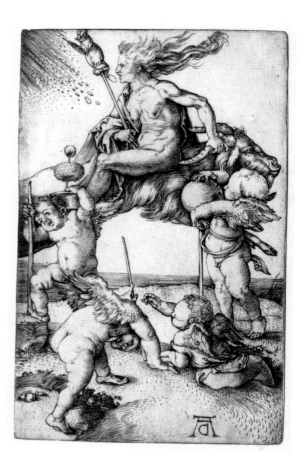

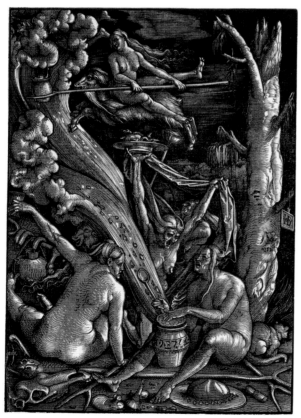

fig. 103a. Hans Baldung Grien, *The Witches' Sabbath,* dated 1510, chiaroscuro woodcut, 379 x 260 (14¹⁵/₁₆ x 10¹/₄), Museum of Fine Arts, Boston, Bequest of W. G. Russell Allen (Hollstein 235).

frequently reprinted thereafter. Compared with its predecessors, the *Malleus,* although unillustrated, had extraordinarily vivid verbal imagery and was marked by a misogynistic bent that is astounding in its fervor.[2]

Dürer's images are fairly mild compared with the *Malleus* or Baldung's representations. The present image is perhaps most striking initially for the inventiveness and elegance of its design. It recalls the clever alphabet figures by the Master E.S.[3] Nevertheless, the witch riding backward on a goat is defined as an old hag, which was to become a stereotypical way to depict witches. She holds a distaff. Traditionally used in spinning and weaving, it was a positive symbol of the faithful housewife. Here, however, it recalls the belief that witches rode on such poles at night as they performed nefarious acts. Riding backward itself is a symbol of evil.[4] The hailstorm seen at the upper left refers to the belief that witches created violent weather to damage farmers' crops.

As Anton Blok has made clear, the goat had long been considered a lascivious, unclean, and evil animal.[5] Traditionally,

goats were cared for by women and were thought to be animals of the devil. He-goats permit access to their females and hence, to call a man a he-goat in Italian, Spanish, or Portuguese is to imply that he consents to the adultery of his wife.[6] When a man has been cuckolded, he is said to have "horns," and these derive from the horns of the goat. The goat thus makes an appropriate beast for the witch to ride, especially as witches were thought to have the power to emasculate men by making them impotent. Dürer's witch controls the beast as she firmly grasps the goat's horn, long recognized as a phallic symbol.

Putti with wings are familiar in such images of love as depictions of Venus with Adonis and Venus with Mars. Here their usual function is turned topsy-turvy as they become little warlocks, which witches had the power to cause. Indeed, one putto literally is about to stand on his head.[7] The sticks that the putti hold are also suggestive of phallic elements, as well as being common devices for controlling both people and animals.

1. The literature on witchcraft is enormous, but on this point see, for example, Dresen-Coenders 1987, 59.
2. For a translation of the *Malleus Maleficarum* into English, see Summers 1970. For discussions of it, see especially Dresen-Coenders 1987; Davidson 1987; and Klaits 1985. Schuyler 1987, 20, has noted that between about 1487 and 1520, there were fourteen editions of the work published in Germany, France, and Italy. As she notes, it "was the first manual to codify the heresy of witchcraft as including the pact with the devil, the witches' Sabbat or Sabbath, and night flight."
3. See, for example, Philadelphia 1967, cats. 72–75.
4. For an extensive investigation, see Ruth Mellinkoff, "Riding Backwards: Theme of Humiliation and Symbol of Evil," *Viator* 4 (1973): 153–176, especially 166–176.
5. Blok 1981, 428–429, notes that "in Mediterranean thought, rams and billy-goats form a distinct pair. Their opposition reflects the differences between honour and shame." The article is concerned with men's codes of honor in Mediterranean countries.
6. Blok 1981, 428, explains that the Italian *becco* and *cornuto,* the Spanish *cornudo* and *cabrón,* and the Portuguese *cabrão,* all denote both billy-goat and a man who consents to his wife's adultery.
7. To turn various people and functions topsy-turvy, especially as regarded the sexes, was very popular at the time. See, for example, Moxey 1989, 101–126.

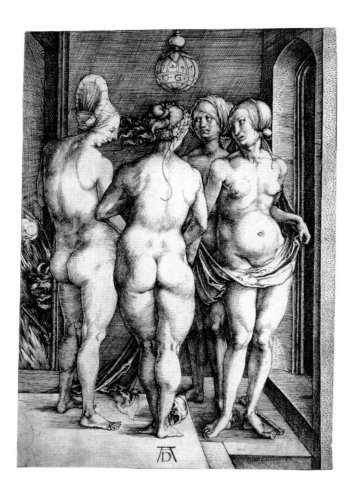

witches. Of the sphere hanging from the ceiling and bearing the initials "O.G.H.," he wrote that it was probably an abbreviation for "O God protect us from conjurers" (*O Gott hüte uns von Zaubereyen*).[2] Panofsky proposed that the print might have been drawn from a story in the *Malleus Maleficarum*, a late fifteenth-century treatise on witchcraft by two Dominican priests. It tells of three women who broke into a lady's chamber and destroyed the child in her womb "by touching her belly and pronouncing an evil imprecation."[3] As Charles Talbot has pointed out, however, all four women in this print seem willing participants in whatever is happening; it may be, as he suggested, that the young woman with her back to us is ridding herself of a devil's child.[4]

More recently, Eugene Dwyer, in a long article, concluded: "The proper identification of these four figures is extremely complex. To their identification as Venus and the three Graces . . . should be added the four Seasons, the four temperaments, the four elements, the nymphs that are called Naiads, and the three Fates and Discord. Above all these, the traditional identification of the figures as four witches is equally correct—and remains the most comprehensive. The subject of the engraving is indicated by the letters "O.G.H.," *Origo Generis Humani*" (that is, the "origin of the human race").[5] While Dwyer's reading is not thoroughly convincing, it does provide stimulating ideas, and it serves to emphasize further the haunting power of the image, in which one certainly feels the invocation of elemental forces.

This is the first engraving that Dürer dated, and given that it was made in 1497, one wonders if it is related to the coming end of the century, which has almost always called forth various kinds of anxieties and disquietude on the part of people.

1. For references to various analyses of the print, see Washington 1971, cat. 12; and Dwyer 1971, 470–472.
2. As quoted in Dwyer 1971, 456. Joachim von Sandrart was a seventeenth-century German historian and theorist of the arts.
3. Panofsky 1971, 71.
4. Washington 1971, 119. Witches were widely thought to copulate with the Devil, who supposedly appeared to them in human male form. Some testified, when on trial, to his "icy, cold member," which became almost a cliché.
5. Dwyer 1971, 470. See, however, Washington 1971, cat. 12, n. 8, for some of the numerous ways in which the initials could be spelled out.

104
Albrecht Dürer

Four Naked Women (The Four Witches)
Engraving, 1497
189 x 131 (7⁷/₁₆ x 5¹/₈)
Meder/Hollstein 69
Rosenwald Collection 1943.3.3462

The subject of this print has been explained by some scholars as deriving from classical mythology and by others as representing witches.[1] While the three full-length figures in front are reminiscent of the Three Graces, the ominous elements in the image are much more suggestive of witchcraft. A skull and bone lie on the floor amid the feet of the women, and in the doorway at the left is a monstrous devil, surrounded by flames and smoke. Joachim von Sandrart, in 1675, was the first to make these observations and to designate the women as

105
Hans Baldung Grien

Bewitched Groom
Woodcut, c. 1544
338 x 199 (13¼ x 7¹³/₁₆)
Hollstein 237
Gift of W. G. Russell Allen 1941.1.100

This famous woodcut by Baldung has been the focus of a great many articles and varying interpretations, suggested by arguments too complex to be rehearsed here with any thoroughness. I will, therefore, comment only on what I think are the most important aspects of the image and give the work a limited reading. References are made to the critical earlier literature.

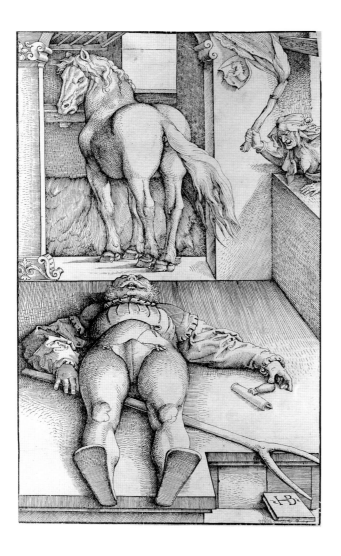

We see part of a stable laid out in sharp perspective. A horse stands partly in and partly out of its stall, the floor of which is covered with hay. The horse is seen form the rear, its tail swished to the right, its head twisted to the left, and its eyes focused on the viewer. To the right on the facing wall is a shield or coat of arms with a unicorn. Also at the right, an old hag, barebreasted, hangs over a window ledge, looking at the figure of a man stretched out on the floor toward the viewer, his feet foremost. The woman holds a lighted torch. The man on the floor is identified as a groom by the curry comb that his left thumb touches and by the pitchfork on which he lies. He appears to be unconscious or possibly dead, his mouth open, his eyes closed. At the lower right is a tablet with Baldung's monogram on it.

The sharp perspectival scheme orders one's visual experience of the elements depicted in the image and, at the same time, provides a strikingly rational framework for the nightmarish expressive effect of the scene. But what, in fact, does the scene represent, beyond the brief description given above? Most reasonably, the old hag is a witch, and she has either cast a spell on the groom herself or has participated with the horse in doing so. Witches were sometimes thought to take the form of horses, but the horse is more likely functioning here as a representation of ferocious, animalistic instincts. The man who has come to the stable to groom and perhaps feed the horse has been repelled from his tasks. He who should be in control, certainly by virtue of his superior human intellect, has lost control to an enraged animal.

The witch appears to be the activator of the irrational force loosed here and by her very nature suggests that the force is demonic. Her torch flame knocks askew the shield with the unicorn. For centuries, the unicorn was understood to represent purity, and in the middle ages, it had significance as a Christological symbol. It is thereby sharply contrasted with the huge, angry horse in the stall.

Irrationality and its power are further evident in what must be a purposeful emphasis on the groom's codpiece and on the horse's hindquarters and genital area, both emphasized by the perspective scheme. Clearly sexuality is one of the most powerful drives that people and animals share. During the Renaissance, men were supposedly infinitely more capable than women of controlling their passions, but this particular man has seemingly failed to do so; there is a suggestion, I think, of attempted bestiality or enticement in that swished tail, and it serves, again, to emphasize the degradation to which one can be led by passion or instinct.

To what extent the print incorporates self-referential elements to Baldung remains uncertain.[1] The shield has been identified as being part of the Baldung family's coat of arms.[2] The groom has been proposed as a self-portrait.[3] Baldung was about sixty-one years old when he made the print and was to

die the next year. He was married but had no children. He had also lived through the excruciatingly painful period of the Protestant Reformation. His own intellectual direction, moreover, and his art had moved almost immediately away from the order and rationality exemplified in Dürer's art, with which he was intimately familiar as a young man.[4]

Baldung's images are complex and challenging and no doubt demand a multivalent interpretation. They reflect acutely, it seems, his response as an artist and a man to the complex world in which he lived. We might focus on his treatment of horses briefly, for it seems to provide a key of sorts toward unlocking the meaning of his images. During the Renaissance period, both Leonardo and Dürer studied and rendered the horse as an embodiment of ideal beauty based on proportional schema, a noble beast. Dürer once intended to include proportional studies of the horse in his treatise on painting.[5] Baldung twice referred to Dürer's horses, once in his *Groom Bridling a Horse* of c. 1510–1512, which is based on Dürer's *Small Horse* of 1505, and again in the present work, which is based on the *Large Horse,* also of 1505.[6] In each case, he gives the animal a very different inflection from Dürer's. The groom in the early print can barely control his steed; he plants his feet on the ground to restrain forward motion, and holds onto its mane and unbridled muzzle. And in this woodcut, of course, the groom has lost control altogether. Finally, in a series of three woodcuts dated 1534, Baldung gave over the images to wild horses in the woods. They fight each other, and they are filled with frenzied sexual passion.[7] Baldung's early parodying of Dürer's art turned, in the end, to his asserting unequivocally the enormous and consuming power of irrationality. That he used the horse as a prime vehicle to convey that idea is not necessarily surprising; horses were widely regarded as embodiments of lasciviousness. It is particularly apt, moreover, that he conjoined horse and woman in this late image, for throughout his career, he had consistently portrayed woman as lustful and lethal (see, for example, cats. 70–72).

1. For references to various important interpretations of the print, see especially Washington 1981, cat. 87; and Hults 1984, 259–279. Hults has long studied Baldung's work, beginning with her doctoral dissertation: Linda Hults-Boudreau, "Hans Baldung Grien and Albrecht Dürer: A Problem in Northern Mannerism" (Ph.D. diss., University of North Carolina, Chapel Hill, 1978). Her 1984 article is the most balanced and perceptive treatment of the print to date, and I am in nearly full agreement with the views she expresses there.
2. For illustrations of the coat of arms and a related drawing, see Washington 1981, fig. 87a and cat. 88. Baldung's ancestors, who were from the town of Schwäbisch-Gmünd, adapted the unicorn from the town's coat of arms.
3. See Washington 1981, 275.
4. See Kaufmann 1985, 28–33.
5. Washington 1971, 134 n. 3. In the discussion there of Dürer's en-
graving, *The Small Horse,* cat. 33, it is suggested that Dürer must have known some of Leonardo's proportional studies of horses.
6. Kaufmann 1985, 30–31, discusses Dürer's pendant prints in relation to Baldung's *Groom* as well as the present print, and reproduces all four prints, figs. 9–12.
7. For reproductions and discussions of these woodcuts, see Washington 1981, cats. 83–85.

106
Giovanni Benedetto Castiglione

Circe Changing Ulysses' Men into Beasts
Etching, c. 1650
212 x 312 (8⁵/₁₆ x 12¹/₄)
Bartsch 22
Ailsa Mellon Bruce Fund 1972.70.2

Circe was a sorceress who specialized in changing men and women into beasts. Her most famous appearance is in Homer's *Odyssey,* where she cast her spell on Ulysses' men. Ulysses himself was protected from her powers by a small plant (moly) that Hermes had given him, and he threatened to kill her unless she promised not to harm him. She swore not to, and she changed his crew back into men, taller and more handsome than before. Circe became Ulysses' mistress, and he and his men stayed on the island of Aeaea with her for a year.[1] In Castiglione's print, she is shown with her magic wand, books that show astrological calculations, various animals, and a great peacock. The armor in the center of the print, cast on the ground, undoubtedly refers to the men Circe has changed into beasts.

Suida Manning has pointed out that Circe has become pensive in this print and no longer dominates her realm as she does in earlier versions of the theme by Castiglione.[2] The scholar sees this as the beginning of Castiglione's amalgamation of the sorceress theme with that of the Vanitas theme, as seen in his etching *Melencolia* of about 1647.[3] Castiglione's message comes to center on the futility of all human endeavors, as time destroys even the powers of the sorceress.

1. See Tripp 1974, 164–165, for brief remarks on Circe, and 409–410, for an outline of her encounter with Ulysses.
2. See Bertina Suida Manning, "The Transformation of Circe: The Significance of the Sorceress Subject in 17th Century Genoese Painting," in *Scritti di storia dell' arte in onore di Federico Zeri* (Electa Editrice–The J. Paul Getty Trust, 1984), 2:689–708. P. Askew called this article to my attention.
3. On the *Circe* and *Melencolia* prints as well as on related works, see also Ann Percy, *Giovanni Benedetto Castiglione: Master Draughtsman of the Italian Baroque* [exh. cat., The Philadelphia Museum of Art] (Philadelphia, 1971).

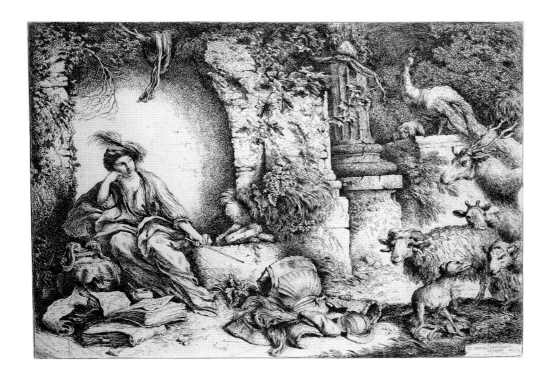

107
Albrecht Dürer

The Dream of the Doctor (Temptation of the Idler)
Engraving, 1498/1499
187 x 119 (7³/₈ x 4¹¹/₁₆)
Meder/Hollstein 70
Rosenwald Collection 1943.3.3481

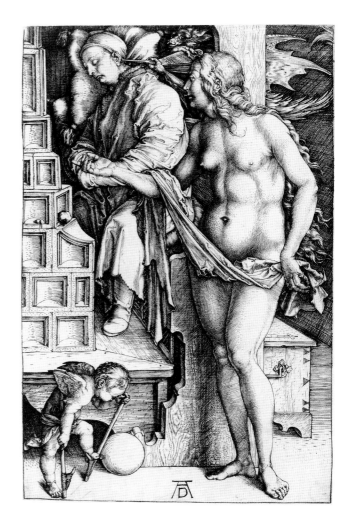

Panofsky's conclusion that the correct title for this print
should be *The Temptation of the Idler* seems unassailable. The
man sits in front of a large ceramic stove; warmed, he leans
against a pillow and has fallen asleep, but while he sleeps, a
monstrous devil places the end of a bellows behind his ear.
Panofsky refers to the proverb, "Idling is the pillow of the
devil," and further connects the idle man with the sins of
sloth and luxury. That the latter connection was current at
the time is made clear by an apt quotation from Sebastian
Brandt's *Das Narrenschiff* (*Ship of Fools*), first published in
1494, with many woodcuts by the young Dürer. According to
moral theology, moreover, idleness encouraged lewdness, and
here the sleeping idler's temptation to lust is manifested in
the figure of the nude Venus in the foreground. She is firmly
identified by the small Cupid.[1] The Cupid's awkwardness
with his stilts, and the ball to the right, indicate instability. It
has been suggested that this is symbolic of the instability of
love, as personified by Venus.[2]

Talbot remarked on "the strangely unerotic nude in the
engraving," but this lack of physical appeal seems characteris-
tic of Dürer's usual handling of the nude female form (com-
pare, for example, cat. 63). While he was the first Northern
artist to introduce classically proportioned and modeled
nudes to Germany, his figures of women, in particular, have a
cold, studied quality, rather than projecting the intense sen-
suality of say, Baldung's and Cranach's nude women (see, for
example, cat. 70).

1. For a discussion of the print, see Panofsky 1971, 71–72.
2. Washington 1971, cat. 17. See there also the entry on Brandt's
book, cat. 210.

108
Albrecht Dürer

Desperate Man
Etching, c. 1514–1515
189 x 137 (7⁷/₁₆ x 5³/₈)
Meder/Hollstein 95
Rosenwald Collection 1943.3.3531

This is one of Dürer's most enigmatic images. A high rocky landscape encloses the figures, separating them from the space beyond, visible at the upper right. A voluptuous, nude female is lying down at the right, asleep against a pillow (it seems). The lower part of her torso is obscured by a kneeling male nude. His body is young and muscular, but his face is hidden by a mass of hair, which he tears at with both hands. Some writers have suggested that his head is on backward, and he is attempting to turn it around. Behind him, a youth stands looking at the woman, with a tankard in his hand and a stolid expression. At the left, is a half-length male figure shown in profile, fully dressed and wearing a hat. He also

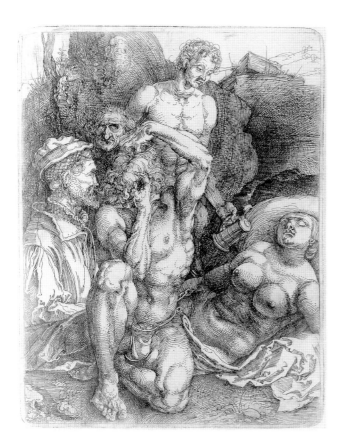

looks at the woman. Placed just above him is the disembodied head of a wall-eyed old man.

Some scholars have suggested that the print is from a plate on which Dürer was testing out the new medium of etching; it may be his first etching. It has also been thought to be the recording of a dream, and hence lacking in conscious meaning. Panofsky has proposed, however, that it represents the doctrine of the four humors.[1] In this reading, the desperate man is melancholic, the old man is choleric, the young man is sanguine, and the woman is phlegmatic. The man at the left in profile, who resembles a drawing of Dürer's brother, Endres, represents a normal, healthy individual. One might ask if the print was made for Endres, if it is "about" him, or indeed if it has anything to do with him as a person?

In the context of the present exhibition, the image may suggest another reading, but not necessarily one that is contradictory to others. The image is indeed dreamlike. The only completed body is that of the desperate man. That he has no face means that any of the other men's faces theoretically could be placed on his shoulders. Those men certainly offer themselves as three distinct ages: young, middle, and old age. By contrast, the young woman remains, as it were, forever youthful, voluptuous, tempting, and unknowable. She recalls numerous sleeping figures from ancient and Renaissance art, and like many of them, she is intimately allied with nature, or indeed is a sleeping *Natura*.[2] We might propose, further, that she is asleep both literally and figuratively, unaware that men of consciousness are confronting her, men of different ages who study her but do not, or cannot, act in relation to her. In this sense, she may be said to represent the eternal, and eternally mysterious woman, whose very existence incapacitates man and outlasts him.

1. See Panofsky 1971, 194–195.
2. On the alliance of nature and woman, see Ortner 1974; and Merchant 1980. See here the illustrations of the sleeping nudes by Giorgione (fig. 80a) and Cranach (fig. 76a).

109
Hans Baldung Grien

The Three Fates: Lachesis, Atropos, and Clotho
Woodcut, dated 1513
223 x 155 (8³/₄ x 6¹/₁₆)
Hollstein 236
Rosenwald Collection 1943.3.904

In *The Three Fates,* three women—one young, one middle-aged, and one old—all participate as the oldest prepares to cut the thread of life of some unknown person. According to some sources, the earliest writer to name the Fates individually was Hesiod in his *Theogony,* where he first called them the daughters of Night and later the daughters of Zeus and Themis and sisters of the Seasons.[1] They came to be associated with different phases of life, that is, birth, marriage, death, just as, in later writings of the middle ages and the Renaissance, they were often conflated with Fortune and Chance.[2]

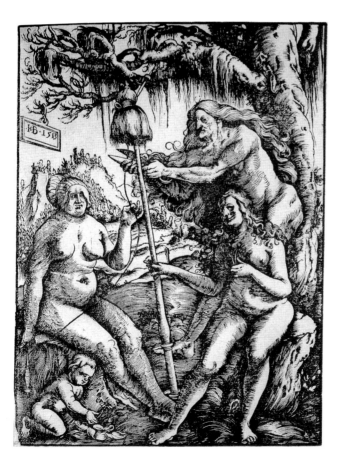

Baldung shows them as they were often represented: spinning, measuring, and cutting the thread of life. As Talbot has pointed out, they closely resemble the artist's depictions of witches, and with the inclusion of the small child at the lower left, they refer to the four stages of life, a theme that Baldung also explored in painting, again using female nudes.[3] Jean Wirth emphasized the natural setting for the scene, with the great moss-laden tree and the flowers that the child touches and the youngest Fate holds to her bosom. He suggested an analogy to Isaiah 40:6–8: "All flesh is grass, and all its beauty is like the flower of the field. . . . The grass withers, the flower fades; but the word of God will stand forever." Certainly he is correct in stressing that the cycle of life is here represented by the degeneration of the flesh.[4] The image, moreover, has a strongly chilling quality not only because of its theme but also because of the facial expressions of the three women, especially that of the youngest, who smiles in a demented way.

Talbot has emphasized the apparent link in Baldung's mind between women and death.[5] While this association is not uncommon in Western art and thought, Baldung's often powerful images convey it with particular force. We should note, finally, that the impression exhibited here must be a rather late one since many of the lines have not held the ink well, resulting in muddy passages.

1. See, for example, the entry on the Fates in Tripp 1974, 246–247.
2. See the discussion in Cioffari 1973, 225–236, as well as the introductory essay on Fortune the final section of the present catalogue.
3. Washington 1981, 36, and figs. 32, 34.
4. Wirth 1979, 63.
5. Washington 1981, 36.

110
Israhel van Meckenem, after the Master of the Housebook

Coat of Arms with Tumbling Boy
Engraving, c. 1480/1490
147 x 115 (5³/₄ x 4¹/₂)
Lehrs 521
Rosenwald Collection 1943.3.166

The image here presents a mock heraldic device of rather raucous humor. A woman prepares to ride on the back of a man who is down on all fours and apparently letting out a bellowing protest while he holds her distaff. He is perched on a knight's helmet, and the shield below, surrounded by elaborately curving vines, shows another peasant standing on his head. Clearly this is a topsy-turvy world, and it is a world that has its own history.

In the visual arts and literature, as well as in actual carnivals and festivals of the period, inverted gender roles were recurrent themes. Men were supposed to rule women, but the opposite is seen here, as indeed it is in that quintessential image from the Power of Women topos, *Phyllis Riding Aristotle* (cat. 87). This type of image is found in various forms, including another work by Meckenem, the *Angry Wife* (cat. 125), in which the wife attacks her husband for his trousers, symbol of male authority.

Natalie Zemon Davis, in a now classic essay, asked what were the "overall functions" of these gender reversals, and drawing in part on studies by anthropologists and historians of literature, gave the following summary: "they afforded an expression of, and an outlet for, conflicts about authority within the system; and they also provided occasions by which the authoritarian current in family, workshop, and political life could be moderated by the laughter of disorder and paradoxical play. Accordingly, they served to reinforce hierarchical structure."[1]

Images of disorderly and domineering women and henpecked men undoubtedly provided amusement for readers and viewers. Keith Moxey has pointed out, however, that amusement could give way to what he has characterized as the brutality and misogyny evident in certain broadsheets of the earlier sixteenth century. One of his examples is a broadsheet with illustration by Barthel Beham and text by Hans Sachs, *The Nine Hides of an Angry Wife*. To cure his wife's "insubordination," the husband beats her through her nine layers of skin, until she promises never to question his authority again.[2]

Meckenem's image is one of twelve copies he made after works by the Master of the Housebook; the image here is

reversed from the original. Hutchison has suggested that the coat of arms itself, *qua* heraldic form, is also being satirized.[3] In this case, the focus would be on the social pretensions of the lower classes—here indeed peasants are represented—who affect and invent such devices.[4]

1. Davis 1975, 142. Called "Women on Top," the essay explores the idea in all of its richness and considerable complexities.
2. See Moxey 1989, 115–117, and fig. 5.15.
3. Hutchison 1972, 72 (Lehrs 89), and 156, for illustration.
4. Hutchison suggested that burghers were being satirized here, but in Amsterdam 1985, 73, and cat. 89, it is stressed that the print represents a negative view of the peasantry. It is relevant to mention, in this regard, that it has never been decisively determined whether the Housebook Master was Netherlandish or German.

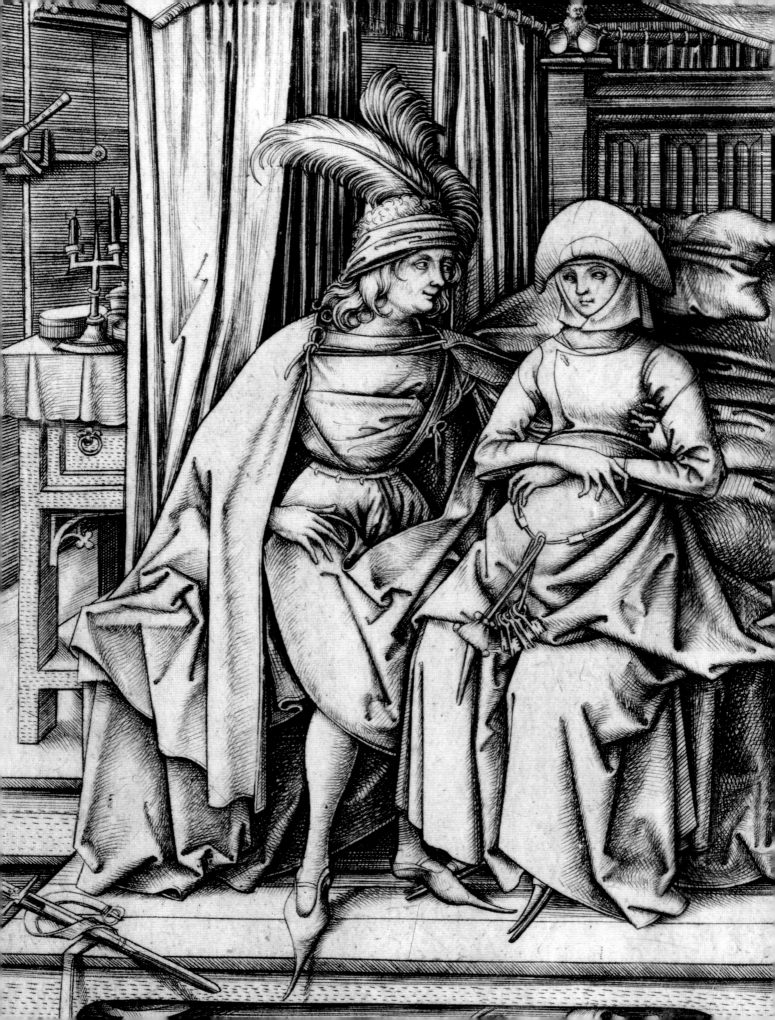

VI
LOVERS, AND LOVERS WITH DEATH

The majority of prints in this section of the exhibition are focused on a man and a woman as they relate to each other in various ways. The moods expressed by the images range from the tender love of two young people (cat. 112) to the acute fear of a woman who, sitting on the lap of a presumed lover, discovers that he is in fact Death (cat. 129). Some images focus on licit, although not necessarily harmonious, relationships. In one print (cat. 125), a wife and husband are engaged in a battle over that common symbol of marital authority: the man's trousers. Other images, conversely, are concerned with illicit relationships, as in cat. 122, which depicts a man about to pay a prostitute for her services.

People of the Renaissance and baroque periods made distinctions between different kinds of love: the love expressed in friendship, that expressed in marriage, and that of rank carnality.[1] Friendship, most often, was a chaste and greatly valued relationship between men, but it could also take place between the sexes. In addition, friendship with one's wife or husband was also extolled as an important part of marriage.[2] The "fury of carnal love," as Alberti called it, was clearly and widely condemned. Licentious behavior, nevertheless, was commonplace, and eroticism is a constant leitmotif in art and literature, as well as in life itself.

From a historical point of view, "courtly love" was on the wane at the beginning of the fifteenth century, although certain of its romantic components lingered on for centuries. Scholars continue to debate what "courtly love" means, and indeed whether it in fact ever existed.[3] Theoretically, at least, it was inextricably bound up with ideals of chivalry, the "manly perfection" cultivated by the military aristocracies of the middle ages. A knight dedicated himself to a lady, and through his devotion to her, he could perform acts of heroism. At the same time, he undertook her protection from any kind of harm. She might be a virgin or someone else's wife, but her relationship with the knight was supposedly a chaste one.[4] An engraving by the Master E.S. reflects the ideal of courtly love (cat. 111). More usually Master E.S. concerned himself with explicitly erotic images of couples cavorting in gardens of love. In these, he often included a court jester or fool to personify the folly of carnal love, while ironically, the image itself offers titillation.[5]

Israhel van Meckenem explored the relationships of various kinds of couples in a number of his engravings. One shown here (cat. 120) shows the popular theme of "ill-matched lovers." These depict foolish old men or old women who are paying young people for their carnal services. In several scenes set in domestic interiors (as in cats. 115–117), Meckenem focused on both licit and illicit sexuality. In actuality, many fifteenth-century people did not have private rooms to which they could withdraw, and sexual intimacy often took place in a room also occupied by other family member or servants. The concept of and desire for privacy, for whatever reason, and their realization came much later.[6]

Soldiers become prominent figures in many images depicting sexual encounters. In one print shown here (cat. 121), a soldier passionately embraces a prostitute. A number of other prints of the time show soldiers moving their gear in baggage trains, and the men are accompanied by women, the proverbial "camp followers."[7] A common saying had it that soldiers were as much in danger from women as from battle. Of all men, whatever their occupation, it was thought that an overindulgence in sexual intercourse could cause death, and women were widely perceived as the insatiable instigators of sex.

It has been noted that there are few periods in which love and death do not play a prominent role in the visual arts.[8] A number of the prints exhibited here show love and death specifically conjoined. In a particularly horrific image, Death attacks and kills a young soldier while preventing the young woman from fleeing by clenching part of her dress in his teeth (cat. 132). It is as if Eros, often depicted with giant wings, has metamorphosed into this winged Thanatos.[9]

Huizinga emphasized the great stress laid on death in the waning middle ages. As he put it, "an everlasting call of *memento mori* resounds through life."[10] This obsession with death as the locus of life continued, *mutatis mutandis,* into the sixteenth and seventeenth centuries. In the works here, it is manifested in two ways. On the one hand, death is invoked in the physical decay that infects the aged, and especially as aging robs women of their former youthful beauty and makes their continuing vanity seem ludicrous (cat. 128). On the other hand, Death is personified in explicit form as a skeleton (cats. 127, 133). As a skeletal form, Death paradoxically moves about as if alive in order to bring the living to an unliving, fleshless state. The juxtaposition of Death with young, vibrant people engenders a particular poignancy. In its most blooming period, life ends. These images are also a strong reminder that many people of the time believed that death appeared in the world as a result of the lust of Eve and Adam.

1. All of these kinds of love are discussed, for example, by Alberti in his *Della Famiglia*. See Guarino 1971. Spiritual love, directed to God, was of course of prime importance.

2. In an essay examining medieval love historically, John F. Benton has noted that Thomas Aquinas "called the affection between husband and wife 'the greatest friendship' (*maxima amicitia*), and following Aristotle said it was based on delight in the act of generation, utility in domestic life, and, in some cases, the virtue of the husband and wife." See Newman 1968, 21.

3. On courtly love, see especially the essays in Newman 1968; and Huizinga 1954, 85–128.

4. Andreas Capellanus wrote a famous treatise, *The Art of Courtly Love,* in which a lover tells a virgin that "pure love" may involve a couple lying together nude on a bed, kissing, and embracing, but "omitting the final solace." Some scholars consider such books to be deliberately "ironic and humorous." See Newman 1968, 3.

5. See Moxey 1980.

6. See Duby 1988, 535–630, as well as Witold Rybczynski, *Home: A Short History of an Idea* (New York, 1986), 15–75.

7. For illustrations of many relevant prints, see Moxey 1989, 67–100.

8. Ann Arbor 1975, 3–39, for an excellent introduction to images of love and death.

9. Koerner 1985, 78, suggests a merging of Eros and Thanatos in relation to Baldung Grien's painting, *Death and the Woman,* as Death embraces and bites the nude woman on her chin. The entire article is a very thoughtful examination of Baldung's works focused on death, including many of his images devoted to Adam and Eve.

10. Huizinga 1954, 138, and 138–151, for his illuminating remarks on "the vision of death."

111
Master E.S.

The Knight and the Lady
Engraving, c. 1460/1465
138 x 113 (5⁷/₁₆ x 4⁷/₁₆)
Lehrs 212
Rosenwald Collection 1943.3.194

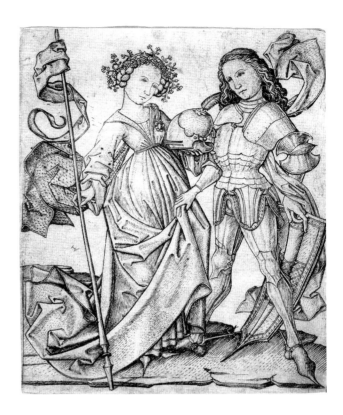

The Master E.S., like a number of other early engravers, made several works that depict amorous couples in garden settings.[1] As Virginia Clayton has made clear, these earthly gardens are profane mirror images of the garden of Paradise, and they are part of a long tradition of love garden imagery that was notably expressed in the famous medieval poem *Roman de la Rose* (completed c. 1277).[2]

In this print, however, the Master E.S. presents a decorous image of a knight and his lady. She holds his lance and helmet, while he holds a shield and touches her gown. Their heads incline gently toward each other, and they are further linked compositionally by the curving X-shape formed by their bodies. Altogether, the image conveys the impression of a licit and harmonious relationship between the two figures.

The name by which the artist is known comes from the fact that he signed some eighteen of his prints with the initials "E.S." Despite archival research, his actual identity remains unknown. He was, however, an influential engraver and is credited with having invented crosshatching strokes and systematic burin work, ways of defining form that came to be perfected by such younger engravers as Martin Schongauer.[3]

1. See, for example, *Amorous Couple on a Grassy Bench* by E.S. (Lehrs 211), illustrated and discussed in Philadelphia 1967, cat. 17.
2. Washington 1990, 32–38, with several illustrations.
3. On the Master E.S. and his works, see both Philadelphia 1967 and Washington 1967, cats. 4–19, and the biographical essay that precedes them. The artist executed another print similar to the present one, a *Knight and Lady with Banderoles,* illustrated and discussed together with our print in Philadelphia 1967, cats. 57, 58.

112
Wenzel von Olmutz, after Master of the Housebook

The Lovers
Engraving, c. 1490
171 X 113 (6¹¹/16 X 4⁷/16)
Lehrs 67
Rosenwald Collection 1943.3.8324

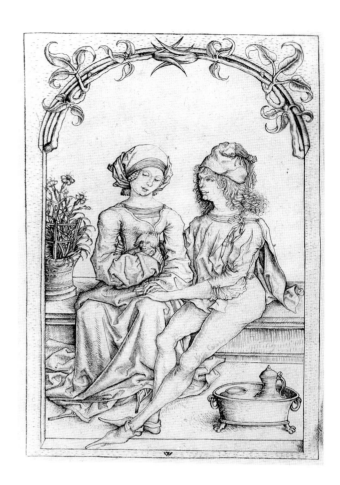

Much of what is conveyed of the relationships between men and women in the prints exhibited here revolves around sexuality, some of it violent or leading to violent ends (see cat. 32), some of it arising from passion or lust (cats. 93, 120). The present print is a pleasant, even charming exception. Two young lovers are seen through an archway covered with a flourishing vine. They are seated on a bench, and the woman, her eyes demurely downcast, holds a small dog, while the man looks at her, his hand resting on her knee. Her own hand covers his. At the left is a vase of carnations, and at the lower right, a tankard of wine and a cup sit in a cooler. The mood of the scene is one of tender and decorous intimacy.

The print is a copy, in the same direction, of a drypoint by the Master of the Housebook, now known in only two impressions. The original print was, in fact, copied a number of times, but the version here is closest to it in mood and deft execution.[1] While the vine culminates, as it were, in two buds that interlock suggestively above the couple, and while drinking wine is often to be associated with lust, nearly all scholars who have written about the print have interpreted it as portraying a still chaste love. Hutchison, for example, has pointed to the couple's "tender concern for one another," and has understood the dog in its traditional role of symbolizing fidelity. She also notes that the carnations, symbolic of virginity, frequently appear in fifteenth-century German engagement portraiture.[2] That the wine is being cooled, moreover, has been said to indicate an unconsummated love.[3]

1. Among the copies is an engraving by Israhel van Meckenem, discussed and reproduced in Ann Arbor 1975, cat. 48, pl. 12. Meckenem reversed the image. The present print is discussed in Washington 1967, cat. 124.
2. Hutchison 1972, no. 75.
3. See Hutchison 1972, 64 and n. 257.

113
Giulio Bonasone

The Triumph of Love
Engraving, dated 1545
281 x 401 (11¹/₁₆ x 15³/₄)
Bartsch 106
Rosenwald Collection 1964.8.375

Bonasone is one of a number of Italian printmakers who, more or less, followed the engraving style that Marcantonio Raimondi had devised and developed in the earlier sixteenth century. He was born in Bologna and is said to have met Marcantonio when the latter returned there following the Sack of Rome (1527). Active himself in Rome after 1531, Bona-sone is known especially for the many reproductive prints he made after works by such artists as Michelangelo, Titian, Parmigianino, and Giulio Romano.[1]

He also executed prints from his own designs, and his signature on the present work indicates that he is the inventor of this composition. The image is perhaps intended to represent the loves of the gods, as is suggested by the classicized nudes and the amorous coupling of various figures as they come under the sway of Cupid. This kind of theme was very popular at the time and frequently appeared not only in prints but also in paintings and fresco decorations in Italy. Ardor for the theme was eventually dampened by the austere spirit and strictures of the Catholic Reform movement.

1. For comments on Bonasone and illustrations of several of his prints, see Claremont 1978, 25–28.

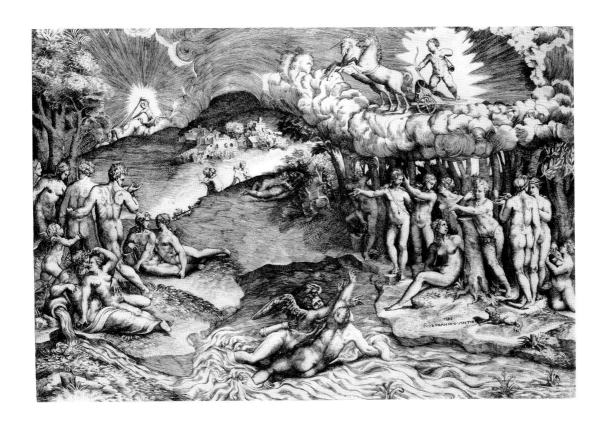

114A–D
Hans Sebald Beham

Fountain of Youth
Woodcut (on four blocks), c. 1536
370 x 1083 (14¹/₂ x 42⁵/₈)
Pauli 1120
Rosenwald Collection 1943.3.1041, 9327–9329

At the left of this large woodcut, ailing and aged people come or are carried to the Fountain of Youth, while some nude figures dance past a bonfire of crutches that have been cast away. The fountain itself, in the next portion of the scene, contains a number of figures, one of whom shoots water with a purgative gun upward toward the bottom of a nude female who, with others, occupies the roof of a palatial bathhouse. The bathhouse takes up the next two sections. The fountain flows into it, and various figures bathe in it, while others are shown around the periphery, reclining on a couch, playing backgammon, conversing, and engaging in sexual and scatological activities.

The theme of the Fountain of Youth is known in both the literature and visual arts of the period.[1] Lucas Cranach the Elder, for example, showed the fountain in a painting of 1546 (Staatliche Museen, Berlin-Dahlem). The bathhouse had its own representations; an important example is the engraving by the Master of the Banderoles of c. 1450–1475. That print shows the bathers participating in explicit sexual activities, and as Alison Stewart has pointed out, actual bathhouses were often thought to double as houses of prostitution.[2] Bathhouses were depicted in numerous other prints by both of the Beham brothers, and by Aldegrever and Dürer, among others. In images that show men and women bathing in segregated facilities, sexual allusions may still be present, and certainly the scenes encourage the viewer to act as voyeur.[3] Apparently, actual bathhouses of the time were decorated with sexually suggestive pictures of bathers, a prime example being Altdorfer's frescoes for a bathhouse in Regensburg, which now exist only as fragments.[4]

Public bathhouses were, in fact, a common institution in German medieval cities, with some cities having as many as ten or fifteen. While priests and preachers objected to the

houses, and city councils tried to regulate what people did there—for example, by banning gambling and drinking from pitchers, and by prohibiting known prostitutes from being hired as bath maids—illicit activities did take place. It was, moreover, common and condoned for men and women to bathe together, a custom that continued until the seventeenth century.[5]

It has been pointed out that the idea of a Fountain of Youth is shown to be a fool's dream in Beham's woodcut by the presence of an actual fool in the upper left corner of the bathhouse roof. He is paralleled by a figure at the right corner, an old woman playing a hurdy-gurdy, an instrument common to fools and the lower classes.[6] As is characteristic of works by the Beham brothers, however, the frolicsome and sexual activities depicted here far outweigh any kind of moral message.

sexual activities, is reproduced and briefly discussed in Stewart 1979, 109–110, fig. 71.

2. See Stewart 1979, 39–41, fig. 13, and also fig. 12, which illustrates an illuminated manuscript page depicting a bathhouse, of c. 1450–1500.

3. See the discussion and illustrations in Lawrence 1988, 46–47. See also the reproduction of and comments on Dürer's woodcut, the *Men's Bath,* of c. 1496–1497, in Washington 1971, cat. 84. As noted there, Wind interpreted the print according to the doctrine of the four humors but also pointed out that the waterspout, decorated with a small cock and coinciding with one of the men's genitals, is a pun on the German word for cock, *Hahn,* which also means the sexual organ. Dürer's drawing, *Women's Bath,* illustrated in Washington 1971, fig. 84a, was later the basis for a woodcut formerly attributed to Baldung Grien (see Hollstein 7:272).

4. For Altdorfer's frescoes, see Winzinger 1975, plates 80–89; the work dates from about 1525.

5. The information is from Wiesner 1986, 95–97.

6. See Austin 1983, cat. 85, the woodcut illustrated being the impression exhibited here.

1. The theme is discussed by Anna Rapp, *Der Jungbrunnen in Literatur und bildender Kunst des Mittelalters* (Zurich 1976) (not available to this author). An engraving of the Fountain of Youth, which shows

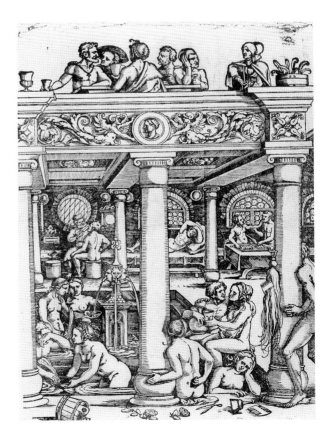

115
Israhel van Meckenem

The Visit to the Spinner
(from the *Scenes of Daily Life* series)
Engraving, c. 1495/1503
161 x 110 (6⁵/₁₆ x 4⁵/₁₆)
Lehrs 509
Rosenwald Collection 1953.4.1

Exhibited here are five scenes of purportedly "daily life" from a series of twelve engravings that Meckenem both invented and executed (see also cats. 116, 117, 124, and 125).[1] Each of the images shows one man and one woman. Six are set in domestic interiors, and six have dark, unarticulated backgrounds with twisting banderoles at the top. The interior settings have been said to be "valuable documents for the cultural history of the late fifteenth century in northern Germany."[2] While this remains true, more recent scholarship leads to quite different realizations about what kind of activities the couples are engaged in, and how the prints are to be interpreted.[3]

Some of the prints in the series put together men and women who are in some way dissimilar, and indeed these works can be understood to be part of a topos known as "dissimilar pairs" or "unequal lovers."[4] Inequality is seen, for example, in a couple formed of a young man and an old woman, or a young woman and an old man, as well as in contrasts of social class that are usually made manifest through the dress of the figures. In a few cases, the viewer may not be certain of the relative ages of the couple, but there may be a marked difference in their behavior, and this serves to set them apart from each other (see cat. 124). A number of the images focus, at least in part, on sexual aspects of the relationships. Finally, we might again emphasize that Meckenem's series does belong to an imagery of dissimilar pairs that began to develop in the fourteenth century (in literature as well as the visual arts), became quite strong in the fifteenth, and continued well into the seventeenth century, especially in Dutch painting and prints.[5] Several scholars think that it arose as a reaction against the ideals of "courtly love," in which women were depicted as beautiful and desirable but were, in essence, physically unattainable. Married to a man other than their protector, they were sweetly venerated by the lover as virtually perfect creatures.[6]

Turning to the present print, we should note that a woman spinning was traditionally understood to be engaged in a "virtuous female occupation." Support for this meaning was drawn from the Bible (Proverbs 31) and from depictions of the Virgin spinning.[7] At the same time, the spindle was sometimes taken to refer to a woman's sex organs (see fig. 115a), and

it seems likely that this is the meaning intended here.[8] The man, seated but wearing a cloak, seems to have just arrived from out-of-doors, and he holds his sword against his crotch in a way suggestive of a phallic symbol. The cat, at the lower left, was one of the pets often kept by prostitutes (along with dogs and apes), and at least at a later date, was considered by the Dutch to be too filthy an animal to be kept in the house.[9] The numerous vessels on top of the cabinet, including a tankard with its lid open, are also highly suggestive. As Moxey, among others, has noted, wine was allied with the enjoyment of sensual pleasure, and drinking was thought to lead to fornication.[10] Glasses, cups, flagons, and tankards are commonly present in many prints (and paintings) with erotic subjects.

1. The National Gallery owns eleven of the twelve prints. For a discussion, see Washington 1967, cats. 233–243.
2. Shestack referring to an essay by H. Kohlaussen, in Washington 1967, preceding cat. 233.
3. An essay on the series by D. Scillia is to be published by The Edwin Mellen Press in *New Images of Medieval Women*. Some comments from her manuscript are quoted in Stogden 1989, following cat. 6. Five prints from the series are reproduced.
4. For a richly informative and well-illustrated account of the topos, see Stewart 1979.
5. For fifteenth- and sixteenth-century material, see, for example, Stewart 1979; and for various of the genre prints, see Lawrence 1983.
6. See, for example, Moxey 1980, 141–143. See also Stewart 1979, 101, where the author observes: "With the waning of courtly love, woman was now cast in the older, more negative mold of temptress and controller of love affairs, a role for which she was considered well suited as the daughter of Eve, who, like her foremother, was easily tempted to lust." What courtly love meant has been vigorously debated, and it has been noted that the term itself originated in an essay by Gaston Paris published in 1883. See the various essays in Newman 1968.

fig. 115a. Anonymous Italian, *Various Occupations*, last quarter fifteenth century, engraved copperplate, 150 x 224 (5⁷/₈ x 8¹³/₁₆), National Gallery of Art, Washington, Ailsa Mellon Bruce Fund 1948.11.11a (Hind 8, p. 20, no. 29).

7. See Linda Stone-Ferrier's discussion of a print by Geertruydt Roghman of a woman spinning in Lawrence 1983, cat. 7, and illustration. We should note that Roghman was a woman artist, born into a family of Amsterdam printmakers in 1625.

8. For a discussion of the copperplate illustrated here (fig. 115a) see Washington 1973, 526–527.

9. Janson 1952, 278 n. 16; and Schama 1988, 377.

10. Moxey 1980, 138–141, with relevant illustrations and quotations from literature of the period.

116
Israhel van Meckenem

The Organ Player and His Wife
(from the *Scenes of Daily Life* series)
Engraving, c. 1495/1503
159 x 109 (6¼ x 4¼)
Lehrs 507 1/3
Rosenwald Collection 1943.3.161

This print has been described as representing a happily married couple in their home, with sexuality held in its proper place.[1] The man and woman appear to be in comfortable, informal dress for being inside, and he wears slippers rather than shoes. The making of music had long been associated with love, and here while the man plays the portative organ, the woman seems to be working the bellows attached to it, hence emphasizing their harmonious relationship. The dog would be understood as a symbol of fidelity. The bedchamber is literally and figuratively put in perspective. Altogether, the engraving presents an image of licit love that may be contrasted with the preceding print (cat. 115), which almost certainly is an image of illicit love.

We should note, however, that some of the elements included here can have virtually the opposite connotations in other contexts. Music-making was often used to emphasize sexuality or lust. Wind instruments, especially bagpipes (fig. 115a), were understood as sexual symbols, but so at times were lutes and other stringed instruments. Dogs (and cats) could also signal that a woman was a courtesan or a prostitute (see cat. 115).

1. Stogden 1989, discussion following cat. 6.

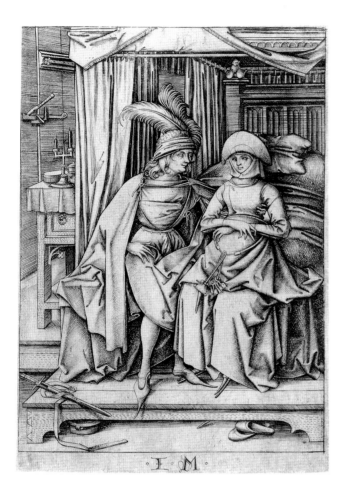

117
Israhel van Meckenem

Couple Seated on a Bed
(from the *Scenes of Daily Life* series)
Engraving, c. 1495/1503
160 x 109 (6⁵/₁₆ x 4¹/₄)
Lehrs 508 2/3
Rosenwald Collection 1946.21.142

This couple appears to be one of Meckenem's "dissimilar pairs" in his series devoted to men and women (see cat. 115). Certainly the two figures are contrasted in their psychological attitudes and their dress. The man wears a gaily plumed hat and open outer cloak, which gives him a kind of foppish appearance. He smiles slightly, looking at the woman intensely, and he puts his left arm around her waist, his left foot on top of hers. She, by contrast, has a very sober costume, her headdress pulled tightly around her throat and cheeks, and the garment closed across her bosom. Her arms are crossed and her expression unsmiling.

That she wears keys around her waist indicates her authority in some domestic realm, whether as wife or trusted servant, for keys generally indicate power of access to rooms or areas in a home. According to Alberti, it was a wife's duty to safeguard and care for whatever was in the house.[1] In Meckenem's print, the keys are juxtaposed with her genital area, which, evidently, may not be safeguarded. The room in which the figures are seated on a bed might be an inn, for none of the objects in it clearly bespeak a domestic bedchamber. Significantly, the upper left bedpost shows a monkey with two shields, a seemingly decorative detail that almost certainly indicates that the bed will be used for lustful and illicit purposes.

1. Guarino 1971, 230. The woman may also have a small purse attached to her belt. On keys and a purse, see Dürer's comment (in relation to his depiction of *Melencolia I*) that "keys mean power, purse means wealth," as discussed in Washington 1971, 146.

118
Albrecht Altdorfer

Pyramus and Thisbe
Woodcut, 1513
122 X 100 (4¹³/₁₆ X 3¹⁵/₁₆)
Winzinger 22
Rosenwald Collection 1943.3.377

The tale of Pyramus and Thisbe, from Ovid's *Metamorphoses* (4:55–166), is about the passion of young love, the thwarting of it, the deleterious role of Fortune or Chance, and the tragedy of premature death. Altdorfer here shows the penultimate moment of the tragedy, as Thisbe looks at the body of Pyramus, a suicide by his own sword or dagger. She will soon commit suicide herself with the same weapon.

The earlier part of the story may be briefly summarized as follows: the two young people lived next door to each other, and although each of their parents' houses was surrounded by thick walls, they met through a break in the walls. They fell in love, but their parents forbade them to marry. After a long time, they arranged to meet each other at night in the open country, near the tomb of King Ninus. Thisbe arrived first, but was frightened away by a lioness; fleeing, she lost her

cloak, which the beast then mauled with its bloody jaws. When Pyramus arrived and found the cloak, he thought Thisbe had been killed and, in great despair, killed himself. She then found him and killed herself.[1]

In Altdorfer's print, the scene takes place in the dark of night, and Thisbe bends prayerfully over her dead lover, shown with the dagger still in his abdomen. Baldung depicted this part of the story in a painting of c. 1530, also as a night scene; but for Baldung, Thisbe, standing over Pyramus, is rather curiously restrained, while Pyramus is shown in a markedly beautiful pose. Thus the scene seems robbed of its more expressive qualities.[2] In a painting of the subject by the seventeenth-century artist Poussin, the figures are placed in a large and stormy landscape, so that Nature seems to embrace the wildly gesturing Thisbe and to reflect the tragedy cosmically.[3]

The story of Pyramus and Thisbe is unusual in presenting not only a woman who kills herself for love but also a man who does so. As Garrard has pointed out, "The suicides of males in art and legend are typically public or political actions, for the sake of philosophical ideals or in the face of danger or disgrace; those of females are acts of private desperation."[4] The theme, nevertheless, is part of what Kiefer has characterized as the "Love-Fortune-Death topos," as found especially in love *novelle* of Italy and France and subsequently in dramas by Elizabethan playwrights who drew on those sources.[5] In the more general forms of the theme, those that focus on love interrupted by death and the alliance of lust and death, it is widely reflected in visual imagery of the period. Here, for example, see cats. 133 and 129, among many others.

1. Ovid relates that when Pyramus stabbed himself under a mulberry tree, his spouting blood changed the tree's snow-white berries to purple.
2. The painting, now in the Staatliche Gemäldegalerie, Berlin-Dahlem, is reproduced and briefly discussed in Washington 1981, 17, and fig. 13.
3. Poussin's painting, dating 1651, is now in the Städelsches Kunstinstitut, Frankfurt.
4. Garrard 1989, 214.
5. Kiefer 1983, 158–192. One example given is Boccaccio's story of Ghismonda and Guiscardo (*Decameron* 4:1). Ghismonda's father discovers the couple making love, later kills Guiscardo, and sends his heart to Ghismonda in a golden cup. She pours poison on it, drinks the liquid, and dies.

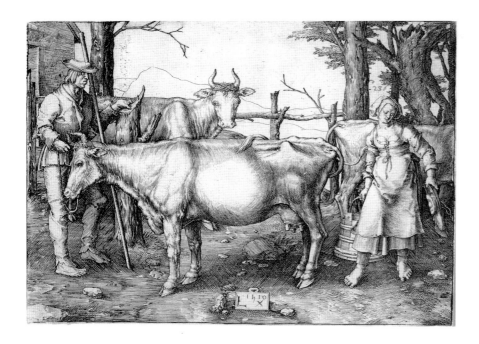

119
Lucas van Leyden

The Milkmaid
Engraving, dated 1510
114 x 156 (4¹/₂ x 6¹/₈)
Hollstein 158
Rosenwald Collection 143.3.9121

Ostensibly a genre scene composed of a farmer, milkmaid,
and cows, Lucas' print immediately suggests the possibility of
erotic interaction between the man and the woman. She has a
rather coy expression, her eyes downcast, while she wears a
low-necked dress that emphasizes her bosom. The farmer,
stolid in expression and bovine-looking himself, places his
hand on a tall tree stump, an edge and limb of which jut up-
ward. It is probably not simply fortuitous that the carefully
detailed udder of the cow taking up the center foreground is
closest to the woman, while its horns are next to the man. In-
deed, it has been argued by a Dutch scholar, Leo Wuyt, that
the image is an allegory of free will and lust. He centered his
views on the observation that "to milk" in sixteenth-century
Dutch connoted "to lure."[1] One might recall, moreover,
that an old Dutch adage had it that a man's two most impor-
tant possessions were his wife and his cow.

1. As explained and referenced in Washington 1983, cat. 26.

120
Israhel van Meckenem, after Master of the Housebook

The Foolish Old Man and the Young Woman
Engraving, c. 1480/1490
145 x 112 (5¹¹/₁₆ x 4³/₈)
Lehrs 489 5/5
Rosenwald Collection 1943.3.154

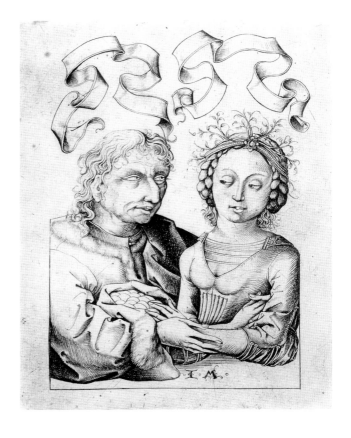

This image is a copy, in reverse, of a drypoint by the Master of the Housebook.[1] The subject is a quintessential example of the "unequal lovers" or "dissimilar pairs" topos that has been discussed in detail by Alison Stewart (see cat. 115). Stewart has also pointed out that our current expression in English that "there is no fool like an old fool" had approximate equivalents in Dutch and German at the time that these prints were made.[2] The theme was a popular one and appears not only in numerous prints but also in paintings of the period (see fig. 120a).[3] It had its counterpart in depictions of foolish old women with young men, and, in fact, Meckenem made such a print, again after the Master of the Housebook.[4] In most representations, the foolish old person is about to give up his or her money, sometimes consciously, as here, sometimes unknowingly, as in the painting by Massys.

1. See Hutchison 1972, no. 55; and Washington 1967, cat. 208.
2. Stewart 1979, 55.
3. On the painting, see Hand and Wolff 1986, 146–150.
4. Discussed and reproduced in Hutchison 1972, cat. 56.

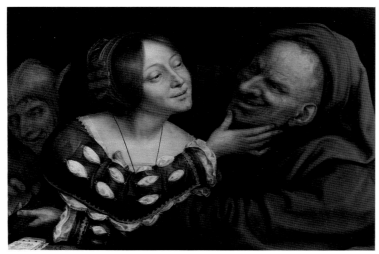

fig. 120a. Quentin Massys, *Ill-Matched Lovers*, c. 1515–1525, oil on wood, 43.2 x 63.0 (17 x 24³/₄), National Gallery of Art, Washington, Ailsa Mellon Bruce Fund 1971.55.1.

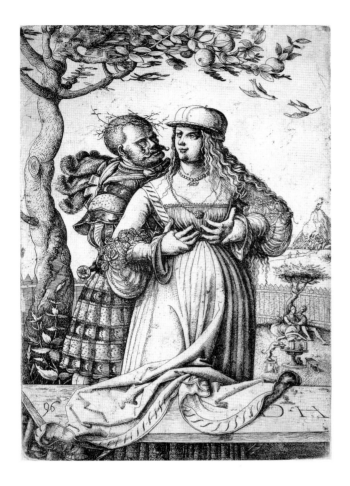

gressive sexuality'' and their mortality, as their profession constantly brought them into contact with death. A number of works depict the movement of troops in large baggage trains, almost always accompanied by loose women, the stereotypical camp followers.[2]

Here Hopfer's soldier grabs a young woman with clearly sexual intent, while another amorous couple sits under a tree in the background. The two foreground figures exchange a lascivious glance, and both her costume and her flowing hair indicate that she is a prostitute. It has been suggested that the apple tree in the foreground is meant to recall the fruit tree in Eden, and the sin of Adam and Eve.[3] In any case, for centuries apples had carried both evil and sexual connotations and, as John Phillips has pointed out, the apple-breast metaphor dates at least from *The Song of Songs*.[4] The birds (*Vögel* in German) are no doubt a punning reference to the German expression *vögeln*, which, then as now, as Christiane Andersson has pointed out, refers to sexual intercourse.[5] It has been suggested that the twiglike branches on the soldier's head might represent ''withered laurel,'' as a sardonic emblem of victory in love and war. The meaning of the dog eating from the table in the middle distance, has not been satisfactorily explained, but certainly the animal is behaving according to its instincts.[6]

Hopfer was one of the first etchers, perhaps indeed the very first, to make plates to be printed on paper. This print was made on an iron plate, and a few areas of the image show ''foul-biting,'' in which the acid has accidentally eaten through the ground and printed as random spots. It is, however, an excellent impression. Later etchers turned to the use of copperplates and perfected the biting process.

1. On mercenaries depicted in prints of this period, see Moxey 1989, 67-100.
2. See, for example, Moxey 1989, fig. 4.11, and the discussion there of that print and others similar to it.
3. Ann Arbor 1975, cat. 40.
4. Phillips 1984, 84–85.
5. Andersson 1982.
6. Cf. Ann Arbor 1975, 85.

121
Daniel Hopfer

Soldier Embracing a Woman
Etching, c. 1520(?)
227 x 153 (8¹⁵/₁₆ x 6)
Hollstein 78 2/2
Ailsa Mellon Bruce Fund 1979.44.8

Licentious encounters between soldiers and women is a leitmotif in northern European prints and drawings of the sixteenth century. Many German and Swiss soldiers of the time were mercenaries who had replaced the feudal armies made up of nobles and those owing allegiance to them.[1] Some prints and their accompanying texts extolled the mercenaries who were in the service of the Holy Roman Emperor, Maximilian I, and his successor, Charles V. Others viewed the soldiers more critically and sometimes focused on their supposed ''ag-

122
Albrecht Dürer

The Ill-Assorted Couple
Engraving, 1495/1496
149 x 137 (5½ x 5⅜)
Meder/Hollstein 77
Rosenwald Collection 1943.3.3454

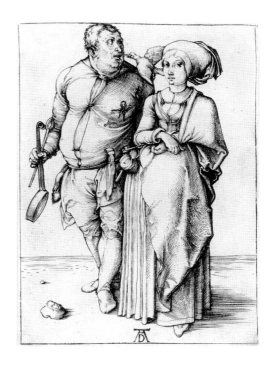

As in the case of the preceding print (cat. 120), this image belongs to the topos of "unequal lovers" in depicting a young woman with an old man. Here she is shown with open hand, frankly demanding money before she will grant sexual favors. The man responds by reaching into his purse, which, not accidentally, rests over his genital area. Talbot has noted that no moralizing is evident in the representation. He also suggested that the horse, tied up to a tree, might be a reference to Jeremiah 5:8, which says: "They were well-fed lusty stallions, each neighing for his neighbor's wife."[1]

1. See Washington 1971, cat. 3.

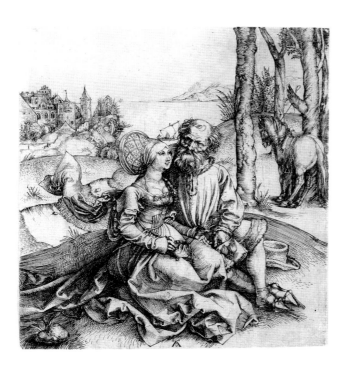

123
Albrecht Dürer

The Cook and His Wife
Engraving c. 1496/1497
108 x 78 (4¼ x 3⅟₁₆)
Meder/Hollstein 85
Rosenwald Collection 1945.5.62

This image is based on a story in *Der Ritter von Turn*, a book of moralizing stories written by the Chevalier de la Tour-Landry in 1370–1371, then translated into German and published about 1493.[1] In this story, a cook has been saving an eel, but his wife and her friend eat it when he is away. The wife tells him that it was stolen by an otter, but her pet talking magpie tells him the truth. The wife and her friend take revenge on the bird by plucking its head bare, and afterward, whenever the magpie saw a bald man, it would say "So you've been telling about the eel."[2]

The cook is characterized by his spoon, skillet, and hefty girth, his shirt nearly popping off his chest and stomach. The wife looks at the viewer with narrowed eyes and crosses her thumb (for good luck) as the bird relates its tale.

1. See Washington 1971, cat. 209. Dürer designed woodcuts for the book while in Basel but did not illustrate this particular story.
2. Washington 1971, cat. 8.

124
Israhel van Meckenem

The Juggler and the Woman
(from the *Scenes of Daily Life* series)
Engraving, c. 1495/1503
159 x 108 (6¼ x 4¼)
Lehrs 503
Rosenwald Collection 1943.3.159

The present work is one of several prints in a series by
Meckenem (see cat. 115) that show the figures of a man and a
woman against a darkened background with twisting ban-
deroles at the top (for others in the series set in domestic inte-
riors, see cats. 115–117). Here the man is trying to interest the
woman by juggling a top on his head to amuse her. The silli-
ness of his behavior is made clearer by her rather bored expres-
sion, as she looks away from him, and by the fact that his
shoes are untied. He has also foolishly laid his money purse
aside, and while he is undoubtedly smitten with this represen-
tative of the "fair sex," the wine tankard at the lower right
may indicate that he has also been drinking. Like the woman
in cat. 117, the female in this print wears keys and a small purse
around her waist, which here enhances the impression that
she is a woman of sense and responsibility.

Men dancing and performing, as it were, in response to
their attraction to women and, in essence, behaving like
fools, are also seen in Meckenem's technically spectacular en-
graving, *Ornament with Morris Dancers*.[1]

1. Washington 1967, cat. 247.

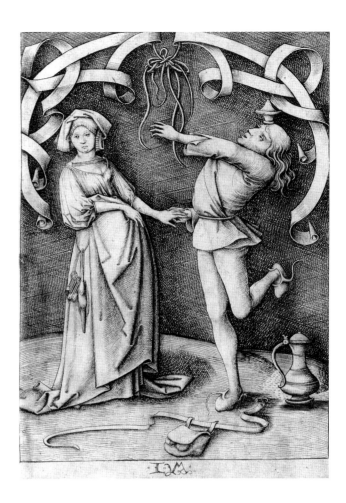

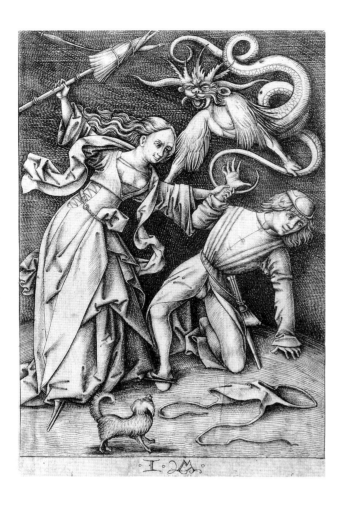

125
Israhel van Meckenem

The Angry Wife
(from the *Scenes of Daily Life* series)
Engraving, c. 1495/1503
167 x 111 (6⁹/₁₆ x 4⁵/₁₆)
Lehrs 504
Rosenwald Collection 1943.3.160

A wife is shown here beating her husband with a spindle, usually a symbol of a devoted and virtuous wife, and she is inspired to do so, as it were, by a curving and twisting devil at the upper right of the print. Below, a dog, usually a symbol of conjugal fidelity, seems to bark at his hapless "master." Finally, the man's trousers are shown on the ground at the lower right. As Moxey has pointed out, this trope goes back at least to European literature of the fourteenth century, and we may note that it survives today in such sayings as "She (or he) wears the pants in the family."[1] Trousers, which seem to have been a strictly male garment during this period, of course symbolized who was in charge of a relationship and a family: "Be master in your house / If your wife wears the pants / She'll be your scourge and your curse."[2]

There are numerous visual representations of the subject during the Renaissance and baroque periods, ranging from prints to paintings.[3] In both literature and the visual arts, this "battle of the trousers" is obviously part of the inclusive concept of the "battle of the sexes," and then, as now, the spirit in which it is presented is often humorous. It rests, nevertheless, on the very serious and deeply felt belief that women were to be governed by their husbands, as in Paul's dictum that the head of a woman is her husband (as the head of every man is Christ; 1 Corinthians 2:3).

1. See Moxey 1989, 156 n. 11.
2. As translated by Moxey 1989, 156 n. 11, from a German poem of about 1400.
3. See, for example, Moxey 1989, 104–106, and fig. 5.6, which also illustrates the present print by Meckenem. A baroque period example is Jan Miense Molenaer's painting, *The Sense of Touch,* 1637, in the Mauritschuis, The Hague. Reproduced and discussed in Schama 1988, 400–402, and fig. 192.

126
Master MZ

The Embrace
Engraving, 1503
158 X 117 (6³/₁₆ X 4⁹/₁₆)
Lehrs 16
Rosenwald Collection 1943.3.182

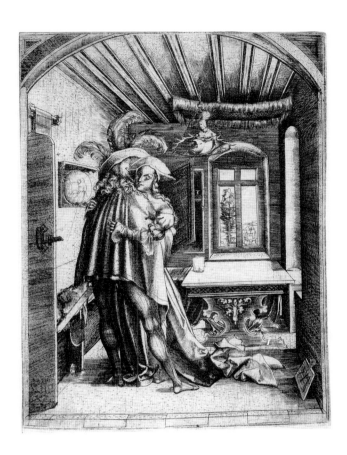

This image creates a mild sense of disquietude in the viewer, perhaps because, as several commentators have noted, the woman's glance suggests that we are intruding on a moment of intimacy.[1] While the woman's off-the-shoulder dress and long, loose hair could be taken to indicate that she is a prostitute, it may mean that she is simply a young, unmarried woman.[2] Nor have any of the objects in the domestic interior been read as other than straightforward representations. The convex mirror at the left seems simply to reflect the couple lightly, and the chandelier, composed of a bust of a woman holding shields and contained by antlers (a Lüsterweibchen), is of a type commonly found in Bavarian rooms of the period.

Perhaps most telling, however, is to compare this work with the Master MZ's *The Ball* of 1500. There the young women and men are similarly dressed and present at what seems to be a ball held in the Munich palace of Duke Albrecht IV of Bavaria. Indeed, the couple playing cards in the background there have been firmly identified as Albrecht and his wife, Kunigunde of Austria.[3]

The Master MZ could, however, create deliberately disturbing images, as in cat. 141, which stresses the transience of life and the inevitability of death.

1. See Washington 1967, cat. 149; and Ann Arbor 1975, cat. 46.
2. See Stewart 1979, 96–97.
3. The print is discussed and reproduced in Washington 1967, cat. 152.

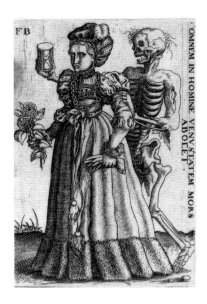

As Huizinga wrote, "No other epoch has laid so much stress as the expiring Middle Ages on the thought of death."[3] In northern Europe, this attitude extended well into the sixteenth century. Secular and religious writings as well as the visual arts laid great emphasis on it. Books with woodcut illustrations, such as the famed *Ars moriendi,* gave instructions to the faithful, literally on the art of dying.[4] It was continually emphasized that all would die, whatever their station and achievements in life, from pope to peasant. Perhaps the best-known images of Death seizing all are those designed by Hans Holbein the Younger for his *Dance of Death* series, composed of forty-one woodcuts first published in 1538.[5] Obviously both men and women, young and old, were subject to Death, which might come, as here, unexpectedly, in the prime of life. With women in particular, however, the loss of corporeal beauty was often emphasized, as aging took its inevitable course, and led to the grave (see cat. 128).

1. On Beham's print, see the discussion and reproduction in Ann Arbor 1975, cat. 29. See also Koerner 1985, an interesting article that discusses Death and women; and Alberto Tenenti, *Il senso della morte e l'amore della vita nel Rinascimento (Francia e Italia)* (Turin, 1957).
2. See Ann Arbor 1975, cat. 31.
3. Huizinga 1954, 138, and through 151, for a discussion of death, with many quotations from literature.
4. See Mâle 1986, 348–355, and from 318, for a discussion of death, and for extensive scholarly references.
5. See Ann Arbor 1975, 51–56, for a discussion of Holbein's prints and the various editions of the *Dance,* as well as a number of illustrations of the woodcuts.

127
Franz Brun

Woman and Death
Engraving, c. 1590
70 x 50 (2³/₄ x 1¹⁵/₁₆)
Hollstein 91
Rosenwald Collection 1943.3.2125

The elegantly dressed woman shown here is presumably just out for a walk; she carries flowers in her right hand and gloves in her left. Her walk has been arrested, however, by Death, represented as a skeleton, who follows behind her and places his hand on her left arm; with his right, he holds an hourglass in front of her. Her expression is one of sudden apprehension. The Latin inscription at the right reads: "Death destroys all human beauty."

The print is closely based on an engraving of 1541 by Hans Sebald Beham (Pauli 1911a, no. 150) that has an identical inscription. Beham's well-dressed woman moves to the right, and Death, in a jester's costume, walks beside her, holding an hourglass and placing his other arm around her waist. Behind them is a grassy area with a fence and a large potted lily.[1] The flowers in each print would seem to symbolize the transience of beauty. In another print, dating from 1547, Beham shows a nude female, facing directly forward, being embraced from behind by a winged Death (Pauli 1911a, no. 151). An hourglass rests on the ground at the lower left, and a large stone at the right bears the same inscription seen in the other two prints.[2]

128

Jeremias Falck, after Johann Liss, after Bernardo Strozzi

An Old Woman at the Toilet Table
Etching and engraving
397 x 318 (15⅝ x 12½)
Hollstein 156
Dr. and Mrs. Ronald R. Lubritz Fund 1976.9.10

An old woman, with a wrinkled face and sagging breasts that hang out of the bodice of her fancy dress, looks into a mirror. Her hair is tied up and decorated with pearls, and there are more strands of pearls on her dressing table. She holds flowers in her hands, one of them in front of her breasts, seemingly trying to decide where to adorn herself with it. Two comely young women, smiling and animated, attend her, and one is placing a feather in her hair.

The mirror is, of course, a traditional symbol of vanity and also of Venus, who was often shown making her *toilette*. In a painting of about 1595 by Annibale Carracci, Venus holds a mirror, assisted by a putto, while she is adorned by the Three Graces; another putto searches for jewelry for her in a case that contains strands of pearls (see fig. 128a).[1] In the present instance, the old woman seems oblivious to the fact that she is aged and ugly, so that her sin of vanity is the more strongly emphasized. Women, moreover, were often admonished to "adorn themselves modestly and sensibly in seemly apparel, not with braided hair or gold or pearls or costly attire" (1 Timothy 2:9). In ignoring this kind of stricture, the old woman is more than vain: she becomes a ridiculous figure.

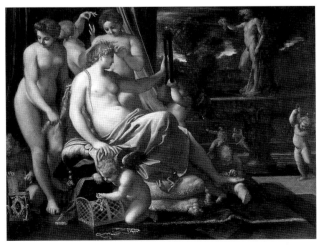

fig. 128a. Annibale Carracci, *Venus Adorned by the Graces*, c. 1595, oil on wood, transferred to canvas, 133.0 x 170.6 (52⅜ x 67⅛), National Gallery of Art, Washington, Samuel H. Kress Collection 1961.9.9.

Old women were especially subject to ridicule since so much emphasis was placed on a young woman's body as beautiful or desirable or tempting, as seen in many prints exhibited here. In the *Parement et Triumphe des Dames,* Olivier de la Marche wrote: "These sweet looks, these eyes made for pleasance, Remember, they will lose their lustre, Nose and eyelashes, the eloquent mouth Will putrefy. . . . If you live your natural lifetime, Of which sixty years is a great deal, Your beauty will change into ugliness. . . ."[2]

1. For a discussion of Annibale's painting, see Shapley 1979, 1: 121–122. One of the most striking uses of a mirror as a *memento mori* is found in the painting, *Hans Burgkmair and His Wife,* 1529, by Lukas Furtenagel (Kunsthistorisches Museum, Vienna). The wife holds up a mirror in which her head and that of her husband are reflected as skulls. The inscription on the mirror has been translated, "Such was our shape in life; in the mirror nothing remains but this." See Cuttler 1968, 406, and fig. 541.
2. As quoted and translated by Huizinga 1954, 142 n. 6. On old women as witches, see cats. 103, 105, and 109. We need only briefly note that many women today are anxious to keep effects of aging in abeyance and are encouraged to do so by strong societal pressures.

129
Albrecht Dürer

The Ravisher
Engraving, c. 1495
113 x 102 (4⁷/₁₆ x 4)
Meder/Hollstein 76
Rosenwald Collection 1943.3.3452

In this work, thought to be one of Dürer's earliest engravings, Death does not surpise or attack lovers (see cat. 132), or lurk somewhere in the scene to remind the viewer of the inevitability of his approach. Rather, he becomes a lover himself. The woman sits on Death's lap on a grassy bench in the countryside, a locale frequently used for images of lovers.[1] She has, however, become aware of who her would-be lover is and struggles against him, but he has forcefully grabbed her skirt. There is a clear sense that his violation of her will be both sexual and murderous.[2] The juxtaposition of woman and Death was to become a major theme for Baldung, who created a number of horrific images of Death embracing and sometimes fondling nude women.[3]

The linking of carnal love and death rests, ultimately, in the idea that the sin of Adam and Eve was carnal knowledge. Baldung again elaborated on this idea in a striking painting (now in the National Gallery of Canada, Ottawa), where

Adam is metamorphosing before our eyes into a putrefying form whose skeletal structure has begun to be visible (see fig. 70a). Hieatt has linked the painting to Agrippa of Nettesheim's suggestion "that sexual intercourse in its first instance was the occasion of the Fall. . . ."[4]

The association of carnality and death runs through western European thought, not least in the admittedly "lighter" sense of intercourse itself being metaphorically referred to as a "little death" (*petit mort,* in French), or in Renaissance and baroque literature and poetry as "dying,"[5] It is rather frequently found in John Donne's sonnets, as: "So to one neutrall thing both sexes fit / Wee dye and rise the same, and prove / Mysterious by this love."[6] Indeed, the metaphor is found in Latin texts, an example being the *Metamorphoses* of Apuleius.[7]

The sexual innuendoes, and even playfulness, found, for example, in the prints of Israhel van Meckenem (see cat. 115), here in Dürer's vision become, literally and metaphorically, deadly serious.

1. See the illustrations, for example, in Moxey 1980.
2. Cf. the discussion of this print in Washington 1971, cat. 1.
3. See especially the well-known painting by Baldung in the Kunstmuseum, Basel, reproduced in Washington 1981, fig. 35.
4. Hieatt 1980, 223.
5. For a very brief but relevant discussion of this literature, see Bassein 1984, 35–43.
6. *The Complete Poetry and Selected Prose of John Donne,* ed. Charles M. Coffin (New York, 1952), 14.
7. Adams 1982, 159.

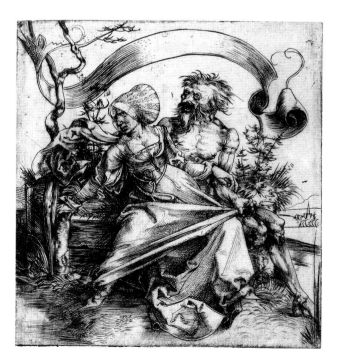

130
Albrecht Dürer

Coat of Arms with a Skull
Engraving, 1503
219 x 157 (8⁹/₁₆ x 6³/₁₆)
Meder/Hollstein 98
Rosenwald Collection 1943.3.3489

This engraving has long been admired for its technical brilliance, especially in terms of the various materials and textures that are evoked in it. It is also one of the prints by Dürer that has tantalized scholars seeking to articulate its iconographical meaning, and hence it has been frequently discussed.

All recent scholars have agreed that the woman wears a bridal crown and a ball gown or dress for a festive occasion.[1] All have recognized, as well, that the figure behind her is a "wild man," a legendary, hairy creature who was noted espe-

cially for his lustfulness. He and the corresponding "wild women" were extremely popular in visual representations of the period.[2] The wild man here holds the elements for a coat of arms, composed of great wings, swirling streamers, a helmet, and a shield. This type of figure had, in fact, often been depicted as holding heraldic devices, notably in a series of engravings by Schongauer, where wild women serve the same function.[3] Charles Talbot sees the shield, on which is depicted a large Death's head, as the key to interpreting the image, saying it reveals the true identity of the wild man: "he is a gentler emissary of the same dread power whose violent aspect was the subject of the earlier print [the figure of Death in *The Ravisher,* here cat. 129]. Yet at this moment the responsive girl has glimpsed neither her lover nor the face of the shield."[4]

Indeed, it seems key that only we, the viewers, can see the shield and the creature who stands behind the woman and gives her a kiss. Her eyelids are lowered, but she glances just a bit toward the helmet, streamers, and wings and touches the strap that holds them on the wild man's staff. What she feels may be the kiss of a lover, and what she sees may be a jousting helmet, used in contemporary Nuremberg "bachelor jousts," surmounted by the great wings, which could be taken as symbolic of Victory or even of Eros.[5] The viewer, however, is likely to interpret the latter as the wings of Death (see cat. 132), being able to associate them with the Death's head on the shield.

It has been pointed out that young villagers sometimes dressed as wild men for German weddings and mocked the bridegroom, but here it would seem that the wild man as Death has simply replaced him. Servants also sometimes dressed as wild men for tournaments in which their masters participated and "guarded the shield in the challenge preceding the actual combat," but again, that does not seem to be represented here.[6] There is, nevertheless, a kind of fascinating and chilling play here between the accoutrements of jousting tournaments, in which outdated chivalric codes and their traditional associations with ladies and love were temporarily perpetuated, and the reality of the looming Death's head.[7] Not surprisingly, many consider this one of Dürer's most striking and unforgettable images.

1. As pointed out in Washington 1971, 130 n. 1, Dürer copied the figure of the woman from a drawing that he had made and inscribed: "This is the way the girls go to the dance in Nuremberg." Richard Bernheimer was apparently the first scholar to recognize the crown as a bride's crown. His book, *Wild Men in the Middle Ages* (Cambridge, Mass., 1952), continues to be a most valuable source for this material.
2. See New York 1980, the excellent exhibition catalogue, profusely illustrated, by Timothy Hubbard.
3. For Schongauer's prints, see Washington 1967, cats. 94–97; and New York 1980, cats. 54, 55.

4. Washington 1971, cat. 27.
5. See New York 1986, cat. 265, for an actual jousting helmet (*Stechhelm*) similar to Dürer's, and cat. 266, for comments on the bachelor jousts (*Gesellenstechen*). There might be some punning going on in Dürer's print. See Panofsky 1962, on the artist's familiarity with personifications of Victory with great wings on antique coins, and see the wings in his depiction of *Nemesis* (here cat. 139). Cupids, as well as the more powerful Eros, were often depicted with wings, and as Wind has shown, Love as a god of death is found both in ancient and Renaissance Neoplatonic literature and the visual arts (see Wind 1968, 152–170). Wild men and wild women were also occasionally depicted as jousting themselves. See New York 1980, cats. 35 and 36, for prints by Meckenem and the Master E.S.
6. See New York 1980, 186, for the quotation, 195, for the information on weddings, and cat. 58, for a discussion of the image examined here.
7. Jousting tournaments were held in Nuremberg from 1446 to 1561 and are said to have been very popular with the patricians, who had been banned from tournaments in the Holy Roman Empire. They were a "regular entertainment," sometimes stage for patrician weddings. See New York 1980, 455–456. Codes of chivalry belong, of course, to the tradition of "courtly love," which had waned by the early fifteenth century. It should be pointed out that burgher patricians, very powerful in Nuremberg, were still distinguished from the hereditary nobility. For remarks on the class system there, see especially Strauss 1976, 78–83.

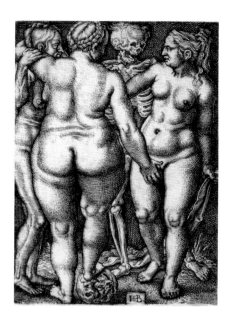

131
Hans Sebald Beham, after Barthel Beham

Death and Three Women
Engraving, c. 1546/1550
77 x 54 (3 x 2⅛)
Pauli 1911a, no. 152 2/3
Rosenwald Collection 1943.3.1081

It is well known that Hans Sebald Beham often copied prints by his younger brother, Barthel, but in the case of this image, he reworked the actual plate, adding his monogram (lower center), strengthening the modeling of the figures, and intensifying the shaded background.[1] In its subject matter, the image is typical of the eroticism so prevalent in both artists' works (see cat. 114).

The corpulent woman whose back is to the viewer stands with one foot on a skull, while she puts her arm around the old woman and reaches toward the genitals of the young, voluptuous woman at the right. All three women are aware of the presence of Death, personified by the skeleton, but only the youngest seems to be startled.

The prints of the Behams must reflect a thriving market for such works and, at the same time, must have fostered a desire for the works. Unlike Baldung's and Dürer's works, the Behams' seem not to carry moral tones or to linger on the poignancy or abject horror of Death. Rather, the brothers exploited their subjects to produce a bawdiness that is often rollicking in its spirit. It may be relevant that the Behams held

unpopular views and were, together with the artist Georg Pencz, temporarily banished from their native Nuremberg in 1525 for their atheistic and anarchical views. Their beliefs would have placed them on the fringes of Nuremberg's society and may have further encouraged them to poke a sharp kind of fun at the human condition. The image of the three women, who probably represent three ages (youth, middle, and old age), has often been compared to Dürer's *Four Witches* (cat. 104).[2] In turn, Dürer's women have been seen as relating to classical and Renaissance depictions of the Three Graces. As one scholar has stressed recently, "Barthel may well have . . . deliberately emphasized the distinctly nonideal qualities of his female figures as a parody on the conventions of the Three Graces iconography."[3]

1. Lawrence 1988, cats. 49A–49B, with reproductions of impressions by each artist.
2. Either or both of the Behams might have studied with Dürer, but there is no documentation on the subject. In any case, they were obviously keenly aware of his work, being citizens of Nuremberg themselves. For biographical facts on each, see Austin 1983, 176, 196; and Lawrence 1988. The latter has now become a very important English language source for the Behams and others of the so-called "little German masters" (referring to the size of the prints). For a perspicacious review of the Lawrence exhibition and catalogue, see Larry Silver, "Less is More: The 'Kleinmeister' in Kansas," *Print Collector's Newsletter* 19, no. 6 (1988): 213–216.
3. Lawrence 1988, 184.

132
Hans Burgkmair

Lovers Surprised by Death
Chiaroscuro woodcut, printed in black, green, and yellow on
red-brown paper, 1510
212 X 150 (8⁵/₁₆ X 5⁷/₈)
Hollstein 724 3 5
Rosenwald Collection 1948.11.15

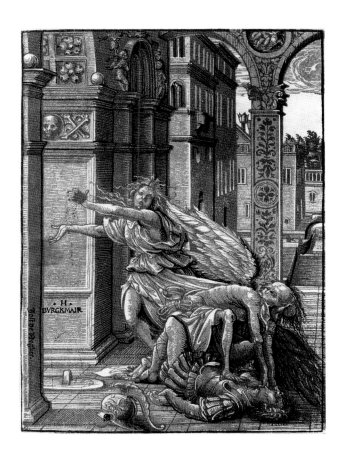

This is perhaps one of the most terrifying images of two lovers
and Death known, for the reason that Death vigorously and
viciously attacks both of them. The soldier lies on his back,
while Death, his foot on the soldier's chest, pries open his
mouth with both hands, as if to reach down his throat and
wrest from him his last breath. The woman tries to flee, but
Death has caught her skirt in his teeth, and one of his great
wings reaches toward her. It has frequently been commented
that images such as this carry with them the implication that
soldiers are as much at risk (if not more so) in courting
women as in being on the battlefield.[1]

Burgkmair worked in Augsburg under the patronage of
Emperor Maximilian I, and the city was a flourishing environ-
ment for the graphic arts in particular. Through its commer-
cial ties with Venice, Augsburg received, and was receptive
to, influences of Italian Renaissance style and interests. The
setting for Burgkmair's print is based on Renaissance architec-
tural motifs, and the view in the middle distance is of a canal
and the prow of a boat. Both of the lovers wear antique
costumes.

The print is the first chiaroscuro known to be made from
three woodbocks, one for the lines and two for the tones. It
has been pointed out, moreover, that each of the three blocks
carries important parts of the image, so that the line block
would be incomplete without the tone blocks.[2] Jost de
Negker, whose name appears on the pilaster at the left, was
the cutter of the blocks and a frequent collaborator of
Burgkmair's.

1. See the discussion in Ann Arbor 1975, cat. 32.
2. See Detroit 1983, cats. 114, 115, and colorplate 5.

133
Jan van de Velde II

Death Taking a Couple by Surprise
Etching, c. 1625(?)
202 x 156 (7^{15}/$_{16}$ x 6^{1}/$_{8}$)
Franken/Keller 115
Rosenwald Collection 1943.3.8238

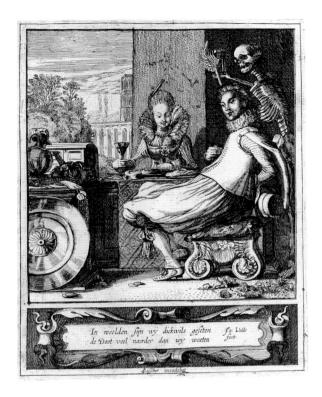

An attractive and elegantly dressed young couple is shown dining outdoors on a terrace. Their postures are relaxed, and they are smiling slightly. At the right, behind the man and unseen by either person is the skeletal figure of Death, who holds an hourglass above their heads. At the lower right, on the floor, are scattered flower blossoms, soon to fade. The inscription below the image reads: "In luxury are we often seated closer to death than we know."[1] Both the text and the image make it clear that death may come at any time, and that excesses—of food, drink, material comforts, sexuality—bring one closer to Death.

1. Arthur Wheelock kindly provided the translation from the Dutch.

134
Anonymous Italian, sixteenth century

Allegory of Vanity (Death Surprising a Woman)
Engraving
359 X 252 (14⅛ X 9¹⁵/₁₆)
Bartsch XV .298.1 (1920)
Rosenwald Collection 1961.17.6

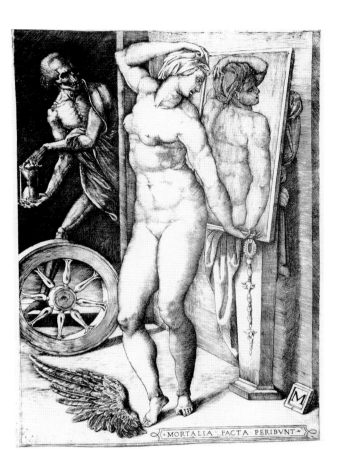

This print has been given a Neoplatonic interpretation by
Anne B. Freedberg, who has connected the wing on the
ground with Plato's concepts of the mortal and the immortal
souls in his *Phaedrus*. The immortal soul soars to heaven,
while the mortal soul drops its wings, settles on earth, and
assumes human qualities. The mortal, represented here, has
become susceptible to Death, Time, and Fortune, as repre-
sented by the skeleton, the hourglass, and the wheel. The in-
terpretation is reinforced by the fact that the nude female
looks at her back in the mirror, presumably emphasizing the
loss of her wings, and by the inscription at the lower right,
which reads: "Made Mortal They Must Die."[1]

The print has been attributed by some scholars to the circle
of Agostino Veneziano de' Musi (c. 1490–c. 1540). Agostino,
however, inscribed his prints with an "AV" when using a
monogram. Freedberg suggested that the "M" on the tablet
at the lower right may refer to Michelangelo, since the nude
resembles his sculpture, *Dying Slave* (now Louvre, Paris),
made for the Tomb of Julius II.

1. Freedberg's analysis is summarized in Ann Arbor 1975, cat. 52.

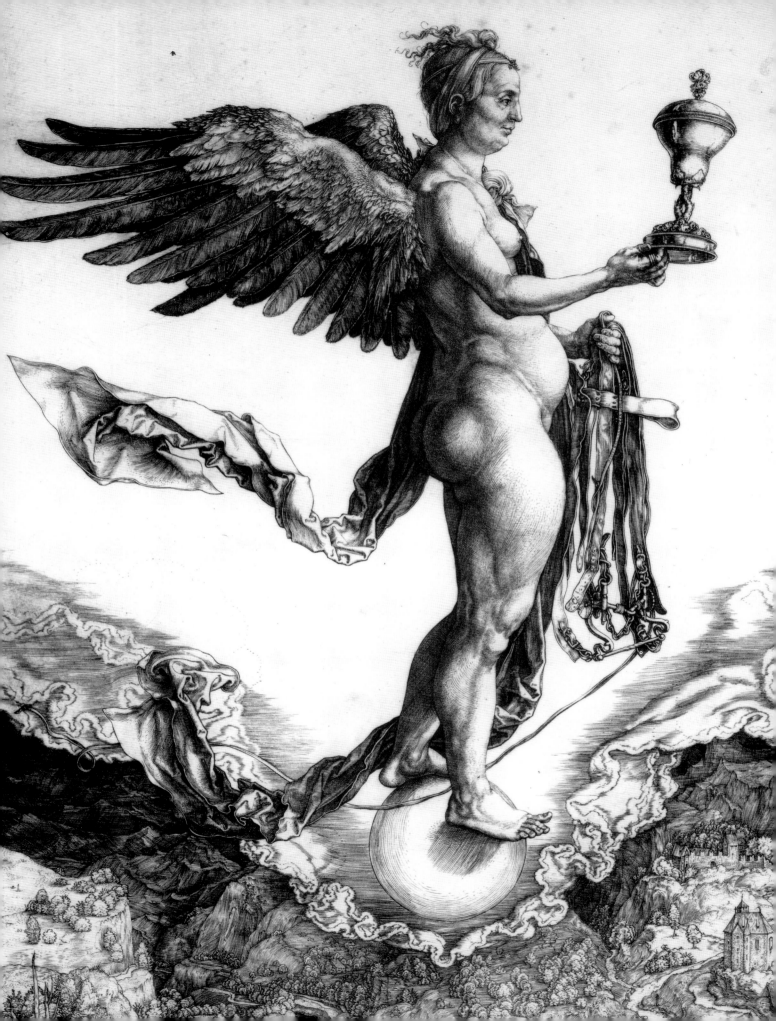

VII
FORTUNE AND PRUDENCE

The prints on view in this section represent the female personifications of Fortune and Prudence. The latter is one of the cardinal virtues (with Temperance, Fortitude, and Justice). Fortune, by contrast, embodies a locus of ideas concerning the force of chance affecting a person's life. Both concepts originated in antiquity. Prudence and the other cardinal virtues eventually joined with the theological virtues, Faith, Hope, and Charity to form the "Seven Virtues." These Virtues are commonly represented in the arts of the Renaissance and baroque periods. Many images of Fortune are also found, and during the sixteenth century, Fortune became frequently conflated with other concepts, especially Opportunity (Occasio).

Men have sometimes been used to personify ideas, qualities, and the like, but it has been much more common to use women. Why is this so? The question is posed only for speculation, since any answer would be fraught with problems. Marina Warner, in her book studying the allegory of the female form, has discussed linguistic gender.[1] She notes that the laws of gender in languages are "arbitrary and adventitious," but she posits the following as a pattern that begins to emerge: "feminine gender is animate, it was named by grammarians after the biological maternal role of female animals, it depends for its verbal formation on the masculine, and it often describes effects or actions."[2]

In the present context, it is best simply to acknowledge that Fortune and Prudence are female nouns in gendered languages, and to focus on how they are visually represented. Prudence is the easier of the two to comment on. As in a standard dictionary definition, to be prudent is to take care to avoid undesired consequences; to be circumspect and discreet. Prudence is usually shown with two faces, so that she can inform herself by looking both forward and backward, as in cat. 147, where she also holds a mirror, to gain self-knowledge. In an image that describes the prudent person's way of proceeding (cat. 150), she stands in the front center, a sifter or colander on her head so as to sift possible occurrences and actions. Around her, men and women take various measures to protect themselves from such possibilities as flood and famine. Prudence was considered an antidote to the vagaries of Fortune (as was Patience). The reasons will quickly become clear.

The most ubiquitous characterization of Fortune focused on her fickleness and capriciousness in meting out good and bad fortune to people. Fortune was thought to exercise power over peoples' external, material goods. Her most frequently represented attribute was a wheel, which turns inexorably and in such a fashion that it rises and falls. In medieval art, people were often depicted as small figures caught in the spokes of a huge wheel; some were shown falling off.[3] The wheel continued to appear in some Renaissance depictions (cat. 137), but more often one finds Fortune standing on, holding, or standing near a sphere (cat. 138). Because a sphere turns easily, it again stresses Fortune's instability.

Ernst Cassirer has drawn a sharp contrast between medieval views of Fortune as she affected peoples' lives and Renaissance views. He pointed out that Dante's image of Fortune was one of intellectual unity. Dante "forced all opposing themes into one great synthesis, making of Fortune an entity with its own being and character and at the same time fitting it into the spiritual and divine cosmos. Such unity was never achieved again."[4] In Renaissance views, by contrast, Fortune remains a powerful force affecting human beings, but she can be influenced greatly by people who take quick and bold action.[5] For example, both Leon Battista Alberti and Machiavelli believed that man could triumph over Fortune by pitting his *virtù,* his manliness, against her.[6] Cioffari has stressed that Machiavelli expanded the areas in which Fortune could affect man, encompassing not only external goods but the events of life itself. He denied to Fortune the providential character that earlier writers had given her and been concerned with, and he focused instead on the practical ways in which man, through his free will, could gain control of his own destiny.[7]

A common representation of Fortune in Renaissance images is reflected in a later print by Rembrandt (cat. 146): Fortune stands at the mast of a sailboat, but the ultimate control of the boat is in the hands of the men who occupy it. In other images of the fifteenth through seventeenth centuries, Fortune is sometimes shown literally seized by a male figure. During this period, Fortune and Opportunity became increasingly conflated, and sometimes it was Opportunity who was seized.[8]

In several prints exhibited here (cats. 137–139), the female personifications of Fortune stand by themselves. They are reminders of the presence of Fortune in human affairs. It is perhaps not surprising, therefore, to find that Dürer's powerful image of *Fortune/Nemesis* (cat. 139) was the stimulus for other artists' images that incorporate Fortune's physiognomy and

attributes with reminders of the inevitability of death (see cats. 141, 142).

Fortune, of course, affected both men and women, but representations of Fortune in the Renaissance and baroque periods tend to emphasize her womanliness, especially when she is shown nude. This creates images that are strongly gendered. Fortune's capriciousness becomes identified with the supposed capriciousness and irrationality of actual women. Actual women, moreover, did not share with men the capacity for *virtù*. It was uniquely men who, by their power to reason and after long study and strenuous efforts, were capable of opposing and controlling the forces of Fortune.

1. See Warner 1985, 63–87.

2. Warner 1985, 68.

3. See, for example, the illustrations in F. P. Pickering, *Literature and Art in the Middle Ages* (Coral Gables, 1970), figs. 1a–8b. Figs. 8a–b are early sixteenth-century prints by Georg Pencz and Hans Burgkmair that depict the large wheel, demonstrating that the tradition continued long after the middle ages. See also Pickering's discussion of Fortuna (pp. 168–222).

4. Cassirer 1972, 76. For another consideration of Dante's views on Fortune, see Vincenzo Cioffari, "The Function of Fortune in Dante, Boccaccio, and Machiavelli," *Italica* 24, no. 1 (March 1947): 1–13.

5. The adage *Fortuna audentes juvat* (Fortune favors the bold) is in fact a Roman one, which Kiefer 1983, 202, points out was frequently revived in the fifteenth and sixteenth centuries.

6. On these two men, see Cassirer 1972, 77. For Alberti's discussion of Fortune, see especially Guarino 1971, 26–34, his preface to *Della Famiglia*. He also wrote about Fortune in one of his *Intercenales*. See Leon Battista Alberti, *Dinner Pieces,* trans. David Marsh (Binghamton, 1987), 23–27. On Machiavelli's views of Fortune, which, as many writers have noted, are sometimes contradictory, see especially Pitkin 1984.

7. On the "function of indeterminism or the element of chance" in the universe, from Greek philosophy to the rise of humanism, see Cioffari 1973.

8. For illustrations as well as a discussion of the conflations, see Kiefer 1983, 193–231.

I o son fortuna buona, ho mecco Amore,
Se mi conosci, ti farò signore.

135
Anonymous Italian, sixteenth century

Allegory of Fortune
Engraving
249 x 187 (9¹³/₁₆ x 7³/₈)
Andrew W. Mellon Fund 1977.80.1

The pagan goddess Fortune, who was thought to control material goods and to give them out or take them away according to her capricious fancy, became greatly popular in ancient Rome. Specialized cults were devoted to her. Fortuna Dux and Fortuna Redux guided mariners, and the Fortune of war gave the laurels to victors. Fortuna Virilis was the goddess of love and marriage.[1] Love continued to be associated with Fortune into the early modern period, and it is love with which the present image is concerned. The inscription reads: "I am good fortune, I have love with me. If you know me, I will make you a Gentleman."[2] The last word, *Signore,* would seem to convey the idea of being a master of love, riches, and social position.

Fortune here has two of her familiar attributes, the great wings and the sphere or globe. She also holds a small child, the personification of Love. This print is, as far as we know, undescribed, and as indicated above, the artist is unknown.

1. See Patch 1922, 154. Preliminary research on the Fortune theme was carried out by Bernadine Barnes, who kindly made it available to me.
2. My thanks to Diane DeGrazia for her translation from the Italian.

136
Giorgio Ghisi, after Giulio Romano(?)

Victory
Engraving, 1556
235 x 129 (9¼ x 5¹/₁₆)
Bartsch 34
Rosenwald Collection 1964.8.1033

In a recent, comprehensive exhibition of Ghisi's works, this figure was designated *Allegorical Figure Holding a Sphere* and dated to the mid-1560s.[1] She has also been called Fortune, Victory, and Temperance. As Suzanne Boorsch has pointed out, she is very similar to the engraving *Primo Mobile* (see fig. 136a) from the E-Series Tarocchi engravings by an anonymous Ferrarese artist of about 1465.[2] That figure is part of the set of prints of the Ten Firmaments, which outlines the world as it

fig. 136a. Master of the E-Series Tarocchi, *Primo Mobile (Prime Mover)*, from *E-Series (Ten Firmaments): no. XLIX*, c. 1465, engraving with traces of gilding, 179 x 100 (7 x 4), National Gallery of Art, Washington, Ailsa Mellon Bruce Fund 1969.6.22 (Hind I, p. 240, no. 49a).

was known to the middle ages: the sun, moon, planets, fixed stars, Prime Mover, and, finally, the Prima Causa, or First Cause.[3] As explained in a discussion of the Ten Firmaments, the Primo Mobile "is the ninth and last of the material spheres, beyond the region of the fixed stars. Crystalline and invisible, it is in direct contact with God, the First Cause, and takes from him its infinite speed, from which the lower spheres derive their various slower motions."[4] As attractive as the connection is, one must note that Ghisi's figure is remarkably stationary and is, moreover, placed in an enclosed, box-like space. She remains closest, it would seem, to personifications of Fortune, although Fortune normally either stands on the globe or places it beside her (see cat. 137),

and it is not really appropriate to contain an image of Fortune in a closed space.

While the figure seems to defy certain identification, its visual source was known to Bartsch. He pointed out that she is found in one of the borders of the nine frescoes in the Loggia of the Grotto, Palazzo del Te, Mantua, which were designed by Giulio Romano. Unfortunately, the context she is in there is not very helpful to unraveling her meaning, for the iconography of the room itself is uncertain. Ghisi could easily have known the visual source at first hand. He was himself a Mantuan artist, born there in 1522. After spending time in both Antwerp and Paris, from about 1550 until the end of the 1560s, he returned to his native city.[5]

1. New York 1984, cat. 38.
2. For information on the E-Series as well as S-Series Tarocchi, see Washington 1973, 81–157.
3. Washington 1973, 140–157.
4. Washington 1973, 156.
5. See New York 1984, 15–30, for biographical information on Ghisi, and 137, fig. 54, for a reproduction of Giulio's figure.

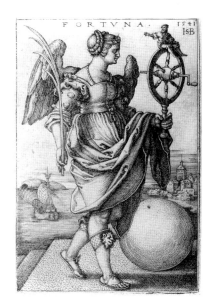

137
Hans Sebald Beham

Fortune
Engraving, 1541
78 x 50 (3^{1}/$_{16}$ x 1^{15}/$_{16}$)
Pauli 1911a, no. 143 3/4
Rosenwald Collection 1943.3.1073

Beham's engraving is inscribed *Fortuna* on the plate, and even if it were not, it is one of the clearest depictions of the pagan goddess among the prints assembled here. Her great wings as well as the sheaf of wheat and the wheel that she holds in either hand, are all traditional attributes of Fortune. So is the large sphere, placed on the ground at the right, which indicates her worldwide dominion. On the wheel is a small man (the artist perhaps?), who reaches out toward her in a pleading gesture; it is evident that he is subject to the powers of this goddess, who was known for her extreme capriciousness in meting out both good and bad fortune to human beings. The wheel, of course, is an apt symbol for her fickleness; inexorably turning, it makes plain the inevitable ascent and descent of human fortunes. The town shown in the right background and the ship at sea to the left indicate the scope of Fortune's realm.

Since antiquity, moreover, Fortune had had a special association with the sea. She was often shown with a rudder or a prow, demonstrating that she had the capacity to direct the course of a person's life.[1] She was also likened to the wind. As

Cicero wrote in *De officiis,* "When we enjoy her favoring breeze, we are wafted over to the wished for haven; when she blows against us, we are dashed to destruction."[2] She was sometimes shown actually holding the sail of a ship (see cat. 146).

Fortune was especially venerated in ancient Rome, so much so that Pliny expressed alarm over her cult.[3] Her worship was attacked by Augustine after his conversion to Christianity, and it was considered by many Christian thinkers, especially the Protestant Reformers of the sixteenth century, to conflict irredeemably with worship of the One God. Fortune, as concept and force, nevertheless survived through the middle ages and into the seventeenth century. The question throughout the Renaissance was how a person was to deal with Fortune. Alberti, for example, thought that a sufficiently determined individual could prevail over her. Ficino was skeptical and recommended the standard remedies of exercising patience and prudence in attempting to overcome her powers. Machiavelli encouraged an aggressive stance against her; he thought that she must be opposed by *virtù,* by which he meant "manliness," and his advocacy of counterattack recalls the ancient Roman adage: "Fortune favors the bold."[4]

The use of male or female figures to personify abstract concepts, qualities or characteristics is a very complex one.[5] We might simply point out here that it is of particular significance that Fortune should be presented as a woman. The way in which Fortune was thought of and described in ancient as well as early modern literature corresponds remarkably to how ordinary woman was thought of: volatile, wayward, inconstant, uncertain, fickle.[6] When Fortune is depicted as a nude female, moreover, other elements may come to bear. She can, for example, be shown as enticing men with her physical charms. Urs Graf in several drawings went so far as to define her as a harlot, who sometimes was and sometimes was not willing to give favors for money.[7] In Dürer's formidable *Nemesis* (cat. 139), which incorporates aspects of Fortune, the woman is shown as a very powerful, muscular human specimen. Unattractive according to classical as well as northern European ideas of female beauty, she repels rather than entices by her physique.

Through the efforts of a number of scholars, especially Howard Patch, Frederick Kiefer, and Hanna Pitkin, we have learned that Fortune was far more than a convention to writers, thinkers, and, indeed, visual artists of the early modern period. She was seriously regarded as a figure who exercised formidable control over the events of their lives.

1. Kiefer 1983, 195.
2. As quoted by Kiefer 1983, 195–196.
3. See the passage from Pliny's *Natural History,* 2:22, as translated in Robinson 1946, 212–213.

4. For an overview, see Kiefer 1983, especially 1–29; see also 197, for an account of how when Giovanni Rucellai asked Ficino if it was within man's power to counter Fortune's caprice, Ficino replied that he believed few men could prevail against her; fig. 4, for an illustration of Rucellai's coat of arms showing Fortune holding the sail of a ship; and pp. 199–203, and throughout Pitkin 1984, for Machiavelli's views. For Alberti's discussion of Fortune in the preface to *Della Famiglia,* see Guarino 1971, 27–34.
5. See Warner 1985 for an extensive study of woman used as an allegorical form.
6. The words are in fact Pliny's, from *Natural History,* 2:5, as quoted by Kiefer 1983, 1.
7. The drawings by Graf were explored in this respect by Christiane Andersson in her paper "Eros and Satire in the Drawings of Urs Graf," presented at the Center for Advanced Study in the Visual Arts, National Gallery of Art, in 1982.

138
Albrecht Dürer

Little Fortune
Engraving, c. 1496
120 X 65 (4¹¹/₁₆ X 2⁹/₁₆)
Meder/Hollstein 71
Rosenwald Collection 1943.3.3461

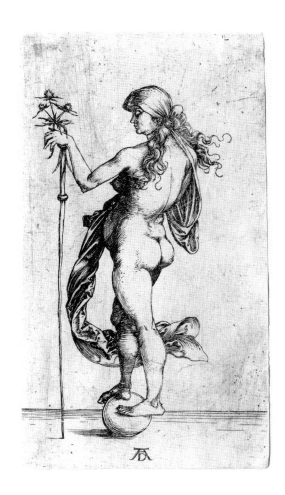

Dürer's figure was apparently inspired by one of the muses in Mantegna's painting *Parnassus* (now in the Louvre, Paris), or perhaps by the engraving of the muses made by Zoan Andrea.[1] The artist has, however, chosen to emphasize the sway of the figure, which, as in much medieval sculpture, requires some kind of external support, in this case, a staff, to steady her. The support is all the more necessary since she stands on a sphere, itself an unsteady base, and deliberately so since it is meant to indicate the unsteadiness of Fortune in human lives.

Like many depictions of Fortune, this figure is "blind." Fortune was sometimes shown blindfolded, but here she either has her eyes closed or they are without pupils.[2] In her hand, she holds a flower, identified by Panofsky as an Eryngium, symbolic of luck in love. As he further commented, "In transferring the attribute of the Eryngium to the goddess Fortuna, Dürer found a humanistic way of saying that love is both omnipotent and fickle."[3]

This print is one of the earliest works in which the artist conjoined the motif of the classical nude with classical subject matter.[4] It seems, however, that Dürer was never thoroughly comfortable with the nude form, male or female, although he came to master it from a conceptual and technical point of view (see cat. 63). Here, he shied away from showing the front view of Fortune's body, emphasizing instead a three-quarter rear position that focuses attention on her back and hips. When, some six or seven years later, Dürer turned once again to the creation of a goddess on a sphere, he boldly but still unclassically defined her anatomy and made her embody enormous power over the lives of human beings (see cat. 139).

1. See Washington 1971, cat. 6. For an illustration of Zoan Andrea's engraving, see Washington 1973, cat. 85.
2. Washington 1971, 115.
3. Panofsky 1971, 70.
4. Panofsky 1971, 70.

139
Albrecht Dürer

Nemesis (The Great Fortune)
Engraving, c. 1501/1502
334 x 230 (13⅛ x 9¹/₁₆)
Meder/Hollstein 72
Gift of R. Horace Gallatin 1949.1.21

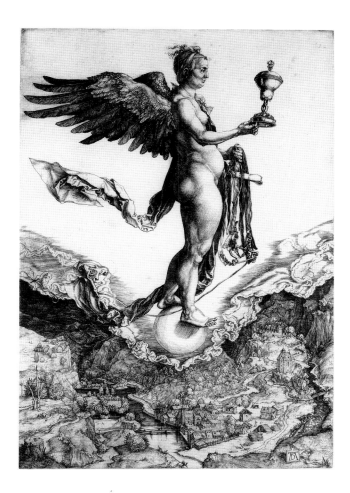

Nemesis is one of Dürer's most influential prints, as can be seen here in other prints that were inspired by it (for example, cats. 141 and 142; there are many others). In the diary that Dürer kept on his much later trip to the Netherlands, this print is recorded as one of those he took with him to give as gifts, exchange for works of other artists, and so on. It is also from the diary that one discovers that the identity of the figure is Nemesis, ancient goddess of vengence and retribution.[1] In early scholarship, this print was referred to as *The Great Fortune* to distinguish it from his print known as *The Small Fortune* (cat. 138), and indeed Nemesis does evoke Fortune in certain respects.[2]

In an exhaustive examination of the ancient and Renaissance sources for the *Nemesis,* Panofsky reaffirmed the finding of Giehlow that the principal literary source is Poliziano's *Manteo,* a poem dedicated to Lorenzo the Magnificent of Florence.[3] There the goddess is described as walking aloft and carrying a bridle and a bowl. In addition to Poliziano's work, Panofsky proposed that Dürer also knew the passage in Pomponius Laetus' *Manual of Roman History* in which the goddess is referred to as "virgin and victress," one who punished the bad and rewarded the good. He concluded that Dürer's visual prototype, suggested by this latter text, was one of the ancient Roman coins that depicted Victory with wings, in profile, and standing on a sphere that symbolized her dominion over the world. The artist is likely to have seen such coins in his friend Pirckheimer's collection.[4]

The figure of Nemesis is said to have been based on a system of proportions, making it part of the proportional studies that Dürer was carrying out at this time. This is not easy to verify, however, and the puzzle remains as to why he chose to represent a classical goddess in what has been called a "grotesque" body.[5] Her facial features have sometimes been said to represent his wife, Agnes Dürer, or one of Pirckheimer's daughters. But while there is some evidence that Dürer may have had a sense of humor—rather than always being the meticulous, staid intellectual depicted by Panofsky among others—it seems unlikely that he would have affixed either woman's head to a nude body, at least not in a "public" work.[6]

The depiction of this vengeful goddess is particularly effective when, as here, she is cast as a powerful, muscular nude.

In one of the passages in *The Prince* (c. 1513), where Machiavelli recommends that man take an aggressive stance against Fortune, he writes: "it is better to be impetuous than cautious, because Fortune is a woman and it is necessary in order to keep her under, to cuff and maul her."[7] It is unlikely that one would lightly undertake, or undertake at all, the cuffing and mauling of Dürer's goddess. But both in Machiavelli's discussions of Fortune and in Dürer's image, the gendering of Fortune/Nemesis is of high significance, for she embodies and epitomizes the wrathful power that woman can exercise over man.

The town view below this figure has long been identified as Klausen or Chiuso, situated in the Tyrols, through which Dürer passed on his first trip to Italy. As with other sites, he probably made a watercolor of it, but if so, it has not survived. The minuteness of the scene shown here obviously makes a striking contrast with the huge figure above, a kind of metaphor, again, of the goddess' power over human affairs. The view recalls, too, another passage in *The Prince,* where

Machiavelli likens Fortune to a river and recommends, essentially, that man take prudent action to shore up canals and dikes against the river's potential for damage (see cat. 150).[8] This idea was commonplace enough that Dürer must have been aware of it, and the choice of Klausen, with a calm river winding through it, seems significant, especially when one notes the extreme, stormy darkness in the left distance, as well as the lumber that has been stacked up in the town.

In interpretations of the print, the bridle has always been taken to symbolize the restraining of those who do evil, and the bowl to contain rewards for the good. The vessel here is a closed goblet, however, a fact that has not really been explored. It is in the shape of a pear and is like goblets that were made in the form of fruit in Renaissance Nuremberg. Dürer made designs for goldsmiths to work from in creating such objects.[9] Earlier in this catalogue it was noted that drinking vessels and wine containers were used to symbolize the dangers of drink and its incitement to lust. It seems to me that the goblet proffered here may be one of those Greek gifts that people had long been cautioned against. This would be to say that this *Nemesis* is in her fully vengeful state.

1. See Dürer 1958 ed., 92–126.
2. On conflations of Fortune and Nemesis, see Kiefer 1983, 34–41.
3. See Panofsky 1962, 13–38.
4. See the Roman Victory coin reproduced in Panofsky 1962, fig. 3.
5. The word is Charles Talbot's, but the sentiment is shared by most viewers. See Washington 1971, cat. 25 and n. 5 for a discussion of the figure's proportions.
6. He did depict Agnes as Saint Anne, a rather different matter. See New York 1986, cats. 143, 144. It is possible, however, that in more general terms, Dürer is indulging in some rather savage humor here at woman's expense, as it were.
7. As quoted by Pitkin 1984, 152.
8. See Kiefer 1983, 199–200.
9. See, for example, the gold goblet, thought to have been designed by Dürer in New York 1986, cat. 208. That object is apple-shaped, and it is noted that in the sketch for the work, Dürer included a snake in the base of the goblet, which the goldsmith then omitted. It seems likely that such objects, even without snakes or the like, continued to be associated with the dangers of drink, if only as clichés.

140
Albrecht Altdorfer

Winged Woman on a Star
Engraving, c. 1515/1518
95 x 48 (3³/₄ x 1⁷/₈)
Winzinger 123b
Rosenwald Collection 1943.3.417

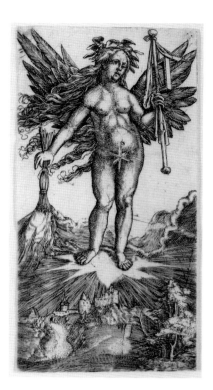

It has not been determined who this figure is or what she represents, but it is widely agreed that Altdorfer took Dürer's *Nemesis* (cat. 139) as his principal source for the idea of placing a winged female nude in the sky and defining a landscape below. The figure is often referred to simply as an "allegorical figure," although it has also been suggested by various scholars that she may represent a witch, Lascivia, Fortune, Frau Welt (a personification of the delusional, mortal world), or Venus.[1] She stands on a star-shaped explosion of light (as opposed to Fortune's globe), has a star covering her genitalia, wears a wreath, perhaps of ivy, holds an inverted torch in one hand and a baton in the other (with Altdorfer's monogram in a cartellino), and is supported by great wings.

The inverted torch usually means earthly as distinguished from celestial love (the latter is personified frequently with an upright torch). The baton could be interpreted as a symbol of authority, as it is used in countless images of military commanders. Silver and Smith have also noted that in an illustration for an *Ovide moralisé* of 1484, Venus is depicted with a star covering her genitalia, and overall, they suggest that the figure may be Venus.[2]

The figure has been acknowledged to be rather visually ambiguous in her attitude, making identification more difficult. Does she communicate a sinister attitude, or does she appear relatively benign?

1. See the discussions of the print in New Haven 1969, cat. 52; Silver and Smith 1978, 265; and Lawrence 1988, cat. 2.
2. Silver and Smith 1978, 294 n. 115.

141
Master MZ

Memento Mori
Engraving, c. 1500/1502
180 x 128 (7¹/₁₆ x 5)
Lehrs 20
Rosenwald Collection 1943.3.186

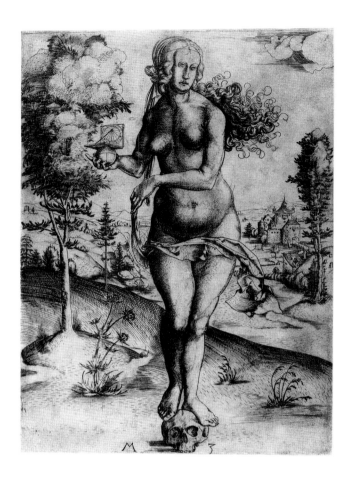

This broad-hipped, small-breasted female nude is often com-
pared with several of Dürer's nudes, including his *Nemesis*
(cat. 139). Viewed frontally rather than sideways, she stands
not on a sphere but on a Death's head. As one scholar has
put it, she is very much rooted in this world, in contrast to
Dürer's airborne goddess, and she offers not the dual possi-
bilities of reward or chastisement, as symbolized by Nemesis'
goblet and bridle, but rather the certainty of death.[1] In addi-
tion to the skull, she holds a portable sundial, a navigational
tool with which one could also calculate time.[2] *Tempus fugit,
vita brevis.* In the background, on the distant hill, is a gallows.
To the left of the figure is the Eryngium, the flower that sym-
bolized luck in love, as seen in Dürer's *Small Fortune* (cat.
138). The nude, together with the flower, invoke the pleasures
of the flesh, but the image simultaneously confronts viewers
with the inevitable fact that such pleasures are ephemeral.

1. See the discussion of the image (in fact, the present impression) in
Ann Arbor 1975, cat. 45.
2. Renaissance Nuremberg was a center for the production of astro-
nomical instruments. See the portable diptych sundial discussed and
reproduced in New York 1986, cat. 244.

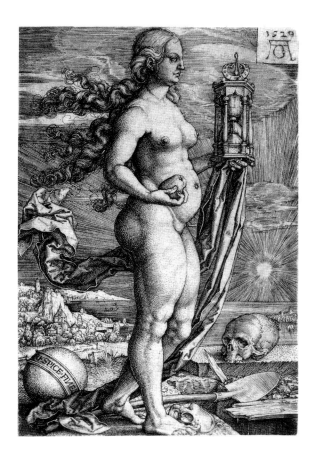

142
Heinrich Aldegrever

Commemoration of the Dead
Engraving, dated 1529
113 x 74 (4⁷/₁₆ x 2⁷/₈)
Bartsch 134
Rosenwald Collection 1943.3.316

Aldegrever's standing female nude is markedly close to
Dürer's *Nemesis* (cat. 139), in her pose, the definition of her
body, the drapery that swirls behind her, and the fact that
both of her hands hold objects. The Anglicized title of the
work is from the Latin inscribed on the globe behind the fig-
ure, which reads *Respice Finem*. Yet if the image is a "com-
memoration," it is also very much a *memento mori* for the
viewer. The skulls on the ground to the right of the figure
have presumably been dug up from the open grave with the
spade that lies next to it, but the skulls and grave are a re-
minder that life ends for all. This idea is further reinforced by
the hourglass that the figure holds in her left hand, above a
setting sun in the far distance. The pear that she holds in her
other hand may allude to the forbidden fruit of the Garden of
Eden, which, having been eaten by Adam and Eve, led to un-
avoidable mortality. The globe itself may refer to the world-
wide scope of mortality.

As in the case of the *Memento Mori* by Master MZ (cat.
141), this figure is earthbound, and the voluptuous nature of
her body emphasizes both carnality and its imminent fading
away. Both images are, of course, related to the many images
of the Renaissance and baroque periods that stressed the brev-
ity of life and the inevitable decay of the flesh (see, for ex-
ample, cats. 132–134).

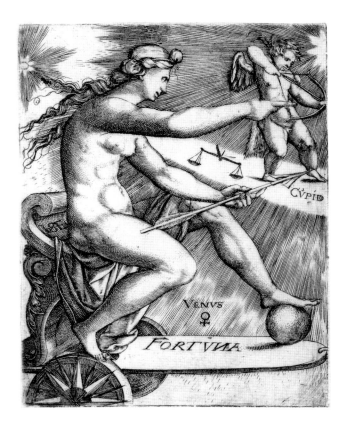

143
Johann Ladenspelder

Venus/Fortuna
Engraving
107 x 82 (4³/₁₆ x 3³/₁₆)
Hollstein 63
Rosenwald Collection 1950.1.87

Fortune and Venus were frequently associated in literature and the visual arts (as seen, for example, in cats. 135 and 138). Their association, indeed their clear conflation, is also evident in the present engraving, which, conveniently, has been precisely labeled by the artist. Venus/Fortune is seated in a chariot, holding one of Cupid's arrows and directing him to shoot at an unseen target to the right. A large star is behind her, and star-shaped spokes form the wheels of her chariot; stars were sometimes associated with Venus (see cat. 138). As Fortune, she rests her left foot on the traditional attribute of the sphere.

While Venus and Fortune are conflated here, in many other instances the two maintain their separate identities, and they may be either allies or adversaries. Both goddesses were sometimes concerned with lovers and intervened in love affairs, for good or ill. Fortune was sometimes portrayed as undoing what Venus had done.[1] Cupid, or Love, child of Venus, was often portrayed with the two goddesses. Kiefer writes at length, moreover, about the topos of Fortune, Love, and Death in literature and Elizabethan tragedy, and notes that the three occur most often in love poetry. He quotes the following beginning of a poem by Petrarch as an early example of the topos: "Give me peace, O my cruel thoughts! / Is it not enough that Love, Fortune, and Death / besiege me around and at the very gates, / without having to find other enemies within?"[2]

1. Patch 1967, 94–96.
2. Kiefer 1983, 173, but also 158–192.

144
Cornelis Schut

Neptune on the Sea and Fortune on a Sphere
Held by Occasio
Etching
247 x 321 (9^{11}/$_{16}$ x 12^{5}/$_{8}$).
Hollstein 124
Ailsa Mellon Bruce Fund 1972.28.94

This title, offered as an alternate one by Hollstein, is almost undoubtedly the correct one. In this reading, the personification of Occasio—Occasion in the sense of Opportunity—holds the sphere on which Fortune stands, and puts her right hand under Fortune's right foot, so as to catch her if she becomes unbalanced. In addition to the sphere, Fortune is shown with a billowing drape that acts as a sail, and she has a shock of hair (forelock) wildly blowing in the wind.[1] In the sixteenth century, Occasio came to be represented as riding the sea waves in a boat. Here the boat seems to be a shell with a great fish

under it, perhaps a dolphin, whose tail is seen toward the right. The dolphin came to be associated with Fortune as Fortune became more closely allied with Occasio. According to Kiefer, this was owing to "the dolphin's swiftness, variability, and friendliness."[2]

Fortune and Opportunity became increasingly linked and sometimes conflated in the sixteenth and seventeenth centuries. The reason for this was the growing belief that man could indeed control or influence events governed by Fortune if he seized Opportunity at the right moment.[3] Here, in the collaboration of the two, it would seem that they have enlisted the help of the sea god, Neptune, who precedes their boat. The two putti in the sky may be little wind gods. The identity of the child in the boat, helping to hold the sphere, is uncertain.

1. Occasio herself was sometimes represented with a forelock.
2. Kiefer 1983, 205.
3. The alliance and sometimes conflation of the two is found in sixteenth-century emblem books, such as Alciati's. For a discussion, with illustrations, see Kiefer 1983, 193–231.

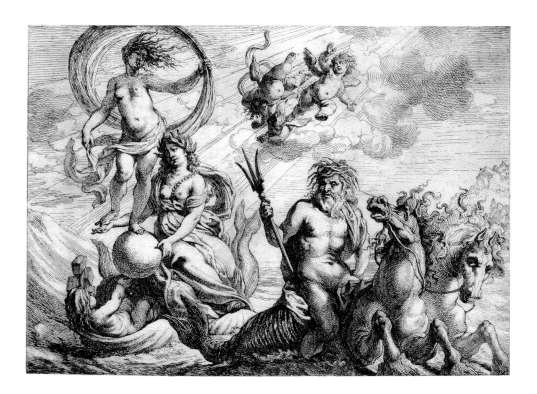

145
Simone Cantarini

Fortune
Etching, c. 1635/1636
251 x 158 (9⁷/₈ x 6³/₁₆)
Bartsch 34 2/2
Ailsa Mellon Bruce Fund 1971.37.40

This is a rather lighthearted portrayal of Fortune compared with several of the images exhibited here. The relaxed pose of the goddess nicely conveys her casual attitude and the typically capricious act of letting loose coins from a bag. The depiction emphasizes her identity as the goddess of material goods. Cupid is shown pulling her hair in a playful way, and his presence may carry some meaning about the foolish behavior of people who are under the sway of love.

Bartsch pointed out that the inscription at the lower right, indicating that the seventeenth-century Italian painter and etcher, Guido Reni, invented and etched the plate, is false.

146
Rembrandt van Rijn

The Ship of Fortune
(illustration to E. Herckmans' *Der Zee-Vaert Lof,*
Amsterdam, 1634)
Etching, dated 1633
113 x 166 (4⁷/₁₆ x 6¹/₂)
White/Boon III 2/2
Rosenwald Collection 1943.3.7092

This is one of only three etchings by Rembrandt that were
used as illustrations in bound books. The title of the particu-
lar book in which this print appeared (see above), is translated
Praise of Sea-Faring, a long narrative poem by the seaman-
poet Herckmans (other prints in the book are by Willem
Basse). As Clifford Ackley has made clear, the image refers to
the text of the third book of the poem, and it was placed at
the beginning of that text. In the foreground, on the fallen
horse, is the Emperor Augustus, who, having defeated Marc
Antony at Actium, now gestures for peace to begin. In the

left background is the Temple of Janus, the doors of which
are being closed to signify peace, and in front of the temple is
a statue of Janus. At the right, a group of merchant ships are
setting sail, and the one just pushing off is guided by the god-
dess Fortune, who acts as the mast and holds the sail.[1]

Fortune is undoubtedly shown here in her role as goddess
of mariners, one of her special assignments during Roman
times, when her cult flourished. While she was thought to be
a fickle goddess, the motif of her acting as a mast is usually in-
terpreted as a favorable omen. Kiefer has suggested that when
she is represented in this way, she is taken to symbolize the
wind; the sail, then, can be adjusted to her force by man,
who can trim it or hoist it.[2] That reading would seem appro-
priate here, in what is certainly meant to laud the beginning
of a new era of peace and prosperity.

1. The information in this paragraph is taken from Boston 1981, cat.
84, where an impression of the print and text in its book form is
illustrated.
2. See Kiefer 1983, 195–196, where he is focusing on the impresa of
Giovanni Rucellai. It incorporates Fortune as mast in a ship with sail.
Kiefer says that representations of Fortune with sail are rare in ancient
art but commonplace by the sixteenth century.

147

Master of the E-Series Tarocchi

Prudencia (Prudence)
(from *The Virtues* series)
Engraving, c. 1465
185 x 105 (7¼ x 4⅛)
Hind 35a
Rosenwald Collection 1943.3.955

Prudence is one of a set of the *Virtues* produced by a Ferrarese artist active around 1465. The set is part of the elaborate series of prints known as the *Tarocchi*, sometimes popularly but incorrectly called "The Tarocchi Cards of Mantegna." As has long been recognized, the series is not a set of tarot cards, and it has no connection with Mantegna.[1]

The Virtues have a long history of representation (see cat. 150). By the time this set was created, the attributes associated with each of the Virtues were reasonably well fixed. Prudence is characteristically shown with two faces. The bearded face of an old man represents the capacity of Prudence for retrospection and drawing on experience. The face of the young woman looking into the mirror represents self-knowledge. The small dragon at her feet is a variant of the serpent with which she was commonly shown in the middle ages. Serpents were known for their cleverness and intelligence, especially as reflected in Matthew 10:16: "Behold, I send you out as sheep in the midst of wolves; be wise as serpents and innocent as doves."

Prudence was considered a prime antidote against the capriciousness of Fortune. Schwarz has pointed out, in an article on the mirror in visual images, that the mirror was the "instrument of most faithful reception and rendering." It had long been associated with the Virgin. As he remarks, it was also frequently used as a symbol of the sin of Vanity, that is, in a directly opposite meaning (see cat. 128).[2] The same might be said of the serpent, who used its intelligence to cause catastrophe for humankind in the Garden of Eden.

The *Tarocchi* are often seen in worn, late impressions, as is the case here.

1. For a full discussion of the *Tarocchi,* with illustrations, see Washington 1973, 81–157; cat. 48, for this print.
2. See Heinrich Schwarz, "The Mirror in Art," *Art Quarterly* 15 (Summer 1952): 96–118; 104–105, for this print.

148
Marcantonio Raimondi, after Raphael(?)

Prudence
Engraving, c. 1513/1514
107 X 81 (4³/₁₆ X 3³/₁₆)
Bartsch 371
Rosenwald Collection 1946.21.314

Marcantonio's engraving depicts Prudence with two of her prime attributes, the mirror and the serpentlike dragon (see cat. 147). She is also shown seated on a lion. The artist may have "borrowed" the lion from the many representations of Fortitude in which it accompanies that Virtue.[1] The lion has two important meanings that are relevant to Fortitude, strength and courage, but it was also, according to medieval thought, believed to represent watchfulness; supposedly, the lion slept with its eyes open. Something like the latter meaning would seem most appropriate to Prudence.[2]

1. For example, see Washington 1973, cat. 49, for the Virtue of Fortitude in the *Tarocchi* series.
2. The lion sometimes appeared with the Virtue of Perseverance in medieval art. See, for example, Mâle 1984, 131–132, and fig. 95.

149
Lucas van Leyden

Prudencia (Prudence)
(from *The Virtues* series)
Engraving, dated 1530
162 x 107 (6³/₈ x 4³/₁₆)
Hollstein 130 I/3
Rosenwald Collection 1943.3.5644

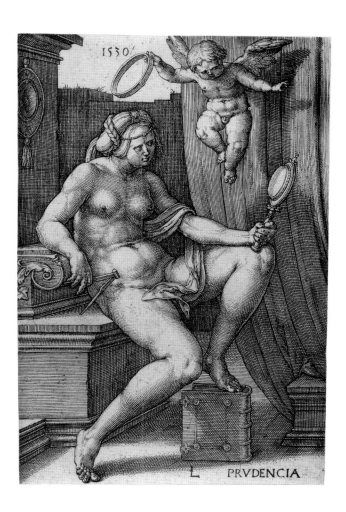

This *Prudence* by Lucas is from a series of the *Seven Virtues* and is the only one actually dated on the plate (see Hollstein 127–133). The figure here holds her usual attribute, a mirror, places her foot on a book (which appears in many medieval depictions of Prudence), and holds a compass (for measurement). The latter also seems to be held by the Tarocchi *Prudence* (cat. 147). In each print in Lucas' series, the Virtue is accompanied by a small putto who carries a crown.[1]

Silver and Smith have pointed to what they term a "heritage of chasteness" in representations of the Christian Virtues.[2] Before Lucas, only the Master IB created nude figures to represent the Virtues, but as the two scholars have stressed, those figures are noted for their decorum and dignity. By contrast, Lucas "deliberately exploited the conflict between nudity and virtue to the fullest, by choosing as his subject the Christian virtues and giving form to those virtues in female nudes of uncompromising physicality, . . . in provocative poses."[3] As Silver and Smith see it, the viewer is asked to invoke his (or her?) intellect to rise above the sensuality communicated by the nudes and thereby to comprehend the spiritual truths of the Christian Virtues.

1. According to Silver and Smith 1978, 271, Lucas borrowed the putti and crowns from Marcantonio's engraving (Bartsch 247) after Raphael's *Parnassus* in the Vatican, Rome.
2. See Silver and Smith 1978, 271–275, for a discussion of Lucas' series.
3. Silver and Smith 1978, 274, and figs. 43–47, for illustrations of the Master IB's prints.

150
Philippe Galle, after Pieter Bruegel the Elder

Prudence
(from *The Seven Virtues* series)
Engraving, published 1559
219 x 293 (8⁹/₁₆ x 11¹/₂)
Bastelaer 136
Rosenwald Collection 1943.3.2114

According to Christian thought, the Seven Sins together with the Seven Virtues encompassed all aspects of human conduct. Bruegel made drawings for a series of prints of both the Sins and the Virtues.[1] Prudence is, of course, one of the Virtues, specifically one of the natural or cardinal Virtues, which were considered to be common to humankind: the others are Justice, Fortitude, and Temperance. The theological Virtues, which bring the number to seven, are Faith, Hope, and Charity, and these were thought to have been imparted to humans by God through Christ. The principal source for the latter is 1 Corinthians 13:13, a passage famous in Paul's teachings.

In both series of prints, Bruegel personified the particular Sin or Virtue as female, and the figure is almost always placed in the center foreground of a large scene, as here. The remainder of the space shows men and women engaged in various kinds of activities that adumbrate the Virtue or Sin being focused on. Here, Prudence has a colander on her head, which probably indicates that one must separate good from evil. Her mirror is the usual attribute of Prudence, symbolizing the necessity of knowing oneself. The coffin is a *memento mori,* for one must live in constant awareness that death will come.[2]

The inscription reads: "If you wish to be prudent, think always of the future, and weigh all conceivable contingencies."[3] At the left, a man who is bedridden has summoned both the physician and the priest, surely a prudent act for one who is very ill and may not recover. At the right, women are shown preparing food to put away for the winter. Behind them, men are storing bundles of branches for fuel, and beyond them, other men are repairing a house.

Prudence was considered the most important of the natural Virtues, and it was the particular antidote to the vagaries of Fortune.

1. The Seven Deadly Sins were engraved by Pieter van der Heyden and published by Hieronymus Cock in 1558. Philippe Galle is probably the engraver for all of the Virtues, and Cock is again the publisher; the dates are 1559–1560. The tradition of representing the Virtues and Sins or Vices is a very long and rich one. See Katzenellenbogen 1964.
2. See Klein 1963, 235–237, and 179–211, 213–245, for discussions and illustrations of both series.
3. Klein 1963, 235.

151
Martin Schongauer

The Fourth Wise Virgin
(from *The Wise and Foolish Virgins* series)
Engraving, c. 1490
122 x 83 (4¹³/₁₆ x 3¹/₄)
Lehrs 79
Rosenwald Collection 1943.3.75

The parable of the wise and foolish virgins comes from Matthew 25:1–13 and, as Shestack has pointed out, "illustrates that the righteous must always be prepared to enter the kingdom of heaven, since the gates of heaven will be closed to the careless and the foolish."[1] The parable involves a bridegroom who will meet his bride and take her to his house for the wedding feast; these figures and events are understood to represent Christ, the Church, and entry into the kingdom of heaven, respectively.[2] Going to meet the bridegroom, five wise virgins plan ahead. They take with them flasks of oil for their lamps, and when the bridegroom is delayed until midnight, they have light for him to find them. Five other virgins, the foolish ones, do not prepare. They have no extra oil for their lamps and must go to shops to buy it. When they return, the house of the bridegroom is closed to them and they are not taken in to the wedding feast, meaning, of course, that they cannot enter heaven.

Schongauer's prints of the wise virgin and of the foolish one that follows (cat. 152) are part of a series he did on the subject. In the present work, the figure holds her lighted lamp and wears a small crown or wreath of laurel, symbol of victory. In the image of the foolish virgin, the wreath has fallen to the ground, the figure holds her empty lamp upside-down, and she rubs a tear from her eye.

The subject was a popular one in medieval sculpture and was included in some of the extensive sculptural cycles of medieval churches. Among the best known of these works are the wise and foolish virgins at the Cathedral of Strasbourg, not so far from Schongauer's home in Colmar. Katzenellenbogen has called attention to the elaborate program on the west porch of St. Gilles at Argenton-Château, c. 1135, where the virgins, as well as personifications of the Virtues and Vices, to which they are related, are part of a Last Judgment cycle. The cycle is intended to provoke the faithful to take heed of the coming day of reckoning.[3]

1. Washington 1967, cats. 101–104.
2. Some biblical scholars take the parable to derive from the Palestinian custom of bridegrooms fetching their brides from the houses of the women's parents and taking them to their own.
3. See Katzenellenbogen 1964, 17–18.

152
Martin Schongauer

The Third Foolish Virgin
(from *The Wise and Foolish Virgins* series)
Engraving, c. 1490
120 x 84 (4¹¹/₁₆ x 3⁵/₁₆)
Lehrs 83
Rosenwald Collection 1952.8.299

Shestack has linked Schongauer's elegant figures representing
the wise virgins (see cat. 151) and foolish virgins, with their
high-waisted dresses and long trains, to Franco-Flemish
manuscript illuminations of the early fifteenth century.[1] On
the subject matter, see the preceding entry (cat. 151).

1. Washington 1967, cats. 101–104.

SELECT BIBLIOGRAPHY

I. CATALOGUES RAISONNÉ

Bartsch
Bartsch, Adam. *Le Peintre-graveur.* 21 vols. Vienna, 1802–1821.

Bastelaer
Bastelaer, René van. *Les estampes de Pieter Bruegel l'Ancien.* Brussels, 1908.

Bellini
Bellini, Paolo. *L'opera incisa di Simone Cantarini.* Milan, 1980.

Bohlin
Bohlin, Diane DeGrazia. *Prints and Drawings by the Carracci Family.* Washington, 1979.

Eisler
Eisler, Colin. *The Master of the Unicorn: The Life and Work of Jean Duvet.* New York, 1979.

Franken/Kellen
Franken, Daniel, and J. Ph. van der Kellen. *L'oeuvre de Jan van de Velde.* 2d ed. Amsterdam, 1968.

Hind
Hind, Arthur M. *Early Italian Engraving: A Critical Catalogue with Complete Reproductions of All the Prints Described.* 7 vols. New York, 1938, 1948.

Hollstein
Hollstein, F.W.H. *Dutch and Flemish Etchings, Engravings, and Woodcuts, ca. 1450–1700.* 29 vols. to date. Amsterdam, 1949–.

Hollstein
Hollstein, F.W.H. *German Engravings, Etchings, and Woodcuts, ca. 1400–1700.* 28 vols. to date. Amsterdam, 1954–.

Lehrs
Lehrs, Max. *Geschichte und kritischer Katalog des deutschen, niederländischen, und französischen Kupferstichs im 15. Jahrhunderts.* 9 vols. Vienna, 1908–1934.

Lieure
Lieure, Jules. *Jacques Callot.* 8 vols. Paris, 1924–1929.

Meder/Hollstein
Meder, Joseph. *Dürer-Katalog: Ein Handbuch uber Albrecht Dürers Stiche, Radierungen, Holzschnitte, deren Zustande, Ausgaben, und Wasserzeichen.* Vienna, 1932.

Passavant
Passavant, Johann David. *Le peintre-graveur.* 6 vols. Leipzig, 1860–1864.

Pauli 1911
Pauli, Gustav. *Barthel Beham: Ein kritisches Verzeichnis seiner Kuperstiche.* Strasbourg, 1911.

Pauli 1911a
Pauli, Gustav. *Hans Sebald Beham: Nachtrage zu dem kritischen Verzeichnis seiner Kuperstiche, Radierungen und Holzschnitte.* Strasbourg, 1911.

Schreiber
Schreiber, W. L. *Handbuch der Holz– und Metallschnitte des XV. Jahrhunderts.* 8 vols. Leipzig, 1926–1930.

White and Boon
White, Christopher, and Karel G. Boon. *Rembrandt's Etchings: An Illustrated Catalogue.* 2 vols. Amsterdam, 1969.

Winzinger
Winzinger, Franz. *Albrecht Altdorfer: Graphik: Holzschnitte, Kupferstiche, Radierungen.* Munich, 1963.

Zerner
Zerner, Henri. *Ecole de Fontainebleau: Gravures.* Paris, 1969.

II. BOOKS AND ARTICLES

Adams 1982
Adams, J. N. *The Latin Sexual Vocabulary.* Baltimore, 1982.

Anderson 1980
Anderson, Jaynie. "Giorgione, Titian, and the Sleeping Venus." In *Tiziano e Venezia: Convegno Internaztionale di Studi.* Vicenza, 1980.

Andersson 1982
Andersson, Christiane. "Eros and Satire in the Drawings of Urs Graff." Paper presented at the Center for Advanced Study in the History of Art, 1982.

Andrews 1977
Andrews, Keith. *Adam Elsheimer: Paintings, Drawings, Prints.* Oxford, 1977.

Bal 1987
Bal, Mieke. *Lethal Love: Feminist Literary Readings of Biblical Love Stories.* Bloomington, and Indianapolis, 1987.

Bassein 1984
Bassein, Beth Ann. *Women and Death: Linkages in Western Thought and Literature.* Contributions in Women's Studies, no. 44. Westport, Conn., 1984.

Bedaux 1986
Bedaux, Jan Baptist. "The Reality of Symbols: The Question of Disguised Symbolism in Jan van Eyck's Arnolfini Portrait." *Simiolus* 16 (1986): 5–28.

Bell 1985
Bell, Rudolph M. *Holy Anorexia.* Chicago and London, 1985.

Berger 1985
Berger, John. *Ways of Seeing.* London, 1985.

Bialostocki 1981
Bialostocki, Jan. "La gamba sinistra della Giuditta: Il quadro di Giorgione nella storia del tema." In *Giorgione e l'Umanismo Veneziano.* Florence, 1981.

Bialostocki 1988
Bialostocki, Jan. "Judith: The Story, the Image, and the Symbol. Giorgione's Painting in the Evolution of the Theme." In *The Message of Images.* Vienna, 1988.

Bible
The New Oxford Annotated Bible with the Apocrypha. Revised
Standard Version. Edited by Herbert G. May and Bruce M.
Metzger. New York, 1977.

Blok 1981
Blok, Anton. "Rams and Billy–goats: A Key to the Mediterranean
Code of Honour." Man 16 (1981): 427–440.

Boccaccio 1963 ed.
Boccaccio, Giovanni. Concerning Famous Women (De claris
mulieribus). Translated by Guido A. Guarino. New Brunswick,
1963.

Brandenbarg 1987
Brandenbarg, Ton. "St. Anne and Her Family: The Veneration of
St. Anne in Connection with Concepts of Marriage and the Family
in the Early–modern Period." In Saints and She–Devils, edited by
Lène Dresen–Coenders. London, 1987.

Broude and Garrard 1982
Broude, Norma, and Mary D. Garrard, eds. Feminism and Art
History: Questioning the Litany. New York, 1982.

Brown 1988
Brown, Peter. The Body and Society: Men, Women, and Sexual
Renunciation in Early Christianity. Lectures on the History of
Religion, n.s., no. 13. New York, 1988.

Bryson 1986
Bryson, Norman. "Two Narratives of Rape in the Visual Arts:
Lucretia and the Sabine Women." In Rape, edited by Sylvana
Tomaselli and Roy Porter. Oxford and New York, 1986.

Bryson 1988
Bryson, Norman, ed. Calligram: Essays in New Art History from
France. Cambridge and New York, 1988.

Burkhard 1932
Burkhard, Arthur. Hans Burgkmair d. Ä. Berlin, 1932.

Bury 1985
Bury, Michael. "The Taste for Prints in Italy to c. 1600." Print
Quarterly 2/1 (1985): 12–26.

Bynum 1982
Bynum, Caroline Walker. Jesus as Mother: Studies in the
Spirituality of the High Middle Ages. Berkeley and Los Angeles,
1982.

Calabi
Calabi, Augusto. "Tempesta." In Ulrich Thieme and Felix Becker,
Allgemeines Lexikon der bildenden Künstler, vol. 32. Leipzig, 1915–
1950.

Callmann 1979
Callmann, Ellen. "The Growing Threat to Marital Bliss as Seen in
Fifteenth-Century Florentine Painting." Studies in Iconography 5
(1979): 73–92.

Carroll 1978
Carroll, Eugene A. "A Drawing by Rosso Fiorentino of Judith and
Holofernes." Bulletin of the Los Angeles County Museum of Art 24
(1978): 25–49.

Carroll 1986
Carroll, Michael P. The Cult of the Virgin Mary: Psychological
Origins. Princeton, 1986.

Carroll 1989
Carroll, Margaret. "The Erotics of Absolutism: Rubens and the
Mystification of Sexual Violence." Representations 25 (Winter 1989):
3–30.

Casey 1976
Casey, Paul F. The Susanna Theme in German Literature. Bonn,
1976.

Cassirer 1972
Cassirer, Ernst. The Individual and the Cosmos in Renaissance
Philosophy. Translated by Mario Domandi. Reprint. Philadelphia,
1972.

Chrisman 1972
Chrisman, Miriam U. "Women and the Reformation in
Strasbourg, 1490–1530." Archive für Reformationgeschichte 63 (1972):
143–168.

Christensen 1979
Christensen, Carl C. Art and the Reformation in Germany. Athens,
Ohio, and Detroit, 1979.

Christine de Pisan 1982 ed.
Christine de Pisan. The Book of the City of Ladies. Translated by
E. J. Richards, with foreword by M. Warner. New York, 1982.

Cioffari 1973
Cioffari, Vincenzo. "Fortune, Fate, and Chance." In Dictionary of
the History of Ideas, edited by Philip Weiner. New York, 1973.

Clark 1986
Clark, Elizabeth A. Ascetic Piety and Women's Faith: Essays on Late
Ancient Christianity. Studies in Women and Religion, vol. 20.
Lewiston, 1986.

Coltellacci 1981
Coltellacci, Stefano, Ilma Reho, and Marco Lattanzi. "Problemi di
iconologia nelle immagini sacre—Venezia c. 1490–1510." In
Giorgione e la cultura veneta tra '400 e '500, Mito, Allegoria,
Analisi iconologica. Rome, 1981.

Copertini 1932
Copertini, Giovanni. Il Parmigianino. 2 vols. Parma, 1932.

Croce 1953
Croce, Benedetto. "Lucrezia nella poesia e nella casistica morale."
In Aneddoti di Varia Letteratura, vol. 1. Bari, 1953.

Cuttler 1968
Cuttler, Charles D. Northern Painting from Pucelle to Bruegel. New
York, 1968.

D'Ancona 1905
D'Ancona, Paolo. "Gli affreschi del Castello di Manta nel
Saluzzese." L'Arte 8 (1905): 94–106.

Davidson 1987
Davidson, Jane P. The Witch in Northern European Art, 1470–
1750. Science and Research, vol. 2. Freren, 1987.

Davis 1975.
Davis, Natalie Zemon. Society and Culture in Early Modern France.
Stanford, 1975

Della Pergola 1967
Della Pergola, Paola. "P. P. Rubens e il tema della Susanna al
bagno." Bulletin des Musées Royaux des Beaux–Arts de Belgique 16
(1967): 7–22.

Detlev 1922
Detlev, Baron von Hadeln. "Early Works by Tintoretto—II."
Burlington Magazine 41 (1922): 278–279.

Diamond and Quinby 1988
Diamond, Irene, and Lee Quinby, eds. *Feminism & Foucault:
Reflections on Resistance.* Boston, 1988.

Dresen-Coenders 1987
Dresen-Coenders, Lène, ed. *Saints and She-Devils.* London, 1987.

Donaldson 1982
Donaldson, Ian. *The Rapes of Lucretia: A Myth and Its
Transformations.* Oxford, 1982.

Duby 1988
A History of Private Life. II. Revelations of the Medieval World.
Edited by Georges Duby. Translated by Arthur Goldhammer.
Cambridge and London, 1988.

Dunand 1972
Dunand, Louis. "La Figuration de Suzanne surprise au bain par
deux vieillards dans les estampes—apropos de deux graveurs des
Carracche sur ce thème au Musée des Beaux-Arts de Lyon."
Bulletin des Musées et Monuments Lyonnais 5 (1972): 57–79.

Dunn 1977
Dunn, Catherine. "The Changing Image of Woman in Renaissance
Society and Literature." In *What Manner of Woman,* edited by
Marlene Springer. New York, 1977.

Dürer 1958 ed.
Dürer, Albrecht. *The Writings of Albrecht Dürer.* Edited and
translated by William Martin Conway. New York, 1958.

Dussler 1971
Dussler, Luitpold. *Raphael: A Critical Catalogue of His Pictures,
Wallpaintings, and Tapestries.* London and New York, 1971.

Dwyer 1971
Dwyer, Eugene J. "The Subject of Dürer's *Four Witches.*" *The
Art Quarterly* 34 (1971): 456–473.

Ehrenstein 1923
Ehrenstein, Theodor. *Das Alte Testament im Bilde.* Vienna, 1923.

Eisler 1979
Eisler, Colin. *The Master of the Unicorn: The Life and Work of Jean
Duvet.* New York, 1979.

Fahy 1956
Fahy, Conor. "Three Early Renaissance Treatises on Women."
Italian Studies 11 (1956): 30–55.

Faranda 1971
Faranda, Rino, ed. *Detti e Fatti Memorabili di Valerio Massimo.*
Turin, 1971.

ffolliott 1986
ffolliott, Shiela. "Catherine de' Medici as Artemisia: Figuring
the Powerful Widow." In *Rewriting the Renaissance,* edited by
Margaret W. Ferguson, Maureen Quilligan, and Nancy J. Vickers.
Chicago and London, 1986.

Freedberg 1984
Freedberg, David. *The Life of Christ after the Passion.* Corpus
Ludwig Rubenianum Ludwig Burchard, vol. 7. Oxford and New
York, 1984.

Freedberg 1989
Freedberg, David. *The Power of Images: Studies in the History and
Theory of Response.* Chicago and London, 1989.

Friedlaender 1955
Friedlaender, Walter. *Caravaggio Studies.* Princeton, 1955.

Frye 1978
Frye, Roland Mushat. *Milton's Imagery and the Visual Arts:
Iconographic Tradition in the Epic Poems.* Princeton, 1978.

Galinsky 1932
Galinsky, Hans. *Der Lucretia-stof in der weltliteratur.* Breslau, 1932.

Garrard 1982
Garrard, Mary D. "Artemisia and Susanna." In *Feminism and Art
History.* New York, 1982, 146–171.

Garrard 1989
Garrard, Mary D. *Artemisia Gentileschi: The Image of the Female
Hero in Italian Baroque Art.* Princeton, 1989.

Geisberg 1930
Geisberg, Max. "Israhel van Meckenem." *Print Collector's
Quarterly* 1 (1930): 236–237.

Geisberg 1974
Geisberg, Max. *The German Single-Leaf Woodcut, 1500–1550.*
4 vols. Revised and edited by Walter L. Strauss. New York, 1974.

Gilbert 1952
Gilbert, Creighton. "On Subject and Not-Subject in Italian
Renaissance Pictures." *Art Bulletin* 34 (1952): 202–216.

Gilbert 1989
Gilbert, Creighton. "On Castagno's Nine Famous Men and
Women." In *Life and Death in 15th Century Florence,* edited by M.
Tetel, R. G. Witt, and R. Goffen. Durham and London, 1989,
174–192.

Ginzburg 1985
Ginzburg, Carlo. *The Night Battles: Witchcraft and Agrarian
Cults in the Sixteenth and Seventeenth Centuries.* Translated by
John and Anne Tedeschi. Harrisonburg, Va., 1985.

Goffen 1987
Goffen, Rona. "Renaissance Dreams." *Renaissance Quarterly* 40
(Winter 1987): 682–706.

Grafton and Jardine 1986
Grafton, Anthony, and Lisa Jardine. *From Humanism to the
Humanities: Education and the Liberal Arts in Fifteenth- and
Sixteenth-Century Europe.* London, 1986.

Guarino 1971
Guarino, Guido A., trans. *The Albertis of Florence: Leon Battista
Alberti's "Della Famiglia."* Cranbury, N.J., 1971.

Guillaume 1972
Guillaume, Jean. "Cleopatra nova Pandora." *Gazette des beaux-
arts* 80 (1972): 185–194.

Hand 1982
Hand, John Oliver. "Saint Anne with the Virgin and the Christ
Child by the Master of Frankfurt." *Studies in the History of Art* 12
(1982): 43–52.

Hand and Wolff 1986
Hand, John O., and Martha Wolff. *Early Netherlandish Paintings*. The Collections of the National Gallery of Art, Systematic Catalogue. Washington, D.C., 1986.

Harprath 1974
Harprath, Richard. "Drei neue Zeichnungen von Parmigianino." *Mitteilungen des kunsthistorisches Institutes in Florenz* 18 (1974): 370–378.

Hartmann 1973
Lucretia Dramen [von] Heinrich Bullinger [und] Hans Sachs. Edited by H. Hartmann. Leipzig, 1973.

Hazard 1979
Hazard, Mary E. "Renaissance Aesthetic Values: 'Example' for Example." *Art Quarterly* 2 (1979): 1–36.

Henry 1988
Henry, Avril. *Bibliapauperum*. Ithaca, N.Y., 1988.

Herlihy and Klapisch-Zuber 1985
Herlihy, David, and Christiane Klapisch-Zuber. *Tuscans and Their Families: A Study of the Florentine Catasto of 1427*. New Haven, 1985.

Herzner 1980
Herzner, Volker. "Die 'Judith' der Medici." *Zeitschrift für Kunstgeschichte* 43 (1980): 139–180.

Hieatt 1980
Hieatt, A. Kent. "Eve as Reason in a Tradition of Allegorical Interpretation of the Fall." *Journal of the Warburg and Courtauld Institutes* 43 (1980): 221–226.

Hind 1963
Hind, Arthur M. *An Introduction to a History of Woodcut*. 2 vols. New York, 1963.

Hofrichter 1980
Hofrichter, Frima Fox. "Artemesia Gentileschi's Uffizi *Judith* and a Lost Rubens." *Rutgers Art Review* 1 (1980): 9–15.

Hope 1980
Hope, Charles. "Problems of Interpretation in Titian's Erotic Paintings." In *Tiziano e Venezia: Convegno Internazionale di Studi*. Vicenza, 1980, 111–124.

Horney 1932
Horney, Karen. "The Dread of Woman: Observations on a Specific Difference in the Dread Felt by Men and Women Respectively for the Opposite Sex," *International Journal of Psycho-analysis* 13 (July 1932): 348–360.

Howell 1986
Howell, Martha C. *Women, Production, and Patriarchy in Late Medieval Cities*. Chicago, 1986.

Huizinga 1954
Huizinga, J. *The Waning of the Middle Ages*. Garden City, N.Y., 1954.

Hults 1984
Hults, Linda C. "Baldung's *Bewitched Groom* Revisited: Artistic Temperament, Fantasy, and the 'Dream of Reason.'" *The Sixteenth Century Journal* 15 (1984): 259–279.

Hults 1987
Hults, Linda C. "Baldung and the Witches of Freiburg: The Evidence of Images." *The Journal of Interdisciplinary History* 18 (1987): 249–276.

Hutchison 1966
Hutchison, Jane Campbell. "The Housebook Master and the Folly of the Wise Man." *Art Bulletin* 48 (1966): 73–78.

Hutchison 1972
Hutchison, Jane Campbell. *The Master of the Housebook*. New York, 1972.

Jacobus de Voragine 1969 ed.
The Golden Legend of Jacobus de Voragine. New York, 1969.

Jaffé and Groen 1987
Jaffé, Michael, and Karin Groen. "Titian's *Tarquin and Lucretia* in the Fitzwilliam." *Burlington Magazine* 129 (1987): 162–172.

Janson 1952
Janson, Horst Woldemar. *Apes and Ape Lore in the Middle Ages and the Renaissance*. London, 1952.

Joost-Gaugier 1976
Joost-Gaugier, Christine L. "A Rediscovered Series of Uomini Famosi from Quattrocento Venice." *Art Bulletin* 58 (1976): 184–195.

Joost-Gaugier 1980
Joost-Gaugier, Chistine L. "Giotto's Hero Cycle in Naples: A Prototype of Donne Illustré and a Possible Literary Connection." *Zeitschrift für Kunstgeschichte* 43 (1980): 311–318.

Jordan 1986
Jordan, Constance. "Feminism and the Humanists: The Case of Sir Thomas Elyot's *Defence of Good Women*." In *Rewriting the Renaissance,* edited by Margaret W. Ferguson, Maureen Quilligan, and Nancy J. Vickers. Chicago and London, 1986, 242–258.

Jordan 1987
Jordan, Constance. "Boccaccio's In-Famous Women: Gender and Civic Virtue in the *De mulieribus claris*." In *Ambiguous Realities: Women in the Middle Ages and the Renaissance,* edited by Carole Levin and Jeanie Watson. Detroit, 1987.

Kahr 1966
Kahr, Madlyn. "Rembrandt's *Esther*: A Painting and an Etching Newly Interpreted and Dated." *Oud Holland* 81 (1966): 228–244.

Katzenellenbogen 1959
Katzenellenbogen, Adolf. *The Sculptural Program of Chartres Cathedral*. Baltimore, 1959.

Katzenellenbogen 1964
Katzenellenbogen, Adolf. *Allegories of the Virtues and Vices in Medieval Art*. Reprint. New York, 1964.

Kaufman 1978
Kaufman, Gloria. "Juan Luis Vives on the Education of Women." *Signs* 3 (1978): 891–896.

Kaufmann 1970
Kaufmann, Thomas DaCosta. "*Esther before Ahasuerus:* A New Painting by Artemisia Gentileschi in the Museum's Collection." *The Metropolitan Museum of Art Bulletin* 29 (1970): 165–169.

Kaufmann 1985
 Kaufmann, Thomas DaCosta. "Hermeneutics in the History of Art: Remarks on the Reception of Dürer in the Sixteenth and Early Seventeenth Centuries." In *New Perspectives on the Art of Renaissance Nuremberg: Five Essays,* edited by Jeffrey Chipps Smith. Austin, 1985.

Kelly 1984
 Kelly, Joan. *Women, History, and Theory.* Chicago, 1984.

Kelso 1956
 Kelso, Ruth. *Doctrine for the Lady of the Renaissance.* Urbana, 1956.

Kiefer 1983
 Kiefer, Frederick. *Fortune and Elizabethan Tragedy.* San Marino, 1983.

King and Rabil 1983
 King, Margaret L., and Albert Rabil, Jr., eds. *Her Immaculate Hand: Selected Works by and about the Women Humanists of Quattrocento Italy.* Binghamton, N.Y., 1983.

Klaits 1985
 Klaits, Joseph. *Servants of Satan: The Age of the Witch Hunts.* Bloomington, 1985.

Klapisch-Zuber 1985
 Klapisch-Zuber, Christiane. *Women, Family, and Ritual in Renaissance Italy.* Translated by Lydia Cochrane. Chicago, 1985.

Klein 1963
 Klein, H. Arthur. *Graphic World of Pieter Bruegel the Elder.* New York, 1963.

Kleinbaum 1983
 Kleinbaum, Abby Wettan. *The War Against the Amazons.* New York, 1983.

Koerner 1985
 Koerner, Joseph. "The Mortification of the Image: Death as a Hermeneutic in Hans Baldung Grien." *Representations* 10 (1985): 52–101.

Labalme 1984
 Labalme, Patricia H., ed. *Beyond Their Sex: Learned Women of the European Past.* New York, 1984.

Ladurie 1987
 Ladurie, Emmanuel Le Roy. *Jasmin's Witch.* Translated by Brian Pearce. New York, 1987.

Landau 1978
 Landau, David, ed. *Catalogo completo dell'opera grafica di Georg Pencz.* English translation by Anthony Paul. Milan, 1978.

Landsberger 1946
 Landsberger, Franz. *Rembrandt, the Jews, and the Bible.* Philadelphia, 1946.

Lawner 1987
 Lawner, Lynne. *Lives of the Courtesans: Portraits of the Renaissance.* New York, 1987.

LCK
 Aurenhammer, Hans. *Lexikon der Christlichen Ikonographie.* 6 vols. Vienna, 1959–1967.

Leach 1976
 Leach, Mark Carter. "Rubens' *Susanna and the Elders* in Munich and Some Early Copies." *Print Review* 5 (1976): 120–127.

Lee 1967
 Lee, Rensselaer W. *Ut pictura poesis: The Humanistic Theory of Painting.* New York, 1967.

Lightbown 1978
 Lightbown, Ronald. *Sandro Botticelli.* 2 vols. London, 1978.

Lightbown 1986
 Lightbown, Ronald. *Mantegna.* Berkeley and Los Angeles, 1986.

Lurie 1965
 Lurie, Anna Tzeutschler. "Jan Steen: Esther, Ahasuerus, and Haman." *Bulletin of the Cleveland Museum of Art* 52 (1965): 94–100.

Machiavelli 1985 ed.
 The Comedies of Machiavelli. Edited and translated by David Sices and James B. Atkinson. Hanover and London, 1985.

Maclean 1977
 Maclean, Ian. "Feminist Literature and the Visual Arts." In *Woman Triumphant: Feminism in French Literature, 1610–1652.* Oxford, 1977.

Maclean 1980
 Maclean, Ian. *The Renaissance Notion of Woman.* Cambridge, 1980.

Mâle 1951
 Mâle, Emile. *L'art religieux de la fin du seizième du dix-septième siècle: Etude sur l'iconographie après le Concile de Trente.* Paris, 1951.

Mâle 1984
 Mâle, Emile. *Religious Art in France—The Thirteenth Century: A Study of Medieval Iconography and Its Sources.* Edited by Harry Bober and translated by Marthiel Mathews from the 9th rev. ed. Princeton, 1984.

Mâle 1986
 Mâle, Emile. *Religious Art in France—The Late Middle Ages: A Study of Medieval Iconography and Its Sources.* Edited by Harry Bober and translated by Marthiel Mathews from the 5th rev. ed. Princeton, 1986.

Malvern 1975
 Malvern, Marjorie M. *Venus in Sackcloth: The Magdalen's Origins and Metamorphoses.* Carbondale and Edwardsville, Ill., 1975.

Mandelbaum 1982
 Mandelbaum, Allen. *The Aeneid of Virgil.* Berkeley, 1982.

Mariacher 1968
 Mariacher, Giovanni. *Palma il Vecchio.* Milan, 1968.

Marrow 1982
 Marrow, Deborah. *The Art Patronage of Maria de' Medici.* Ann Arbor, 1982.

Marshall 1989
 Marshall, Sherrin, ed. *Women in Reformation and Counter-Reformation Europe.* Bloomington, 1989.

McGrath 1984
 McGrath, Elizabeth. "Rubens' *Susanna and the Elders* and the Moralizing Inscriptions on Prints." In *Wort und Bild in der niederlandischen Kunst und Literature des sechzehnten und siebzehnten Jahrhunderts,* edited by Herman Vekeman and Justus Muller Hofstede. Erftsadt, 1984.

Meiss 1978
 Meiss, Millard. *Painting in Florence and Siena after the Black Death.* Princeton, 1978.

Merchant 1980
 Merchant, Carolyn. *The Death of Nature: Women, Ecology, and the Scientific Revolution*. San Francisco, 1980.

Miles 1985
 Miles, Margaret R. *Image as Insight: Visual Understanding in Western Christianity and Secular Culture*. Boston, 1985.

Mommsen 1959
 Mommsen, Theodor E. "Petrarch and the Decoration of the Sala Virorum Illustrium in Padua." In *Medieval and Renaissance Studies*, edited by Eugene F. Rice, Jr. Ithaca, 1959.

Moxey 1980
 Moxey, Keith P.F. "Master E.S. and the Folly of Love." *Simiolus* 2 (1980): 125–148.

Moxey 1989
 Moxey, Keith. *Peasants, Warriors, and Wives: Popular Imagery in the Reformation*. Chicago and London, 1989.

Muller 1958
 Muller, Jean. *Barthel Beham: Kritischer Katalog seiner Kupferstiche, Radierungen, Holzschnitte*. Studien zur deutschen Kunstgeschichte. Baden-Baden and Strasbourg, 1958.

Myers 1966
 Myers, Mary L. "Rubens and the Woodcuts of Christoffel Jegher." *Metropolitan Museum of Art Bulletin* 25 (1966): 7–23.

New Catholic Encyclopedia
 New Catholic Encyclopedia. Prepared by an editorial staff at the Catholic University of America. 16 vols. New York, 1967.

Newman 1968
 Newman, F. X., ed. *The Meaning of Courtly Love*. Albany, 1968.

Nochlin 1988
 Nochlin, Linda. *"Women, Art, and Power" and Other Essays*. New York and Cambridge, 1988.

Nordenfalk 1961
 Nordenfalk, Carl. "Saint Bridget of Sweden as Represented in Illuminated Manuscripts." In *De Artibus Opuscula XL: Essays in Honor of Erwin Panofsky*, edited by Millard Meiss. New York, 1961.

Oberhuber 1963
 Oberhuber, Konrad. "Noch eine Pferdzeichnung von Jacques Callot." *Albertina Studien* 1 (1963): 118–119.

Oberhuber 1963a
 Oberhuber, Konrad. "Parmigianino als Radierer." *Alte und moderne Kunst* 8 (1963): 33–36.

Ortner 1974
 Ortner, Sherry B. "Is Female to Male as Nature is to Culture?" In *Women, Culture, and Society*, edited by Michelle Zimbalist Ranaldo. Stanford, 1974.

Ovid 1976 ed.
 Ovid. *Metamorphoses*. Loeb Classical Library. London, 1976.

Pagels 1988
 Pagels, Elaine. *Adam, Eve, and the Serpent*. New York, 1988.

Panofsky 1962
 Panofsky, Erwin. *Studies in Iconology: Humanistic Themes in the Art of the Renaissance*. Reprint. New York and Evanston, 1962.

Panofsky 1962a
 Panofsky, Erwin. "'Virgo et Victrix': A Note on Dürer's Nemesis." In *Prints: Thirteen Illustrated Essays on the Art of the Print*, edited by Carl Zigrosser. New York, 1962.

Panofsky 1969
 Panofsky, Erwin. *Problems in Titian, Mostly Iconographic*. New York, 1969.

Panofsky 1971
 Panofsky, Erwin. *The Life and Art of Albrecht Dürer*. Reprint. Princeton, 1971.

Patch 1922
 Patch, Howard Rollin. "The Tradition of the Goddess Fortuna in Roman Literature and in the Transitional Period"; and "The Tradition of the Goddess Fortuna in Medieval Philosophy and Literature." *Smith College Studies in Modern Languages* 3 (April 1922): 131–235; and (July 1922): 179–232.

Patch 1967
 Patch, Howard Rollin. *The Goddess Fortuna in Medieval Literature*. Reprint. New York, 1967.

Phillips 1984
 Phillips, John A. *Eve: The History of an Idea*. San Francisco, 1984.

Pigler 1974
 Pigler, Anton. *Barockthemen, eine Auswahl von Verzeichnissen zur Ikonographie des 17. und 18. Jahrhunderts*. 2 vols. 2d ed. Budapest, 1974.

Pitkin 1984
 Pitkin, Hanna Fenichel. *Fortune Is a Woman: Gender and Politics in the Thought of Niccolò Machiavelli*. Berkeley, 1984.

Pohlen 1985
 Pohlen, Ingeborg. *Untersuchungen zur Reproduktionsgraphik der Rubenswerkstatt*. Munich, 1985.

Pollock 1988
 Pollock, Griselda. *Vision and Difference: Femininity, Feminism, and the Histories of Art*. London and New York, 1988.

Pomeroy 1975
 Pomeroy, Sarah Booth. *Goddesses, Whores, Wives, and Slaves: Women in Classical Antiquity*. New York, 1975.

Popham 1971
 Popham, A. E. *Catalogue of the Drawings of Parmigianino*. 3 vols. New Haven and London, 1971.

Power 1975
 Power, Eileen. *Medieval Women*, edited by M. M. Postan. Cambridge, 1975.

Purdie 1927
 Purdie, Edna. *The Story of Judith in German and English Literature*. Paris, 1927.

Rearick 1978
 Rearick, William R[oger]. "Jacopo Bassano and Changing Religious Imagery in the Mid-Cinquecento." In *Essays Presented to Myron P. Gilmore*, edited by Sergio Bertelli and Gloria Ramakus. Florence, 1978.

Réau 1955–1959
 Réau, Louis. *L'iconographie de l'art chrétien*. 3 vols. in 6. Paris, 1955–1959.

Reff 1963
Reff, Theodore. "The Meaning of Titian's *Venus of Urbino*." *Pantheon* 21 (1963): 359–366.

Ringbom 1962
Ringbom, S. "*Maria in Sole* and the Virgin of the Rosary." *Journal of the Warburg and Courtauld Institutes* 25 (1962): 326–330.

Robinson 1946
Robinson, David M. "The Wheel of Fortune." *Classical Philology* 41 (1946): 207–216.

Roelker 1972
Roelker, Nancy Lyman. "The Role of Noblewomen in the French Reformation." *Archiv für Reformationgeschichte* 63 (1972): 169–195.

Romano 1981
Romano, Serena. "Giuditta e il Fondaco dei Tedeschi." In *Giorgione e la cultura veneta tra '400 e '500, Mito, Allegoria, Analisi iconologica*. Rome, 1981.

Rooses and Ruelens 1887–1909
Rooses, Max, and C. Ruelens. *Correspondance de Rubens*. Antwerp, 1887–1909.

Rorimer and Freeman 1948–1949
Rorimer, James J., and Margaret B. Freeman. "The Nine Heroes Tapestries at the Cloisters." *Metropolitan Museum of Art Bulletin* 7 (1948/1949): 243–260.

Rosand 1980
Rosand, David. "Ermeneutica Amorosa: Observations on the Interpretation of Titian's Venuses." In *Tiziano e Venezia: Convegno Internazionale di Studi*. Vicenza, 1980, 375–381.

Rosenberg 1968
Rosenberg, Jakob. *Rembrandt: Life and Work*. London and New York, 1968.

Rotermund 1969
Rotermund, Hans-Martin. *Rembrandt's Drawings and Etchings for the Bible*. Translated by Shierry M. Weber. Philadelphia, 1969.

Ruggiero 1985
Ruggiero, Guido. *The Boundaries of Eros: Sex Crime and Sexuality in Renaissance*. Venice, New York, and Oxford, 1985.

Schama 1988
Schama, Simon. *The Embarrassment of Riches: An Interpretation of Dutch Culture in the Golden Age*. Berkeley, Los Angeles, and London, 1988.

Schroeder 1971
Schroeder, Horst. *Der Topos der Nine Worthies in Literatur und bildenden Kunst*. Göttingen, 1971.

Schulte van Kessel 1986
Schulte van Kessel, Elisja, ed. *Women and Men in Spiritual Culture*. The Hague, 1986.

Schuyler 1987
Schuyler, Jane. "The *Malleus Maleficarum* and Baldung's Witches' Sabbath." *Source: Notes on the History of Art* 6 (Spring 1987): 20–26.

Scott 1988
Scott, Joan Wallach. *Gender and the Politics of History*. New York, 1988.

Shannon 1941
Shannon, Edgar F. In *Sources and Analogues of Chaucer's Canterbury Tales,* edited by W. F. Bryan and Germaine Dempster. Chicago, 1941.

Shapley 1979
Shapley, Fern Rusk. *Catalogue of the Italian Paintings*. 2 vols. National Gallery of Art. Washington, D.C., 1979.

Silver and Smith 1978
Silver, Larry, and Susan Smith. "Carnal Knowledge: The Late Engravings of Lucas van Leyden." *Nederlands Kunsthistorisch Jaarboek* 29 (1978): 239–298.

Simons 1988
Simons, Patricia. "Women in Frames: The Gaze, the Eye, the Profile in Renaissance Portraiture." *History Workshop* 25 (1988): 4–30.

Small 1976
Small, Jocelyn Penny. "The Death of Lucretia." *American Journal of Archaeology* 80 (1976): 349–360.

Smith 1978
Smith, Susan L. " 'To Women's Wiles I Fell': The Power of Women *Topos* and the Development of Medieval Secular Art." Ph.D. diss., University of Pennsylvania, 1978.

Snow 1989
Snow, Edward. "Theorizing the Male Gaze: Some Problems." *Representations* 25 (Winter 1989): 30–41.

Starn 1986
Starn, Randolph. "Reinventing Heroes in Renaissance Italy." *Journal of Interdisciplinary History* 17 (1986): 67–84.

Stechow 1951
Stechow, Wolfgang. "Lucretia Statua." In *Essays in Honor of Georg Swarzenski*. Berlin and Chicago, 1951.

Stewart 1979
Stewart, Alison G. *Unequal Lovers: A Study of Unequal Couples in Northern Art*. New York, 1979.

Stock 1984
Stock, Julien. "A Drawing by Raphael of 'Lucretia,' " *Burlington Magazine* 126 (1984): 423–424.

Stogden 1989
Stogden, Nicholas. *Oh Happy State…!: Prints on a Theme from the 15th to the 20th Century*. Sales catalogue 7, N.G. Stogden, Inc. New York, 1989.

Straten 1983
Straten, Adelheid. *Das Judith-Thema in Deutschland im 16. Jahrhundert: Studien zur Ikonographie*. Munich, 1983.

Strauss 1973
Strauss, Walter L. *Chiaroscuro: The Clair-Obscur Woodcuts by the German and Netherlandish Masters of the XVIth and XVIIth Centuries*. Greenwich, Conn., 1973.

Strauss 1976
Strauss, Gerald. *Nuremberg in the Sixteenth Century: City Politics and Life between Middle Ages and Modern Times*. Bloomington and London, 1976.

Summers 1970
Summers, Montague, ed. and trans. *Malleus Maleficarum*. New York, 1970.

Thomas 1969
 Thomas, David H. "A Note on Marcantonio's Death of Dido."
 Journal of the Warburg and Courtauld Institutes 32 (1969): 394–396.

Tripp 1974
 Tripp, Edward. *The Meridian Handbook of Classical Mythology.*
 New York, 1974.

Vasari/Milanesi 1906 ed.
 Vasari, Giorgio. *Le vite de' più eccellenti pittori, scultori, et
 architetti.* Edited by G. Milanesi. Florence, 1906.

Veldman 1986
 Veldman, Ilja M. "Lessons for Ladies: A Selection of Sixteenth
 and Seventeenth Century Dutch Prints." *Simiolus* 16 (1986): 113–127.

Von Erffa 1969
 Von Erffa, Hans Martin. "Judith—Virtus Virtutum—Maria."
 Mitteilungen des Kunsthistorisches Institut in Florenz 14 (1969/1970):
 460–465.

Von Simson 1953
 Von Simson, Otto. "*Compassio* and *Co-redemption* in Rogier van
 der Weyden's *Descent from the Cross.*" *Art Bulletin* 35 (1953):
 9–16.

Waith 1975
 Waith, Eugene M. "Heywood's Women Worthies." In *Concepts
 of the Hero in the Middle Ages and the Renaissance,* edited by
 Norman T. Burns and Christopher J. Reagan. Albany, 1975.

Walton 1965
 Walton, Guy. "The Lucretia Panel in the Isabella Stuart Gardner
 Museum in Boston." In *Essays in Honor of Walter Friedlaender.*
 New York, 1965.

Warner 1976
 Warner, Marina. *Alone of All Her Sex.* New York, 1976.

Warner 1981
 Warner, Marina. *Joan of Arc.* New York, 1981.

Warner 1985
 Warner, Marina. *Monuments & Maidens: The Allegory of the
 Female Form.* New York, 1985.

Watson 1979
 Watson, Paul F. *The Garden of Love in Tuscan Art of the Early
 Renaissance.* Philadelphia, 1979.

Weinstein and Bell 1982
 Weinstein, Donald, and Rudolph M. Bell. *Saints and Society: The
 Two Worlds of Western Christendom, 1000–1700.* Chicago and
 London, 1982.

Wethey 1975
 Wethey, Harold E. *The Paintings of Titian.* Vol. 3: *The
 Mythological Paintings.* London, 1975.

White 1969
 White, Christopher. *Rembrandt as an Etcher: A Study of the Artist
 at Work.* 2 vols. University Park and London, 1969.

Wiesner 1986
 Wiesner, Merry E. *Working Women in Renaissance Germany.* New
 Brunswick, N.J., 1986.

Wilde 1981
 Wilde, Johannes. *Venetian Art from Bellini to Titian.* Oxford, 1981.

Wilkins 1969
 Wilkins, Eithne. *The Rose-Garden Game: A Tradition of Beads and
 Flowers.* New York, 1969.

Wilson 1987
 Wilson, Katharina M., ed. *Women Writers of the Renaissance and
 Reformation.* Athens and London, 1987.

Wilson and Wilson 1984
 Wilson, Adrian, and Joyce Lancaster Wilson. *A Medieval Mirror:
 Speculum Humanae Salvationis: 1324–1500.* Berkeley, 1984.

Wind 1937
 Wind, Edgar. "Donatello's *Judith:* A Symbol of 'Sanctimonia.'"
 Journal of the Warburg Institute 1 (1937/1938): 62–63.

Wind 1968
 Wind, Edgar. *Pagan Mysteries in the Renaissance.* 2d ed. New
 York, 1968.

Winzinger 1975
 Winzinger, Franz. *Albrecht Altdorfer: Die Gemälde.* Munich, 1975.

Wirth 1979
 Wirth, Jean. *La jeune fille et la mort: Recherches sur les thèmes
 macabres dans l'art germanique de la Renaissance.* Geneva, 1979.

Wright 1940
 Wright, Celeste Turner. "The Amazons in Elizabethan
 Literature." *Studies in Philology* 37 (1940): 433–456.

Wright 1946
 Wright, Celeste Turner. "The Elizabethan Female Worthies."
 Studies in Philology 43 (1946): 628–643.

Wyss 1957
 Wyss, Robert L. "Die neun Helden, eine ikonographische
 Studie." *Zeitschrift für schweizerische Archäologie und
 Kunstgeschichte* 17 (1957): 73–89.

Young 1964
 Young, Arthur M. *Echoes of Two Cultures.* Pittsburgh, 1964.

Zschelletzschky 1974
 Zschelletzschky, Herbert. *Das graphische Werk Heinrich
 Aldegrevers.* Baden-Baden, 1974.

III. EXHIBITION CATALOGUES

Amsterdam 1985
 *Livelier than Life: The Master of the Amsterdam Cabinet or the
 Housebook Master, ca. 1470–1500.* Compiled by J. P. Filedt Kok.
 Rijksprentenkabinet, Amsterdam, 1985.

Ann Arbor 1975
 Images of Love and Death in Late Medieval and Renaissance Art.
 Exh. cat. by William R. Levin, Clifton C. Olds, and Ralph G.
 Williams. The University of Michigan Museum of Art, Ann Arbor,
 1975–1976.

Austin 1983
 Nuremberg: A Renaissance City, 1500–1618. Exh. cat. by Jeffrey
 Chipps. The Archer M. Huntington Art Gallery, The University of
 Texas at Austin, 1983.

Basel 1974
 Lukas Cranach: Gemälde, Zeichnungen, Druckgraphik. Exh. cat.
 by Dieter Koepplin and Tilman Falk. 2 vols. Kunstmuseum, Basel,
 1974.

Boston 1981
Printmaking in the Age of Rembrandt. Exh. cat. by Clifford S. Ackley. Museum of Fine Arts, Boston; Saint Louis Art Museum, 1980–1981.

Boston 1989
Italian Etchers of the Renaissance and Baroque. Exh. cat. by Sue Welsh Reed and Richard Wallace. Museum of Fine Arts, Boston; Cleveland Museum of Art; National Gallery of Art, Washington, 1989.

Brooklyn 1988
Courbet Reconsidered. Exh. cat. by Sarah Faunce and Linda Nochlin. The Brooklyn Museum; The Minneapolis Institute of Arts, 1988–1989.

Claremont 1978
Sixteenth-Century Italian Prints. Exh. cat. by Marcus S. Sopher with the assistance of Claudia Lazzaro-Bruno. Montgomery Art Gallery, Pomona College, Claremont, 1978.

Cleveland 1978
The Graphic Art of Federico Barocci. Exh. cat. by Edmund P. Pillsbury and Louise S. Richards. The Cleveland Museum of Art, 1978.

Detroit 1983
From a Mighty Fortress: Prints, Drawings, and Books in the Age of Luther, 1483–1546. Exh. cat. by Christiane Andersson and Charles Talbot. The Detroit Institute of Arts, 1983.

Lawrence 1981
The Engravings of Marcantonio Raimondi. Exh. cat. by Innis H. Shoemaker and Elizabeth Brown. The Spencer Museum of Art, Lawrence, Kansas, 1981.

Lawrence 1983
Dutch Prints of Daily Life: Mirrors of Life or Masks of Morals? Exh. cat. by Linda A. Stone-Ferrier. The Spencer Museum of Art, Lawrence, Kansas; The Yale University Art Gallery, New Haven; The Huntington Gallery, Austin, Tex., 1983–1984.

Lawrence 1988
The World in Miniature: Engravings by the German Little Masters, 1500–1550. Exh. cat. edited by Stephen H. Goddard. The Spencer Museum of Art, Lawrence, Kansas; Yale University Art Gallery, New Haven; Minneapolis Institute of Arts; Grunwald Center for the Graphic Arts, Los Angeles, 1988–1989.

Los Angeles 1976
Women Artists: 1550–1950. Exh. cat. by Ann Sutherland Harris and Linda Nochlin. Los Angeles County Museum of Art, 1976.

New Haven 1969
Prints and Drawings of the Danube School. Yale University Art Gallery, New Haven; City Art Museum, St. Louis; Philadelphia Museum of Art, 1969–1970.

New York 1980
The Wild Man: Medieval Myth and Symbolism. Exh. cat. by Timothy Husband. The Cloisters, The Metropolitan Museum of Art, New York, 1980–1981.

New York 1984
The Engravings of Giorgio Ghisi. Introduction and entries by Suzanne Boorsch and catalogue raisonné by Michal Lewis and R. E. Lewis. The Metropolitan Museum of Art, New York, 1984.

New York 1986
Gothic and Renaissance Art in Nuremberg, 1300–1550. The Metropolitan Museum of Art, New York, 1986.

Northampton, Mass., 1978
Antiquity in the Renaissance. Exh. cat. by Wendy Steadman Sheard. Smith College Museum of Art, Northampton, Mass., 1978.

Philadelphia 1967
Master E.S.: Five Hundredth Anniversary Exhibition. Exh. cat. by Alan Shestack. Philadelphia Museum of Art, 1967.

Philadelphia 1988
Pietro Testa, 1612–1650: Prints and Drawings. Exh. cat. by Elizabeth Cropper. Philadelphia Museum of Art; Arthur M. Sackler Museum, Cambridge, Mass., 1988–1989.

Princeton 1969
Symbols in Transformation: Iconographic Themes at the Time of the Reformation: An Exhibition of Prints in Memory of Erwin Panofsky. Exh. cat. by Craig Harbison. The Art Museum, Princeton University, Princeton, 1969.

Rome, 1977
Rubens e l'incisione. Exh. cat. by Didier Bodart. Gabinetto Nazionale delle Stampe, Rome, 1977.

Rome 1985
Raphael Invenit. Exh. cat. by Grazia Bernini Pezzini, Stefania Massari, and Simonetta Prosperi Valenti Rodino. Instituto Nazionale per la Grafica, Rome, 1985.

Stanford 1978
Seventeenth-Century Italian Prints. Exh. cat. by Marcus S. Sopher with assistance of Claudia Lazzaro-Bruno. Stanford University Museum of Art, Stanford, 1978.

Stuttgart 1973
Hans Burgkmair: Die Graphische Werk. Graphische Sammlung Staatsgalerie, Stuttgart, 1973.

Vienna 1963
Parmigianino und sein Kreis. Exh. cat. by Konrad Oberhuber. Graphische Sammlung Albertina, Vienna, 1963.

Washington 1965
Fifteenth Century Woodcuts and Metalcuts. Exh cat. by Richard S. Field. National Gallery of Art, Washington, 1965.

Washington 1967
Fifteenth Century Engravings of Northern Europe. Exh. cat. by Alan Shestack. National Gallery of Art, Washington, 1967.

Washington 1971
Dürer in America: His Graphic Work. Exh. cat. by Charles W. Talbot, Gaillard F. Ravenel, and Jay A. Levenson. National Gallery of Art, Washington, 1971.

Washington 1973
Early Italian Engravings from the National Gallery of Art. Exh. cat. by Jay A. Levenson, Konrad Oberhuber, and Jacquelyn L. Sheehan. National Gallery of Art, Washington, 1973.

Washington 1975
Jacques Callot: Prints and Related Drawings. Exh. cat. by H. Diane Russell. National Gallery of Art, Washington, 1975.

Washington 1976
Titian and the Venetian Woodcut. Exh. cat. by David Rosand and Michelangelo Muraro. National Gallery of Art, Washington; Dallas Museum of Fine Arts; Detroit Institute of Arts, 1976–1977.

Washington 1981
Hans Baldung Grien: Prints and Drawings. Exh. cat. by James H. Marrow and Alan Shestack. National Gallery of Art, Washington, 1981.

Washington 1983
The Prints of Lucas van Leyden and His Contemporaries. Exh. cat. by Ellen S. Jacobowitz and Stephanie Loeb Stepanek. National Gallery of Art, Washington, 1983.

Washington 1988
The Art of Paolo Veronese, 1528–1588. Exh. cat. by W. R. Rearick. National Gallery of Art, Washington, 1988–1989.

Washington 1990
Gardens on Paper: Prints and Drawings, 1200–1900. Exh. cat. by Virginia Tuttle Clayton. National Gallery of Art, Washington, 1990.

INDEX OF ARTISTS

Master MZ
German, active, c. 1500
cats. 87, 99, 126, 141

Master S
Flemish, active 1505/1520
cat. 7

Meckenem, Israhel van
German, c. 1445–1503
cats. 2, 34, 60, 89, 110, 115, 116, 117, 120, 124, 125

Mocetto, Girolamo
Italian, c. 1458–c. 1531
cat. 21

Muller, Herman Jansz.
Netherlandish, c. 1540–1617
cat. 102

Parmigianino, Francesco, and after
Italian, 1503–1540
cats. 22, 82, 83

Pencz, Georg
German, c. 1500–1550
cats. 13, 14, 29

Raimondi, Marcantonio
Italian, c. 1480–c. 1534
cats. 5, 6, 77, 79, 93, 148

Raphael Sanzio, after
Italian (Urbino), 1483–1520
cats. 5, 77, 78, 93, 148

Rembrandt van Rijn
Dutch, 1606–1669
cats. 16, 42, 49, 73, 146

Reverdy, Georges
French, active 1531–active 1564/1570
cat. 84

Robetta, Cristofano
Italian, 1462–in or after 1535
cat. 74

Rubens, Peter Paul, after
Flemish, 1577–1640
cats. 19, 32, 45

Schongauer, Martin
German, c. 1450–1491
cats. 46, 55, 59, 61, 151, 152

Schut, Cornelius, I
Flemish, 1597–1655
cat. 144

Strozzi, Bernardo, after
Italian, 1581–1644
cat. 128

Tempesta, Antonio
Italian, 1555–1630
cat. 30

Testa, Pietro
Italian, 1612–1650
cat. 85

Titian (Tiziano Vecellio), after
Italian, c. 1488–1576
cat. 81

Velde, Jan van de, II
Dutch, 1593–1641
cat. 133

Veronese (Paolo Caliari), after
Italian, 1528–1588
cat. 86

Vico, Enea
Italian, 1523–1567
cats. 82, 83

Wenzel von Olmütz
German, active 1481/1497
cat. 112